ANTIHERO

intellect Bristol, UK / Chicago, USA

First published in the UK in 2016 by
Intellect, The Mill, Parnall Road, Fishponds, Bristol, BS16 3JG, UK

First published in the USA in 2016 by
Intellect, The University of Chicago Press, 1427 E. 60th Street, Chicago, IL 60637, USA

Copyright © 2016 Intellect Ltd

A catalogue record for this book is available from the British Library.

Series: Crime Uncovered
Series ISSN: 2056-9629 (Print), 2056-9637 (Online)
Series Editors: Tim Mitchell and Gabriel Solomons
Copy-editing: Emma Rhys
Cover Design: Gabriel Solomons
Layout Design and Typesetting: Stephanie Sarlos
Production Manager: Tim Mitchell

ISBN: 978-1-78320-519-6
ePDF: 978-1-78320-520-2
ePUB: 978-1-78320-631-5

Printed & bound by Bell & Bain, UK.

ANTIHERO

edited by Fiona Peters & Rebecca Stewart

intellect Bristol, UK / Chicago, USA

Contents

EDITOR'S INTRODUCTION

Rebecca Stewart

The antihero, a term that in itself may seem paradoxical, can be found throughout literature, film and television. In *Notes from Underground* (1864), Dostoevsky explicitly relates the word to the notion of the paradox when he subverts the idea of a hero within the novel, and throughout literature we encounter protagonists that are ineffectual, flawed and seemingly contain no qualities that relate to heroism. Although the chapters in this collection all focus on products of the twentieth and twenty-first century, the antihero is certainly not a phenomenon of this time, as seen, for example, in Dostoevsky's existential novella.

Indeed, even the tradition of the hero can be seen to feed into the role of the antihero of modern and contemporary fiction, with Achilles, Oedipus, Antigone, etc. all being capable of extreme violence in honour of their personal codes. However, what the antiheroes looked at in this book all do is critique the notions of heroism by disturbing and disrupting our expectations, and furthermore by enticing us to be complicit in this. We can begin to consider the antihero in terms of negation, of what they are not – honest, idealistic, courageous, honourable, noble. And yet they continue to appeal. The role of the antihero then, it seems, is to challenge the ways in which we see, or wish to see, ourselves, and whereas heroes are celebrated and revered due to their commitment to their honour and pride, the antihero, whilst possibly having their own code of conduct, requires no veneration; in fact, these characters refuse to bow to the expectations of society and rebel against the rules that bind us all, perhaps explaining why literature containing the antihero seems to blossom in reactionary times, such as films of the 1960s as Vietnam ended and the Cold War began.

The dualistic and divided heroism present in the antihero, a person whose moral compass is never firmly pointing north, is ever present in crime fiction. Like the tragic hero, antiheroes such as Tom Ripley, Lou Ford, Tony Soprano and Walter White allow the darker side of their nature to surface. We are faced with characters who seem to have an endless struggle with the society that would have them crushed, defeated or incarcerated, even those that on one level belong to this society as teachers, fathers and even law-enforcement agents. Focusing on both 'private' antiheroes and those that exist within

7

law enforcement and related social structures, the case studies and essays in this book all look to examine the specifics of the antihero's status and actions within a variety of familial and social structures in order to trace the role of the antihero in crime fiction, contemporary television and film.

Throughout discussions of the antihero in crime fiction, it is Patricia Highsmith who is often acknowledged as the main proponent of this archetypal character, and it is the character of Tom Ripley, Highsmith's most famous creation, who captures readers' imaginations as the one who 'gets away with it'. Whereas other 'heroes' in her narratives suffer from a sense of guilt and, in the majority of cases, do not escape 'justice', either morally or legally, Ripley does exactly that. Fiona Peters examines Ripley's 'disturbing human nature', and analyses the ways in which he can be viewed as the exemplar of the modern antihero. Highsmith always viewed the writing of the Ripley novels as a form of escape from what she classed as the depressing nature of her other work, and indeed viewed him as her alter-ego: whilst Ripley was exceptional in his lack of developed conscience, her other characters were all too human. As such, it is Tom Ripley who is widely discussed in reference to the antihero. However, in setting up a definition of what the term antihero means, Peters goes further to look at another of Highsmith's protagonists, Vic Allen in *Deep Water* (1957). Whilst in many ways Allen can be seen in polar opposition to Ripley, Peters looks at the ways in which we can also classify him as a 'Highsmithian antihero'. Whilst Highsmith in *Deep Water* examines psychoses in suburbia, with Allen essentially going crazy, she adopts a number of mechanisms in her writing in order to get the reader to identify with him. Peters looks at the manner in which this gives Vic Allen the same status as Tom Ripley as an antihero: you do not need to survive the narrative in order to be an antihero.

The superhero is one that is particularly interesting with regard to discussions of heroics, and by extension the antihero. Arguably we are drawn to antiheroes specifically because they are not superhuman and do not have entirely virtuous qualities; it is the flaws, the rebellious nature or immoral undertones of the antihero, that makes them more interesting, seen in the way we are attracted to Batman above Superman. Kent Worcester looks at the character of Frank Castle, better known as the Punisher. First introduced in the Marvel comic *Amazing Spiderman* #129 in 1974, this 'death-wish vigilante' is one of the most popular of Marvel's characters; seen by some as hero and some as villain, Worcester looks on him as antihero. Responsible for the deaths of nearly 50,000 people in the Marvel Universe, why are readers, gamers and audiences so drawn to him? A vigilante with a remorseless campaign against crime, the Punisher displays a transgressive morality that Worcester sees as directly responsible for this attraction. The Punisher is examined here not as a flawed hero, in the vein of Spiderman or Daredevil, but as an antihero whose relationship with the mass audience has evolved, and whose role in the Marvel Universe as a one-man campaigner against violence is certainly formidable.

One of the recurring features of all the antiheroes discussed in this collection is the

way in which they are difficult to define and that they often exhibit multiple identities, ones that do not always sit comfortably with each other. A clear example of this can be found in the character of the Royal Thai Police Detective, Sonchai Jitpleecheep, created by British author John Burdett in his Bangkok series: he is a member of a dirty police force, an honest detective, *consigliore* to a crime lord, devout Buddhist, monk *manqué* and *papasan* of his mother's brothel. Nicole Kenley in her chapter examines the multiple identities of Jitpleecheep in relation to globalization, justice and karma. Exploring the interplay between western and eastern cultures, these novels examine multiplicities of justice and focus on a character that straddles the role of hero and antihero. Examining the ways in which Detective Jitpleecheep embraces postmodern multiplicity of solution by way of his own hybridity, Kenley examines Jitpleecheep's dichotomy and fluid identity, as criminal/cop, western/eastern, hero/antihero, and considers the ways in which these narratives present a model for police globalization, a modernization of the classic detective trope of subjective justice.

Schizophrenic duality can be seen in many of the texts being analysed within this collection and certainly the duality of Lou Ford in Jim Thompson's 1952 novel *The Killer Inside Me* is no exception. This novel was described by the director Stanley Kubrick as 'probably the most chilling and believable first-person story of a criminally warped mind'. In keeping with traditions of pulp novelists of the era, Thompson adopts a first-person narrator, and it is through the central character Lou Ford that this novel is narrated; however, rather than the hardboiled detective, Ford's Texan deputy sheriff is in fact a sociopath with sadistic sexual tastes. Despite the fact that this narrative offers us an insight into Ford's psychopathic mindset, Gill Jamieson examines the manner in which the reader becomes intimate with Ford, thus placing us within his dysfunctional worldview. There are multiple versions of *The Killer Inside Me*, including a 2010 film adaptation of the same title directed by Michael Winterbottom, and at the forefront of all these versions is deviance, and Jamieson utilizes theories of adaptation to consider the creative process of *The Killer Inside Me* from novel, through screenplay, to final film, focusing on the implications of adapting a book that invites readers to identify with an extremely violent antihero. Whereas in the novel we are invited to 'understand' Ford, the limited voice-overs in the film version offer little explanation of the violence that we see, which is extremely erotic and sadomasochistic, something that critics typically reacted to with disgust. Jamieson's chapter specifically examines the adaptation process in relation to the antihero Lou Ford and looks to answer whether the 'cranked up' violence portrayed in the movie was merely a choice made by screenwriter John Curran and director Michael Winterbottom, or whether this was an inevitable consequence of the adaptation process.

Although film had been inundated with antiheroic figures portrayed by actors such as Al Pacino, Robert De Niro and Clint Eastwood, the introduction of the troubled patriarch Tony Soprano in 1999 when *The Sopranos* (HBO, 1999–2007) hit the small screen marked a new televisual focus that would soon be followed by characters such as Dexter

Morgan, Walter White and Don Draper. Several of the chapters in this book focus on the antiheroes from contemporary television series, demonstrating the continued interest in this character type. Indeed, television is swarmed by the antihero, from the white-collared Dexter Morgan and Walter White to the professional criminals Tony Soprano and Ray Donovan.

Abby Bentham asks what is it about Tony Soprano's character, a calculating, vicious and narcissistic sociopath, that audiences find so appealing, and examines his popularity in relation to his vulnerable crisis of masculinity: the competing demands of the 'Family' and his family. The birth of this antihero is defined by the representations of ideals of masculinity in the latter parts of the twentieth century, where masculinity had become utterly focused on family relationships and the role of the father. Compared to his father, Johnny Boy Soprano, whose 1950s-defined gender roles and masculinity Tony sees as much simpler, Tony must combine the gangster masculinity of his father with the sensitive, familial masculinity required of him in the 1990s. Unlike expected notions of gangsters, Tony is insecure and vulnerable, and we as an audience are privy to this through his psychotherapy sessions with Dr Jennifer Melfi: Tony Soprano is recognizably human, needy for love and validation, and as such we relate to this character, despite his sociopathy and undeniable aggression. Utilizing theories of masculinity, Bentham's chapter looks at Tony Soprano as Everyman: we, the audience, are able to identify with this antiheroic mobster, and are therefore empathetically drawn to this man, who Bentham describes as a 'ruthless thug'. Kristeva's 'vortex of summons and repulsion' (1982: 1) are at the heart of our relationship with Tony Soprano, and we watch *The Sopranos* not to view Tony's redemption, but rather despite the fact that he will not change.

In 2013, TV critic Maureen Ryan looked at images of masculinity in Showtime's *Ray Donovan* (2013–ongoing), a show undoubtedly following on from the traditions created by *The Sopranos*, and found this show to be very much from the 'testosterone-soaked past' (Ryan 2013). Indeed, as Gareth Hadyk-DeLodder points out, criticism of this show all seems to focus on the ideas of clichéd antiheroic narratives and the idea that this show is derivative, but perhaps, as Hadyk-DeLodder examines, this overlooks the manner in which Donovan's character can be seen to be exposing rather than recreating the negative ideas of hegemonic masculinity. Examining Freud's 'instinct of life and instinct of destruction', this chapter places Donovan, as an example of the antihero, outside of society: rather than seeking a balance between 'Eros and Death', between life and the 'death instinct', Donovan is a fusion of Freud's drives, and thus finds himself on the path of destruction. Although not denying all of the elements of criticism of this show, this chapter focuses on masculinity as a double bind: characters must either conform to these masculine roles, taking them outside of familial society, or they can resist, thus bringing their masculinity constantly into question and subjecting themselves to a misogynistic fate, often death. It is the performative nature of masculinity that *Ray Donovan* focuses on in its representations of the male antihero. Certainly this show is 'testosterone-soaked', but rather than being

merely derivative, these normalized views of masculinity mark the downfall of characters such as Donovan, Tony Soprano, and other television antiheroes: hegemonic masculinity is shown to be both unstable and dangerous.

Although shows such as *The Sopranos* and *Dexter* (Showtime, 2006–13) were, unlike *Ray Donovan*, generally well received by critics on their release, criticism of later seasons all focused on the stagnant nature of the principal characters, often accusing them of becoming caricatures of themselves. Katherine Robbins quotes David Segal in identifying the cause of this stagnation, which can be related to the open-ended nature of these programmes. Walter White in *Breaking Bad* (AMC, 2008–13), however, breaks this mould and the show's creator Vince Gilligan specifically talks of this: he wanted an antihero who 'would not only change over the course of the series but also suffer crushing reversals with lasting impact' (quoted in Segal 2011). Walter White arguably is 'breaking bad' in the very first episode, making a Faustian pact for financial gain, and the rest of the series narrates the slippery slope that he could never get off. What is vital for this series is the transition from protagonist to antagonist that is witnessed throughout the series. Dexter Morgan, on the other hand, is introduced very much as 'fallen', a blood splatter analyst for the Miami Metro Police Department and serial killer, although due to his unique Code of Morality he is, like so many of the characters being analysed within this collection, difficult to define. Robbins looks to compare these two television shows in order to define what it is about the television antihero that enthrals, in particular in reference to the shows' finales. Comparing the character arcs of White and Dexter to Shakespeare's Macbeth, Robbins' case study chapter looks at the ways in which White, like Macbeth, has a full character arc towards antithesis, whereas Dexter's journey is one of stagnation, with neither ascent nor descent of this antagonist, who is left at the end of the series in a type of purgatory, continuing to ask 'who am I?' White, on the other hand, is very much aware of who he is in the final episode, and his 'Dark Passenger', Heisenberg, turns out to be not the mask of his real self, but instead the self that the mild-mannered teacher had hidden.

Of course, although depictions of masculinity are paramount to the antihero in television shows such as *The Sopranos*, and scholarship in masculinity has attempted to define the term antihero more concretely, the role of the female characters is also vital. There have been a number of discussions surrounding the female roles in televised antihero narratives: female characters in shows such as *Ray Donovan* and *Breaking Bad* are cast in the conventional role of wife, mother and, as Sabrina Gilchrist asserts in her chapter, the antihero's 'better half'. Both Gilchrist and Hadyk-DeLodder look at the indignation felt when these female characters transgress the patriarchal expectations of femininity: what these characters do is challenge the patriarchal system from within and female characters that reject or undermine these traditional feminine roles can become vilified, both within the shows and by audiences. However, Dr Alice Morgan from BBC's *Luther* (2010–ongoing) manages to gain the support of viewers as an antihero(ine), despite the fact that she upsets the heteronormative expectations of this genre. Gilchrist's chapter examines the

ways in which Alice Morgan's character as a sociopath, genius and murderer in fact shares the role of antihero with the overtly masculine DCI John Luther. Although she challenges the accepted female role of the antiheroic narrative, a story that follows a clear trajectory like that of the heroic cycle, audiences seemed to embrace Morgan rather than turning on her, to the point that producers even considered making a spin-off series based entirely on this character. Rather than seeing Morgan as defying the antihero Luther, she is cast in the role of antihero(ine), and as such foreshadows shows such as *Orange Is the New Black* (Netflix, 2013–ongoing) and *Scandal* (ABC, 2012–ongoing).

In a similar vein to Gilchrist's chapter, Joseph Walderzak also focuses on gender in relation to masculinity and the role of the antihero in cable television. Looking at the American crime series *The Killing* (AMC, 2011–13; Netflix, 2014), based on the Danish series *Forbrydelsen* (DR1, 2007–12), Walderzak examines the ways in which Sarah Linden (Mireille Enos) exemplifies antiheroic traits. The term antihero, or the less provocative term 'flawed protagonists' offered by media theorist Amanda Lotz, is undeniably associated with masculine traits, and this has largely remained unquestioned. Walderzak suggests that unlike other female television cops, who despite character flaws do not struggle with moral ambivalence attributed to their male counterparts, Linden embodies the antihero in many ways: her struggle with personal demons; her willingness to forgo police procedure for justice, as seen in her murder of a corrupt detective and subsequent cover-up; and her absolute disregard for parental duties. Whilst not denying that other female antiheroes exist in television, Walderzak's interest lies in the fact that Linden's traits can be seen as directly similar to her male counterparts'. This case study looks to theorize the antihero phenomenon and examines the ways in which Linden's status as antihero suggests a complex anxiety about masculinity and femininity in the twenty-first century, specifically in relation to a shared gender crisis between men and women, with neither gender being able to escape the traditions of gender roles: whereas male antiheroes fail to find contentment as father and husband, seeking meaning in illegal activities, as seen in Walter White and Tony Soprano, female antiheroes are punished for pursuing traditionally masculine roles and therefore sacrificing traditionally feminine roles, such as motherhood.

The female antihero, however, is not confined to television, and Mary Marley Latham's chapter looks at the female antiheroic detectives that have emerged in the late twentieth century to the present day. There has been an increase in literary texts that explore themes relevant to feminist literary theories and criticism, detective novels that manipulate the crime fiction genre's conventions and structures such as Barbara Neely's *Blanche on the Lamb* (1992), Barbara Wilson's *The Dog Collar Murders* (1992) and Alexander McCall Smith's *No. 1 Ladies Detective Agency* (1998). This case study however focuses on a writer who Latham describes as an 'academic pedigree': Julia Kristeva's third novel *Possessions* (1998 [1996]) introduces readers to Stephanie Delacour, whose antiheroism Latham argues challenges not only expectations of gender, but also modes of narrating crime fiction, in keeping with Kristeva's outlook as a French post-structuralist. Kriste-

va has described herself as the 'James Bond of Feminism', a somewhat paradoxical title considering the often misogynistic portrayals of Bond in many of his films. Similarly to characters such as Sarah Linden, Delacour's indifference towards other characters, her arrogance and inward-looking nature, connect her to the traditional male hero/antihero.

Televised antiheroes often take the form of characters that could have been cast in the role of villain: the mafia boss, serial killer and meth cook, for example. With HBO's 2014 *True Detective*, the antiheroes are not outside of the law but are the CID homicide detectives Rust Cohle and Marty Hart. Isabell Große examines the fascination that Cohle holds with audiences, despite his 'failings', examining his unconventional nature as part of his appeal. Nic Pizzolatto's *True Detective*, although originally imagined as a hunt for a serial killer, became a character study of the two detectives: Cohle and his partner Hart. Once again following on from the traditions of the hardboiled detective, Große examines Cohle as a philosophizing antihero. As with all the characters being discussed within this collection, Cohle too is an outsider: it is his otherness and our inability to categorize him that fascinates us. Just as Tony Soprano cannot be purely defined as a mafia boss, Rust Cohle is not merely a detective, and *True Detective* is not merely a police procedural. Looking at the manner in which Cohle's metaphysical monologues and philosophizing take him outside the traditions of the tough man and hardboiled detective, Große focuses on the existential nature of Cohle: this cathartic narrative which focuses on the emotional journey of the investigators, rather than merely the investigation, marks an evolution in the noir genre.

The author Paul Johnston, whilst stating that many of the characters in his own novels (his Matt Wells series, Quint series, Alex Mavros series, as well as his stand-alone novel) should be classed as mavericks rather than antiheroes, he acknowledges that his work is informed by Greek and Latin literature, where the antihero arguably was born. He continues that his mavericks are working against the establishment, as the antihero does, and even acknowledges that characters such as Quint Dalrymple, a disillusioned labourer and spare-time PI, spends as much time fighting the establishment as he does the criminals, in some ways casting him in the role of antihero. Fiona Peters's interview with Paul considers many of the main themes examined in this collection, and ideas about evil and seduction in the crime novel are analysed, thus exploring the ways in which he as an author relates to the antihero and how this character type has evolved and developed through crime fiction. In his interview, Paul discusses certain writers in the crime fiction *oeuvre* who specifically engage with the antihero in their writing and concludes that it is Patricia Highsmith who is the most vital of these authors.

What Highsmith created was a narrative that focused not on the process of detection, but rather on the perpetrator. Critics such as Julian Symons and Tony Hilfer have defined this subgenre of 'murder fiction' as the 'crime novel', which tells the story from the perspective of the criminal and focuses much more evidently on the characters than on the story. The author James M. Cain, usually associated with hardboiled fiction and the

roman noir, spoke of the genesis of his narratives, claiming that '[m]urder [...] had always been written from its least interesting angle, which was whether the police could catch the murderer': rather than looking to the police and their process of detection, authors such as Cain and Highsmith went inside the mind of the killer. Carl Malmgren's chapter looks at both of these authors in order to examine principal characters in a functional analysis, arguing that crime fiction lends itself perfectly to this type of analysis due to the quest formula that most murder fiction follows: the quest for truth. Of course, when a narrative is written from the perspective of the killer, the reader is already aware of 'whodunnit', and therefore the reader is captivated not by a puzzle, but an interest in what the character will do next. Analysing Cain's 1943 crime novel *Double Indemnity* and Highsmith's 1955 *The Talented Mr Ripley*, Malmgren looks at the ways in which the antiheroes of these novels infect the reader, and the manner in which this affects their role as both Subject of their own search, and the Object of the search for the perpetrator. It is this duality, this schizophrenia, that Malmgren, through his functional analysis, reads as the contagious element of crime fiction.

And we are undoubtedly captivated by crime fiction, and in particular by the antihero. Beyond Highsmith's Ripliad, there have been numerous incarnations of Tom Ripley, including films, television, radio and stage adaptations. Jacqueline Miller argues that it is Ripley's character above Highsmith as an author who perpetuates the desire to adapt these texts, and this can be felt most keenly in fanfiction. Writers of fanfiction do not merely adapt, they reimagine and revise characters, and Miller looks at the ways in which fanfiction authors of Ripley novels heroize Ripley as a character, moving away from his dark side in order to romanticize, through constructions such as vulnerability and redemption. This softening or sensitizing of Ripley's character can also be seen in the 1999 film *The Talented Mr Ripley*, directed by Anthony Minghella, which Miller suggests forms the basis of the majority of fanfiction, rather than the novels created by Highsmith. Looking at a number of fanfiction texts, this chapter examines the appeal of Tom Ripley, specifically examining fans' determination to cast him in the role of vulnerable, misunderstood antihero; hero; and even sometimes superhero.

Connecting to other chapters in this collection, Mark Hill focuses his attention on the masculinity as portrayed in *True Detective*, in particular in reference to place: set in Louisiana, this is a narrative that is steeped in southern masculinity, with both protagonists coming to terms with their overtly gendered roles. Whilst Hart can be seen to be reacting to the changing notions of fatherhood and being a husband, Cohle's nihilism places him in the role of lone-warrior. Both of these characters can be traditionally described as 'tough men', and as such find themselves entrenched in a womanless world: mirroring characters such as Philip Marlowe or Sam Spade, Cohle and Hart reject the home and instead embrace alienation and isolation, only being able to engage with the female characters of the show as victims, when these males can confirm the patriarchal ideas of masculinity by becoming protectors, and more importantly come to terms with their

failure to protect a defenceless woman. Examining not just roles of masculinity, but also the traditional ideals of southern femininity, Hill looks at the ways in which several of the female characters attempt to redefine themselves, and the manner in which Cohle and Hart resist these changes: redemption for these antiheroes is not held within the familial world, but rather a womanless world, which has their masculine friendship at its centre.

In his biographical essay on James Ellroy, Rodney Taveira, having spoken to the often elusive author, traces the role of the antihero in Ellroy's fiction and memoirs. As the self-proclaimed greatest crime novelist of the twentieth century, it is not only many of Ellroy's characters that can be examined in relation to the antihero, but the author himself. Looking at Ellroy's two memoirs, *My Dark Places* (1996) and *The Hilliker Curse* (2010), Taveira focuses on the way in which Ellroy constructs a version of himself as a 'loser anti-hero'. From the boy who had wished his mother dead only for her to be murdered, through his own time as petty criminal and drunk, and finally to his sobering act of becoming the world-acclaimed author of novels such as *L.A. Confidential* (1990), Ellroy has written and then rewritten his own literary identity. And we are drawn to this author, as we are drawn to the many antiheroes that have been analysed in this collection.

Indeed, the antihero has enticed readers and audiences for generations. Iconic and popular figures of literature, television and film such as Walter White, Tom Ripley and Lou Ford are examined in this collection, alongside lesser-known characters from crime fiction that you will discover here. This collection gives an insight into the characterization, methodology, social context and morality that make up these unlikely protagonists. The case studies and essays in this collection have at their heart the same question: why is it that we root for the antihero, despite our conscious revulsion at some of their actions? *

REFERENCES

Kristeva, Julia (1982), *The Powers of Horror: An Essay on Abjection*, New York: Colombia University Press.

Ryan, Maureen (2013), '"Ray Donovan" Review: Take the Anti-hero Pop Quiz!', *Huffington Post*, http://www.huffingtonpost.com/maureen-ryan/ray-donovan-showtime_b_3505256.html. Accessed 18 March 2015.

Segal, David (2011), 'The Dark Art of "Breaking Bad"', *New York Times*, http://www.nytimes.com/2011/07/10/magazine/the-dark-art-of-breaking-bad.html?pagewanted=all&_r=0. Accessed 10 January 2014.

CASE STUDIES

TOM RIPLEY AND VIC VAN ALLEN
NATIONALITY: AMERICAN / CREATOR: PATRICIA HIGHSMITH

Patricia Highsmith's antiheroes
Fiona Peters

To the general reader of crime fiction, Patricia Highsmith is best known for her urbane and guilt free antihero, Tom Ripley. The author always saw him as her alter-ego, what she would have liked to have been freed from: the vagaries of guilt, conscience and passion, 'afflictions' she suffered a surfeit of throughout her life. The character stayed with her for many years after his 'birth', when, staying in Positano in 1954, she spotted a young man, quite alone, walking along the beach first thing in the morning. The feeling of solitude, the exclusion from the world of others that she perceived in him stayed with her:

> Then I noticed, a solitary young man in shorts and sandals with a towel flung over his shoulder, making his way alone along the beach from right to left [...] I could just about see that his hair was straight and darkish. There was an element of pensiveness about him, maybe unease. And why was he alone?
>
> (Wilson 2003: 195)

Highsmith's most popular novel, and the one for which she is best known, *The Talented Mr Ripley*, was published in 1955, with *Ripley Under Ground* in 1970, *Ripley's Game* in 1974, *The Boy Who Followed Ripley* in 1980, and finally *Ripley Under Water* in 1991, four years before her death. She often contrasted Tom Ripley with her other 'heroes', for several reasons. While the heroes of the majority of her other novels suffer anguish due to their sense of guilt, even if they do not actually carry out actions that they should even feel guilty for, for the most part they don't 'get away with it' either legally or morally. Tom Ripley gets away with it in both senses: 'Things go wrong in life, justice is not done and people sort of get used to it. Maybe Ripley is appealing because people like to imagine that somebody can get away with it all the time' (Stewart 1992).

Tom Ripley's truly radical, disturbing and anti-human nature can only, I would argue, be found within the pages of her novels – the various film versions, including the

best known *The Talented Mr Ripley*, directed by Anthony Minghella in 1999, whatever their individual merits, dilute the merciless potential of Highsmith's favourite character. This chapter will examine the ways in which Tom Ripley exemplifies the modern antihero but it will not concentrate solely on him. The 'other' protagonists who populate the rest of Highsmith's extensive *oeuvre* are, I would argue, antiheroes in very different but no less interesting ways. The chapter will firstly explore Tom Ripley as the exemplar of the antihero, then move on to examine how another of Highsmith's protagonists, Vic Van Allen in *Deep Water* (1957), while in many respects appears to be diametrically opposed to Tom Ripley, nonetheless can also be classified as a 'Highsmithian antihero'.

Tom Ripley

From the very first lines of *The Talented Mr Ripley*, as soon as the reader is introduced to Tom, the sense of him being a little 'off', imbues the text:

> Tom glanced behind him and saw the man coming out of the Green Cage, heading his way. Tom walked faster. Tom had noticed him five minutes ago, eyeing him carefully from a table, as if he weren't *quite* sure, but almost.
>
> (Highsmith 1955: 5; original emphasis)

Tom's 'life of crime' and antihero status is not, at this stage, very advanced, but he already watches his back, perceiving any stranger to be after him. He is rather listlessly trying to make money from a tax scam; pretending to be a tax inspector he phones randomly chosen 'victims' and scares them into paying him cheques for tax he convinces them that they owe. A financial drawback of this scheme is that he uses a false name and so cannot cash the cheques; thus Highsmith demonstrates Tom's propensity for making malicious mischief even if it induces anxiety in him; he simply cannot stop himself creating malign mischief. She highlights his sense of fear as he is approached in a New York street by Mr Greenleaf, who, believing him to be a friend of his son Richard, wants to suggest that Tom might go to Europe to attempt to persuade Richard to return home to New York, his family and the lucrative family business. Before Mr Greenleaf speaks to him, Tom automatically views him as a threat, a representative of the law, about to arrest him:

> Was that the kind they sent on a job like this, maybe to start chatting to you in a bar and then *bang!* – the hand on the shoulder, the other hand displaying a policeman's badge. *Tom Ripley, you're under arrest.* Tom watched the door.
>
> (Highsmith 1955: 9; original emphasis)

The opening chapters of *The Talented Mr Ripley*, set in New York, are vital for establishing Tom's amorality, his attraction towards petty crime, and his feelings of superiority and

resentment towards the world around him – a world in which he has not had the luck of birth that Dickie Greenleaf enjoyed, the advantages of good schooling and money that allow Dickie to treat those gifts lightly and leave his obligations to go to Europe on a whim to pursue his fantasy of becoming a painter. Highsmith herself was very aware that this character trait is disturbing, yet also seductive and appealing:

> I make Ripley amoral, and naturally this disturbs an ordinary person. It would disturb me. It's as if somebody steals from my house or anybody's house, and thinks nothing of it. Ripley doesn't suffer as much as the rest of us do from the knowledge that he has done something wrong.
>
> (Stewart 1992)

It is difficult to imagine that the Tom of the first section of *The Talented Mr Ripley* becomes what the reader encounters at the beginning of *Ripley Under Ground* – the owner of an aesthetically pleasing house, Belle Ombre, situated near Paris, and moreover living there with his wife Heloise and trusty housekeeper Madame Annette. Belle Ombre means beautiful shadow, a name that is arguably a deliberate nod to Tom Ripley's shadowy existence, on the fringes of the bourgeois society in which he lives, always just outside of it, shadowing it, never sure if he is going to be unmasked as the killer that he became in *The Talented Mr Ripley*. This sense of non-belonging and outsider status does not unduly perturb him; as Highsmith indicates, he has so far 'got away with it' in two senses, both the legal sense insofar as his masquerade as Dickie Greenleaf and the murders he carried out have not been discovered and thus punished by the law, in the guise of the police, but additionally in the moral sense.

Tom quite literally 'gets away with murder' because he has no awareness of guilt or empathy with others, yet at the same time a very powerful sense of anxiety permeates each novel in the Ripliad. While a lack of guilt, conscience and empathy might mark Tom out as a psychopath as defined by the Hare test, the almost overwhelming sense of anxiety that marks the Ripley texts, and which is also present in her other novels where protagonists certainly feel guilt and conscience, works to undermine such an easy categorization. In fact, one could ask whether a psychopath (in the clinical definition of the term) could ever function as an antihero that we can identify with, as Highsmith points out in the above quote. Tom Ripley disturbs, but he also attracts and beguiles his readers. This is partly because he is funny:

> Ripley is funny, I hope. He's amoral, in a way he's a flexible sort of character. I consider him an adventurer, he came from a very ordinary, rather limited background in the U.S. and took the plunge into Europe. He's amoral about murder, he does it and then he reasons it away.
>
> (Hubert 1974)

Highsmith once told an interviewer that she had read psychiatrist Karl Menninger's *The Human Mind* (1930) at the age of 8: "'They're case histories of crackpots, sadists, murderers, and other nuts, but it's like reading Edgar Allan Poe'"(Lobrano 1989). Even at such a young age, she was particularly fascinated by human responses to murder, and the ways in which, to one extent or another, we are all capable of 'evil' actions. However, despite her early forays into the field of criminal psychology, her exemplary antihero is neither a sadist nor straightforwardly a crackpot. At first, Tom appears to be the least psychically unstable of her antiheroes, but this masks a particularly 'normal' psychosis, one that it would be both pointless and unhelpful to label as degraded or pathological:

> He is the ultimate psychotic, the best exemplification of what Lacan had in mind when he claimed that normality is a special sort of psychosis – of not being traumatically caught up in the symbolic web, of retaining freedom from the Symbolic order.
>
> (Žižek 2003)

One of the most unusual characteristics of Tom Ripley, as contrasted with other serial killers, is that he gains no pleasure from committing his acts of murder. In fact, Highsmith often argued that her hero, Tom, always detested murder, unless he believed it to be necessary or expedient. Except of course, his idea of what makes a murder neccesary may not be the same as the majority of people; even if the result may be something they desire, they would not necessarily act upon it to make it happen. Throughout *Ripley's Game*, Highsmith uses Tom's relationship with Jonathon Trevanny to reflect upon the ways in which her antihero challenges the status of conventional morality, and, through the portrayal of Jonathon and his wife Simone, demonstrates how his transgressive persona can attract other people into identifying with him: "'I cannot understand. I cannot,' she said. "Jon, what do you *see* in this monster?" Her husband Jon, surrogate to Highsmith's bemused reader, reflects, "Tom was not really such a monster. But how to explain?"' (Hilfer 1984: 361; original emphasis).

In '"Not Really Such a Monster": Highsmith's Ripley as Thriller Protagonist and Protean Man' (1984), Anthony Hilfer argues for Ripley's status as a 'protean man', more at home among the annuls of 'high' literature rather than what would be expected within the pages of the crime novel: 'say, for a short list, Gide's Lafcadio, Mann's Felix Krull, Barth's Jacob Horner... among others' (Hilfer 1984: 371). According to Hilfer, this 'alternative tradition' that he believes Ripley belongs to, shifts him from being an amoral (or anti) hero in the generic sense into a protean man whose paradigm is the figure of Iago. Casting Tom as protean man: 'changing in form, characterised by variability, changing, varying' (OUP 2007: 1692) is a description, according to Hilfer, that might account for his lasting appeal as a very unusual serial killer, as distinct from others within the crime fiction tradition.

As previously mentioned, Tom Ripley is also very funny, a talented mimic who

ingratiates himself with Dickie and Marge in Mongibello by describing his meeting with Mr Greenleaf as a hilarious event: 'Tom took a breath and began. He made it very funny and Marge laughed like someone who hadn't heard anything funny to laugh at for years' (Highsmith 1955: 50). Of course, his talent for mimicry takes a sinister turn after he murders Dickie and, for a time, adopts his identity. According to Hilfer, as 'fatherless' the protean man is able to be endlessly 'reborn' (Tom's fortunes improve as he escapes the restrictions of post-WWII American culture and steps into what he sees as the freedom of Europe). He links the death of Tom's parents at a young age to his supposed lack of a Freudian super-ego:

> Divested of past and parentage, Tom is remarkably free of the conventional restraints of super-ego, again matching Lifton's definition of protean man: 'What has actually disappeared is the *classical* super-ego, the internalization of clearly defined criteria of right and wrong transmitted within a particular culture by parents to their children.
>
> (Hilfer 1984; 370; original emphasis)

This, according to Hilfer, allows Tom to remake himself and appropriate other people's identities at will. The lack of a super-ego, the psychological 'policeman' who perches on our shoulder imbuing actions, and also thoughts, with guilt, is markedly absent in Tom. Highsmith avoids the impetus to explain away Tom's psychopathology by having recourse to an abusive or traumatized childhood, but she does however draw attention to his early loss and subsequent upbringing by his Aunt Dottie, a woman who according to Tom took every opportunity to verbally abuse him and denigrate his dead father:

> 'Sissy! He's a sissy from the ground up. Just like his father!' It was a wonder he had emerged from such treatment as well as he had. And just what, he wondered, made Aunt Dottie think his father had been a sissy? Could she, had she, even cited a single thing? No.
>
> (Highsmith 1955: 34)

According to Freud, young children are free of internalized prohibitions – the 'policeman on our shoulder' is acquired rather than innate. He argues: 'as is well known, young children are amoral and possess no internal inhibitions against their impulses striving for pleasure' (Freud 1975: 93). For Freud, it is a parental agency, not necessarily the physical parents but a structural model of authority that channels external prohibition into the sense of morality that the super-ego represents:

> Parental influence governs the child by offering proofs of love and by threatening punishments which are signs to the child of loss of love and are bound to be

feared on their own account. This realistic anxiety is the precursor of the later moral anxiety.

(Freud 1975: 93)

This specifically relates to Tom Ripley at this point; later in the chapter I will demonstrate how this absence of parents (or parental concern) is identified in other Highsmith antiheroes.

A Freudian reading – demonstrating that as paternal authority shifts from Tom Ripley's parents to his aunt – can go so far along the road towards demonstrating how love is lost, in an Oedipal sense. Also, the undermining of the original lost objects – the parents, and especially the father in this case – could, according to Freud, destroy the transition every child has to go through between identification (with parents or other stable figures) to object-choice, which would result in the human being becoming fixed in a cycle of attempts to assimilate the ego of the other into the self: 'If one has lost an object or has been obliged to give it up, one often compensates oneself by identifying oneself with it and setting it up once more in one's ego, so that here object-choice regresses, as it were, to identification' (Freud 1975: 95). This occurs in several of Highsmith's other antiheroes, such as David Kelsey in *This Sweet Sickness* (1961, but in respect of Tom Ripley, this point is developed by Slavoj Žižek – his lack of a super-ego to restrict his transgressive actions here articulated in terms of the cultural and moral law, and the symbolic order (the world of others in which, for order to prevail, each person must be treated as Kantian 'ends in themselves'):

One way to read Ripley is as an angelic figure, living in a universe which as yet knows nothing of the Law and its transgression (sin) and thus feels nothing of the guilt generated by our obedience to the Law. This is why Ripley feels no remorse after his murders: he is not yet fully integrated into the symbolic order.

(Žižek 2003)

Highsmith never gives any indication throughout the five Ripley novels that he will ever become integrated into such a symbolic order. Everything has its price however, and Žižek argues that the price that he pays for the lack of guilt is 'his inability to experience sexual passion' (Žižek 2003). Even when he is settled at Belle Ombre with Heloise, their marital happiness is predicated upon separate bedrooms and hints abound that their sex life is infrequent and performed as a duty rather than out of a sense of desire. Another consequence of the lack of passion, or desire, I would argue, is the constant and unremitting sense of anxiety that inhabits the texts, unmediated by a sense of right and wrong, or a moral compass. Freud argues that the experience of anxiety shifts from a realistic to a moralistic mode (and can lead to extreme neurotic anxiety) as the super-ego is established. If this fails to happen for Tom Ripley, then he will remain afflicted by, not

guilt, but by an excess of affect that acts both as a pathological symptom and at the same time an essential tool for self-preservation: 'Anxiety, it seems, in as far as it is an affective state, is the reproduction of an old event which brought a threat of danger; anxiety serves the purposes of self-preservation and is a signal of a new danger' (Freud 1975: 9). The 'old event' or trauma, would be for Tom the death of his parents, instigating a schism in the formation of his super-ego that both prevents him from moving from identification towards mature object-choice and will leave him endlessly reproducing the real lived experience of that event.

I have mentioned that Tom is a wonderful mimic – and many critics have argued that this is integral to the flexibility of his character, insofar as it allows the reader to identify with him despite his transgressive actions, thus making him an exemplary antihero. Paradoxically however, this sediments into an inflexibility: after *The Talented Mr Ripley* Tom never changes – his life is conducted through and around ritual, and although he continues to respond to and deal ingeniously with situations that threaten his freedom, this is never breached even (especially) by Heloise. So, although it is undisputable that the flexibility of the character adds to his status as antihero, not mere villain, the surface pliability masks a persistent and unremitting drive towards control and cold, undemanding and clean rationalism. This too, while seemingly incompatible with his ability to remake himself on a surface level, adds to his attraction. As mentioned above, unlike 'run of the mill' serial killers, Tom never acts from passion or uncontrollable urges, only killing when he is forced into unavoidable and threatening situations. For the reader, he acts in a way that, if we were really honest with ourselves, we would like to but cannot, due to our sense of conscience and guilt, even when we merely fantasize about a transgressive action.

There is a pivotal moment in *The Talented Mr Ripley* where Tom recognizes the absolute unreachability of other people. This is exquisitely played out in the following passage: the reader is drawn into an identification with Tom's devastation when Dickie fails to allow him to achieve the move towards integration into the symbolic order. Tom confronts him after Dickie refuses to take part in a madcap scheme of Tom's to smuggle dope in a coffin from Italy to Paris. The confrontation, coming shortly after Marge had begun to intimate to Dickie that Tom is gay, is often erroneously attributed to Tom's unreciprocated desire for Dickie. On the contrary, as stated above, Tom does not know passion, or desire, and is instead attempting to seek a recognition from Dickie that would allow him to move towards a symbolic identity:

> He stared at Dickie's blue eyes that were still frowning, the sun-bleached eyebrows white and the eyes themselves shining and empty, nothing but little pieces of blue jelly with a black dot in them, meaningless, without relation to him. You were supposed to see soul through the eyes, to see love through the eyes, the one place you could look at another human being and see what really went on inside, and in

Dickie's eyes Tom saw nothing more than he would have seen if he had looked at the hard, bloodless surface of a mirror.

(Highsmith 1955: 78)

I would argue that this passage, far from being an account of an individual who has hoped for the other to return a sexual attraction, in fact resonates beyond the individual and is instead Tom's epiphany, albeit a negative one that contradicts other accounts of the recognition of the 'face to face' as found in, for example, the work of philosopher Emmanuel Levinas. For Levinas the 'face to face' moment provides the point of a human subject's recognition of the ethical value of each human being who stands before them. For Tom Ripley however, that moment fails him – his lack of stability already evidenced in the ways in which he mimics and takes on identities at will means that the demands of recognition leave him, not in an ethical relation with the Other, but free to kill. Highsmith outlines Tom's awareness of this in a second key passage very shortly after the first:

They were not friends. They didn't know each other. It struck Tom like a horrible truth, true for all time, true for all the people he had known in the past and for those he would know in the future: each had stood and would stand before him, and he would know time and again that he would never know them, and the worst was that there would always be the illusion, for a time, that he did know them, and that he and they were in complete harmony and alike. For an instant the wordless shock of his realization seemed more than he could bear.

(Highsmith 1955: 78)

Tom murders Dickie shortly after this scene, and continues to kill when it becomes absolutely necessary. The line that the super-ego instigates in most people simply does not exist for him. But, as argued previously, he is no passion-driven murderer – the essential loneliness that enables him to dispose of those who get in his way, without gaining satisfaction from his actions, is predicated on this pivotal scene in *The Talented Mr Ripley*. He becomes the exemplary antihero, the man without illusions. After this moment, there is never again another scene like it throughout the Ripliad; from this point on it is all self-preservation and the seduction of the reader.

Vic Van Allen

Patricia Highsmith viewed writing the Tom Ripley novels as an escape from the more depressing nature of her other work. She adored Ripley, as an exception to her other central characters, who she contrasts with Ripley: 'Other characters are very much concerned with conscience. "They're always chewing over their guilt, wondering how well they'll sleep at night with that on their consciences"' (Hubert 1974). For the author, Tom was

exceptional while the others were all too human.

As I have examined in respect of Tom Ripley, his lack of a developed conscience and thus feelings of guilt enables him to transgress the moral and social laws regarding killing. However, Highsmith's other antiheroes kill as well, not in every novel but very often. Sometimes they just make a wrong decision or move, and other times their failure or inability to make decisions at all leads to their downfall. Ian Hamilton argues:

> Her killer heroes *do* have consciences, they do tend obsessively to examine and question their behaviour, but at the centre of even their most intricate self-interrogations there is a crucial blankness, a missing ingredient, an impassable limitation, and it is this that makes it possible for them to kill.
>
> (Hamilton 1971: 18; original emphasis)

There is a blankness at the heart of Highsmith's other heroes that manifests in different ways to that of Tom Ripley. They are obsessive and introspective, as Hamilton points out, but there is a point beyond which they *will* go. In the above extracts from *The Talented Mr Ripley* I demonstrated that the pivotal moment when Tom Ripley realized he had no prospect of human empathy for Dickie, does not occur at the moment he kills him – that comes a little later, like an afterthought. Symbolic murder takes place before the physical act. Murder is treated in a very similar fashion when it comes to her non-Ripley antiheroes.

For the purpose of this chapter, I am arguing that another of Highsmith's non-Ripley protagonists can be viewed as an antihero; I could however have chosen several others. In her first novel *Strangers on a Train* (1950) Highsmith split good and evil between two characters: Bruno, representing the psychopathic villain; and Guy, the good man who becomes caught in a spiral of circumstances out of his control that lead him to commit an act of murder. By the time she wrote *The Talented Mr Ripley* five years later, there was no longer any need for this split between good and evil. Tom is an antihero while the abjected and repulsive Bruno is written as a villainous foil to Guy and did not demonstrate antiheroic tendencies.

The novels written shortly after *The Talented Mr Ripley*, *Deep Water* (1957) which I will discuss, *This Sweet Sickness* (1961) and *The Cry of the Owl* (1962), are all set in the United States and paint a very different picture as compared to *The Talented Mr Ripley*, in which Tom Ripley escapes the restrictions of America and sets out for Europe on an adventure reminiscent of Henry James's *The Ambassadors* (1903), a book that is in fact referenced while Tom is on the boat travelling to Europe. In *Deep Water*, Victor Van Allen is married to Melinda and father to Trixie. He is however, an outsider, even while he owns a business and is a member of his local community, Little Welsey, a comfortable suburban town. Highsmith establishes his perspective from the opening lines of the novel:

Vic didn't dance, but not for the reasons that most men who don't dance give to themselves. He didn't dance simply because his wife liked to dance. His rationalization of his attitude was a flimsy one and didn't fool him for a minute, though it crossed his mind every time he saw Melinda dancing: she was insufferably silly when she danced. She made dancing embarrassing.

(Highsmith 1957: 7)

Through this first statement the reader is immediately drawn into Vic's point of view; Highsmith sets Melina up as flighty and unreliable. As with *The Talented Mr Ripley* the novel is written in the third person yet it reads as if it were in the first person insofar as she gives the reader access to Vic's thoughts and feelings. We see though his eyes, a device utilized to underline his antiheroic status. As with Tom Ripley, we identify with him and, as the novel progresses, begin to see the world through his eyes. Melinda gets drunk and flirts openly with men in front of Vic, and is carelessly unfaithful to him with a series of lounge lizard characters who all fall far short of Vic's own tasteful and thoughtful persona. One of her lovers is Malcolm McRae: 'Tall and lean and immaculate, with a long and narrow face in which nothing stood out in Vic's memory except a large wart on his right cheek like Abraham Lincoln's' (Highsmith 1957: 13). When McRae is found murdered in his Manhattan apartment Vic is comfortable with the presumption of people around him that he has perhaps killed him. Highsmith does not present Vic as a solitary being in quite the same way as she does Tom. Others see what is happening under his nose, one friend commenting: '*You're like someone waiting very patiently and one day – you'll do something*' (Highsmith 1957: 53; original emphasis). The unsolved murder of McRae validates Vic's apparent lack of jealousy and 'humanizes' him in the eyes of the community: 'He had seen it in their faces, even in Horace's. He didn't react with normal jealousy and something was going to give. To have burst out, finally, was merely human. People understood that' (Highsmith 1957: 52).

Immediately after this point, the real murderer is caught, which plunges Vic into a crisis of identity; he realizes that he will once again be viewed as a sad cuckold, stagnating while his wife humiliates him in front of his peers. The reader, privy to Vic's thoughts and feelings, realizes that his seeming passivity towards Melinda's series of lovers masks a deep and visceral disgust. We are drawn into Vic's perspective; similarly to Tom Ripley, we see the world through his eyes, thus establishing an identification with him that provides him with an antiheroic status – we *want* the world to treat him better than it does. His false appropriation of responsibility for the murder of McRae frightens off a couple of Melinda's 'admirers' and perversely raises his status in the eyes of the community who had previously found his lack of jealousy strange: 'Far from noticing any coolness in their friends – as Melinda still insisted she did – Vic found their social relations much easier. Everybody treated them as a couple now, and as a couple supposedly happy and getting along' (Highsmith 1957: 47). When it is discovered that McRae was killed by somebody

else, it becomes impossible for Vic to move back into his previous self-protective state, that of indifference.

Tom Ripley recognizes the impossibility of reciprocity just prior to his murder of Dickie; another non-event, the not-killing of McRae, acts as the pivotal moment in *Deep Water*. Once Vic has got used to the idea that he *could* have killed McRae out of jealousy, a human emotion that people expected him to feel, he feels thwarted by the arrest of the actual murderer. It is then only a matter of time before the enjoyable fantasy is played out in reality. Vic wants to become 'really human' like those around him, and feel what they feel. His psychic dilemma, similar to Tom's, is that his difference is played out as a lack, a lack of desire as discussed in relation to Ripley, and while Vic functions within a community defined by socially accepted boundaries, unlike Tom in *The Talented Mr Ripley*, that cannot last. He attempts to manifest a faint version of jealousy in relation to another of Melinda's lovers, Charlie De Lisle. The nature of his jealousy is ambivalent, predicated less on any underlying possessiveness or desire, and more on shame and embarrassment concerning her poor choice of lover.

Just prior to murdering De Lisle, Vic is repulsed by his physical proximity – viewing the water in the pool as contaminated because De Lisle has been there: 'He felt a revulsion about getting into the water while Melinda and De Lisle were there, even about getting near the pool, because De Lisle had been in its water' (Highsmith 1957: 89). He then kills De Lisle in the pool without passion, without desire and without any dramatic effect. In fact it happens almost accidentally, virtually as if it were a joke that went too far:

> It's a joke, Vic thought to himself. If he were to let him up now, it would be merely a joke, though perhaps a rough one, but just then De Lisle's efforts grew violent, and Vic concentrated his own effort, one hand at the back of De Lisle's neck now, his other holding De Lisle's wrist away from him under the water.
>
> (Highsmith 1957: 91)

Vic kills De Lisle, but this act provides him with no more emotion than he felt before. The only difference is that he can now touch the body without the repulsion he had previously felt and immediately acts like he knows he should in the case of a drowning:

> 'Do you think,' said Vic between strokes, 'we should turn him over and try to massage his heart?' and though he thought he was calm, he felt it was a stupid, excited question, and just the kind of question he might be expected to ask.
>
> (Highsmith 1957: 93)

After this point in *Deep Water,* Vic retreats from the inter-subjective world that he had up until that point managed to sustain his place within, however precarious he had found this. Unlike Tom Ripley however, Vic cannot sustain a pretence of interaction with others

and the almost forced action – that of killing McRae – leads him into a distancing from the symbolic universe. In a manoeuvre that is typical of Highsmith, the reader's identification with Vic is strengthened by his anthropomorphism in relation to the 'loving' relationship between his two pet snails, Hortense and Edgar. Ascribing human emotions to the snails' activities enables Highsmith to present a scenario for Vic that temporary releases him from the threat posed by Melinda and her sordid sexual flaunting:

> Hortense and Edgar were making love. Edgar reached down from a little rock to kiss Hortense on the mouth. Hortense was reared on the end of her foot, swaying a little under his caress like a slow dancer enchanted by music. Vic watched for perhaps five minutes, thinking of absolutely nothing, not even the snails, until he saw the cup-shaped excrescences appear on the right side of both the snails' heads. How they did adore each other and how perfect they were together! The glutinous cups grew larger and touched, rim to rim. Their mouths drew apart.
>
> (Highsmith 1957: 231)

This is (aside from *Carol* [1952] and *Small g: A Summer Idyll* [1995] both of which are anomalies in her *oeuvre*) the only example of a pure and untainted loving scene, albeit projected by Vic onto his snails. She offers no chance of a human alternative; her novels almost universally disallow her heroes hope from another person. Vic craves silence and distance from others; the world is too much for him, and the total silence of the snail-mating ritual reinforces this.

Vic is certainly a peculiar and unlikely antihero. Following on from his killing of De Lisle, the novel charts his gradual slide into psychosis, culminating in his murdering Melinda. The final lines of the novel, when Vic leaves his house and walks towards the policeman's car waiting for him in the drive, is quite possibility the closest that the reader of Highsmith will ever come to her own thoughts on the world and the people within it:

> Vic kept looking at Wilson's waggling jaw and thinking of the multitude of people like him on the earth, perhaps half the people on earth were of his type or potentially his type, and thinking it was not bad at all to be leaving the ugly birds without wings. The mediocre who perpetuated mediocrity, who really fought and died for it. He smiled at Wilson's grim, resentful, the-world-owes-me-a-living face, which was the reflection of the small, dull mind behind it, and Vic cursed it and all it stood for. Silently, and with a smile, and with all that was left of it, he cursed it.
>
> (Highsmith 1957: 250–60)

This is Vic's endgame – he has descended into psychosis and 'leaves' the world, symbolically detaching himself from the others who he views, in very much a Nietzschean sense, as mediocre. His antiheroic status lies in the ways in which Highsmith, as in the

Ripley novels, beguiles the reader into an identification with Vic; throughout *Deep Water* the sense of 'being on his side' and almost wishing him to rid his world of the gross characters that populate it, works in a similar way to the effect that the Ripley novels have on the reader. It could be argued that an antiheroic status depends fundamentally on the author's success in implicitly persuading her readers to identify with characters when they perform transgressive, morally wrong actions. If we accept this definition, then Highsmith, through Tom and Vic, is eminently successful at creating lasting and disparate antiheroes. *

REFERENCES

Freud, S. (1975), 'The Dissection of the Psychical Personality', *New Introductory Lectures on Psychoanalysis. P.F.L.2.* (trans. James Strachey), London: Penguin.

Highsmith, P. (1955), *The Talented Mr Ripley*, London: Penguin.

----- (1957), *Deep Water*, London: Penguin.

Hilfer, A. (1984), '"Not Really Such a Monster": Highsmith's Ripley as Thriller Protagonist and Protean Man', *Midwestern Quarterly Journal of Contemporary Thought*, 25: 4, p. 371.

Hubert, H. (1974), 'Maid a'Killing': Review of Ripley's Game', *Arts Guardian*, 18 March, Bern Archive.

Lobrano, A. (1989), 'Patricia Highsmith: Serial Thriller', *The Lively Arts*, 20 October, Bern Archive.

OUP (2007), *The Shorter Oxford English Dictionary*, vol. II, Marl – Z, Oxford: OUP.

Stewart, L. (1992), 'Animal Superior', *New York Observer*, 21 September, Bern Archive.

Wilson, A. (2003), *Beautiful Shadow: A Life of Patricia Highsmith*, London: Bloomsbury.

Žižek, S. (2003), 'Not a Desire to Have Him, But to Be Like Him', Review of Andrew Wilson's *Beautiful Shadow*, www.lrb.co.uk, August. Accessed 19 January 2004.

Note on Bern Archive: Some of the reviews and articles used in this paper were discovered at the Highsmith Archive, Swiss National Gallery, Bern, Switzerland. They were in Box 63 and represent Highsmith's lifelong collection of interviews she gave, and many reviews and articles. Many of these are not collated and have no page numbers. I have included all the available information.

GO FURTHER
Novels
The Ripliad

Highsmith, P. (1991), *Ripley Under Water*, New York: Knopf.

----- (1980), *The Boy Who Followed Ripley*, London: Heinemann.

----- (1974), *Ripley's Game*, New York: Knopf.

----- (1970), *Ripley Under Ground*, New York: Doubleday.

----- (1955), *The Talented Mr Ripley*, London: Penguin.

Vic Van Allen
Highsmith, P. (1957), *Deep Water*, New York: Harper & Brothers.

Other Patrica Highsmith novels
Highsmith, P. (2014 [1964]), *The Glass Cell*, London: Virago.

----- (2004 [1952]), *The Price of Salt*, also published as *Carol*, New York: W. W. Norton & Company.

----- (2002 [1983]), *People Who Knock on the Door*, New York: W. W. Norton & Company.

----- (2001 [1954]), *The Blunderer*, New York: W. W. Norton & Company.

----- (1995), *Small g: A Summer Idyll*, London: Bloomsbury.

----- (1987), *Found in the Street*, London: Penguin.

----- (1977), *Edith's Diary*, London: Heinemann.

----- (1972), *A Dog's Ransom*, New York: Knopf.

----- (1969), *The Tremor of Forgery*, New York: Doubleday.

----- (1967), *Those Who Walk Away*, New York: Doubleday.

----- (1965), *A Suspension of Mercy*, London: Heinemann.

----- (1964), *The Two Faces of January*, New York: Doubleday.

----- (1962), *The Cry of the Owl*, New York: Harper & Row.

----- (1961), *This Sweet Sickness*, New York: Harper & Brothers.

----- (1958), *A Game for the Living*, New York: Harper & Brothers.

----- (1950), *Strangers on a Train*, New York: Harper & Brothers.

Books
Peters, F. (2011), *Anxiety and Evil in the Writings of Patricia Highsmith*, Burlington: Ashgate.

Highsmith, P. (1999 [1966]), *Plotting and Writing Suspense Fiction*, New York: St Martin's Press.

Harrison, R. (1997), *Patricia Highsmith*, New York: Twayne Publishing.

Hilfer, T. (1990), *The Crime Novel: A Deviant Genre*, Austin: University of Texas Press.

Films
Adaptations of Patricia Highsmith novels
The Cry of the Owl:

Thraves, J. (2009), *The Cry of the Owl*, UK: BBC Films.

Chabrol, C. (1987), *The Cry of the Owl*, France: TF1/Italfrance Films.

The Glass Cell:

Geißendörfer, H. W., (1978), *Die gläserne Zelle*/The Glass Cell, Germany: Bavaria Film.

The Price of Salt/Carol:

Haynes, T. (2015), *Carol*, UK/USA: Number 9 Films/Film 4/Killer Films.

Ripley's Game:

Cavani, L. (2004), *Ripley's Game*, US: Fine Line Features.

Wenders, W. (1977), *Der amerikanische Freund/The American Friend*, West Germany: Road Movies/ WDR/Wim Wenders.

Ripley Under Ground:

Spottiswoode, R. (2005), *Ripley Under Ground*, Germany/France/UK: Fox Searchlight Pictures.

Strangers on a Train:

Hitchcock, A. (1951), *Strangers on a Train*, USA: Warner Bros.

The Talented Mr Ripley:

Minghella, A. (1999), *The Talented Mr Ripley*, USA: Miramax/Paramount.

Clement, R. (1960), *Plein Soleil/Purple Noon*, France: Titanus.

The Two Faces of January:

Amini, H. (2014), *The Two Faces of January*, UK,/USA: Studio Canal/Timnick/ Working Title Films.

'Well, whatever you do, however terrible, however hurtful, it all makes sense, doesn't it, in your head. You never meet anybody that thinks they're a bad person.'

TOM RIPLEY

THE PUNISHER
NATIONALITY: AMERICAN / CREATOR: MARVEL COMICS

Marvel Universe icon and murderous antihero
Kent Worcester

> Punishment is unpleasant to inflict and not particularly pleasant to discuss. But clearly we need to discuss it. – Brand Blanshard, 'Retribution Revisited'

In the summer of 2011, comic book writer Greg Rucka and editor Stephen Wacker organized a conference call with bloggers and critics to promote the relaunch of one of Marvel's better-known characters, the Punisher. During the conversation, Rucka admitted that the 'death-wish vigilante never really appealed to me', but said he accepted Marvel's offer because he came to recognize that the character's decades-long war on crime raised intriguing questions from a storytelling perspective. 'How it is that he can keep going, that he survives, that he hasn't eaten his own gun – those questions are really interesting to me', he told his listeners. 'He has the image of a bull in a china shop, but he's anything but. I love how smart he is', Rucka added (Manning 2011).

First introduced in the pages of *Amazing Spider-Man* #129 (February 1974), Frank Castle, aka the Punisher, was approaching his 40th anniversary when this phone conference took place. While Castle does not quite stand at the apex of the Marvel line-up – that honour belongs to figures like Spider-Man, the X-Men and the Avengers – he is nevertheless a significant player in the Marvel Universe (MU). He is one of only a handful of the company's characters to have inspired three or more solo movies, as well as to have featured in multiple simultaneously published comic book series. He is also one of a small number of MU personalities whose name, costume and core-story might just ring a bell with people who don't read comics. For these reasons alone the character rewards a certain level of brand management. As the Marvel Universe's most famous angry lone wolf, the Punisher is a high-concept avatar of vengeance-based entertainment. He is more than just another highly motivated fictional crime fighter – he is a brand within a brand, a storyworld nested within a larger storyworld, and, at the same time, valuable

intellectual property.

By the time Greg Rucka assumed responsibility for writing Punisher stories, the character had already appeared in 11 ongoing series, 25 limited series, 33 one-shot titles, 11 crossover events and several standalone graphic novels. Iterations of the same basic template had featured in over 700 individual comic books and around 50 bound volumes, many of which were written, pencilled, inked and coloured by industry heavy-hitters like Mike Baron, Howard Chaykin, Steve Dillon, Garth Ennis, Matt Fraction, Frank Miller and John Romita Sr. In addition, a futuristic version of the character appeared in the 34-issue series *the Punisher 2099* between 1993 and 1995. The character's cultural reach extends to feature-length movies and shorts (1989, 2003, 2008, 2012), video games (1990, 1993, 2005, 2009, 2013), animated television programmes and films (1995, 1996, 2009, 2014), and endless licensed products, from socks, hats and T-shirts to action figures, floor mats and studded earrings. If the Punisher is not quite as ubiquitous as Captain America or Iron Man, he is nevertheless a fixture in comic book culture. Given his fan base, track record and clarity of purpose – not to mention the perennial resonance of revenge-centric narrative – it seems unlikely that the character will be permitted to fade into the background anytime soon.

Vigilantism, broadly defined, is far from uncommon in the Marvel Universe, or comic books more generally. The *Marvel Database* designates hundreds of MU characters as vigilantes, most of whom, such as Spider-Man and Daredevil, turn wrongdoers over to the authorities rather than, say, executing them on the spot (Marvel Database 2014). These characters usually view themselves as augmenting rather than supplanting lawfully constituted authority, even if those in charge do not necessarily concur. This is one reason why readers, creators and publishers view these characters as heroic, despite (or because of) their theatrical and extrajudicial methods. By contrast, the Punisher operates on the assumption that the system has definitively broken down and that he has no choice but to take matters into his own hands. Rather than delivering lawbreakers to the nearest police station, the Punisher invokes the vigilante's 'right' to act as judge, jury and executioner. As the literary historian John G. Cawelti pointed out in the context of discussing Mickey Spillane's Mike Hammer, the vigilante rejects 'the ordinary social and ethical pieties and faces a world that he has learned to understand as fundamentally corrupt, violent, and hostile' (1976: 150).

Armed with an obdurate will, retributive worldview and specialized training and skill set, the Punisher's remorseless anti-crime campaign enacts a transgressive morality that pits one man's natural law against an entire social order. And over time, the character has wracked up a prodigious body count. In this respect, Mike Hammer is a neonate in comparison to the Punisher. In his advertorial conversation with Rucka, Marvel's Stephen Wacker stated that the character was officially responsible for the deaths of 48,502 people in the Marvel Universe (Manning 2011), a figure that is derived from events that have either been depicted or implied in the pages of Marvel comics. The scale and dura-

tion of the Punisher's one-man campaign of imaginary violence is a weirdly formidable accomplishment.

The Punisher storyworld

The Punisher is one of a small number of prominent Marvel figures who were introduced at the end of the so-called Silver Age; other examples include Ghost Rider, Moon Rider and Swamp Thing. Of these post-1960s franchises the only one that rivals or exceeds the Punisher in commercial potential is X-Men's Wolverine. While many of the company's high-profile characters were unveiled in the 1940s or the 1960s, the Punisher entered the Marvel Universe the same year as the emotionally volatile Wolverine, 1974, when the crusading vigilante was flourishing on the movie screen and in paraliterary fiction. The outpouring of vengeance-narrative in the mid-1970s is striking; films like Michael Winner's *Death Wish* (1974), Don Siegel's *Dirty Harry* (1971) and Tom Laughlin's *Billy Jack* (1971), as well as the *Dakota Warpath*; *Death Merchant*; *Destroyer: Remo Williams*; *Executioner*; *Enforcer*; *Lone Wolf*; and *Penetrator* pulp fiction series, all date to this period.[1] The florescence of revenge serial fiction, which often but not always revolved around disaffected combat veterans, no doubt reflected the bitter impact of the Vietnam War on service personnel, their families and their local communities, as well as the larger cultural shock-waves unleashed by the political scandals, inflationary surges and rising crime rates of the 1970s. Given the genre's growing popularity, and the wider context of social decomposition and economic stagflation, it is easy to imagine how an enterprising creator in this period might come up with the idea of dropping a hardboiled crime-fighter into the Marvel Universe. At this point the Marvel Universe already housed aliens, androids, demons, dinosaurs, gods, human–animal hybrids, magicians, mutants, ninjas, spies, time travellers, werewolves and vampires, including Dracula. A storytelling canvas this capacious and accommodating of generic diversity could surely make room for an unappeasable gunman.

It was in fact Gerry Conway, a comic book writer just out of his teens, who proposed adding a stern moral absolutist to the cast of *The Amazing Spider-Man* (1963–1999). First seen peering through the scope of a high-calibre rifle, this self-consciously violent new character raised the stakes in a title that sometimes threatened to veer off into soap opera territory. From a storytelling perspective, the character's methods and philosophy offered a stark and dramatic contrast with Peter Parker's good-natured humanism. While Spider-Man tried reasoning with the bad guys, and cracked bad jokes, the Punisher embraced a different approach. 'I kill only those who *deserve* killing', he explained in his inaugural appearance. 'It's not something I *like* doing, it's simply something that has to be done' (Conway and Andru 1974: 3, 11; original emphases). The character's morbid outfit – black Kevlar bodysuit, ammunition belt, oversized skull-face emblem, white gloves and boots – underscored the binary nature of his thinking and implicitly disdained the

snazzier clothing styles favoured by Spidey and others. From the outset, the Punisher's rejectionist ethos cast a discomfiting light on mainstream values and institutions. His comic book and related media appearances continue to constitute 'an alternative location for discussing the nature of justice' (Greenfield, Osborn and Robson 2010: 198), both within the Marvel Universe and beyond.

During the first decade of the Punisher's existence he mainly served as a trouper in Spider-Man and Daredevil stories that explicitly distanced themselves from his fierce rhetoric and tactics. During this formative period he was effectively part of Spider-Man's storyworld rather than a star in his own right. The crucial shift in his ontological status came in the mid-1980s, with the bestselling limited series *Circle of Blood*, written by Steven Grant and drawn by Mike Zeck (Scully and Moorman 2014). From this point on his ability to shoulder responsibility for one or more solo monthly series was taken for granted, by fans and professionals alike. Writers on superhero comics often cite the Punisher's Reagan-era rise as a prime example of the so-called 'grim and gritty' sensibility that flourished in the era of Alan Moore and Dave Gibbons' *Watchmen* (1986–87) and Frank Miller's *The Dark Knight Returns* (1986). In his book on *Supergods*, for example, Grant Morrison bemoans the extent to which 'Frank Castle became the template for a new generation of cookie-cutter no-compromise superthugs' (2011: 217; see also Scott 2009). Beloved characters like Spider-Man and Daredevil continued to make the case for bending rather than breaking the law, of course. But in the wake of *Circle of Blood*, Marvel's mostly young and mostly male audience now enjoyed unfiltered access to stories in which the Punisher's holistic critique of conventional legal and political norms was placed front and centre. If it is indeed the case, as Leonard Cassuto has argued, that 'inside every crime story is a sentimental narrative that's trying to come out' (2009: 7), then the Punisher's 'sentimental narrative' is buried beneath a hard shell of single-minded revanchist fury.

In his encyclopedia entry on 'fanaticism', Voltaire described the fanatic as 'a man in a frenzy' who is filled with

> paroxysms of rage [...] The persons in question are fully convinced that the Holy Spirit which animates and fills them is above the law; that their own enthusiasm is, in fact, the only law which they are bound to obey.
>
> (Voltaire 1764)

The Punisher's 'paroxysms of rage' traced back to his origin story, which was first recounted in *Marvel Preview* #2 (Conway and DeZuniga 1975), and fleshed out by later writers. Toward the conclusion of 1974's *The Amazing Spider-Man* #129, Spider-Man had asked the Punisher 'what's this whole *kick* you're on? You said you were a Marine – so how come you're fighting over *here*?' The Punisher responded by intoning, 'That's my business, super-hero, not *yours*', adding, 'Maybe when I'm dead it'll *mean* something' (Conway and Andru 1974: 19; original emphases).

The Punisher's 'business' was revealed a year later in a bleak story penned by Gerry Conway and drawn by Tony DeZuniga. During a lull in the action the Punisher reflects on the fact that 'there's a *war* going on in this country – between citizen and *criminal* – and the citizens are losing – just as my family lost' (Conway and DeZuniga 1975: 8; original emphases). The character flashes back to the fateful day he took his wife and kids to Central Park. 'It's good to be home', says Frank Castle to his wife Maria as the family enjoys a quiet picnic in the city's most famous green space. But everything quickly falls to pieces.

> 'Get *out* of here, honey! *Run*!!' he shouts, as gangsters discharge their weapons, hoping to take out anyone in the park who might have inadvertently witnessed their mob hit. 'I think I've been – *shot* – Honey. Don't worry – nothing – serious? Honey? Answer m – *no*. Dear lord, *no*. *Noooo*.' He then intones, to no one in particular, 'After a thing like that, I suppose a man *does* go – mad.
>
> (Conway and DeZuniga 1975: 8; original emphases)

Readers subsequently learned that the Punisher was of Sicilian ancestry, that he nearly joined the priesthood, and that he served three tours of duty in Vietnam. As a Marine Captain he earned the Medal of Honour, the Navy Cross, multiple Silver Stars, Bronze Stars and Purple Hearts, and the Presidential Medal of Freedom; his service record indicates that he was one of the most capable soldiers of his generation. After his family was murdered he jettisoned his civilian identity and never looked back. From this point on he occasionally attracted allies, such as David 'Microchip' Lieberman, a computer genius, but failed to develop meaningful friendships. From day one the character was an outsider, hardliner, loner and non-joiner. As he warned Captain America during one of their many encounters, when Cap was tempted to do away with a particularly corrupt political leader, '*Lower* the *shield*, man! Just *walk away*! Or you can *never* go *back* [...] and it's *lonely* as hell once you get here! There's *nothing* [...] but the cold satisfaction of *punishment*!' At this point Klaus Janson's pencils offer a close-up of the Punisher giving the barest of smiles (Chichester, Clark and Janson 1992: 45; original emphases).

While his commitment to the cause of retributive violence has been steadfast, and his contempt for established institutions unwavering – 'The American justice system: what a farce' he snarls at one point (Starlin and Wrightson 1991: 1) – the Punisher has on occasion expressed doubts about the efficacy of his actions. In the graphic novel *Punisher: An Eye for an Eye*, for example, he conceded that 'sometimes I lose sight of what or whom I'm fighting for' (Potts and Lee 1992: 9), and in the *Circle of Blood* miniseries he sounded a rare note of existential despair:

> The dream is dead in me. I can't go back. I have my mission. My war. A war I'll never win. The more I do, the worse things seem to get. A mob boss dies, someone else takes his place. Nothing changes. Not really. I can't kill all of them. I see a day, not

too far off, when I'll be too slow then I'll be dead and they'll go on, and nothing will have changed.

(Grant and Zeck 1988: 55)

Or as he tells a seductive escort named Audrey, who is simultaneously a contract assassin, 'every time I go after *any* kind of criminal scum, I *always* wonder "is this the time I feel my family's *avenged*?" And every time [...] it never seems *enough!*' Audrey replies mournfully, 'I had you tell me all this to get it off your *chest*, love! But you sound grimmer than *ever.*' She offers him a 'special massage' but instead moves to stab him. He quickly draws his gun and fires at her point blank. As the scene closes, the Punisher offers a sadistic eulogy: 'The Syndicate's lost an effective *assassin*, lady [...] but you know *what*, Audrey? It *still* isn't enough' (Goodwin, DeZuniga and Rival 1989 [1975: 55]).

When the Punisher dons his costume, it is more like a uniform than a disguise. The character has no family or friends to protect, nor does he struggle to contain his inner demons. From time to time the Punisher remembers his dead wife and children, but he mainly thinks about his vocation. Over time he has wreaked havoc on drug dealers, drug cartels, arms merchants, crime bosses, street gangs, biker gangs, paedophiles, human traffickers, corrupt cops, corrupt officials, rogue intelligence agents, religiously inspired terrorists, white-collar criminals, mercenaries, superpowered villains, the Aryan Brotherhood, the Japanese Yakuza, the Chinese Triads, Jamaican Yardies and Albanian, Irish, Italian, Russian and Serbian mobsters. He has extinguished lives with guns, knives, arrows, axes, bombs, gasses, poisons, mines, flames, boulders, gravity, garrotes, cars, trucks, tanks and his own bare hands. As a consequence of these unsanctioned activities, he has clashed with everyone from the FBI, the CIA and the New York City Police Department, to the Avengers and S.H.I.E.L.D. While his stories are often set in New York City's five boroughs, he has criss-crossed the United States, Mexico and Canada, as well as Europe, Asia and Latin America. An alternate version of the character has even fought baddies in outer space (Tieri and Texeira 2012). Given that he navigates a storytelling environment populated by intergalactic armies, secret societies, scientific geniuses and godlike beings, his longevity seems more than a little improbable. The fact that he functions in a world as dangerous, crowded and technologically advanced as the Marvel Universe may be one reason why the character has been killed off more than once, albeit in 'imaginary stories' that by definition never leave a mark on the character's 'continuity'.

A fair number of iconic characters predate the Punisher, from James Bond and Sherlock Holmes to Superman and Batman. Whereas the costumes, methods and mannerisms of such characters tend to evolve over time, the Punisher has more or less stayed the same. Writers, artists and editors have tweaked the character, adding biographical details and placing him in exotic settings, but his mission, speech patterns and facial expressions have remained almost entirely unchanged. At root, he personifies the belief, as expressed by the nineteenth-century historian and philosopher Thomas Carlyle, that

revenge 'is forever intrinsically a correct, and even a divine feeling in the mind of every man' (quoted in Blanshard 1968: 70). Whenever his creators have tampered with the character's basic formula – such as in the 1998 limited series *The Punisher: Purgatory*, when he committed suicide and is resurrected by celestial beings in order to serve them as an earthbound avenging angel, and the 2009–10 *FrankenCastle* misfire, in which he joined forces with the Legion of Monsters to safeguard the monsters of Monster Metropolis – Marvel has sooner or later hit the reset button and returned him to his original state. Those entrusted with the brand have mostly recognized that the Punisher represents a remorseless, dogmatic and lucrative storytelling nexus that sums up an entire worldview. He may be psychologically disturbed – Andrew Getzfeld, a specialist in abnormal human behaviour, has found that the character exhibits symptoms associated with Antisocial Personality Disorder (2008: 167) – but at least the Punisher is not a neurotic, unlike so many MU costumed adventurers.

The Punisher is the way he is because he argues with the culture rather than responds or conforms to it. He encapsulates a doctrine of retributive justice and natural law that speaks to some readers and leaves others cold. In the apt words of Karl Marx, a character of this type conflates his 'own brutality' with 'eternal law' (1982 [1853]: 359). 'Punishment', wrote Marx in 1853,

> is nothing but a means of society to defend itself against the infraction of its vital conditions, whatever may be their character. Now, what a state of society is that which knows of no better instrument for its own defense than the hangman, and which proclaims through the 'leading journal of the world' [the *London Times*] its own brutality as eternal law.
>
> (Marx 1982 [1853]: 358–59)

Frank Castle's vindictiveness also recalls the menacing political ideas of Carl Schmitt (1888–1985), who famously insisted that the

> specific political distinction to which political actions and motives can be reduced is that between friend and enemy [...] Only the actual participants can correctly recognize, understand, and judge the concrete situation and settle the extreme case of conflict. Each participant is in a position to judge whether the adversary intends to negate his opponent's way of life and therefore must be repulsed or fought in order to preserve one's form of existence. Emotionally the enemy is easily treated as being evil and ugly, because every distinction, most of all the political, as the strongest and most intense of distinctions and categorizations, draws upon other distinctions for support.
>
> (Schmitt 1976 [1927]: 26–27)

Like Schmitt, the Punisher favours decisive violence over judicial niceties, and it makes sense that the character refuses to trim his sails. According to Marvel continuity, Frank Castle left the seminary because he developed doubts about the Church's policy of forgiveness and redemption. Recalling his days as a priest in training, he remembers thinking that 'I don't know what I'm doing here. There is so much hatred in the world, so much suffering. How could God allow this to *happen*?' (Baron and Reinhold 1989: 34; original emphases). Conditioned to believe in absolutes – right, wrong and eternal damnation – he came to reject the idea of deferring to the law or waiting for judgment day. He resolved instead to act in the here-and-now, outside the framework of Christian precepts, legal statutes or conventional morality.

Heroes, superheroes, antiheroes

Fans and scholars have long wrestled with the question of whether and to what extent the Punisher fits the superhero mould. In certain respects he fits it quite well. The character wears a highly stylized costume and is almost impossibly expert at hand-to-hand combat, intelligence-gathering and marksmanship. While he does not exhibit such powers as flight, invisibility, super-strength or super-speed, he recovers from beatings, falls, tortures, knife wounds and gunshots in ways that defy any ordinary definition of what it means to be 'human'. It is also the case that Punisher comics are routinely sold in stores that specialize in superhero comics. On the other hand, the character was fashioned out of pulp-fiction archetypes rather than superhero tropes, and his pattern of murderous behaviour is highly atypical within the context of mainstream superhero culture. He has, after all, killed tens of thousands of people, albeit on paper. These numbers, along with the occasional smirks and private asides, suggest that the character derives pleasure from killing, despite his protestations. Given his arguably sadistic proclivities, it perhaps makes sense to describe him as an 'aggressor type' (Kittredge and Krauzer 1978) rather than as a 'hero', super or otherwise. Peter Coogan usefully addresses these definitional issues in his study of the superhero genre:

> Within the Marvel universe, he is fairly clearly a superhero, but his allegiance with the aggressor hero-type pushes him out of the center of the superhero formula. As he became popular in the 1980s and was featured in multiple series, the Punisher switched back and forth between the aggressor formula and the superhero genres depending on whether he appeared in his own comics or made guest appearances in superhero stories, that is his definition as a superhero varied depending upon the concatenation of conventions in any particular story.
>
> (Coogan 2006: 54–55; see also DiPaolo 2011 and Palmer 2007)

The term 'antihero' is sometimes bandied about in comics discourse and has been applied

to Marvel characters as diverse in behaviour and outlook as Black Widow, Daredevil, Hulk, Iron Man and sweet-natured Spider-Man (Scott 2012). The term is often used to suggest that a character has failed to achieve Superman's lofty standards. But not even Superman always manages to live up to his Boy Scout reputation. It should be possible, in other words, to draw a clear distinction between 'flawed heroes' and 'antiheroes'. All superheroes are flawed to some extent or another, but flaws can be forgiven, even over-looked. Flaws help readers identify with characters. Flawless heroes are boring.

The Punisher's brutality and lethal mania places him in the antihero rather than the flawed hero camp. If the term is to mean something other than merely 'imperfect', then the contemporary antihero can be viewed as a paraliterary character that thinks and acts in ways that are seriously counter-productive from the standpoint of the community at large. The Punisher's open-ended war on crime provides a template for what *should never be allowed to happen.* ✳

REFERENCES
Baron, M. and Reinhold, B. (1989), *Intruder*, New York: Marvel.
Blanshard, B. (1968), 'Retribution Revisited', in E. H. Madden, R. Handy and M. Farber (eds), *Philosophical Perspectives on Punishment*, Springfield, IL: Charles C. Thomas Publishers.
Cassuto, L. (2008), *Hard-Boiled Sentimentality: The Secret History of American Crime Stories*, New York: Columbia University Press.
Cawelti, J. G. (1976), *Adventure, Mystery, and Romance: Formula Stories as Art and Popular Culture*, Chicago: University of Chicago Press.
Chichester, D. G., Clark, M. and Janson, K. (1992), *Punisher/Captain America: Blood and Glory #3*, New York: Marvel.
Conway, G. and Andru, R. (1974), 'The Punisher Strikes Twice', *The Amazing Spider-Man* 129, New York: Marvel.
Conway, G. and DeZuniga, T. (1975), 'Death Sentence', *Marvel Preview #2*, New York: Marvel.
Coogan, P. (2006), *The Secret Origin of a Genre*, Austin: MonkeyBrain Books.
DiPaolo, M. (2011), *War, Politics and Superheroes: Ethics and Propaganda in Comics and Film*, Jefferson, NC: McFarland.
Getzfeld, A. (2008), 'What Would Freud Say? Psychopathology and the Punisher', in R. S. Rosenberg (ed.), *The Psychology of Superheroes: An Unauthorized Exploration*, Dallas: Ben Bella Books.
Goodwin, A., DeZuniga, T. and Rival R. (1989 [1975]), 'Accounts Settled... Accounts Due!', in C. Potts (ed.), *Classic Punisher*, New York: Marvel.
Grant, S. and Zeck, M. (1988), *The Punisher: Circle of Blood*, New York: Marvel.
Greenfield, S., Osborn, G. and Robson, P. (2010), *Film and the Law: The Cinema of Justice*, Oxford: Hart Publishing.
Hatfield, C., Heer, J. and Worcester, K. (2013), 'Introduction', in C. Hatfield, J. Heer, and K. Worcester (eds), *The Superhero Reader*, Jackson, MS: University Press of Mississippi.
Jackson, Gordon M. (2015), 'The Weirdest Spy Action Novels Ever Published', *io9.com*, 11 February,

http://io9.com/the-weirdest-spy-action-novels-ever-published-1685259336. Accessed 29 April 2015.

Kittredge, W. and Krauzer, S. (1978), 'Introduction', in W. Kittredge and S. Krauzer (eds), *The Great American Detective: Fifteen Stories Starring America's Most Celebrated Private Eyes*, New York: New American Library.

Manning, S. (2011), 'Greg Rucka Unleashes the Punisher', *comicbookresources.com*, 8 July, http://www.comicbookresources.com/?id=33171&page=article. Accessed 4 January 2015.

Marvel Database (2014), 'Vigilantes' [Wikia], 3 January, http://marvel.wikia.com/Category:Vigilantes. Accessed 3 January 2015.

Marx, K. (1982 [1853]), 'Punishment and Society', in G. Ezorsky (ed.), *Philosophical Perspectives on Punishment*, Albany: SUNY Press.

Morrison, G. (2011), *Supergods: What Masked Vigilantes, Miraculous Mutants, and a Sun God from Smallville Can Teach Us About Being Human*, New York: Spiegel and Grau.

Palmer, L. (2007), 'Le Western Noir: The Punisher as Revisionist Superhero Western', in T. R. Wandtke (ed.), *The Amazing Transforming Superhero! Essays on the Revision of Characters in Comic Books, Film and Television*, Jefferson, NC: McFarland Press.

Potts, C. and Lee, J. (1992), *Punisher: An Eye for an Eye*, New York: Marvel.

Schmitt, C. (1976 [1927]), *The Concept of the Political*, Piscataway, NJ: Rutgers University Press.

Scott, C. (2009), 'The Alpha and the Omega: Captain America and the Punisher', in R. Weiner (ed.), *Captain America and the Struggle of the Superhero: Critical Essays*, Jefferson, NC: McFarland Press.

––––– (2012), 'Anti-Heroes: Spider-Man and the Punisher', in R. M. Peaslee and R. G. Weiner (eds), *Web-Spinning Heroics: Critical Essays on the History and Meaning of Spider-Man*, Jefferson, NC: McFarland Press.

Scully, T. and Moorman, K. (2014), 'The Rise of Vigilantism in 1980s Comics: Reasons and Outcomes', *The Journal of Popular Culture*, 47: 3, pp. 634–53.

Starlin, J. and Wrightson, B. (1991), *Punisher P.O.V. #1*, New York: Marvel.

Tieri, F. and Texeira, M. (2012), *Space: Punisher*, New York: Marvel.

Voltaire (1764), 'Fanaticism', https://ebooks.adelaide.edu.au/v/voltaire/dictionary/chapter199.html. Accessed 19 June 2015.

GO FURTHER

Graphic novels

Ennis, G. and Dillon, S. (2011), *The Punisher: Welcome Back, Frank*, New York: Marvel.

Maberry, J. and Parlov, G. (2011), *Marvel Universe vs. the Punisher*, New York: Marvel.

Ennis, G. and Robertson, D. (2007), *Punisher MAX: Born*, New York: Marvel.

Conway, G. (2004), *Essential Punisher Volume 1*, New York: Marvel.

Dixon, C. and Wellington, J. (1990), *Punisher: Kingdom Gone*, New York: Marvel.

Grant, S. and Zeck, M. (1989), *Punisher: Return to Big Nothing*, New York: Marvel.

Books

Ndalianis, A. (ed.) (2009), *The Contemporary Comic Book Superhero*, New York: Routledge.

Barry, M. (1973), *The Lone Wolf: Night Raider,* New York: Berkley.

Derrick, L. (1973), *The Penetrator: The Target is H*, New York: Pinnacle.

Ralston, G. (1973), *Dakota Warpath*, New York: Pinnacle.

Pendeleton, D. (1969), *The Executioner*, New York: Pinnacle.

Extracts/Essays/Articles

Worcester, K. (2012), 'The Punisher and the Politics of Retributive Justice', *Law Text Culture*, 16, pp. 329–52.

Debose, M. S. (2007), 'Holding Out for a Hero: Reaganism, Comic Book Vigilantes, and Captain America', *Journal of Popular Culture*, 40: 6, pp. 915–35.

Lovell, J. (2003), 'Nostalgia, Comic Books & the 'War Against Crime!' An Inquiry into the Resurgence of Popular Justice', *Journal of Popular Culture*, 36: 2, pp. 335–51.

Films

Film adaptations of the Punisher

Alexander, L. (2008), *Punisher: War Zone*, USA: Lionsgate.

Hensleigh, J. (2004), *The Punisher*, USA: Artisan Entertainment.

Goldblatt, M. (1989), *The Punisher*, USA: New World Pictures.

Other vengeance-narrative films

Winner, M. (1974), *Death Wish*, USA: Paramount Pictures.

Laughlin, T. (1971), *Billy Jack*, USA: Warner Brothers.

Siegel, D. (1971), *Dirty Harry*, USA: Warner Brothers.

Video games

Lego Marvel Super Heroes (2013, Warner Brothers Interactive Entertainment).

The Punisher (2005, THQ).

Notes

1 Tom Laughlin's *Billy Jack* was released in 1971 and re-released in 1973; the titular character first appeared in *Born Losers* (1967), and the sequel *The Trial of Billy Jack* was released in 1974. Michael Winner's 1974 film *Death Wish* spawned four sequels (1982, 1985, 1987, 1994) and was loosely based on a 1972 novel, also titled *Death Wish*. Released in 1971, Don Siegel's *Dirty Harry* inspired four sequels (1973, 1976, 1983, 1988) as well as twelve paperback novels. Gilbert Ralston's *Dakota Warpath* series commenced in 1973; there were four sequels. Both Joseph Rupert Rosenberger's *Death Merchant* and Warren Murphy and Richard Sapir's *The Destroyer: Remo Williams* series kicked off in 1971 and ultimately spun off 71 and 150 titles respectively. Andrew Sugar's *Enforcer* series, launched in 1973, generated six titles. Mike Barry's *Lone Wolf* series, also starting in 1973,

generated fourteen titles. Lionel Derrick's *Penetrator* series began in 1973 and yielded 53 titles. The most successful of these franchises, Don Pendleton's *The Executioner*, was first published in 1969; its hundreds of sequels have collectively sold more than 200 million copies.

SONCHAI JITPLEECHEEP
NATIONALITY: THAI / CREATOR: JOHN BURDETT

Globalization, justice and karma in John Burdett's Bangkok series
Nicole Kenley

British author John Burdett's Bangkok Detective series (2003–12) comprises five novels featuring Royal Thai Police Detective Sonchai Jitpleecheep and his recurring cast of characters, including his brothel-running mother, his prostitute and sociology student wife, his viciously corrupt police colonel and his transsexual sidekick. Burdett's novels explore the interplay between eastern and western models of policing, tackling differing modes of justice, detection, science, evidence, capitalism and globalization. Burdett's main character Sonchai Jitpleecheep occupies a complex array of identities, including member of a dirty police force, honest detective, *consigliore* to a crime lord, devout Buddhist, monk *manqué,* and *papasan* of his mother's brothel. These conflicting identities establish Detective Jitpleecheep as an antihero in many ways; he believes in justice, but frequently commits crimes in order to bring about that justice. Further, though, Jitpleecheep's conflicting antiheroic traits allow Burdett to portray a new version of a solution for global crime: an acceptance of multiplicities of meaning rather than an insistence on a singular solution. For Detective Jitpleecheep, crimes can and, in fact, must have multiple differing solutions in order to even attempt to satisfy an array of global victims and perpetrators.

One of the biggest reasons that Burdett's novels are able to capture the spirit of simultaneity that globalization requires is his widely varied main character Sonchai Jitpleecheep. Serving as narrator for all five Bangkok novels, Jitpleecheep directly addresses the white western reader, or *farang* in Thai, as a way of allowing an outsider to look in on a complex other. Jitpleecheep represents multiple different perspectives on the globe contained within one person. As the son of a prostitute and an American GI, he is a literal embodiment of the East meeting the West (Burdett 2003). As a member of the Royal Thai police force, he is charged with maintaining law and order, but he fluctuates on either side of that line, going beyond his duties to enforce the law when he calls on his

morals as a devout Buddhist, but also defying those morals to serve as the *papasan* or pimp in his mother's brothel. Further, Sonchai serves the incredibly corrupt police colonel Vikorn as his *consigliore*, which he frequently tries to reconcile with his Buddhist values. Sonchai's complexity can serve him well or ill, as he is both a fit for many different situations and out of place in all of them. As Vikorn says when discussing Sonchai's fitness to be an international *consigliore*,

> 'You speak English. You are the half-*farang* bastard son of an American serviceman and so can pass for near white. You are also accustomed to international travel. [...] You're actually interested in truth and justice. I had a feeling that might come in useful eventually.'
>
> (Burdett 2012: 10–11)

While Jitpleecheep's appearance and background are useful to Vikorn in carrying out, for example, international drug-trafficking schemes, they also make him an ill fit in most situations. He has 'permanent pariah status in [...] society [...] you're a *leuk kreung*, a half-caste [...] your mother's illustrious lovers taught you way above your station' (Burdett 2010: 209). Jitpleecheep is an exile not only for his racial status but also for his global education. As his mother travelled the world as a high-class consort to international businessmen, Jitpleecheep accompanied her and soaked up cultural globalization. 'In case you're wondering how a Thai pimp-cum-cop acquired such erudite taste in movies, *farang*, it's all thanks to one of my mother's former clients, a Frenchman [...] who taught me many things' (Burdett 2010: 135). As a youth Sonchai travelled the globe, with prolonged stays in Europe and America, and he developed an understanding of western culture that he draws on in policing global crime.

Jitpleecheep has a flair for the dramatic in describing himself, but in his description comes an awareness of why he is a fit global detective.

> I'm in a four-button, double-breasted blazer by Zegna, a spread-collar linen shirt by Givenchy, tropical wool flannel slacks, and best of all, patent leather slip-ons by Baker-Benjes, which uncoplike wardrobe is entirely thanks to my junior share of profits from my mother's bar. My cologne is a charming little number by Russell Simmons. I am a humble self-effacing Buddhist, so you can believe me when I say that I look – and smell – sexy as hell. The Thai genes give me a haunted look; the *farang* genes provide an illusion of efficiency: a high-tech dick or a third-world ghost buster? These concepts are not mutually exclusive.
>
> (Burdett 2007: 111)

Even in his attire, Jitpleecheep sports an international assortment: Italian blazer, French shirt, Manhattan shoes, and cologne from a hip hop mogul. Further, these outfits come

courtesy of the profits of a bar – read brothel – that caters to a global clientele found on the Internet. Jitpleecheep sees himself as 'haunted' by his genetic make-up, which is in essence an 'illusion', because the sometimes contradictory elements of his persona are somehow 'not mutually exclusive'. This ability to view the 'high-tech' and the 'Third World' as concepts that can and do exist simultaneously, especially in policing crime, mark him as capable of understanding the multiplicities of solutions that global crime requires.

Jitpleecheep seems to access whichever mode of himself the crime requires, adapting his approach based on the circumstances and his own experiences. At one crime scene,

> While staring at the victim as they turn him over again, I am thinking *farang*, I'm thinking France, Germany, England, Japan, the United States, G8, I'm thinking *decadence*. In a single stroke the case has been taken out of Thai psychology, and I'm reduced to whatever cultural insights I acquired overseas.
>
> (Burdett 2006: 27; original emphasis)

Though Jitpleecheep describes himself as 'reduced' in this circumstance, he actually has a better insight into the crime – a grisly Bangkok murder of an American CIA operative – than either his colleagues on the police force or his co-investigator, an FBI agent that he repeatedly refers to as simply 'the FBI' or, in one instance, 'the American hero' (2006: 4). Solving a crime of this nature, one which requires the consideration of multiple national and religious cultural influences (in this case American, Japanese and Thai, as well as Islamic and Buddhist) requires a detective figure capable of accessing all of these registers through experience and background. Jitpleecheep also applies his Buddhist mores while on a case, seemingly abandoning his role as an investigator to become a moral arbiter, as when he tells a suspect 'I'm not working for the Royal Thai Police today. I'm moonlighting for the Buddha' (2007: 254). Jitpleecheep's ability to switch from one role to the other, however, is belied by his constant moral doubts about his function in the process of policing global crime. He cannot shed his training as cop, just as he cannot shed his background as Buddhist or as a product of both western and Thai culture. He occupies all of these registers simultaneously, making him fit to occupy the role of global detective.

Another key facet of Jitpleecheep's identity is his relationship to Buddhism, which gives him a sense of the simultaneity of human existence that greatly influences his detection. Through Buddhism, Sonchai gains not only investigative techniques which diverge from the standard western conception of evidence-gathering but also an understanding of how multiple scenarios can exist simultaneously. After committing petty crimes as a youth, Jitpleecheep and his first police partner Pichai were allowed to serve for a year in a monastery in lieu of jail time, an experience which changed both

boys irrevocably,

> in a way that is impossible for nonmeditators to understand. Ever since, I have experienced flashes of insight into the past lives of others. Sometimes the information is precise and easy to interpret, but most of the time it consists of rather vague phantasmagoric glimpses of another person's inner life.
>
> (Burdett 2006: 44)

Jitpleecheep uses these flashes of inspiration intuitively, rather than based on factual evidence-gathering, and frequently allows them to dictate the course of an investigation. While the tradition of detectives following their intuition rather than a strict set of facts is a well-established literary trope, Burdett extends this concept far beyond its usual parameters. For example, in meeting an imam suspected of terrorism in *Bangkok Tattoo* (2006), Jitpleecheep decides, based on his flashback to the man's inner life, that he can be trusted. 'I'm almost certain of it: we met at the great Buddhist University at Nandala, India, oh, about seven hundred years ago. I have to admit he's kept his glow' (2006: 44). Jitpleecheep reveals here, for the first but not only time, that he has a sense of what he believes to be his former incarnations throughout history, stretching back nearly a millennium. This belief not only allows him to gain insight periodically into the true natures of the suspects he investigates but, more crucially, demonstrates a sense of simultaneity in identity. Currently he is Sonchai Jitpleecheep, Royal Thai Police Detective, but in other iterations he has been men (and women, and transsexuals) of many different nationalities and social strata. In a way, Jitpleecheep simultaneously embodies all these different identities, truly demonstrating his fitness to serve as a global detective because he understands, and in a way encompasses, the vastness of globalization and the simultaneity of solutions it requires.

Jitpleecheep structures the way he views crime around the fundamentals of karma, which functions analogously in the novels to market forces. Crimes and markets work in 'reference to the law of karma: cause and effect. I kick you, you kick me back' (2010: 12). The principles of Buddhism make Jitpleecheep one of the few moral voices in the Royal Thai Police Force, a detective who refuses to take bribes from suspects or kickbacks from the department, even when these actions would be culturally expected, because of his respect and fear of karma. Yet serving as Vikorn's *consigliore* also presents Jitpleecheep with the opportunity to nudge his own karma forward, making merit as Vikorn extorts various bigwigs in the Thai hierarchy. When shaking down a high-level banker, the two negotiate.

> 'This could put my life at risk, Colonel.'
> He raises his eyebrows, then looks away. 'Ten percent for the relief of poverty.'
> 'Twenty.'

'Done.'

I shrug. If it is the Buddha's will that Khun Tanakan's wealth be more equitably distributed, who am I to argue?

(Burdett 2007: 73)

In this instance, the 20 per cent is to come out of 5 million dollars, so Jitpleecheep manages to pocket a tidy sum – or, rather, to pass it along to benefit the poor and his own karma to boot. Yet despite the occasional benefits to the Buddha, Jitpleecheep's negotiations more often than not place him in quandaries that require no small amount of moral dexterity.

Frequently, Jitpleecheep is charged with taking care of his colonel Vikorn's dirty laundry, a task which never fails to incite him to new levels of moral anxiety. After all, as Jitpleecheep notes, according to his principles 'The next life is determined by how generous we are in this one, how much compassion we show, not by the extent to which we're bent by market forces' (2007: 21). With such a reward comes a high cost, though, as Vikorn's tasks include asking Jitpleecheep to cover up the true cause of death in multiple murders, dispose of bodies, bait elaborate traps for his enemies, and traffic internationally in, among other things, cocaine, methamphetamine and a large shipment of Chinese eyeballs.

> In more than a decade of feudal service to my chief, he has never asked me to perform a socially useful task. On the contrary, my personal contribution to the community has largely consisted in modifying his personal interpretation of Western capitalism.

(Burdett 2012: 10)

Jitpleecheep serves Vikorn as part of a complicated Thai system called *gatdanyu*, or blood debt, which ensures Jitpleecheep's loyalty and compliance, but this indebtedness also triggers waves of guilt regarding his complicity in these crimes. Jitpleecheep is 'supposed to be a Mafioso, a despicable international drug trafficker' but instead just feels like 'a poor sucker among six billion poor suckers ensnared irrevocably in karma from which there has never been any escape' (2010: 50). Jitpleecheep's ambivalence about his role in Vikorn's organization (which, ostensibly, falls under the umbrella of the national police force) demonstrates the unease with which he exists inside the multiple spaces he inhabits. His moral code (he frequently refers to himself as a 'monk manqué [...] ensnared by a nefarious process' [2010: 48]) is at odds with his professional obligations, but also with the system under which those obligations operate. While his 'sacrifice of integrity only made [him] feel like [he] was drowning in a sewer', he ultimately 'blame[s] the version of capitalism which is destroying the world: you have to be a shit to survive' (2010: 57). That survival and morality should be at odds within a global system should not come

as a surprise, but what sets Jitpleecheep apart is his ability to not only survive but thrive within the corruption because of his ability to embrace simultaneous and, often, contradictory versions of reality. Ultimately, Jitpleecheep emerges as a fit figure to police global crime precisely because he embraces the multiple versions of himself that are required for him to do so. Honest cop, *consigliore*, husband, pimp; these various facets create a detective who can exist in multiple states simultaneously. Commenting on his life, Jitpleecheep opines,

> Sometimes I envy my Western counterparts the simplicity of their lives; presumably they have no care in the world beyond bringing perps to justice? A little schoolboyish, though, and lacking in moral challenge. I doubt you can burn much karma that way.
>
> (Burdett 2007: 158)

Single-mindedness, even when focused on a seemingly laudable concept like 'bringing perps to justice', fails in the face of the complexity presented by the global landscape. Alternate dimensions of morality, justice and even existence present extraordinary challenges, and only a detective who embraces this 'moral challenge' can navigate these waters.

Burdett continues to play with generic tropes and readerly expectations when it comes to describing the crimes themselves. Describing a particularly gruesome murder in *The Godfather of Kathmandu* (2010), Jitpleecheep says,

> 'Sure, anyone can simply glance at something like that without suffering psychic overload, but try absorbing its significance on a deeper level – okay, okay, *farang*, you don't want to know about that, you want to know about sex, drugs, and murder, I understand.'
>
> (Burdett 2010: 33)

The narrative is a product on the market like any other, and in order to appeal to the global marketplace Jitpleecheep must at times curtail the depth of his spirituality and its interplay with his investigative techniques in order to attend the classic, and classically marketable, tropes of the genre, namely 'sex, drugs, and murder'. The central case in *Kathmandu* does in fact contain a high percentage of these elements, but as the forces of globalization exert increasing influence on Thai society, they start to matter far less on the individual level and far more in bulk. The central mystery of *Kathmandu* loses interest even for its primary investigator, and global crimes take precedence.

> The case of the murder of Frank Charles, aka the Case of the Fat *Farang*, also nicknamed the Hollywood File, was the last thing I wanted to deal with. Who cares

whodunit? The grim, mechanical rituals of the world grind on, monochrome now, and entirely without interest to me.

(Burdett 2010: 64)

Jitpleecheep's ennui is no mere affect. His dealings as the *consigliore* for Vikorn and his arch-rival, Army General Zinna, become hugely complicated as both men transition into international drug traffickers, registered as corporations. These men have the force of corporate entities, with both controlling nationalist organizations but in many ways being far bigger than the nation they represent. The Hollywood mogul, by contrast, turns out to have been murdered not due to his involvement with an international jewel syndicate (forging gemstones) but by an individual he jilted. This murder rates even below the interest level of the syndicates he was involved with and, despite how grisly the murder was (the victim's skull was opened and chunks of his brain were removed, in a parody of the genre's sensationalism), it fails to stir up any notice. Even Jitpleecheep, investigating the case, loses interest in comparison to the global crimes he has to monitor. The corporations are content with the fictional versions of the solution to the mystery that they concoct for themselves, and those versions exist simultaneously with Jitpleecheep's solution to the crime. Regardless, as Jitpleecheep himself admits, this individual murder really does not matter – it has been eclipsed by global crime.

This conception of global policing affects nearly all of Jitpleecheep's cases, and allows Burdett to subtly mock the tradition of detective novels focused on solving a single murder. As Jitpleecheep says,

I mean, nine times out of ten you know whodunit so you grow the evidence accordingly – it's one of those efficient Asian techniques you'll have to adopt as global competition heats up – can't have your law enforcement potting fewer perps per cop than us, can you – especially now that you've dumped the rule of law in all cases where it proves inconvenient, right?

(Burdett 2006: 121)

Jitpleecheep's dismissal of the genre's driving question, *whodunit*, as an obvious answer allows him to transition to the idea of law enforcement as yet another global commodity trying to move as many units – in this case, criminals – as possible. The dig at post-September 11 American justice is configured as a response to 'efficient Asian techniques', simply a realization that law enforcement has proceeded as if it knew whodunit and shaped 'the evidence accordingly' all along, implying that the West has been slow to catch on to this model and must needs adjust if it wants to compete.

Jitpleecheep endorses a different method of detection than the traditional gumshoe, who doggedly follows leads and gathers clues until the true perpetrator emerges. Instead, as a nod to the need for multiple solutions in a global environment, he uses his

spiritual instincts as a method of information-gathering. He frequently meditates on important clues or issues that give him difficulty, choosing to believe in a deeper reality than the one empirically presented to him. In *Bangkok Tattoo*, when puzzling over the case, Jitpleecheep reports that

> in my sleep my dead partner and soul brother Pichai comes to me, or rather I visit him. He sits in a circle of meditating monks who exude honey-colored glows and at first does not want to be disturbed. I insist, and slowly he emerges from his divine trance. *Want to help?* I ask. *Look for Don Buri*, Pichai replies, then returns to the group.
>
> (Burdett 2006: 20)

For Jitpleecheep, consulting his former partner from beyond the grave comes just as naturally as it did before he was killed. The figure of Pichai exists in multiple forms throughout the novels – in a monkish destiny fulfilled, as here, or reincarnated in Jitpleecheep and Chanya's son, named Pichai to represent his true status as the reincarnated partner. That one person should exist in multiple states is part and parcel of Jitpleecheep's philosophy of detection, and consulting one version of that state is as natural as consulting another, as when he converses with the imam in his current iteration while recalling their dialogue from 700 years ago. It is worth noting that while Burdett is clearly cognizant of how easy it would be to write off Jitpleecheep's spirituality as so much hogwash – 'The trouble with inspirational detection: it can make you appear scatty' (2007: 258) – Pichai's clue actually turns out to be on the mark. While Jitpleecheep at first misinterprets it, in another classic generic trope, asking all over Bangkok for a man named Don, Pichai alludes in truth to the titular tattoo, *donburi* in Japanese, which was indeed completed by a Japanese tattoo artist.

Burdett insists on the lack of logic present in his vision of crime fiction in direct contrast to the typical generic mode of insisting on the rational. One of the cardinal rules of the genre, in place since its inception and toyed with in classics like *The Hound of the Baskervilles* (Conan Doyle 1902), is that every mystery must have a logical solution rather than a supernatural one. For the genre to play fair with its readers, the crime and its circumstances must ultimately be explicable and in keeping with the evidence laid out in advance. Burdett repeatedly points to this insistence on rationality as a limiting aspect of the genre as it insists on a unified explanation, which in dealing with crimes of global scope is often impossible. In *Bangkok Haunts* (2007), a novel which deals with the supernatural extensively, Jitpleecheep insists on the existence of ghosts which can haunt multiple parties at once. The explanation to the crime ends up depending on a haunting, and Burdett hammers this defiance of generic convention home as Jitpleecheep says 'Any vestigial notion that there might be a rational explanation, or that "A cannot be not-A," is quite erased' (2007: 285). The insistence on rationality in detective fiction cre-

ates for Burdett a limiting dependence on the way that data can be interpreted, such that the Aristotelian dictum that 'A cannot be not-A' disallows any degree of multiplicity. Burdett insists on multiplicities being available for data, even if it means moving beyond rationality, because global crime requires the simultaneity of multiple explanations.

This move beyond the strictly explicable in the name of multiplicity and simultaneity is preserved as Burdett delves into the subgenre of forensic detective fiction. The relatively few moments when forensics appear in Burdett are notable for the ways in which they confront western scientific views in order to allow for a dimension of the world outside what science can properly explain. For Chanya in *Vulture Peak* (2012), the problem is one of limits: 'It seemed to her there was something seriously missing in *farang* logic: it only dealt with measureable things and had no way of incorporating the Unnameable – or even basic human nuance – in its calculations' (2012: 40). While some forensic novelists do demonstrate the extent to which forensic science can be seen as not telling the entire story, Burdett is not wrong to think about scientific logic as incapable of treating situations outside the dictates of data.

The central crime of *Vulture Peak* – worldwide organ trafficking – points to the growing featurelessness of the victims of global crime in an extremely literal sense. Describing bodies at a crime scene, Jitpleecheep says,

> The Buddha taught that the distinction between subject and object, the self and other, even between you and me, Dear *Farang* Reader (may I call you DFR?), is illusory. This lesson is brought home with perhaps more drama than the Master intended when the human forms before you have been stripped of faces, eyes, genitals, and – as the good doctor indicates by pointing to gaping wounds in each cadaver – kidneys and livers too. To call them anonymous would be to evade the issue. [...] [They are] stripped of every vestige of personal identity.
>
> (Burdett 2012: 4)

Jitpleecheep begins by pointing towards the way in which his spiritual principles elide the distinctions which structure most societal interactions – breaking down even the distinctions that he spends so much time drawing out, between himself and the outside *farang* culture. These distinctions matter less and less in a global market, which makes everyone and everything a consumer, in this case quite literally – the bodies are stripped for parts to the extent where even anonymity is a misnomer since the corpses cease to have any identity to protect. As Jitpleecheep remarks later, 'Organs are very personal things. You sell one, it's the same as saying you don't really exist except as an economic unit' (2012: 30). The commodification of people is facilitated in the novel by a new drug that gets around one of the primary roadblocks of organ transplants: the host rejecting the new organ. Thanks to this drug, the organs taken from these corpses can be transported anywhere around the globe and transplanted into anyone with the means to pur-

chase them on the black market. The technological trappings that so facilitate globalization have as one of their chief benefits the anonymity that e-commerce allows, but Burdett shows the sword cutting both ways, with global crime robbing people of identity just as easily (and far more permanently).

The degree to which Jitpleecheep is actually expected or able to contain global crime is up for debate. In Jitpleecheep's estimation, new strategies for policing combined with an understanding of the multiplicities of globalization can have, if not total success in policing global crime, then at least some measure of containment. The version of reality Jitpleecheep experiences daily is already enough to confound those less experienced in the world of globalization or, as he puts it to a foreign colleague, "'I'm a busy policeman. I have to cope with an existential reality that would have you messing your diaper'" (2012: 140). The extraordinary multiplicity of Jitpleecheep's own life renders him more receptive to concepts of containing global crime that, while perhaps antithetical to traditional conceptions of justice, fit well into the genre's standard conception of subjective justice. One of the ways that globalization requires the revision of standard figurations of justice is its insistence on the obsolescence of individuality. Anonymity rules the day to the extent that determining individual guilt does not matter. This is true in novels like *The Godfather of Kathmandu*, wherein solving a single murder fades compared to the global crime rings surrounding the case, and in the novels more generally, as Jitpleecheep declares that individual perpetrators matter less and less in the global landscape. In the case of *Vulture Peak*, when asked if he knows the identity of the perpetrator, he again invokes the traditional driving question of the genre to reply, "'You mean whodunit? Only in the more general sense. [...] Ronald Reagan, Milton Friedman, Margaret Thatcher, Adam Smith. Capitalism dunit'" (2012: 5). As Jitpleecheep would have it, then, since the perpetrator is in one sense always already known, he is free to audition other modes of detection better suited to global crime. A detective colleague from Hong Kong seconds this assessment, saying that "'a feature of modern policing [...] we already touched on it [is that] a fixed sense of personal identity will be a fatal impediment in law enforcement of the future'" (2012: 253). The 'fixed sense of personal identity' must be discarded with regard to the criminals but also with the detectives as well. For the global detective to compete with global crime, he or she must also become corporate. Jitpleecheep's colleague espouses a system of networking that mimics the way Internet technology has developed.

> 'Ever hear of cloud policing? [...] it's going to be the next phase in humanity's descent. No one cop will have all the evidence – it will be shared out among significant players. A cop will need to maintain high-level contacts, like a diplomat. Guilt will be only one factor in any investigation and by no means conclusive. Negotiation, relative politico-socio-economic status, *guanxi*, all become relevant.'
>
> (Burdett 2012: 253)

A method of policing that takes advantage of the expertise and connections that globali-zation enables creates a conglomerate that operates similarly to the Internet itself: an instantly-accessible network where individual identity matters less than the collective. The crimes featured in the novels (the ring of organ traffickers stands as one example) follow this model, and it is only logical for policing to fall in step. The concept *guanxi*, a Mandarin term connoting both network and relationship and yet going beyond both, becomes the watchword for this new method of detection. In *Vulture Peak* especially this model is put into practice with great effect, as police from three different countries pool their resources to shut down one branch of the organ ring. Individual murders, though ultimately solved by Jitpleecheep, are incidental to the novel's overall take on global crime. While Burdett offers no false hope that the crimes enabled by globalization can be fully contained, he does present strategies that, with slight variation to the models already suggested by the model of detective fiction, allow for at least a mitigation of global crime as the detective, following suit, becomes ever more corporate.

Ultimately, in the global landscape of John Burdett's Bangkok series, the classic genre of detective fiction is updated into a fully realized version of the global detective novel. The crimes and the characters that attempt to contain them exist in multiple states at once, requiring multiple solutions and multiple identities, including corporate ones. While the novels do not offer the false promise that global crime can be contained, they do suggest that, with a retooling of certain tropes, the genre of detective fiction provides a template for mediating and mitigating global crime. The end result of *The Godfather of Kathmandu* is telling in this regard.

> I am afraid there is not much to do but sigh. I could, of course, have the bloodstains on the saw tested [...] but I don't really have the time. [...] And anyway, who cares? As far as the world is concerned, two unrelated suicides [...] happened to occur within hours of each other on the same night in Bangkok. What else is new? And that's just the way the [criminal syndicates] Kongrao and the Japanese gem traders want it left. But I had to solve the case, didn't I?
>
> (Burdett 2010: 280)

Jitpleecheep's insouciant concluding question mark speaks volumes about the nature of individual crimes in the global era as well as the possibility of a definitive solution. The two conflicting criminal networks mentioned above each require their own version of the facts to meet their own needs, as do Jitpleecheep's Colonel Vikorn, the interested American and Japanese law-enforcement agencies, and even Jitpleecheep himself. In-deed, for murders like these, by-blows of massive criminal networks, 'what else is new?' and 'who cares?' Jitpleecheep must find mediating solutions to these crimes, in order to continue to limit the damage done by the syndicates, not to bring justice to the individ-ual victims. In this way, Burdett takes the classic detective fiction trope of subjective

justice and updates it for a globalized world – Jitpleecheep applies a subjective version of justice not to the victims themselves, and not to individual criminals (which do not truly exist in this case) but rather to the multiple, corporate parties that exist simultaneously around these crimes. ∗

REFERENCES

Burdett, J. (2003), *Bangkok 8*, New York: Knopf.

––––– (2006), *Bangkok Tattoo*, New York: Knopf.

––––– (2007), *Bangkok Haunts*, New York: Knopf.

––––– (2010), *The Godfather of Kathmandu*, New York: Knopf.

––––– (2012), *Vulture Peak*, New York: Knopf.

GO FURTHER

Novels

The Bangkok Detective novels

Burdett, J. (2012), *Vulture Peak*, New York: Knopf.

––––– (2010), *The Godfather of Kathmandu*, New York: Knopf.

––––– (2007), *Bangkok Haunts*, New York: Knopf.

––––– (2006), *Bangkok Tattoo*, New York: Knopf.

––––– (2003), *Bangkok 8*, New York: Knopf.

Other novels by John Burdett

Burdett, J. (1997), *The Last Six Million Seconds*, New York: Hodder and Stoughton.

––––– (1996), *A Personal History of Thirst*, New York: William Morrow and Co.

Online

Fuller, T. (2007), 'At Home Amid the Red Lights', *New York Times*, 25 October, http://www.nytimes.com/2007/10/25/books/25burd.html.

Website

John Burdett, http://john-burdett.com

LOU FORD
NATIONALITY: AMERICAN / CREATOR: JIM THOMPSON

Adapting *The Killer Inside Me* and the dynamics of deviance from page to screen
Gill Jamieson

Deviance is evident in the multiple versions of *The Killer Inside Me*: the subject matter of the novel, its treatment in the screenplay and the cinematic treatment of that subject matter, dealing as they all do with the twisted inner workings of a psychotic character – a 'sick fuck' – that finally makes it to the screen in the form of the boyish good looks of Casey Affleck. 'Adaptation' itself is potentially a type of deviance. The whole process of adapting a literary source can be regarded as a constant negotiation with contested meanings. In adaptation studies this process has long been articulated in debates about fidelity, intertextuality and more recently paratextuality has energized discussion of the parameters of the process. This chapter examines *The Killer Inside Me* as a case study of the adaptation process, with a particular focus on the implications of adapting a novel that compels the reader to identify with an extremely violent antihero figure in the central protagonist of Lou Ford.

I am interested in the response to this particular film, not least because the reviews tended to stoke the controversy around the images of sex and violence presented on-screen. I want to consider the production and release of this film as an opportunity to revisit the screen violence debate from the perspective of the challenge of adaptation: the first signs of controversy around the release of the film occurred when it was screened at Sundance in 2010 and members of the audience reportedly walked out of the screening. When the film went on general release in the same year, reviewers typically reacted with disgust.[1] This kind of active revulsion would be repeated at further screenings and seemed exacerbated when Jessica Alba – the actress who played Joyce Lakeland in the film – was unable to sit through a full screening. However, when the film was released with an 18 certificate in the United Kingdom, the British Board of Film Classification commented on its website: 'The graphic violence and sadomasochistic sex are strong in tone and feel, but they are presented within an overall justifying narra-

tive context, which is carefully controlled by the filmmakers' (BBFC 2010).

How should we view the creative decisions taken by John Curran (screenwriter) and Michael Winterbottom (director) through the adaptation process? How might our discussion of this particular example inform our understanding of the challenge of adaptation especially when the material to be adapted presents the screenwriter and the potential audience with morally repugnant material? How did they handle the sex and violence in this adaptation? Did they crank up the violence, as some reviewers seemed to suggest? Or was this a necessary consequence of an adaptation process that sought to align itself with Lou's point of view?

Jim Thompson is of course one of the leading exponents of crime fiction of the 1950s – described by James Naremore as 'one of the great *maudit* authors of paperback crime fiction' (2008: 92), and his work has been adapted on numerous occasions to great acclaim: *The Getaway* (Sam Peckinpah, 1972) and *The Grifters* (Steven Frears, 1990) are two of the most well-known examples.[2] Thompson's 1952 novel *The Killer Inside Me* has been adapted twice – the first adaptation appeared in 1975 and starred Stacy Keach as Lou Ford and it deviates markedly from Thompson's novel. The screenwriters – Edward Mann and Robert Chamblee – transposed the story to a 1970s Montana setting, replacing the oil fields of Texas with mining, and pivoting the narrative around a mayoral election race between Howard Hendricks and Chester Conway. The initiating incident between Lou and Joyce does not take place until 26 minutes into the film, whereas in Winterbottom's version the fateful scene where Lou beats Joyce ostensibly to death has already taken place by the 26-minute mark. The handling of Lou's love interest Amy Stanton is also very different: she is introduced as Lou's childhood sweetheart, an agreeable young woman he collects from school every day and takes horseback-riding through the Montana hills. Lou's undisclosed 'sickness' precedes his meeting with Joyce and is therefore disconnected directly from the feelings of violent sexual desire she instills in him – he experiences hallucinations in which his father appears (played by John Carradine), in the local diner, and then again during the scene when he beats Joyce like a 'pumpkin', although in this version Lou dispatches Joyce with one punch. The subplot involving the murder of Lou's stepbrother is abandoned and with it Lou's desire for revenge on Chester Conway. When Lou sets out to run Joyce out of town at Chester's instigation, he does so without any intention of hurting her or framing a murder suicide on Chester Conway's son Elmer. In fact he urges Joyce to leave town with Elmer and start afresh with the $50,000.[3]

The violence is brief and abrupt. The fantastic twist of the novel – that Joyce is still alive – is revealed immediately by Chester Conway when he arrives on the scene. This represents a major departure from the series of events as recounted by Lou in the novel, which builds to the 'reveal' in the last scene that Joyce, contrary to Lou's earlier assumption, has in fact survived the savage beating inflicted on her by Lou. It is this reveal that is retained by Winterbottom and Curran, and it represents a much more sat-

isfying conclusion for the audience when they have the realization that they were onto Lou all along (as Bob Maples hints in Fort Worth, 'you got it wrong Lou... It's always lightest just before the dark' [Thompson 2006 (1952): 70]).

Most commentators swiftly gloss over the 1975 version of Thompson's tale because it is universally regarded as a botched affair that merits scant critical attention. According to Thompson's biographer Robert Polito (1997: 496), the film 'almost merits enshrinement at midnight theaters devoted to camp cinema'. However, it is necessary to recognize that the 1975 version is a product of its time, the historical moment of mid-1970s Hollywood cinema was more interested in political maneuverings and government corruption, which was at the forefront of the collective consciousness following the Watergate scandal. It seems that in 1975 Hollywood was not quite ready to make a film about a man who had been sexually abused by the housekeeper as a child, who would then go on to rape a 3-year-old girl, have his stepbrother take the blame for that crime and then be murdered for the same offence, and finally viciously beat and kill the women he loved. In 1975 Lou's psychosis is handled in a series of vague flashbacks and as Polito notes they typically and bizarrely feature 'a crescendo of dripping faucets' (Polito 1997: 497). Comparison with this version serves to illustrate Hila Shachar's argument that

> adaptations, just like any other work, do not come to fruition in a social, cultural or historical vacuum. To analyse them as self-contained entities made up of certain aesthetic and formal aspects alone, is to ignore a large aspect of their cultural meanings as products of a specific context and time.
>
> (Shachar 2012: 5)

The failure of the 1975 film is cited at some length here because it serves to illustrate two contentious aspects of the adaptation process: firstly, it exposes the potential pitfalls involved in meddling with the source material – the notion of being faithful to Thompson's vision does not appear to have troubled this particular production. This is important to note because adaptation studies seems reluctant to acknowledge that sometimes fidelity might actually be a good thing. Secondly, I believe it serves to illustrate Winterbottom and Curran's achievement with their version of Thompson's novel – a version that strives to recreate the difficult subject matter on-screen in a cinematically sympathetic manner, but would ultimately be damned by critics for being too faithful to the source.[4]

I will argue that the film creates a spectating position which is at one with Lou's perspective, emulating the reading position of the 'homo-diegetic narrator' (Genette 1980) in a deliberate attempt to invoke feelings of unease in the spectator. As a result of this narrational strategy it's not surprising that people walked out and critics mauled the film – how else should we react when we have been forced to identify with a sick

fuck? Debates about screen violence following Stanley Cavell's (2005) intervention, in which he argues for a cinema of revulsion, are relevant to understanding what it is that *The Killer Inside Me* achieves. Brown argues, *pace* Cavell, that an ethical mode of engagement is a possible and desirable consequence of films that depict extreme acts of violence:

> While films that revolt us raise issues about the ethics of regarding the pain of others (to paraphrase Susan Sontag), perhaps there are benefits to be yielded from watching horrific films – particularly those featuring violence or sexual violence. Those benefits include the possibility of reaching an ethical mode of film viewing, in which we do not watch films for pleasure/we do not necessarily take pleasure in seeing others suffer on film.
>
> (Brown 2013: 26)

Brown's argument is relevant to *The Killer Inside Me* because the revulsion we feel when Lou is beating on Joyce or when he attacks Amy, doesn't create a pleasurable viewing experience and that is exactly the point: although we have been forced to identify with Lou the fact that we don't enjoy seeing these women suffer is emotionally heightened in the film because of the primacy of the visual – it often seems worse than in the book – because we can see the bodily functions – the sweat breaking out on Lou's brow as he pummels Joyce; the hideous slapstick of Lou slipping on Amy's urine as he pursues the vagrant he plans to pin Amy's murder on; the terrible scarring of Joyce's face in the closing scene. The ontological actuality of the violence is necessary to convey the brutality of Lou's voice which shocks in the novel with stark lines like 'I backed her up against the wall, slugging, and it was like pounding a pumkin' (Thompson 2006 [1952]: 43), and, 'I gave her two hard kicks in the head and she rose off the floor' (166).

'I'm not perfect': First person and the challenge of adaptation

In common with many pulp novelists of the era, Jim Thompson utilizes the first-person narration of central character Lou Ford to position the reader with his psychopathic mindset. This is a key marker of deviance as Lou's voice creates an intimacy with the reader and spectator that fundamentally positions us with a transgressive, dysfunctional worldview – as Polito says, 'the central grotesquery of *The Killer Inside Me* remains Lou Ford's voice' (1997: 5). This is retained through the strategic deployment of voice-over in the screenplay and the film; however, it is inevitably reduced in the 2010 film. The convention of first person presents a dilemma for adapters. Linda Hutcheon notes that popular screenwriting manuals by Syd Field and Lynn Seger are famously dismissive of the voice-over – because they consider it to be disruptive: 'for they make us focus on the words we are hearing and not on the action we are seeing' (Hutcheon 2006: 54).

Hutcheon goes on to argue – citing Robert Stam's work on adaptation – that point of view in a multitrack medium is much more complex than simple alignment with the literal voice-over of a protagonist within the narrative. There are six sequences in the film in which voice-over is deployed and it becomes necessary to use other cinematic devices to convey point of view.

Analysis of the six examples of voice-over in the film indicate that the film-makers sought to utilize the multitrack possibilities of the cinematic – particularly in the way the soundtrack works to create a dramatic counterpoint – for example, the jaunty track 'Shame on You' (1945)[5] and the subsequent tonal shifts, such as the way the scene pans out when Amy is murdered with the hapless bum running down the street – which is portrayed as a moment of slapstick – and that's because we are experiencing this from the point of view of Lou whose grip on reality has completely slipped by this point.

Genette's (1980) distinction between paralipsis and paralepsis is instructive here in explaining the different modalities of voice in fiction. The distinction between the two offers a key reason why the novel 'works' for the reader but the film potentially appalls the spectator: paralipsis refers to a narrational mode wherein the narrator omits important actions or thoughts that are with certainty known by a character within the diegesis; paralepsis on the other hand refers to a mode where more information is given than is necessary by a character, a focalized mode of narration which 'gives too much away'. Lou's first-person narration in the novel keeps us with Lou throughout – he tells his reader too much in advance: what he thinks about people; how he sees himself; how he is perceived by others; and crucially, he tells us when he is going to kill Joyce and Amy *before* he kills Joyce and Amy. Arguably, this creates a feeling of dread in the mind of the reader when we have knowledge of the kind of violence Lou is capable of – after the attack on Joyce – and this is not something we can 'unlearn', therefore the anticipation of what could happen to Amy compels the reader through the rest of the novel. It doesn't quite work in the same way in the film: where Lou gives away too much information in the novel, in the film we experience the immediacy of the events as they unfold on-screen; we're not 'cued' to anticipate the violence before the violence takes place.

Winterbottom's film begins with the second scene from the novel – the first minor deviation from fidelity, which in this case is sequential (relating to the ordering of the scenes); it is a minor change because the diner scene is still included in the film. The film begins in the middle of the scene on the line of dialogue uttered by Bob Maples (Tom Bower): 'Name of Joyce Lakeland.' This is the scene where Maples tasks Lou with paying a visit to Joyce Lakeland (to 'size her up'). The following scene brings in the voice-over which positions us with Lou. What is interesting is that it features as a distraction from the classic cinematic bridge scene – the kind of minor scene which links two major scenes, typically featuring brief scenes of characters making their way somewhere else. Therefore it could be argued that the function of the voice-over here is to transform the scene from something banal into something compelling – this is Lou's

take on Central City, his guide to how people get by, etiquette and social conventions. When he pulls up outside Joyce's modest front porch the voice-over comes to an end with 'you're nothing if not a gentleman, God help you if you're not'. The audience is positioned to regard Lou as a guide to this insular community – the kind of community that finds it necessary to run a woman like Joyce out of town. Following his meeting with Joyce, which culminates in Lou beating her with his belt and violent lovemaking, Lou is once again in his car heading back to town:

> LOU: [Voice-over] I went back the next day and the day after that. I couldn't help it. It was like a wind had been turned on a dying fire. I began needling people. I began thinking of settling scores with Chester Conway of the Conway Construction Company.

The sequence is a montage of Lou driving, Lou making love with Joyce, and Lou driving again. It begins with Lou singing along to the popular rockabilly track 'One Hand Loose' by Charlie Feathers.[6] The use of diegetic popular music to accompany the voice-over is repeated throughout and further underscores Lou's perspective. In the novel this particular example of voice-over corresponds to the opening scene in the diner when Lou sees the 'bum' hanging about outside and ends with the first act of random violence – when Lou stubs his cigar out on the palm of that same bum's hand. However, in the film the scene with the bum is placed after the first meeting with Joyce and subsequent montaged scenes of Joyce and Lou making love on the pink sheets of her bed. In changing the order of the scenes the film effectively retains the shocking quality of the scene in Joyce's bedroom – the first six minutes of the film culminate in this erotic act of spontaneous sadomasochism. In not showing the random act of violence against the bum, which exposes Lou's cruelty in the first scene in the novel, the spectator is not cued to Lou's cruel and deviant nature.

The embedded viewpoint means the reader shares Lou's perspective and what Vera Tobin calls the 'rug-pull moment' (2009) is therefore possible for the reader. We are cued to anticipate the violence in the novel because Lou tells us very clearly that 'I kissed her, a long hard kiss. Because baby didn't know it, but baby was dead, and in a way I couldn't have loved her more' (Thompson 2006 [1952]: 11). The novel typically favours paralepsis and moreover restricts narration to Lou's point of view: '*Joyce and Elmer were going to die. Joyce had asked for it. The Conways had asked for it*' (38; original emphasis). This is right before the scene where he goes out to Derrick Road and beats Joyce unconscious, it is flagged up beforehand for the reader so that we are prepared for it. One of the most shocking aspects of the novel is the way Lou is so brutally candid about his intention to dispatch Joyce, despite his acknowledgement that he loves her. The absurdity of this is inconceivable to the reader but the fact that it is logical to Lou that she has to die is a clear indication of his psychosis. In the novel the scene in which

Joyce is beaten savagely starts with a revealing line from Lou, 'I knew. I knew how *that* would look in an autopsy'(40, original emphasis), which betrays Lou's intentions to kill her. The scene works to position us with a protagonist who will sleep with the woman he thinks he loves and then beat that same woman to a bloody pulp. In the film we don't know, just as Joyce doesn't know, that he is going to kill her until he slips on a pair of black leather gloves. We are generically cued here to expect something bad to happen within the scene because we understood the act of putting on black leather gloves within the crime genre to convey an element of danger, of a desire on the part of the person slipping on the gloves to conceal fingerprints and such like. The gesture is sinister and calculating, and as such, doubly shocking.

Thompson shocks his reader through the play on knowledge and subject positioning. What shocks in the film is seeing a beautiful woman being beaten like a 'pumpkin'. This is prefigured by an intensely erotic scene of sadomasochistic lovemaking in which Lou is shown throttling Joyce with a thick leather belt, sweat glistening on his neck he whispers a barely audible 'I love you', at the same time as he takes Joyce from behind. That isn't in the book. Putting things in and leaving things out has always been the dilemma facing the adapter. Representational transformation is inevitable and in some instances desirable to achieve the same effect. So while the reader gets the visceral shock of the line 'I knew. I knew how *that* would look in an autopsy', film audiences experience a similar shock following the spectacle of the sadomasochistic sex punctuated by the eventual outcome of the scene.

'Our kind. Us people': A different kind of victim, a different kind of empathy

It is also symptomatic of his own masochistic tendencies: he kills the people he loves. By the end of the novel Central City is littered with corpses: Mike Dean, Elmer Conway, Bob Maples, the hapless bum, Johnny Pappas, Joyce Lakeland and Amy Stanton. When interviewed about the film, Michael Winterbottom was keen to assert his sympathy for the character of Lou – something that doesn't sit comfortably with critics accustomed to retributive justice and unambiguous morality on-screen. Although Winterbottom rejects simplistic explanations for the violence as such, he goes on to explain Lou's appeal as a character in response to an interview question about Lou's antihero status and the sympathy we develop for him:

> Lou is a victim as much as an abuser; he has been formed by his childhood and by his father. It's what made him the man he is. The shorthand is a very crude thing. A simple explanation is never enough; it is just one way of formalizing it. The fascination is that you see this character Lou who does perverse things, who destroys people who seem to love him and whom he seems to love and could be happy with. This potential for love seems to trigger the desire to kill them, to destroy

them. I guess a lot of people could recognize something like that in themselves. Everybody does things that are self-destructive to a greater or less degree. Lou is a very extreme version of what you see around you in real life.[7]

Winterbottom's take on Lou – that he is a victim because he is the product of a dysfunctional family, and that as such he is a character with the potential to instil feelings of empathy in the audience ('I guess a lot of people could recognize something like that in themselves'), contributed to feelings of unease when the film went on general release. The inclusion of the two flashback sequences in the film – retaining the immersive viewpoint of Lou – depicting two scenes of child abuse – the first implying the rape of the little girl in the car witnessed by Mike (Noah Crawford) – is an involuntary memory which is triggered by the meeting with Joe Rothman (Elias Koteas) and their discussion of Mike's fate. The second takes place when Lou finds the explicit photographs of his abuser, the housekeeper Helene (Caitlin Turner), and he remembers her urging him to beat her. Genette would describe this as a 'return', a passage of retrospection that is clearly marked as subjective (Genette 1980: 39). Lou is battling from the start with memory – Joyce makes him remember, he seeks to forget: what happened fifteen years before, what happened to Mike, what might happen to Joyce and Elmer if he could only 'forget', but is unable to do so because the sexual attraction to Joyce and to the violence of that sex keeps making him remember. 'Forget it, Lou, it's not too late if you stop now... But right after that, right after the voice, her hand gripped one of mine and kneaded it into her breasts; and she moaned and shivered... and so I didn't forget' (Thompson 2006 [1952]: 11).

According to Payne (1994), 'schizophrenia, psychosis, delusions and the dislocation of the personality are the clinical conditions which Thompson uses as tropes to describe the fractured and chaotic condition of the American psyche as he perceived it' (Payne 1994: 56). In a discussion of Thompson's later novel *Pop. 1280*, in which events are narrated from the point of view of another 'sick fuck' sheriff of a small Southern town, Payne argues that these characters offer a subversive critique of the failure of the American dream. He notes the parallel with *The Killer Inside Me*: 'Like Lou Ford in *The Killer Inside Me*, Nick Corey is one of Thompson's role-playing psychotics – perceptive and intelligent men who make use of sarcasm and irony as part of their protective weaponry' (1994: 52).

In the closing stages of the novel Lou will offer a damning description of a suffocating town and its miserable inhabitants: 'The Conways were part of the circle, the town, that ringed me in; the smug ones, the hypocrites, the holier-than-thou-guys – all the stinkers I had to face day in and day out' (Thompson 2006 [1952]: 197).

He expresses a desire to escape this environment – and he is almost giddy with excitement when he gets to Fort Worth after beating Joyce into a coma, 'I could have enjoyed seeing the sights' (161) – but when Joyce offered him a way out of Central City

he didn't take it.

Christiana Gregoriou distinguishes between different types of deviance within the representational framework of crime fiction: linguistic, social and generic (Gregoriou 2007: 3). Lou is clearly a social deviant and his deviance is defined by terrible acts of violence. However, it is also expressed through the act of narration and his attempts to retain control over his narrative throughout. When Lou recounts events leading up to the murder of Amy we see another example of involuntary loss of control over the narrative: Chapter 18 begins and ends with the chilling line 'I killed Amy Stanton on Saturday night on the fifth of April, 1952, at a few minutes before nine o'clock' (152; 163). In an attempt to regain control he chooses to stall 'I guess I'm not ready to tell about it yet'. The feeling of dread intensifies when Lou seems to covet some kind of intervention: 'They wouldn't see it. No one would stop me' (161). In the film this scene is as shocking as the earlier scene with Joyce and it begins with Lou telling Amy not to say anything before he punches her with such force in the stomach that she collapses. His desire to silence her in a literal sense corresponds to his perception that she is something of a nag: where Joyce physically lashes out at Lou, Amy subjects him to verbal lashings – their relationship is fraught with tension. This is acknowledged by Lou in the last two weeks of Amy's life after they have agreed to elope and he takes her anywhere she wants to go. They actively avoid having the arguments, the verbal battles that typified their relationship. Amy is only physically abusive to Lou when she realizes he has been with Joyce – in an oral sex scene which was extremely daring and crude in the book – retained in the 2010 film and dismissed in the 1975 film as Amy smelling another woman's perfume on Lou when she kisses him. The film manages to capture the contradictory impulses Lou appears to experience when he yells at the bum 'I was going to marry that poor little girl!' (168). Of course it's not Lou's fault the bum tried to hustle him or Amy got too close to the truth, it's not Lou's fault that no one stopped him although he'd 'dropped it in their plates, and rubbed their noses in it' (161).

Conclusions: Casting Casey Affleck: 'A boy scout with a badge'

One of the boldest decisions taken by Michael Winterbottom is in the casting of Casey Affleck as Lou Ford: casting an actor that was all American and yet capable of extreme, ugly violence. This is Lou's self-conscious description of his own somewhat dandyish physical appearance and it certainly seems that Affleck fits the part:

> I was still wearing my Stetson, shoved a little to the back of my head. I had on a kind of pinkish shirt and a black bow tie, and the pants of my blue serge suit were hitched up so as to catch on the tops of my Justin boots. Lean and wiry; a mouth that looked all set to drawl.
>
> (Thompson 2006 [1952]: 23)

In that first encounter with Lou, Joyce describes him as a 'lousy snooping copper' (8) whereas in the film the line is softened to 'a boy scout with a badge' – a line that directly alludes to Casey Affleck's boyishness – he's playing a man of 29 but he's a youthful looking 29. Although it is not necessarily a hugely important line, the change is suggestive of the transformative power of performance that takes place through the adaptation-to-screen process. Casting is one of the first stages in the pre-filmic transformation and it is interesting to compare the two actors who have portrayed Lou Ford on-screen. Stacy Keach is an actor capable of portraying muscular, ambiguous roles.[8] His distinctive cleft lip would typically be concealed by a moustache but for the role of Lou Ford he remained clean-shaven and his cleft lip would be a distinctive feature visible in a number of close-ups. Like Affleck, he is charismatic, but Affleck is somewhat conventionally good-looking in comparison. Affleck is an actor according to Winterbottom able to

> convey the sense that what's going on inside his head is not necessarily the same as what he's doing. I want the audience to get a sense that Lou Ford's interior world is at odds with how he behaves. Lou is this character who pretends to be something he isn't and interacts with people almost like a game. He thinks about things very self-consciously. So I was looking for an actor who was able to give you some sense of a complex and interesting world inside his head and I think Casey is a brilliant actor and was ready to do that.[9]

It is worth noting that an earlier draft of the screenplay was written by Australian Director Andrew Dominik. Dominik pulled out of the project because his casting choice – Tom Cruise – passed on the opportunity to play Lou. The idea that Tom Cruise – very much older than 29 and long considered the embodiment of an American masculine ideal – would be capable of pulling off the role of Lou is perplexing.

Affleck is lean and wiry to Keach's muscularity. His face seems open and symmetrical and his distinctive feature is a slightly rounded and protruding dimpled chin. In an interview with *Boston Magazine* from 2004, Affleck is described by the journalist as

> looking clean-cut: his brown hair is a little-tousled [...] the gunmetal grey eyes and matching steel-wool voice (sometimes so slow and drawling it gives the impression of slacker indifference) are the same, though, and so are the sharp angles of his chiselled, porcelain face.

> (Atkinson 2004)

This is echoed in Roger Ebert's online blog: 'Casey Affleck, an effective actor, is so convincing with his innocent, almost sweet facade that the movie sets us up to expect he'll be solving a crime, not causing one' (Ebert, 2010). Although admiring of Affleck's physical appearance, however, Ebert is critical of the film because of his performance of

blankness (in other words the quality that so attracted Winterbottom): 'The dominant presence in the film is Lou Ford, and there just doesn't seem to be anybody at home.' But for me, that's why he makes such a convincing psychopath.

One wonders what Thompson would have made of Michael Winterbottom's version of his most celebrated novel. He was notably appalled by Burt Kennedy's interpretation, as Polito notes, and his encounters with Hollywood were often brutal, even characterizing his collaborations with Stanley Kubrick[10] (Polito, 1995: 400; 496). I think that he would have been pleased that his material was once again resonating with a contemporary audience, reimagined by a director who has taken some trouble to preserve his distinctive voice and perspective. *

REFERENCES

Atkinson, Kim (2004), 'The Other Affleck', http://www.bostonmagazine.com/2006/05/the-other-affleck/. Accessed 22 June 2015.

Barton, Steve (2010), 'The Killer Inside Me Causes a Ruckus in Berlin', 20 February, *Dread Central*, http://www.dreadcentral.com/news/15881/the-killer-inside-me-causes-a-ruckus-in-berlin/. Accessed 22 June 2015.

BBFC (British Board of Film Classification) (2010), 'Case Study | The Killer Inside Me', http://www.bbfc.co.uk/case-studies/killer-inside-me. Accessed 22 June 2015.

Brown, William (2013), 'Violence in Extreme Cinema and the Ethics of Spectatorship', *Projections*, 7: 1, pp. 25–42.

Cavell, Stanley (2005), *Cavell on Film*, (ed. William Rothman), Albany: State University of New York Press.

Cobley, Paul (2000), *The American Crime Thriller*, Basingstoke: Palgrave.

Cook, Rachel (2010), 'Michael Winterbottom on *The Killer Inside Me*', http://www.theguardian.com/film/2010/may/23/michael-winterbottom-killer-inside-me. Accessed 22 June 2015.

Ebert, Roger (2010), 'The Killer Inside Me', *RogerEbert.com*, 23 June, http://www.rogerebert.com/reviews/the-killer-inside-me-2010. Accessed 22 June 2015.

Genette, Gerard (1980), *Narrative Discourse*, Oxford: Basil Blackwell.

Gregoriou, Christiana (2007), *Deviance in Contemporary Crime Fiction*, Basingstoke: Palgrave.

Gronstad, Asbjorn (2008), *Transfigurations: Violence, Death and Masculinity in American Cinema*, Amsterdam: AUP.

Hutcheon, Linda (2006), *A Theory of Adaptation*, London: Routledge.

Naremore, James (2008), 'Kubrick, Douglas, and the Authorship of *Paths of Glory*', in David L. Kranz and Nancy C. Mellerski (eds), *In/fidelity: Essays on Film Adaptation*, Newcastle: Cambridge Scholars Publishing, pp. 91–109.

Payne, Kenneth (1994), 'Pottsville, USA: Psychosis and "Emptiness" in Jim Thompson's *Pop. 1280*', *The International Fiction Review*, 21, pp. 51–57.

Polito, Robert (1997), *Savage Art: A Biography of Jim Thompson*, London: Serpent's Tail.

Rommey, Jonathon (2010), '*The Killer Inside Me*' [Review], 6 June, http://www.independent.co.uk/arts-

entertainment/films/reviews/the-killer-inside-me-18-1992307.html. Accessed 22 June 2015.

Schneider, Steven Jay (ed.) (2004), *New Hollywood Violence*, Manchester: Manchester University Press.

Shachar, Hila (2012), *Cultural Afterlives and Screen Adaptations of Classic Literature:* Wuthering Heights *and Company*, London: Palgrave MacMillan.

Thompson, Jim (2006 [1952]), *The Killer Inside Me*, London: Orion.

Tobin, Vera (2009), 'Cognitive Bias and the Poetics of Surprise in *Language and Literature*', 18: 2, pp. 155–72.

GO FURTHER

Selected novels

Thompson, Jim (1969), *The Undefeated*, New York: Popular Library, based on a screenplay of the same name by James Lee Barrett (movie tie-in).[11]

----- (1964), *Pop. 1280*, Minnesota: Gold Medal.

----- (1963), *The Grifters,* New York: Regency Books.

----- (1959), *The Getaway*, New York: New American Library.

----- (1957), *The Kill-Off*, New York: Lion Books.

----- (1955), *After Dark, My Sweet*, New York: Popular Library.

----- (1954), *A Hell of a Woman*, New York: Lion Books.

----- (1954), *A Swell-Looking Babe*, New York: Lion Books.

----- (1954), *The Nothing Man*, New York Dell Publishing Company.

----- (1953), *Savage Night,* New York: Lion Books.

----- (1953), *The Criminal,* New York: Lion Books.

----- (1952), *The Killer Inside Me,* Minnesota: Gold Medal.

Books

Stanfield, Peter (2015), *The Cool and the Crazy: Pop Fifties Cinema*, New Brunswick, NJ: Rutgers University Press.

----- (2011), *Maximum Movies – Pulp Fiction: Film Culture and the Worlds of Mickey Spillane, Samuel Fuller, and Jim Thompson*, New Brunswick, NJ: Rutgers University Press.

Grant, John (2013), *A Comprehensive Encyclopedia of Film Noir: The Essential Reference Guide*, New York: Applause Theatre & Cinema Books.

Worthington, Heather (2011), *Key Concepts in Crime Fiction*, Basingstoke: Palgrave Macmillan.

Knight, Stephen (2010), *Crime Fiction since 1800: Detection, Death, Diversity*, Basingstoke: Palgrave MacMillan.

Hirsch, Foster (2008), *The Dark Side of the Screen: Film Noir*, 3rd edn, Da Capo Press.

Naremore, James (2008), *More than Night: Film Noir in Its Contexts*, 2nd edn, Berkeley/Los Angeles: University of California Press.

Scaggs, John (2005), *Crime Fiction: The New Critical Idiom*, London: Routledge.

Thompson, Jim (2014 [1976]), *Bad Boy*, Boston/New York/London: Mulholland Books.

Online

Geffner, David (1996), 'Jim Thompson's Lost Hollywood Years', *Moviemaker*, http://www.moviemaker.
com/archives/moviemaking/directing/articles-directing/jim-thompsons-lost-hollywood-
years-3165/.

Website

Mulholland Books | Jim Thompson, http://mulhollandbooks.com/jimthompson

Films

Adaptations of Jim Thompson novels

A Hell of a Woman:
Corneau, Alain (1979), *Série Noire/Bad Luck*, France: Gaumont.
A Swell-Looking Babe:
Shainberg, Steven (1996), *Hit Me*, USA: Castle Hill Productions.
After Dark, My Sweet:
Foley, James (1991), *After Dark, My Sweet*, USA: Avenue Pictures Productions.
The Getaway:
Donalson, Roger (1994), *The Getaway*, USA: Universal Pictures.
Peckinpah, Sam (1972), *The Getaway*, USA: National General Pictures.
The Grifters:
Frears, Stephen (1990), *The Grifters*, USA: Miramax/Palace Pictures.
The Kill-Off:
Greenwald, Maggie (1990), *The Kill-Off*, USA: Cabriolet Films.
The Killer Inside Me:
Winterbottom, Michael (2010), *The Killer Inside Me*, USA: Revolution Films/Hero Entertainment/
Indion Entertainment Group.
Kennedy, Burt (1976), *The Killer Inside Me*, USA: Warner Bros.
Pop. 1280:
Tavernier, Bertrand (1981), *Coup de Torchon/Clean Slate*, France: Parafrance Films.

Jim Thompson screenplay credits

Kubrick, Stanley (1957), *Paths of Glory*; adapted from the novel *Paths of Glory* (Humphrey Cobb, 1935).
----- (1956), *The Killing*; adapted from the novel *Clean Break* (Lionel White, 1955).

NOTES

1 For an account of the response to the film at this and other festivals see Barton (2010).
2 Other notable adaptations include *Coup de Torchon* (Bertrand Tavernier, 1981), an adaptation of
 Pop. 1280.
3 In the 1952 novel the sum involved is $10,000.
4 See negative reviews such as Ebert (2010); Cook (2010) and Rommey (2010).

5 'Shame on You', written by Spade Cooley (as Donnell Clyde Cooley). Performed by Spade Cooley and the Western Swing Gang, released in 1945. Cooley would later be convicted of first-degree murder after he beat his second wife to death.

6 'One Hand Loose', written by Joe D. Chastain, Charlie Feathers and Jerry D. Huffman. Performed by Charlie Feathers.

7 Presskit, available online: KillerInsideMe-presskit-fr. Accessed 22 June 2015.

8 Keach''s breakthrough role was as a faded boxer in *Fat City* (John Houston, Columbia Pictures, 1972). He would go on to play Frank James in *The Long Riders* (Walter Hill, United Artists, 1980). He also played private detective Mike Hammer in the television series *Mickey Spillane's Mike Hammer* (NBC, 1984–1985).

9 Interview with Winterbottom, from the presskit, available online: KillerInsideMe-presskit-fr. Accessed 22 June 2015.

10 Thompson had scriptwriting credits on Kubrick's adaptations of *The Killing* (1956) and *Paths of Glory* (1957).

11 The film *The Undefeated* (Andrew V. McLaglen, United States, Twentieth Century Fox Corporation) was released in 1969, starring Rock Hudson and John Wayne. The screenplay was written by James Lee Barrett, and Thompson adapted the movie 'tie-in' as a novel in the same year.

TONY SOPRANO
NATIONALITY: AMERICAN / CREATOR: DAVID CHASE

Summons and repulsion: The curious appeal of Tony Soprano
Abby Bentham

In a *Los Angeles Times* article published in the wake of James Gandolfini's death, Chris Lee described Tony Soprano, Gandolfini's most famous incarnation, as 'a cultural sensation', 'one of TV's most indelible icons' and 'the unlikeliest of all sex symbols' (Lee 2013). Lee was not alone in his summation of the character; Tony Soprano is widely recognized as one of popular culture's most challenging, impactful and compelling figures. But what is it about this calculating, vicious and narcissistic sociopath that audiences find so appealing?

By his own admission, Tony Soprano is 'a fat fucking crook from New Jersey' ('Calling All Cars' 2002); a mob boss with an unnerving knack for sudden and devastating violence. He is also a middle-aged, obese family man, prone to panic attacks and undergoing therapy. Hardly the stuff of dreams, yet the character retains his stranglehold on the cultural imaginary and continues to top 'best TV antihero' polls more than seven years after the final episode aired. The key to Tony's popularity, it seems, is the fact that despite the singularity of his chosen profession, he is surprisingly relatable. His efforts to balance work and home life are certainly familiar, and parents around the globe will recognize his struggle to control his unruly, ungrateful children. When, in a discussion about their wayward teenage daughter, Tony admits to Carmela, 'if she finds out we're powerless, we're fucked' ('Toodle-Fucking-Oo' 2000), he voices the fears of parents everywhere. Indeed, when held up against mob life, there's no contest: 'being a parent, that's the hardest job. It's harder than this other thing we do' ('Employee of the Month' 2001). It is instructive, then, that the panic attacks that cause Tony's fainting episodes and put him into therapy are related to his familial relationships. As the series develops, it becomes increasingly clear that Tony's masculinity is in crisis; torn between the competing demands of 'Family' and family, he captures perfectly the post-feminist, *fin-de-siècle* zeitgeist, his vulnerability offering a humanizing and beguiling counterpoint

to his brutality.

Tony's angst reflects the representational crisis that masculinity underwent in the 1990s and early 2000s, a period where, as Donna Peberdy notes, 'the instability of the male *image* [was] evident in the overwhelming permeation of a discourse of masculinity crisis' (Peberdy 2011: 7, original emphasis). Peberdy's emphasis on the instability of the male *image*, rather than on the male psyche, recognizes that it is only possible to access and adjudge the *representation* and rhetoric of masculine crisis, as masculinity itself is necessarily performative and contingent, rather than natural and instinctive. Tony Soprano's masculine performance is based on that of his gangster father, Johnny Boy Soprano, who ran a moderately successful crew of 'wise guys' in the 1950s. Tony looks back with nostalgia on the mob heyday of the 1950s as a simpler, less conflicted time, where gender roles were clearly defined and traditional values of loyalty and *omerta* were upheld. As E. Anthony Rotundo notes, '[a]lthough [Tony is] aware of his father's shortcomings, he admires his father's certainty and his fidelity to principle – and he contrasts that with his own doubts and failures' (Rotundo 2002: 68). Tony's romanticization of the past creates an intolerable version of masculinity which is incompatible with the demands of modern life. His performance of 1950s gangster masculinity does not correspond with the sensitive, emotionally literate and demonstrative version of masculinity required within the late-twentieth-century home, and this creates tension between his public and private selves.

In the latter decades of the twentieth century, representations of successful masculinity increasingly focused on family relationships and, as Hannah Hamad has argued, 'the naturalization of involved fatherhood as the paradigmatic template for ideal masculinity [...] [took] place through paternally inflected negotiations of all manner of variations and iterations of cinematic postfeminist masculinities' (Hamad 2013: 103). This focus was not confined to film, but also informed 'cinematic television', of the type pioneered by HBO, which used the techniques and production values of film-making when creating *The Sopranos* (David Chase, 1999–2007). At first glance, paternity may seem ill-suited to hyper-masculine genres such as action or gangster narratives, but its representation encourages audience identification with, and acceptance of, transgressive or otherwise problematic characters. In her discussion of the work done by critics such as Karen Schneider and Yvonne Tasker, Hamad explains that the 'paternalization' of masculinist genres enables

> the reification of patriarchal family values alongside an apparent accommodation of changing mores regarding ideal masculinity. This [takes] place through their paternally signified, and therefore 'sensitive', leading men, thus offsetting what would otherwise be the problem of negotiating the troublingly recidivist masculinities on show.
>
> (Hamad 2013: 105)

Accordingly, scenes depicting Tony playing *Mario Kart* with AJ as the rest of the family sleeps ('Meadowlands' 1999) or gently carrying a drunken Meadow to bed ('College' 1999), allow the viewer to focus on Tony's tenderness rather than his ruthless brutality. Tony's psychotherapy sessions with Dr Jennifer Melfi also have an important identificatory function, in that they allow the viewer to glimpse the insecurities and vulnerabilities that make the character more recognizably human. Sociopathy aside, Tony has an endearing neediness which betrays his secret status as a man-child still desperate for the love and validation of his uncaring, castrating mother. His wife and children function as necessary signifiers of successful, hegemonic, adult masculinity, but whilst Tony genuinely loves them, he also finds it necessary to disavow the castrating nature of the marriage contract and signal his virility by taking a string of young and beautiful lovers. Tony's attitude towards his marriage – and his wife's forbearance of it – may represent a form of wish-fulfilment for conforming male audiences; it also constitutes a simultaneous incorporation and repudiation of post-feminist dictates, and signifies the tension between Tony's 1950s- and 1990s-inflected masculine performances.

Negotiating the public and private spheres is a source of continual anxiety to Tony Soprano; his failure to maintain a successful equilibrium reveals the impossibility of reconciling his anachronistic and conflicting selves, and also recalls Judith Butler's conception of heterosexuality as doomed to a compulsive Freudian cycle of repetition and failure:

> heterosexuality is always in the process of imitating and approximating its own phantasmatic idealization of itself – *and failing*. Precisely because it is bound to fail, and yet endeavours to succeed, the project of heterosexual identity is propelled into an endless repetition of itself.
>
> (Butler 1997: 307, original emphasis)

The ceaseless repetition of failed and traumatic self-making situates Tony Soprano in a tradition of dysfunctional masculinity that has a broader historical reach than the close focus of 1990s critical discourse would suggest. Within the diegesis it is revealed that Tony's father suffered from the debilitating, emasculating panic attacks that Tony himself struggles with, as did an ancestor back in 'the old country'; extra-diegetically, Tony's filmic gangster forebears and heroes, including Tom Powers in his favourite film *The Public Enemy* (William A. Wellman, 1931) and Michael Corleone in *The Godfather* (Francis Coppola, 1972), also perform flawed and defective versions of embattled masculinity which predate Tony's crisis by several decades. Beyond the screen, social historian Michael Kimmel has charted masculine crises across a variety of historical and geographical locations, including Restoration England and America in the late nineteenth century (cited in Peberdy 2011: 5).[1] Tony Soprano may make no cognitive link between himself and seventeenth-century Englishmen, but he certainly feels the weight of his-

tory; unable to escape the pervasive feeling that the best has already happened, he feels that life is an endless, unedifying struggle. In this, Tony is Everyman; his melancholy yearnings for recognition and meaning aligning him, as Ingrid Walker Fields observes, 'with other baby boomers who feel cheated by the unfulfilled promises of their youth' (Fields 2004: 615). By offering audiences multiple points of identification with Tony, the show's creator, David Chase, increases the character's empathetic appeal and allows the audience to focus on those elements of Tony's character that are socially acceptable.

Tony's approval rating is also boosted by favourable comparisons with certain other characters in the show, who are shown to be his moral inferiors. Tony places extreme value on loyalty and despite his tortured relationship with his mother, Livia, he strives to be a good son.[2] Livia's version of parenthood stands in stark contrast to Tony's loving and demonstrative paternity; flashbacks to the 1950s reveal her as a modern-day Medea, at one point telling a young Tony 'I should stick this fork in your eye!' ('Down Neck' 1999) and later in the same episode warning her husband that she would rather smother their children with a pillow than allow him to move them to Nevada. With the same absence of emotion, Livia vindictively orders the adult Tony's execution (by his uncle Junior!) as punishment for placing her in a luxurious 'retirement community', which she views as a dereliction of his filial duties. Likewise, mobsters such as Richie Aprile, Ralph Cifaretto and even loyal Paulie Walnuts are shown to be ruthless, amoral psychopaths: Richie, with encouragement from Tony's sister Janice, plots to kill Tony ('The Knight in White Satin Armour' 2000); Ralph beats to death a dancer from 'Bada Bing!' who is pregnant with his child ('University' 2001); Paulie murders and robs his mother's friend, Minn, in order to boost his weekly payment to Tony ('Eloise' 2002). Even seemingly straight-laced and innocuous characters, such as the attorney from whom Tony almost buys a holiday home ('Whitecaps' 2002), are shown to be unethical and dishonest, and this raises the question of who is worse – the white-collar criminals running America, or guys like Tony who at least are upfront about what they do. The Feds, although honest and uncorrupted, are shown to be morally suspect; their single-minded, unfeeling manipulation of informants such as Big Pussy Bonpensiero and Adriana La Cerva leading directly to the murders of those characters.[3]

However, despite concerted efforts to portray Tony in a more favourable light than many of his contemporaries, the viewer of *The Sopranos* is also repeatedly reminded of Tony's capacity for untrammelled aggression. At times this is mediated by the scenario's context, such as when he beats Ralph to death ('Whoever Did This' 2002) in response to Ralph's suspected arson attack on the stables which killed the horse shared by Tony and Ralph; and also Ralph's murder of Tracee, the pregnant dancer from 'Bada Bing!' Although the kill scene is disturbing and difficult to watch, the viewer feels vindicated as there is a sense that Tony is meting out well-deserved justice to an intransigent character. On other occasions, such as when Tony launches a vicious, unprovoked attack on his bodyguard and driver ('Mr and Mrs John Sacramoni Request' 2006), or

sabotages Janice's attempts at anger management ('Cold Cuts' 2004), his behaviour is gratuitous and ugly. This presents a severe threat to viewer empathy, yet it also reveals Tony's psychological depth and complexity, and this glimpse into what Martha P. Nochimson has termed his 'intricately marbled guilt and innocence' (Nochimson 2005: 190) is strangely compelling. The knowledge that the attack on the muscular young bodyguard was predicated on Tony's urge to reassert his masculine primacy in the wake of his shooting, and that his behaviour towards Janice is rooted in his feelings of inadequacy and despair at having inherited 'the Soprano curse' of panic attacks and a volatile temper, enables the viewer to understand and excuse Tony's actions. By contrast, when Tony beats Davey Scatino ('The Happy Wanderer' 2000) over an unpaid gambling debt there is no psychological excuse; as Tony tells Davey: 'This is what I do'. The viewer is reminded that Tony isn't sensitive and misunderstood; he is a ruthless thug. Scatino is an old high school buddy and the father of one of Meadow's friends, a regular, law-abiding guy whose embattled masculinity sees him selling jock-straps for a living and seeking thrills in high-stakes poker games. When a low camera angle shows Tony looming over Davey and filling two-thirds of the screen, the menace that the camera conveys is also a warning to the viewer: this is what happens when you fuck with Tony Soprano; this is what happens when you get involved with a mobster. Forced to confront the nature of his or her empathetic engagement with the screen villain, the viewer must soberly acknowledge the moral and ethical complexities of the transaction. When Tony tells Meadow 'Everything this family has comes from the work that I do' ('The Happy Wanderer' 2000), she must accept her own complicity. The same is true of the viewer. However, *The Sopranos* does not advocate a particular moral standpoint. Rather, its focus on moral relativity encourages the viewer to consider the psychic manoeuvres that empathetic engagement relies upon. As Dana Polan explains,

> the moral questioning in *The Sopranos* manifests itself in strategies of irony by which the spectator is encouraged to glide in and out of a series of ethical positions and to see, perhaps, the facility by which shifts of moral attitude can be constructed and deconstructed.
>
> (Polan 2009: 123)

As Tony struggles to negotiate and reconcile his conflicting versions of masculinity, the viewer struggles with him; torn between identification, admiration, disapprobation and horror.

Chase's playful manipulation of the viewer means that s/he is never on solid ground; the narrative situation and the terms of the viewer's relationship with the character are as mercurial as Tony's temper. Seemingly straightforward scenes are complicated when glimpses of Tony's pathology threaten viewer empathy, such as when Carmela, struggling to connect with their teenage daughter, complains to Tony that

Meadow never talks to her ('Down Neck' 1999). Tony smirks as he remembers the heart-to-heart conversation that he shared with Meadow as he drove her to visit universities ('College' 1999), when they spoke frankly about Tony's involvement with the Mafia and Meadow's recreational drug use. The scene has potential to illustrate a loving moment of connection between father and daughter, husband and wife; instead Tony's nasty smirk betrays his narcissism and need for control. Significantly, the narrative elements that make Tony appealing to the viewer are often the ones that later repel. For instance, the pilot episode ('The Sopranos' 1999) depicts Tony's relationship with a family of ducks that has made a home of his pool. Tony forms a strong attachment to the ducks and although his family is bemused by his emotional investment in the birds, the viewer is charmed by his careful ministrations. The look of utter joy on Tony's face as he watches the ducklings learning to fly is particularly endearing and it appears to reveal a level of kindness and sensitivity missing in modern society.[4] Coming so early in the series, this episode plays a foundational role in the viewer's acceptance of Tony, positing him as a man of essential goodness battling alone in a hostile and uncaring world. All the more affecting then, that the next time the viewer sees such joy on Tony's face is when he is chasing a debtor, Mahaffey, in Christopher's Lexus. Tony runs the man down then proceeds to administer a severe beating, yet significantly the overriding emotion for the viewer is pleasure rather than disgust. The jaunty doo-wop soundtrack ('I Wonder Why' by Dion and the Belmonts, 1958) that accompanies the scene highlights the dissonance between the abjection of the visual image and the viewer's consumption of it as entertainment. Significantly, this does not signal the viewer's getting-off point, but rather a thrilling promise of the kind of treats that the rest of the season has in store.

The first episode neatly encapsulates the Kristevan 'vortex of summons and repulsion' (Kristeva 1982: 1) which will typify the viewer's relationship with the troubling yet charismatic Tony Soprano as the series unfolds. It also introduces the character who will function as the moral touchstone in *The Sopranos*: Dr Jennifer Melfi, Tony's psychotherapist. According to Polan, 'the target viewer for *The Sopranos* is probably more like Jennifer Melfi than Tony Soprano' (Polan 2009: 53) – a view borne out by the findings of the ethnographic research of Joanne Lacey ('One for the Boys? *The Sopranos* and its Male British Audience' [2002]) – and Melfi quickly becomes a key point of audience identification. Tony's therapy sessions are integral to the series in that they offer the viewer unique insight into Tony's psychological make-up. Significantly, the sessions not only provide Tony's own inner perspective, which is necessarily subjective and sometimes skewed: they also deliver Melfi's outside perspective. Her psychoanalytical insights are of course instructive, but the true value of these sessions lies in the impact they have on the viewer's relationship with, and acceptance of, Tony. Bruce Plourde explains:

Whereas our more omniscient position actually limits our ability to judge Tony's

behavior, Melfi's more limited but more insightful reading of Tony stems from her better ability to see through his deceptive language and to read his malevolence, serving as a corrective to our more accommodating perspective.

<div align="right">(Plourde 2006: 74)</div>

Melfi reminds the viewer that it is dangerous to take Tony at face value; that he is a dangerous sociopath and that often his 'insight' is simply a lie he tells himself in justification of his actions. Responses to the character remain complex and (at times) counter-intuitive, however. When Melfi informs Tony that she will bill him for a missed session ('The Legend of Tennessee Moltisanti' 1999), he becomes enraged. Shouting and swearing, he throws money at her before storming out of the office. Tony's powerful physical presence, emphasized as he looms menacingly over the comparatively diminutive doctor, leaves Melfi feeling 'frightened and revolted', yet, interestingly, the viewer's reaction does not mirror Melfi's in this instance. Rather than condemning Tony and withdrawing approval of him, the viewer observes the scene with intrigue and empathy – intrigue as to how Tony's outburst will affect the narrative, and empathy with regards to Tony's devastation at feeling as though Melfi is interested in his money, rather than his wellbeing. The incident reveals Tony's emotional vulnerability; having opened up to Melfi, he felt that their relationship was meaningful and personal, rather than transactional. Within the therapeutic environment, Melfi provides the acceptance and compassion that is missing from Tony's relationship with his mother. The audience responds to Tony's pain with a desire to offer the nurturance and understanding that he needs and desires, simultaneously assuming the role previously held by Melfi and disavowing her interdictions regarding Tony's unacceptable social behaviours. Such a response is rooted in what Suzanne Keen has described as '[d]eliberate perspective taking' (Keen 2015: 131), a kind of empathy whereby the empath retains a separation between him or herself and the other, rather than temporarily 'merging' in a moment of emotional connection. As Keen notes, 'the empath who engages in perspective taking employs observation of the other and knowledge of that person [...] [in what is] a more cognitive operation that depends on having a theory of (another's) mind' (2015: 131). This separation remains a crucial element of the viewer's mental and emotional relationship with Tony Soprano and it is a separation which references and recognizes the complex negotiations upon which the relationship is predicated.

Melfi is similarly aware of the moral complexities of engaging with a man like Tony Soprano. Her professionalism ensures than she retains her clinical focus and treats Tony the same as any other patient. Yet, like Tony's wife and family – and the viewer – she is also complicit in his crimes. In treating Tony, Melfi becomes an enabler, as the coping mechanisms she teaches him help him to become a better mob boss. When she offers Tony what Chris Messenger has termed 'balm, understanding, and [...] acceptance of the sorrow that underlies Tony's rage and depression' (Messenger 2002:

277), Melfi validates the viewer's instinct to forgive Tony his transgressions on the basis of her or his knowledge of the mob boss's drives and motivations.

Significantly, Melfi is not impervious to Tony's considerable charms; as their professional relationship develops, she finds herself increasingly drawn to him. During a discussion with her own therapist, Dr Elliot Kupferberg, Melfi sums up the attraction of repulsion when she admits: 'It's like watching a train wreck. I'm repulsed by what he might tell me but somehow I can't stop myself from wanting to hear it' ('House Arrest' 2000). As Plourde notes, it is Melfi's 'proximity to the audience's own fascination with this bad guy' that informs her understanding of Tony; she 'experiences the same morbid fascination we do, curious about a lifestyle that both disturbs and entices' (2006: 75). As the series progresses, Melfi's professional interest in treating such a complex case develops into a sublimated sexual attraction which manifests in erotic dreams, an increasingly sexy image and her subtle encouragement of the psychotherapeutic transference that allows Tony to develop romantic feelings for her. Melfi's attraction reveals that, like the audience, she is compromised and conflicted, seduced by Tony's beguiling amorality. Significantly, however, Melfi's personal feelings are not allowed to cloud her professional and moral judgement. When her rapist is released on a technicality following a procedural error committed by the police, Melfi has the option of informing Tony of the rape and allowing him to deliver justice on her behalf. She demurs, her emphatic 'No' recalling her pleas to her attacker and voicing her empowering refusal to allow the rape to engender further acts of violence ('Employee of the Month' 2001). Eager to see justice served, however, the viewer is left frustrated by Melfi's decision. As Messenger observes, 'Melfi [...] hold[s] Tony's moral balance (and that of the audience) in [her] hands' (2002: 276); the juxtaposition of Melfi's rationality and the viewer's own bloodlust forcing an uncomfortable moment of self-reckoning. When Melfi's subconscious works through her emotions as she sleeps, the dream work is significant, as Jessica Baldanzi demonstrates:

> When Melfi dreams of a rottweiler mauling her attacker, Jesus Rossi, she later explains to her therapist that her subconscious must have chosen that breed of dog not only because of its viciousness, but because of its 'Italian' history as a Roman guard dog. The choice is, however, even more appropriate than we realize. Melfi remarks that in the dream she's afraid at first that the dogs will attack her, yet rottweilers today are rarely unleashed; police dogs, impeccably trained, their violence is always in control, as we want to believe Tony's violence will be.
>
> (Baldanzi 2006: 82)

Melfi's subconscious need to keep Tony's violence controlled and contained mirrors that of the viewer, who is willing to sanction 'appropriate' outbursts but takes comfort in the fact that Tony appears to be more pragmatic and restrained than his volatile colleagues.

Despite the viewer's desire to compartmentalize the various elements of Tony's personality in order to better navigate the moral complexities of engaging and empathizing with such a character, *The Sopranos* refuses to reduce the character to a convenient set of interchangeable behaviours. David Chase's commitment to psychological complexity and hyperrealism ensures that Tony is as capricious and impulsive as any 'real' person, and his character is subject to psychological change and development. However, whereas in a more conventional, mainstream narrative this would ultimately lead to Tony's betterment and redemption, Chase actually sends his character arc in the opposite direction. Rather than becoming more socially acceptable and relatable, Tony Soprano becomes progressively more spiteful, unpredictable and unsympathetic as the series develops. Melfi's enthrallment with him is displaced by feelings of revulsion, as she explains to her therapist: 'You know at first, I did find him a little sexy – the dangerous alpha male – but as year followed year, the ugliness I saw, that I heard...' ('Two Tonys' 2004). As the series approaches its end point in Season 6, Tony is shown struggling with his sociopathic urges to murder Paulie ('Remember When' 2007) and mistreating his old friend, Hesh ('Chasing It' 2007) in scenes that are puzzling and alienating to the viewer. It becomes clear that Tony's relationships are all about power and as he struggles to reassert himself in the wake of the life-threatening gunshot wound that Junior inflicted upon him, he threatens not just the cohesion of his crew but also the support of the audience. When a drug-addled Christopher crashes the car that he and Tony are travelling in, Tony murders Christopher whilst glaring hatefully at the mangled baby seat in the back of the vehicle ('Kennedy and Heidi' 2007).[5] Tony's justification for the crime – that Christopher's baby daughter would have been killed if she'd been in the car – sounds hollow and ridiculous and the viewer must question all of the other times that s/he glibly accepted Tony's version of events. The scene is so shocking and visceral that empathy for Tony is immediately lost and the viewer is forced to acknowledge what Nochimson has termed 'the insufficiency of Tony's charm in the face of murder and other forms of social devastation' (Nochimson 2005: 192). Despite the refocusing of audience responses to the character, from summons to repulsion, empathy is restored (to a degree) in the final episode of the series, when the Soprano family gathers in a diner for a family meal and the viewer begins to fear Tony's assassination. In part, this is because Tony is restored to the patriarchal role that endeared him to the viewer in the earliest episodes of the series, and the viewer is reminded of Tony's love for his children. However, this awareness is tempered by the knowledge that Tony Soprano is a murderous sociopath whose loyalty to family and Family are contingent at best. The viewer's empathetic and emotional response to the situation, then, appears to reveal more about his or her own humanity than it does about Tony Soprano's.

Over the course of six seasons and eight years, Tony Soprano proved to be one of television's most complex and beguiling antiheroes. The character has acquired an extraordinary amount of cultural capital, with a reach far beyond what can usually be

expected of a cable television series. Commentators have been effusive in their praise (although, of course, the series also had its fair share of vociferous detractors), with critics such as Maureen Ryan, in her blog for the *Chicago Tribune*, describing *The Sopranos* as 'the most influential television drama ever' (Ryan 2007). It quickly transcended its cult status and, according to Sam Delaney,

> [a]t its peak the show attracted 18 million viewers and was syndicated to channels across the world. It won numerous Emmy and Golden Globe awards and was declared by many critics as the greatest drama series of all time.
>
> (Delaney 2009)

Perhaps most importantly, *The Sopranos* set a new precedent for television, characterized by cinematic techniques and high production values, and a heavy focus on charismatic but morally ambiguous antiheroes. Tony Soprano made possible many of the twenty-first century's most enigmatic characters, including Vic Mackey from *The Shield* (FX, 2002–08). *The Shield* renegotiates conventional morality, confounds genre expectations and, as Glyn White observes, 'self-consciously belongs to the type of quality television that intentionally troubles its audience's sense of right and wrong' (White 2012: 90). Such a lack of moral sanction is at once titillating and thought-provoking and television has increasingly sought to capitalize on the curious appeal of the characters ushered in by Tony Soprano. His legacy continues to be felt, in shows such as *The Wire* (HBO, 2002–08), *Dexter* (Showtime, 2006–13) and *Breaking Bad* (AMC, 2008–13).[6] The antihero has become an essential part of popular culture and the interest in beguiling malefactors and moral complexity shows no sign of abating – proof indeed of the attraction of repulsion. ∗

REFERENCES

Baldanzi, Jessica (2006), 'Bloodlust for the Common Man: *The Sopranos* Confronts Its Volatile American Audience', in David Lavery (ed.), *Reading* The Sopranos: *Hit TV from HBO*, London/ New York: I.B. Tauris, pp. 79–89.

Butler, Judith (1997), 'Imitation and Gender Insubordination', in Linda Nicholson (ed.), *The Second Wave: A Reader in Feminist Theory*, London/New York: Routledge, pp. 300–15.

'Calling All Cars' (2002), Tim Van Patten, dir., *The Sopranos*, Season 4, Episode 11, New York: HBO.

'Chasing It' (2007), Tim Van Patten, dir., *The Sopranos*, Season 6 Pt 2, Episode 4, New York: HBO.

'Cold Cuts' (2004), Mike Figgis, dir., *The Sopranos*, Season 5, Episode 10, New York: HBO.

'College' (1999), Allen Coulter, dir., *The Sopranos*, Season 1, Episode 5, New York: HBO.

Coppola, Francis Ford (1972), *The Godfather*, Hollywood, CA: Paramount.

Delaney, Sam (2009), 'HBO: Television Will Never Be the Same Again', *The Telegraph*, 25 February, http://www.telegraph.co.uk/culture/tvandradio/4733704/HBO-television-will-never-be-the-same-again.html. Accessed 1 February 2015.

'Down Neck' (1999), Lorraine Senna, dir., *The Sopranos*, Season 1, Episode 7, New York: HBO.

'Eloise' (2002), James Hayman, dir., *The Sopranos*, Season 4, Episode 12, New York: HBO.

'Employee of the Month' (2001), John Patterson, dir., *The Sopranos*, Season 3, Episode 4, New York: HBO.

Fields, Ingrid Walker (2004), 'Family Values and Feudal Codes: The Social Politics of America's Twenty-First Century Gangster', *The Journal of Popular Culture*, 37: 4, pp. 611–33.

Hamad, Hannah (2013), 'Hollywood Fatherhood: Paternal Postfeminism in Contemporary Popular Cinema', in Joel Gwynne and Nadine Muller (eds), *Postfeminism and Contemporary Hollywood Cinema*, London: Palgrave Macmillan, pp. 99–115.

'The Happy Wanderer' (2000), John Patterson, dir., *The Sopranos*, Season 2, Episode 6, New York: HBO.

'House Arrest' (2000), Tim Van Patten, dir., *The Sopranos*, Season 2, Episode 11, New York: HBO.

Keen, Suzanne (2015), 'Intersectional Narratology in the Study of Narrative Empathy', in Robyn Warhol and Susan S. Lanser (eds), *Narrative Theory Unbound: Queer and Feminist Interventions*, Columbus: Ohio State University Press.

'Kennedy and Heidi' (2007), Alan Taylor, dir., *The Sopranos*, Season 6 Pt 2, Episode 6, New York: HBO.

'The Knight in White Satin Armour' (2000), Allen Coulter, dir., *The Sopranos*, Season 2, Episode 12, New York: HBO.

Kristeva, Julia (1982), *The Powers of Horror: An Essay on Abjection*, New York: Colombia University Press.

Lacey, Joanne (2002), 'One for the Boys? *The Sopranos* and Its Male British Audience', in David Lavery (ed.), *This Thing of Ours: Investigating* The Sopranos, New York/London: Columbia University Press/Wallflower, pp. 95–108.

Lee, Chris (2013), 'James Gandolfini's Tony Soprano Was a Cultural Sensation', *Los Angeles Times*, 21 June, http://articles.latimes.com/2013/jun/21/entertainment/la-et-st-gandolfini-cultural-impact-20130621. Accessed 30 September 2014.

'The Legend of Tennessee Moltisanti' (1999), Tim Van Patten, dir., *The Sopranos*, Season 1, Episode 8, New York: HBO.

'Meadowlands' (1999), John Patterson, dir., *The Sopranos*, Season 1, Episode 4, New York: HBO.

Messenger, Chris (2002), The Godfather *and American Culture: How the Corleones Became 'Our Gang'*, Albany: State University of New York Press.

'Mr and Mrs John Sacramoni Request' (2006), Steve Buscemi, dir., *The Sopranos*, Season 6, Episode 5, New York: HBO.

'Mr Ruggiero's Neighborhood' (2001), Allen Coulter, dir., *The Sopranos*, Season 3, Episode 1, New York: HBO.

Nochimson, Martha P. (2005), 'Whaddaya Lookin' At? Rereading the Gangster Film Through *The Sopranos*', in Lee Grieveson, Esther Sonnet and Peter Stanfield (eds), *Mob Culture: Hidden Histories of the American Gangster Film*, Oxford: Berg, pp. 185–204.

Peberdy, Donna (2011), *Masculinity and Film Performance: Male Angst in Contemporary American Cinema*, London: Palgrave.

Plourde, Bruce (2006), 'Eve of Destruction: Dr. Melfi as Reader of *The Sopranos*', in David Lavery (ed.), *Reading* The Sopranos: *Hit TV from HBO*, London/New York: I.B. Tauris, pp. 69–76.

Polan, Dana (2009), *The Sopranos*, Durham/London: Duke University Press.

'Remember When' (2007), Phil Abraham, dir., *The Sopranos*, Season 6 Pt 2, Episode 3, New York: HBO.

Rotundo, E. Anthony (2002), 'Wonderbread and Stugots: Italian American Manhood and *The Sopranos*', in Regina Barecca (ed.), *A Sitdown with* The Sopranos: *Watching Italian American Culture on TV's Most Talked-About Series*, New York: Palgrave, pp. 47–74.

Ryan, Maureen (2007), '*The Sopranos* is the Most Influential Television Drama Ever', *Chicago Tribune*, 1 April, http://featuresblogs.chicagotribune.com/entertainment_tv/2007/04/the_sopranos_th.html. Accessed 30 January 2015.

'The Sopranos' (1999), David Chase, dir., *The Sopranos*, Season 1, Episode 1, New York: HBO.

'Toodle-Fucking-Oo' (2000), Lee Tamahori, dir., *The Sopranos*, Season 4, Episode 16, New York: HBO.

'Two Tonys' (2004), Tim Van Patten, dir., *The Sopranos*, Season 5, Episode 1, New York: HBO.

'University' (2001), Allen Coulter, dir., *The Sopranos*, Season 3, Episode 6, New York: HBO.

Wellman, William A. (1931), *The Public Enemy*, Hollywood, CA: Warner Bros.

White, Glyn (2012), 'Quality, Controversy and Criminality: *The Shield* as Post-*Sopranos* Cop Show', in Nicholas Ray (ed.), *Interrogating* The Shield, New York: Syracuse University Press, pp. 87–104.

'Whitecaps' (2002), John Patterson, dir., *The Sopranos*, Season 4, Episode 13, New York: HBO.

'Whoever Did This' (2002), Tim Van Patten, dir., *The Sopranos*, Season 4, Episode 9, New York: HBO.

GO FURTHER

Books

Martin, Brett (2013), *Difficult Men*, London: Faber & Faber.

Silver, Alain and James Ursini (eds) (2007), *The Gangster Film Reader*, New Jersey: Limelight Editions.

McCarty, John (2004), *Bullets Over Hollywood: The American Gangster Picture from the Silents to* The Sopranos, Cambridge, MA: Da Capo Press.

Barreca, Regina (ed.) (2002), *A Sitdown with the Sopranos*, New York: Palgrave Macmillan.

Munby, Jonathan (1999), *Public Enemies, Public Heroes: Screening the Gangster from* Little Caesar *to* Touch of Evil, Chicago/London: UCP.

Warshow, Robert (2001 [1948]), 'The Gangster as Tragic Hero', reprinted in *The Immediate Experience*, Cambridge, MA: Harvard University Press, 2001.

Television

The Shield (March 2002–November 2008, Texas: FX).

The Sopranos (January 1999–June 2007, New York: HBO).

Notes

1 Although Donna Peberdy challenges the validity of Kimmel's argument, which she says 'locate[s] crises of masculinity historically, quantifying them schematically according to dominant social positions' such as 'profeminist, antifeminist, and promale' and therefore overlooks or precludes

'those readings that occupy or cross a number of social positions' (2011: 5), Kimmel's account of the existence of these historical stress-points nevertheless points to the cyclical and enduring nature of masculine crisis.

2 Significantly, Tony's two sisters, Janice and Barbara, have long since severed contact with their mother. Unwilling and unable to endure her toxic personality any longer, they have moved away to focus on building their own lives. Although they both rejoin the family as Livia's life draws to a close, they do not strive to win her love in the way that Tony does.

3 It's interesting to note, however, that the show's nuanced treatment of the Feds sees the viewer shifting from scorn, such as when the agents pettily crow about the fact that their surveillance equipment has revealed that Tony's boiler is about to burst, to breathless enjoyment of the *Mission Impossible*-style operation to infiltrate and reconnoitre the Soprano home, and grudging admiration at the skill of the experts at Quantico who create an exact replica of a lamp in Tony's basement which they install as a bugging device ('Mr Ruggiero's Neighborhood' 2001). Such episodes recognize the complexity of human emotion; the power of the narrative apparatus; and the shifting, malleable identification of the viewer.

4 This point is emphasized by the scornful reaction of his teenage daughter, Meadow.

5 It's important to note here that Tony and Paulie goaded Christopher into renouncing his sobriety, after feeling jealous and rejected by his decision to distance himself from the temptation of 'Bada Bing!' and other mob hangouts. After his masculinity is impugned by the pair, Christopher joins them for a drink and quickly descends back into addiction.

6 Bryan Cranston who played Walter White in *Breaking Bad* acknowledged this debt when James Gandolfini died in 2013. He tweeted 'I'm saddened by James Gandolfini's passing. He was a great talent & I owe him. Quite simply, without Tony Soprano there is no Walter White' (@ BryanCranston, 20 June 2013, https://twitter.com/bryancranston/status/347735374602321921. Accessed 17 June 2015).

'What kind of person can I be, where his own mother wants him dead?'

TONY SOPRANO

RAY DONOVAN
NATIONALITY: AMERICAN / CREATOR: ANN BIDERMAN

The discontents of hegemonic masculinity
Gareth Hadyk-DeLodder

I know what a bad father is. – *Ray Donovan*

Ray Donovan (Ann Biderman, 2013–ongoing) constitutes another Showtime foray into the increasingly routine and muddy waters of the modern cable antihero. Stylized violence, sex, machismo, repression, Oedipal struggles and a brooding undercurrent mark one of Showtime's latest dramas as unmistakably *heimlich* (homely, familiar): we've seen 'it' before. In fact, much of the current criticism surrounding the show echoes this last point. *Huffington Post* goes so far as to offer up satirically the 'Anti-Hero Pop Quiz!' in honour of *Donovan*'s premiere, in which quiz-takers are entreated to respond to questions ranging from the protagonist's 'brooding' good looks to the systematic devaluation of the show's female characters. TV critic Maureen Ryan (2013) decries the show's slide into a 'testosterone-soaked past', and indeed, it's hard to disagree with many of her points. One of the most consistent threads in the show's criticism centres on viewer fatigue: Ryan refers to it as 'derivative', another reviewer remarks that it is '*typical* violent antihero dreck' (Tigges 2013, original emphasis), and Emily Nussbaum contends that 'most of the show feels like a dose of the same dirty candy that's dished out all over adult cable' (2013). Indeed, it is the nature of this 'dirty candy' with which this chapter is chiefly concerned: while the show's narrative can feel imitative at first glance, a closer examination reveals a complex network of relationships between characters and systems of power that expose some of the more troubling ideological foundations of hegemonic masculinity.

My intention here is not to refute wholly the claims of many critics who regard *Donovan* as clichéd, nor is it to reclaim or lionize what Amanda Lotz (2014) refers to as the 'male-centric serial' and *Donovan*'s clear allegiance to many of its tropes. Instead, I hope to demonstrate that *Ray Donovan*'s most important hermeneutic may lie well

outside of its well-worn facade, and that, rather than upholding or reinscribing the normalizing influence, value or sex appeal of its muscular antihero, the show serves to illustrate vividly the troubling teloi for this type of television character. As the brilliant and unbalanced motivational speaker Steve Knight remarks to Ray during the second season's finale, 'Eros, Thanatos, it's all the same' ('The Captain' 2014), words that resonate both for Ray personally as well as for the narrative. That the show suggests the collapse of both of Freud's drives in Ray's characterization is a stark reminder that this is not a protagonist who balances, or seeks to balance, life-giving forces and the 'death instinct' (Freud 1989 [1920]: 53). Rather, as multiple characters point out, Ray is caught and actively engages in a cycle of repetition: like his father, 'Everything he touches turns to shit' ('Volcheck' 2014). Freud notes that '[Civilization] must present the struggle between Eros and Death, between the instinct of life and the instinct of destruction, as it works itself out in the human species. This struggle is what all life essentially consists of' (Freud 1962 [1929]: 111). If Ray, or the antihero, embodies the conflation of both, as Steve Knight suggests in the second season, then he exists outside of civilization – a collapse that leads to self-destruction.

As opposed to the critics who tire of Ray's threshold for violence, smarts and conquests (sexual and otherwise), I am more interested in the ways that the narrative frames this type of masculinity as a double bind. Consequently, characters can either (1) be assimilated, in which case they, like Ray, Mickey and many others, suffer as family and personal ties deteriorate; or (2) they can resist the mould, in which case they are subjected to homophobic or misogynist slurs, their 'manhood' is questioned routinely, and many of them are killed. Within such a rigid system, *Ray Donovan* illustrates that achieving this type of masculinity is a pyrrhic victory at best. At its worst, this desire is compared to Ahab's quest, communicating both its futility and destructiveness. In a noteworthy sequence, Mickey transitions from looking up black women twerking on a public library's computer to reading a scene aloud from Melville's *Moby Dick* (1851): 'Queequeg had handled so roughly, was swept overboard; all hands were in a panic; and to attempt snatching at the boom to stay it, seemed madness' ('Twerk' 2013). Both the line itself and Melville's narrative trajectory are suggestive here: the scene that Mickey is reading from is one of redemption (Queequeg saves a drowning ship-hand), but ultimately Queequeg is destroyed by the whale, along with everyone on the ship save Ishmael. It cannot be a coincidence that Mickey, who refers to himself as 'the Captain' several times in Season 2, reads aloud a part of a story where the captain leads all to ruin.

Ray Donovan joins a long list of many similarly themed cable programmes following the success of *The Sopranos* (HBO, 1999–2007), *Sons of Anarchy* (FX, 2008–2014) and *Breaking Bad* (AMC, 2008–2013), in which family politics, violence and masculinity are interwoven and explored under the aegis of the antihero. The show's eponymous protagonist, a menacing Liev Schreiber, embodies all three on the narrative's surface. A native Boston 'Southie', with its attendant class signification, Donovan lives with his

family in Hollywood, where his work as a 'fixer' for Hollywood's noblesse has him quip with relative equanimity to a client during the show's first episode: 'You think you're the first person I've dealt with woke up in bed with a dead body?' ('The Bag or the Bat' 2013). The show, however, often juxtaposes the shocking or gratuitous – an NBA star waking up next to a dead and naked 'broad' ('The Bag or the Bat' 2013) – with far more serious matters. The pilot, after all, opens with the aging paterfamilias (Ray's father) murdering a priest in Boston after forcing his pistol into the man's mouth and asking 'How does it feel, you cocksucker? You like it?'. The significance of the phallic overtone is revealed later in full: Ray's father, Mickey, believes that this is the priest who sexually abused or attempted to abuse all three of his sons when they were children. The pilot's opening sequence establishes the ethos of both locations for the series as a whole. The oscillation between the superficiality and dangers of Hollywood with the dark, neo-noir Boston becomes one of the defining aesthetics for the show. Boston is synonymous with the Donovan family's repressed past: clerical abuse, drugs, suicide and the collapse of the nuclear family – Ray's daughter writes an essay on his family that is marked down (fittingly) for being too 'vague' ('Twerk' 2013). Hollywood, by comparison, is presented as ultimately vacuous, avaricious and morally bankrupt: the only point of similitude between both locations involves familial instability. It is in this space that Ray, his family, his brothers and his father navigate a constantly shifting landscape, one where the law, religion, social institutions and the family unit are in a constant state of flux and/ or degeneration.

It should come as little surprise, then, that *Ray Donovan* offers another treatise on what Michael Kimmel (2013) terms a 'male crisis' in twentieth and twenty-first-century gender politics. Multiple critics have rightly pointed to some of the ways that *Ray Donovan* engages a 'troubled' masculinity, with many lauding the show's move to investigate the impacts of clerical sexual abuse. What sometimes seems lost in many reviews, however, is both the degree and scope through which the show explores the varied relationships between and ramifications of abuse, addiction, suicide, gendered violence and class demarcations, often through the show's depiction of women. The Donovan clan exists in an exclusively male space, in which, tellingly, the deceased mother and sister are shown only as gravestones. The markers underscore the relationship of both women to the men: 'Mary Campbell Donovan: Devoted Wife and Mother' and 'Bridget Elizabeth Donovan: Beloved Sister' ('New Birthday' 2013). Each woman's death figures largely in the lives of the brothers: Mary died from cancer when the boys were younger, but not before Mickey had taken up with, as multiple characters term her throughout the series, a 'nigger from the projects' – the first of many revealing references to race in the narrative ('New Birthday' 2013). We are told that Bridget committed suicide as a teenager due to a combination of drugs, pregnancy and her fear of others' reactions. Further exposition on the female Donovans is silenced, however. As Ray's wife, Abby, finds out more about his past (she seems to be assuming the mantle of *Breaking Bad*'s [AMC, 2008–13] Skyler

White, to a certain degree), her appeals to 'emotional honesty' from him are met with the dismissive and condescending, 'Oh jeez, you been seeing that same therapist you sent Bridget to?' ('Bridget' 2013).

Ray Donovan is distinct from several other popular antihero cable shows because of its hermeneutical silences. There is no meta-narrative that has become popularized in shows like *Dexter* (Showtime, 2006–13), *Sons of Anarchy* (FX, 2008–14), and others, in which the protagonists' voice-overs allow us to enter more deeply into the narrative, or to understand the antihero in his own voice. Dexter and Jax Teller connect with the audience through frequent monologues that establish a critical perspective for the audience. Ray, however, rarely speaks about himself, his past or his emotions. 'You don't talk much', an observation from one of the show's characters, Stu Feldman, is an understatement. Throughout both seasons, the most we learn about Ray is revealed through troubled dream sequences, alcohol and his many and varied silences in response to questions. For this reason, most of my readings will involve the characterization, narrative role and language of *Ray Donovan*'s other characters, especially those who occupy marginal or peripheral roles. More often than not they interact with and disclose much about the antihero figure, especially for the purposes of examining the show's construction and understanding of gender roles. Heidi Hartmann's reading of these homosocial relationships is particularly germane: 'Relations between men, which have a material base, and which, though hierarchical, establish or create interdependence and solidarity among men that enable them to dominate women' (Hartmann, cited in Sedgwick 1985: 3).

Moreover, each male member struggles with assimilating the personal, sexual and social expectations that are imposed on them. Mickey is an unrepentant voice for racism, homophobia and xenophobia; Ray represses the sexual abuse he suffered as a child and the guilt he carries over his sister's suicide, which leads to a 'hyper-sexualized' diagnosis from his wife's therapist ('Yo Soy Capitan' 2014); Terry, the 'good man' and nominal moral centre, struggles with early onset Parkinson's caused by (or exacerbated by) his father's mismanagement of him as a young boxer; and Bunchy, the youngest of the original Donovan nuclear family, is a 'sexual anorexic' and an addict (both drugs and alcohol) who cannot hold a job, and is referred to multiple times as a 'child' developmentally and emotionally ('Twerk' 2013). Consequently, all four men are a product of some type of patriarchal violence, and the ways that the show traces the diffusion and consequences of the family's past offer up a fertile space to map out R. W. Connell's and James Messerschmidt's (2005) understanding of 'hegemonic masculinity'. They write, 'Hegemonic masculinity was understood as the pattern of practice (i.e., things done, not just a set of role expectations or an identity) that allowed men's dominance over women to continue' (2005). As we will see presently, the show spares no expenses to drive home the subordination and objectification to which women and other groups are subjected in this world.

The masculine project

One of the show's clearest ideological undertakings focuses, unsurprisingly, on masculinity, and especially on its performative nature. Indeed, multiple characters exchange questions, accusations and aspersions that all concern, on a fundamental level, the public legitimacy and performance of their (or others') manhood, both symbolically and literally.[1] As smarmy lawyer Lee Drexler panics about one of his movie-actor clients and a compromising situation, he yells 'Guy has a $200-million heterosexual movie coming out in a month [...] picks up a tranny' ('The Bag or the Bat' 2013), underscoring the sometimes fluid (or fictional) nature of sexual identity and expectation. Like several other aspects of the show, the fault lines separating the 'right' kind of masculinity from its counterpart(s) are marked both by humorous turns as well as tragic.

One of the chief examples of this is illustrated by the character of Stu Feldman, a studio executive who hires Ray to investigate whether or not his girlfriend is cheating on him (despite the fact that he is married). The first time that the audience sees him he is seated across from Ray. He is figured as a weak, ingratiating man. While Ray is outfitted – as he almost always is – in a dark suit, Stu is in a light-pink sweater and white trainers. Though both men are the same age, Stu is short, squat and balding. 'I don't feel good about myself', he confides in Ray, after revealing that his wife doesn't want to have sex with him, before abruptly asking 'You ever do growth hormone?' ('The Bag or the Bat' 2013). He desperately wants to *be* Ray: he asks after his trainer, his virility, and more. The conflation of sex, control (power) and the 'manly' are unmistakable in the scene, as he is depicted as equal parts lascivious and repugnant, a man whose prurience and libidinal deficiency marks him as Ray's opposite – thus, not the kind of man who 'gives his power away' as Stu fears.

Stu's power lies in his money and, importantly, in his social currency, whereas Ray is regarded as a 'common street thug' by several of Stu's associates. He can block Ray's daughter from attending a prestigious prep school, but he can't prevent himself from being harmed (by Ray or others), kidnapped during a sex scene in the second season, or bullied by those around him. In a rather lucid exchange that functions both within the narrative as well as a sly critique of the genre itself, Stu asks Ray, 'You ever take testosterone? Of course not, they probably milk it from you like blood plasma'. An apt assessment of Ray, but the irony should not be lost on the audience, given that Ray's entire ethos (and by extension all of the 'difficult men' in the show, to borrow Brett Martin's term)[2] is predicated on a normalized view of testosterone: aggressive, violent and erotic. Stu recognizes this, and again delivers a line whose double entendre is at once amusing and revealing for the show's antiheros: 'it was the testosterone [...] it's dangerous stuff. People need to know' ('Gem and Loan' 2014). The line's meaning is lost on Ray at the moment, but its significance is frightening in the context of the narrative, given that Season 2 is built around the erosion of family ties, death and the threat of incarcer-

ation for almost every male member of the Donovan family, in addition to the gendered violence that women are subjected to throughout.

If both Stu and Ray stand on opposite ends of the show's male spectrum, however, they still both exert power over women in troublingly similar ways, a reading that can be extended to many of the show's male characters. Above all, those who seem most invested in the performance of a certain type of masculinity, whether explicitly or implicitly, fixate on sexual potency or sexual fantasy. The show often visualizes this, for example, when Mickey and another man are standing holding different sized (phallic and erect) cacti in Season 1, or when others are comparing the relative size and merit of their guns in Season 2. Stu is married, has an off-again–on-again relationship with a young woman (with whom Ray also has a sexual relationship), and he pays tens of thousands of dollars to sleep with a porn star. Young, desirable women become both object and commodity, reduced to their sex in form and act. This is a move, however, that is appended to almost every woman in the show: 'Broad', 'bitch', 'ho', 'pussy', 'whore', 'that ass', 'hooker' and 'cunt' are used frequently and interchangeably, with an apparent ease that betrays a casual familiarity and cavalier attitude towards this kind of dehumanizing language.

More troubling than Stu, however, is the depiction of Conor, Ray's teenage son. Where Stu illustrates both the risible and the satiric in terms of an adult counterpart to the antihero's physical and sexual presence, Conor represents a nascent apprehension of the 'manly' model, and one that lays bare the prejudice, misogyny and violence that buttresses the Donovan patriarchy. Where the first season relegates Conor to the narrative's periphery as a somewhat clueless 13-year-old lost in the violence of first-person shooters, Season 2 establishes its thrust much more clearly in the premiere in the form of a question posed to Conor: 'What kind of man do you want to be?' ('Uber Ray' 2014). Alarmingly, this question parallels the plotlines of Ray and Mickey – and, to a much lesser degree, the character Sean White, a movie star who escaped conviction for accidentally killing a girl – who manifest a systematic disregard for the women in their lives, which leads to the murder of two lovers for both men over the course of the two seasons. On the cusp of 'manhood', as Mickey pointedly tells him in Season 2, Conor wavers in terms of his performance of this masculine typology. Thus he craves the attention of his peers at a new school, but he also reacts violently when he is teased by one of them, striking him in the back of the head with a metal cone and pushing another down a flight of stairs ('Yo Soy Capitan' 2014). He desperately yearns to train as a boxer at the family's gym ('Fite Club') like his father, uncles and grandfather. It is there where, in response to his father's order to apologize to the boy whom he pushed down the stairs, Conor shouts, 'What kind of man am I going to be? Donovans don't apologize. You're going to try to make me a bitch' ('Uber Ray' 2014). Conor parrots back Mickey's own words later in the episode again: 'He's trying to make me a bitch' ('Uber Ray' 2014). His assertion is all the more striking because these are not his words: to be or not to be a 'bitch' holds little meaning for Conor, but he rapidly embraces a signifier that equates

what is feminine with a brand of masculinity to be reviled. As the series continues to demonstrate, the roots of hegemonic masculinity are learned, unstable and, as Stu, confides, 'dangerous'.

'We're all your victims': The effects of hegemonic masculinity on women

From Stu's effeminacy (often coded as a 'lack' of masculinity, libido or testosterone) to Conor's (and other characters') burgeoning misogyny and Ray and Mickey's mistreatment of or violence towards their lovers, *Ray Donovan* embodies a systemic devaluation of its female characters. This does not occur by happenstance, nor is it simply the result of the antihero's plot-function within the narrative. In other words, Ray's philandering and sex-appeal certainly reflect an ideological position towards women, but the roots of the show's misogyny run much deeper. As I indicated before, the linguistic register to name and describe women ('broad', 'bitch', 'pussy', 'whore', 'that ass' and 'cunt') moves beyond a sexualized and objectified range typically associated with popular antihero shows. Here, the language reflects a violence (a typology at once sexual and non-sexual) that is overwhelmingly coded as male. Women are raped, sexually assaulted and battered. Moreover, the perpetrators are often characters framed as sympathetic in other parts of the narrative, or characters involved with these women: Marvin Gaye, Bridget's boyfriend from Compton, orders her to 'pipe me [fellatio], bitch' when the two are alone after he hears of his mother's death, with which he believes Ray was involved ('New Birthday' 2013); Abby has to shove Ray away after repeatedly trying to rebuff his sexual advances ('I said no') in a season that deals, in part, with spousal rape, to which Ray responds 'Are you fucking kidding me?' ('Uber Ray' 2014); and Mickey orders Linda, his brief lover, to 'suck it' while pointing a loaded pistol at her after confusing her figure of speech for a legitimate sexual fantasy ('Bridget' 2013). That these incidents all occur within the parameters of different kinds of relationships (marriage, adolescent dating, etc.) suggests the pervasiveness of sexual threats and violence towards women, even within putatively domestic or 'safe' spaces.

Given the backlash that characters/actresses experience when they deviate from normalized social expectations – especially as it concerns sex – sexual objectification within the narrative and from the fans is not unexpected. Thus Betty Draper, Skyler White, and others are exposed to a collective (and often male) indignation when their characters transgress comfortable, domestic boundaries. In *Ray Donovan*, however, multiple wives and mothers are dead, dying or, in Ray's summation of his wife after her repeated inquiries into his emotional state, 'fucking nuts' ('Bridget' 2013), a status that obviously complicates questions of agency within the narrative. Ray's wife, Abby, one of the show's more complex female characters, condemns Ray's treatment of her as a 'child' instead of a 'partner' ('Uber Ray' 2014). Correspondingly, as I indicated before, the body count for women runs very high in the serial, almost to the point where the

spectacle ceases to be noteworthy or titillating (similar to the sexualized language assigned to many women). A brief overview is revealing: Ray's mother and sister are dead; his previous girlfriend was killed; the mother of Marvin Gaye (Bridget's boyfriend) is murdered; Mickey's lover is killed; and more.

Moreover, the pilot opens with a scene where a professional basketball player wakes up next to a dead woman. What unfolds becomes standard treatment for the woman's body: she is naked, exposed from the waist up, viewed and assessed by men, and left after the room is cleaned and manipulated. She is, quite literally in the opening scene, a cipher: nameless, and useful only in how meaning can be written onto her and onto her body. There are other examples of this type of treatment: Season 2 opens with Mickey's one-time lover's body being dug up and savaged by wild dogs, a 'broad' that he 'hardly knew' ('Fite Nite' 2013). During a subsequent FBI interrogation, the deputy director lays several pictures of her dead body in front of Mickey: 'dogs were chewing on her', he remarks, before Mickey turns the pictures over ('Irish Spring' 2014). Season 2 also ends with Ray's lover, Kate McPherson, a reporter from Boston, murdered to satisfy the claims of the Hebrew *din rodef* (law of the pursuer) to protect Ray and his employers. The claims that the show is 'needlessly graphic in its depiction of sexual violence against women' are hardly surprising in light of the brutality and silencing of women and what they might say (Ostrow 2013). That said, I am inclined to read these scenes, especially when they are visualized in such a way and with such frequency that we reach a saturation point, as an important way to trace the effects of this brand of hegemonic masculinity – a reading that criticizes the assumed banality of female violence. The prevalence of this trope reinforces the sexual and violent ramifications when the woman's body is evacuated of meaning and agency – when she is rendered, in other words, an object, the cipher from the pilot who is alternately written onto and erased. Tellingly, as Abby informs Ray, 'We're all your victims' ('Viagra' 2014).

Queerness, race and otherness in *Ray Donovan*

Part of the show's construction of its 'robust' masculinity involves its boundaries with homosexuality, transgender identity and cultural and racial otherness. Racial stereotypes abound, whether the 'black, violent rap artist' embodied by Re-Kon (whom we first meet while he is shirtless and wielding a katana) and Cookie (who instigates the only drive-by shooting in the series to date), or the 'intemperate Jew' in Lee Drexler, who gleefully shares that 'We've done worse [than buying children]' for the sake of future profit ('Twerk' 2013). Similar to the antihero's linguistic treatment of women, the show encompasses a broad range of slang, pejoratives and slurs to refer to and articulate the heterodoxy. Thus 'towelhead', 'tranny', 'fag', 'cocksucker', 'nigger', and more are used throughout both seasons. The pervasiveness of these signifiers highlights the instability of the antihero's ideological make-up. When, for example, Ray's father

finds himself at one of Bunchy's SNAP meetings (Survivor Network of Those Abused by Priests), the clearly discomfited Mickey tells inappropriate jokes, attempts to 'lighten' the mood, and is wildly insensitive and offensive ('Twerk' 2013). Coming from a professed 'feminist' who also declares 'I'm not racist [...] I don't like black men much', his callous words are perhaps unsurprising. Mickey's panacea for childhood abuse victims is to 'toughen you up' ('Twerk' 2013). Similarly, his solution for Bunchy's 'sexual anorexia' is a steady stream of prostitutes, despite his son's clear discomfort and failure 'to perform'. Fundamentally, he cannot apprehend the consequences of his son's afflictions; he shouts 'a man's got needs', but seems oblivious to the shifting and fluid nature of those needs in his family ('Twerk' 2013). Ultimately, the Donovan family points to the intersections of race, queerness and otherness in important ways despite both Ray's and Mickey's espousal of hyper-masculinity, if only to interrogate the foundations of apparently stable, 'normal' relationships. The heteronormative narrative for Ray – his wife, two children and suburban house – is gradually eroded as infidelity and discord proliferate; his daughter is dating a young black man from 'the projects' (Compton) who is shot; Ray's son 'doesn't know' if he is gay or straight; Bunchy has a traumatic background of abuse; Terry is involved with a married woman; and Mickey has two families, one white and one black, and seeks to bring his 'other' son, Daryll, into the fold, despite Ray's open hostility to his half-brother. Clearly, the nuclear family is more heterogeneous than its first impression suggests.

While similar in many respects, Ray and Mickey confront otherness in remarkably different ways. While it is suggested that Ray is worried about his son's sexual orientation, he says nothing to Conor. Mickey, however, confronts him directly: 'Conor, you a fag?' ('A Mouth is a Mouth' 2013). The ensuing conversation is suggestive: while Mickey admits that there are some 'stand up fags' (only those who are 'tough', however), he avers: 'don't let anyone fuck you in the ass [...] that's how you get sick' ('A Mouth is a Mouth' 2013). The elision of homosexuality, disease and death is tendered more than once, but only by older men. While Ray is shown to be more open-minded – a close associate is a lesbian, and he calls a transgender woman by her name, later providing money for a sex change operation ('A Mouth is a Mouth' 2013) – he still has difficulty with the male body. Confronting a naked man in his bathroom, he venomously spits out 'Cup your fucking genitals; I don't want to look at that shit' ('The Bag or the Bat' 2013), an aversion to the potentially homoerotic that is both traditionally (heterosexually) masculine and possible evidence of his own trauma. Looking at the placement of otherness in the narrative, and in light of the show's deployment of homosexual and transgender slurs, I argue that these encounters illustrate, in Sedgwick's words, that '"obligatory heterosexuality" is built into male-dominated kinship systems, or that homophobia is a *necessary* consequence of such patriarchal institutions as heterosexual marriage' (Sedgwick 1985: 3). If nothing else, *Ray Donovan* points to the many epistemological gaps involved in what constitutes and perpetuates the 'obligatory' identities throughout.

Ray Donovan's future

In a fitting gesture, the only teacher that we meet in the series, an English teacher at a prestigious prep school, tells future parents: 'Our curriculum begins with *Hamlet*' ('Black Cadillac' 2013), a line that also serves to frame the series as a whole. Given its narrative locus, it is unsurprising that the produced antihero draws much from Shakespeare's tragic figure. The attendant patterns – violence, madness, sexuality and Oedipal struggles – are both familiar and familial. And yet the audience is kept from a Hamlet-like intimacy with Ray, an intimacy, it must be noted, that has been granted with many of his fellow antiheros. Thus, while his narrative arc is not as subtle or nuanced as that of Walter White, or as introspective as Dexter's, Ray's narrative expands to consider the ramifications of the normalizing and subordinating forces at play in hegemonic masculinity. Shows about corrupt police and criminals abound, but a series that criticizes the father and patriarchal forms of power from the nuclear family up to the papacy merits further examination. Season 2's finale offers the hopeful line about abuse and the recurrence of violence: 'That's why we're here: to break the cycle' ('The Captain' 2014), but the show seems to resist such a sanguine option. As Terry asks Ray angrily, 'What the fuck do you know about being a good man, Raymond? ('The Captain' 2014), a question that remains unanswered, if not unanswerable.

In a narrative world almost wholly encapsulated within patriarchal violence (stemming from the church, family, industry and the government), Ray comes to symbolize the futility of a happy escape, pointing to a productive and topical discourse on how the antihero becomes a metonym for the instability (or failure) of the paterfamilias. While some look to this as stale or as a show that 'just doesn't have anything new to say' (Thomas 2013), I think it is important to consider how similar shows address this attenuation, especially in a character like Mickey, or how adolescents come to acquire such a distinct habitus under the guise of 'masculinity'. As I have indicated previously, *Ray Donovan* forces us to consider the various sociological strata implicit in this identity, and consequently opens itself up to a number of different and productive readings. Ultimately, I envision the placement of this chapter within a larger, emerging conversation about the social role and ideological make-up comprised by the 'dastardly antiheroism of cable protagonists' (Lotz 2014: 12). Future considerations of the show could look to how trauma studies can help us to understand the development and interactions of Bunchy, Ray, and others,[3] while feminist scholarship allows us to continue exploring the delimitations of gender roles in these types of narratives. Hopefully, future seasons will anticipate and promote some of these conversations, which are becoming especially important hermeneutics as shows like *Orange Is the New Black* (Netflix, 2013–ongoing), *The Americans* (FX, 2013–ongoing) and similar series challenge and reshape the genre.∗

REFERENCES

'The Bag or the Bat' (2013), Allen Coulter, dir., *Ray Donovan*, Season 1, Episode 1, 22 June, New York: Showtime.

'Black Cadillac' (2013), John Dahl, dir., *Ray Donovan*, Season 1, Episode 4, 21 July, New York: Showtime.

'Bridget' (2013), Guy Ferland, dir., *Ray Donovan*, Season 1, Episode 8, 18 August, New York: Showtime.

'The Captain' (2014), Michael Uppendahl, dir., *Ray Donovan*, Season 2, Episode 12, 28 September, New York: Showtime.

Connell, R. W. and Messerschmidt, J. (2005), 'Hegemonic Masculinity: Rethinking the Concept', *Gender and Society*, 19: 6, pp. 829–859.

'Fite Nite' (2013), Tucker Gates, dir., *Ray Donovan*, Season 1, Episode 10, 8 September, New York: Showtime.

Freud, S. (1962 [1929]), *Civilization and Its Discontents*, New York: W.W. Norton.

––––– (1989 [1920]), *Beyond the Pleasure Principle* (ed. J. Strachey), New York: Norton.

'Gem and Loan' (2014), Phil Abraham, dir., *Ray Donovan*, Season 2, Episode 3, 27 July, New York: Showtime.

'Irish Spring' (2014), Daniel Attias, dir., *Ray Donovan*, Season 2, Episode 5, 10 August, New York: Showtime.

Kimmel, M. S. (2013), *Angry White Men: American Masculinity at the End of an Era*, New York: Nation Books.

Lotz, A. D. (2014), *Cable Guys: Television and Masculinities in the Twenty-first Century*, New York: NYUP.

Martin, B. (2013), *Difficult Men: Behind the Scenes of a Creative Revolution: From* The Sopranos *and* The Wire *to* Mad Men *and* Breaking Bad, New York: Penguin Books.

'A Mouth is a Mouth' (2013), Allen Coulter, dir., *Ray Donovan*, Season 1, Episode 2, 7 July, New York: Showtime.

'New Birthday' (2013), Lesli Linka Glatter, dir., *Ray Donovan*, Season 1, Episode 7, 11 August, New York: Showtime.

Nussbaum, E. (2013), 'Vice Versa: Good and Bad in *Orange Is the New Black* and *Ray Donovan*', *The New Yorker*, http://www.newyorker.com/magazine/2013/07/08/vice-versa-2. Accessed 5 January 2015.

Ostrow, J. (2013), 'Engrossing Drama *Ray Donovan* Finds Focus Approaching Season Finale', *Denver Post*, http://www.denverpost.com/television/ci_26561707/engrossing-drama-ray-donovan-finds-focus-approaching-season. Accessed 5 January 2015.

Ryan, M. (2013), '*Ray Donovan* Review: Take the Anti-hero Pop Quiz!', *Huffington Post*, http://www.huffingtonpost.com/maureen-ryan/ray-donovan-showtime_b_3505256.html. Accessed 5 January 2015.

Scott, J.-A. (2014), 'Illuminating the Vulnerability of Hegemonic Masculinity through a Performance Analysis of Physically Disabled Men's Personal Narratives', *Disability Studies Quarterly*, 34: 1, p. 10.

Sedgwick, E. F. (1985), *Between Men: English Literature and Male Homosocial Desire*, New York:

Columbia University Press.

Thomas, J. (2013), 'Enough with the TV Antiheroes Already', *Slate*, http://www.slate.com/blogs/browbeat/2013/07/01/the_tv_anti_hero_from_tony_soprano_to_ray_donovan_why_so_many_and_when_will.html. Accessed 5 January 2015.

Tigges, J. (2013), 'TV Review: *Ray Donovan* Is Typical Violent Antihero Dreck', *Columbia's Alive*, http://www.columbusalive.com/content/stories/2014/07/10/tv-review-ray-donovan-is-typical-violent-antihero-dreck.html. Accessed 5 January 2015.

'Twerk' (2013), Greg Yaitanes, dir., *Ray Donovan*, Season 1, Episode 3, 14 July, New York: Showtime.

'Uber Ray' (2014), Michael Uppendahl, dir., *Ray Donovan*, Season 2, Episode 2, 20 July, New York: Showtime.

'Viagra' (2014), John Dahl, dir., *Ray Donovan*, Season 2, Episode 6, 17 August, New York: Showtime.

'Volcheck' (2014), Michael Uppendahl, dir., *Ray Donovan*, Season 2, Episode 10, 14 September, New York: Showtime.

'Yo Soy Capitan' (2014), Tucker Gates, dir., *Ray Donovan*, Season 2, Episode 1, 13 July, New York: Showtime.

GO FURTHER

Television

Ray Donovan (June 2013–ongoing, New York: Showtime).

Sons of Anarchy (September 2008–December 2014, Texas: FX).

Breaking Bad (January 2008–September 2013, New York: AMC).

The Sopranos (January 1999–June 2007, New York: HBO).

Books

Cowlishaw, B. (2015), *Masculinity in* Breaking Bad*: Critical Perspectives*, Jefferson, NC: McFarland.

Watson, E. (2009), *Pimps, Wimps, Studs, Thugs and Gentlemen: Essays on Media Images of Masculinity*, Jefferson, NC: McFarland & Co.

Feasey, R. (2008), *Masculinity and Popular Television*, Edinburgh: EUP.

Cuklanz, L. M. (2000), *Rape on Prime Time: Television, Masculinity, and Sexual Violence*, Philadelphia: University of Pennsylvania Press.

Hatty, S. (2000), *Masculinities, Violence and Culture*, Thousand Oaks, CA: Sage.

Robinson, S. (2000), *Marked Men: White Masculinity in Crisis*, New York: Columbia University Press.

Halberstam, J. (1998), *Female Masculinity*, Durham: Duke University Press.

Butler, J. (1990), *Gender Trouble: Feminism and the Subversion of Identity*, New York: Routledge.

Extracts/Essays/Articles

Franco, J. (2008), '"The More You Look, the Less You Really Know": The Redemption of White Masculinity in Contemporary American and French Cinema', *Cinema Journal*, 47: 2, pp. 29–47.

Schippers, M. (2007), 'Recovering the Feminine Other: Masculinity, Femininity, and Gender Hegemony', *Theory and Society*, 36: 1, pp. 85–102.

Notes

1 Additionally, Season 1 is marked by the anxiety of legacy, specifically male legacy. Ray tells his son that he is the 'last male Donovan', implying an added responsibility and fear about the family line.

2 See *Difficult Men: Behind the Scenes of a Creative Revolution: from* The Sopranos *and* The Wire *to* Mad Men *and* Breaking Bad (Martin 2013).

3 See 'Illuminating the Vulnerability of Hegemonic Masculinity through a Performance Analysis of Physically Disabled Men's Personal Narratives' (Scott 2014).

'You think you're the first person I've dealt with woke up in bed with a dead body?'

RAY DONOVAN

WALTER WHITE AND DEXTER MORGAN
NATIONALITY: AMERICAN / CREATORS: VINCE GILLIGAN AND JAMES MANOS, JR.

Regression vs stagnation
Katherine Robbins

In several interviews *Breaking Bad* (AMC, 2008–13) creator Vince Gilligan talked about the theme of 'change' regarding the character development of Walter White. He postulated how shows are designed to protect the franchise and thus run with an open-ended timeframe that creates stasis in the leading characters (Segal 2011). In a *New York Times* article, 'The Dark Art of "Breaking Bad"', David Segal identifies this stagnation as the Number One rule of a TV series: 'the personality of the main character must stay the same'. Instead of ascribing to this television code, Gilligan wanted to create a series where the main character changes, and so he created Walter. Gilligan wanted an antihero who 'would not only change over the course of the series but also suffer crushing reversals with lasting impact' (quoted in Segal 2011). Gilligan's explanation was a lightbulb moment that explained why characters like Tony Soprano, Donald Draper and Dexter Morgan, who start devilishly hypnotic and sympathetic, became flat, boring, almost caricatures of themselves in later seasons. While the antiheroes of *The Sopranos* (David Chase, HBO, 1999–2007), *Mad Men* (Matthew Weiner, AMC, 2007–15) and *Dexter* (James Manos Jr., Showtime, 2006–13) stagnated, Walt descends, and both he and the audience wrestle with his regression.

This tension between allowing a character to change versus a character stagnating is clearly demonstrated by the successful ending of *Breaking Bad* versus the failed ending of *Dexter*. Both shows ended within a week of each other: *Dexter* on 22 September 2013 and *Breaking Bad* on 29 September. The two shows have a lot in common; both have antiheroes who kill, who wrestle with balancing family and dark sides, and who struggle with an inner polarity. However, while reviews of the ending of *Breaking Bad* featured comments like 'Near-Perfect Finale' (Neumyer 2013) and 'Kills It in Series Finale' (Moorhouse 2013), headlines for the finale of *Dexter* read, 'A Terrible End" (Rys 2013), 'Sloppy Send Off' (Lowry 2013) and 'A Betrayal of the Characters We Knew' (Day-Preston

2013). Surrounding *Dexter*, there was repeated mention of the failure of later seasons as 'unfocused, and at times, sloppy' (Day-Preston 2013). The success of *Breaking Bad* versus the failure of *Dexter* speaks to the narrative arc of the two shows. Television follows the narrative theory assigned to serials but adds an open-ended cycle of stagnation where the character arc repeats every season. *Breaking Bad* broke this cycle by allowing its hero to wrestle with his descent. Conversely, *Dexter* maintained the cycle of keeping Dexter's hero status while also questioning whether that status is warranted. In defending the series finale, the producers of the show argued that the last season and episode is about Dexter finally achieving humanity: 'It's the horrible awareness of what it was to be a human being and how overwhelming that is for him. His punishment is banishment' (Hibberd 2013). Realization is a resolution, whereas banishment is perpetual purgatory, the ultimate stagnation.

Although most television series hold to a cyclical serial format, the potential for regression in the antihero character arc is consistent with narrative-structure theories. The debate between the success of the antihero in *Breaking Bad* versus the failure of *Dexter* helps illustrate the need for a clear character arc used to define either ascent or descent of the principal character. By exploring the archetypal model for antiheroes and the use of the narrative structure of binary opposition, this chapter will explore the model for creating satisfying antiheroes that enthral us with a fully developed regressive arc instead of a circular cycle of stagnation.

While most character arcs for heroes work towards some positive character development, the arc for antiheros is the inverse. In explaining the narrative theories of Vladimir Propp and Tzvetan Todorov, Nick Lacey characterizes the beginning, middle and end of a story as situation, problem and resolution. However, he also describes the sequence as 'thesis, antithesis, and synthesis' (2000: 19). In thinking about the progression of the antihero, this beginning situation and thesis is reversed towards its opposite, only to return with a new sense of wholeness, a synthesis of the thesis and antithesis. Progressing from thesis to synthesis is also a corner theme in Vogler's theory of Hero Quest. In facing the shadow, the hero must address the thing like him or herself, reject it, only to emerge from the conquest as a whole person (Vogler 2007: 65, 69). The sense of opposition also models the theory of binary opposition discussed by Claude Levi-Strauss and Peter Berger (Lacey 2000). For the antihero, the binary opposition is often within the character – 'good self' versus 'bad self' – and there is a move from protagonist to antagonist. The synthesis is either a failure to reconcile thesis and antithesis, or a recognition that the antithesis has taken over and become the 'true' person. The arc is a failure to accept and embrace full redemption and instead replaces a reconciled protagonist self with the stronger antagonist self.

An example of a regressive antihero is Shakespeare's Macbeth, a character heralded for over four hundred years as a classic model of the antihero. Through the course of the play, Macbeth regresses from the hero of King Duncan to a hated, ambitious and

child-murdering antagonist. Once Duncan is killed, the cognitive dissonance slowly changes Macbeth. With cognitive dissonance, there is a disjoint between the act – killing the king – and the belief – it is wrong to kill the king. Since the act is done, what has to change is the belief. Once Macbeth changes this belief and perception of himself, his acts of murder increase in intensity. By the end of the play, Macbeth has regressed to the antagonist and Macduff the victorious hero. The polarity between the two is offered through Malcolm's list of characteristics of a great king with his earlier description of the person and king Macbeth has become. To Malcolm, a good king has 'king-becoming graces, / As justice, verity, temperance, stableness, / Bounty, perseverance, mercy, lowliness, / Devotion, patience, courage, fortitude' (Shakespeare 1997, 4.3.92–95: 2605). Conversely, Macbeth as a king has become 'bloody, luxurious, avaricious, false, deceitful, / Sudden, malicious, smacking of every sin / That has a name' (1997, 4.3.59–61: 2604). Through binary oppositions, the play reminds the audience of what is evil, Macbeth, and what is good, Macduff. Upon first encountering Macduff on the field, Macbeth refuses to fight him. Macbeth gives his reason of 'my soul is too much charged / With blood of thine already' (5.10.5–6: 2615). At this acknowledgement of wrongdoing, there is a glimmer of Macbeth's recognition of his former code and thesis, but that glimmer is quickly diminished as the two start to fight. Macbeth's character arc is a failure of synthesis and failure to see his downward spiral to antithesis. The harmony of Scotland is only restored upon the death and beheading of Macbeth and the ascension of Macduff.

Compared to the successful full arc from protagonist to antagonist in *Macbeth*, Dexter Morgan's journey is one of stagnation. The failure of Dexter's arc comes from a central question of the show: who is Dexter? Is Dexter the protagonist or antagonist? If Dexter is a protagonist, he is capable of synthesis and redemption. If Dexter is the antihero, he will regress as Macbeth does and choose his antithesis as his true self. Although problematic for the ending, the writers built in this binary opposition and tension in order to sell the idea of Dexter to the audience. Unlike binary opposition in *Macbeth* which is used to define Macbeth as a villain, polarities are used in *Dexter* to justify his serial-killer, Dark Passenger lifestyle. In justifying his actions, the show by default reframes Dexter as the protagonist, an unlikely role for a chronic killer. To sell Dexter as a hero, the show had to redefine the term 'good'. Lacey writes about binary opposition that 'we only understand language by using a system of oppositions [...] we cannot conceive of "good" if we do not understand "evil," "black" without "white"' (2000: 47). Harry's code that was instilled in Dexter helps provide a definition of good: killing only those people who are confirmed killers of innocents and who have also escaped being convicted or caught by police. The code creates a binary opposition that allows Dexter to be the 'good guy'. Dexter, though a killer, is the opposite of the people he kills because he has a code and they do not; they kill innocents and he killers.

Because of the tensions created by the binary opposition of Dexter as hero and Dexter as potential antihero, the major theme of the series is Dexter asking, 'who am I?'

The binary opposition of each season furthers Dexter as the hero because he faces an antagonist who is like him, a killer, but yet not like him, redemptive. Vogler writes that 'if a story has done its work, the character has experimented with something unfamiliar, realized that some special quality was lacking, and incorporated some aspects of that quality into his life' (2007: 328). Through the binary oppositions of each season, Dexter incorporates those qualities. Lila, Dexter's Narcotics Anonymous sponsor, tempts Dexter in Season 2 with his need to kill, allowing Dexter to recommit to controlling his urges. In Season 3, Dexter befriends and teaches Miguel Harry's code, but Miguel uses the code for his own political gain. Dexter is reminded again to uphold the code if he wants to avoid being caught. Dexter's vigilante justice with Lumen Pierce, a woman kept captive by five men who repeatedly raped and tortured her, ends Season 5 with the bittersweet reminder that though Lumen can overcome her need for vengeance, Dexter's Dark Passenger lingers. However, the two seasons that wrestle most extensively with the 'who is Dexter' question are Season 1 and Season 4.

Through the face-off in Season 1 with Rudy – Dexter's brother – Dexter is reminded that though he could be a killer, the code and values Harry provided make him a potential hero. While both children experienced the same horrific death of their mother, Dexter was adopted by Harry, who provided Dexter a code as an outlet for Dexter's murderous urges. Rudy had no code and ended up a cold-blooded killer of innocents. Because Rudy is proud of his Dark Passenger, he tempts Dexter to abandon his code. The season even places Dexter's two siblings in binary opposition: Rudy, his biological brother, against Debra, his adopted sister. They represent the two sides of Dexter: Dexter's Dark Passenger and his moral centre. As Rudy tempts Dexter to kill Debra, Dexter has to not just choose between his siblings but choose who he wants to be. Rudy asks Dexter to say who Rudy is. Dexter replies, 'I am a killer, without reason or regret, you're free' ('Born Free' 2006). Although the 'I' is meant to stand for Rudy, as made clear by the 'you're free' and Rudy's response 'You could be that way, too', the 'I' is also meant to reflect a confusion of whether Dexter could be like Rudy, or whether he is as Debra sees him. When Dexter admits that he is confused, Rudy provides an ultimatum: 'You can't be a killer and a hero. It doesn't work that way.' At this point, the show is reminding the viewer of our previously held belief in a protagonist: a hero is not a killer. Yet, in choosing to save Debra, Dexter creates a new definition of hero.

In choosing to be both and choosing between his siblings, the show reinforces Dexter as the hero. Dexter even plays with that fantasy at the end of the season. In a daydream, he imagines that everyone has found out about all of the people Dexter killed and they celebrate what he has done: 'This is what it must feel like to walk in full sunlight, my darkness revealed, my shadow-self embraced. Yeah, they see me. I'm one of them [...] In their darkest dreams' ('Born Free' 2006). In his fantasy, Dexter imagines the integration of both sides into one through the public acceptance of his Dark Passenger as an asset to them.

In Season 4, Dexter wrestles with 'who am I?' in trying to balance his Dark Passenger with learning to be a family man. Dexter comes into contact with Arthur Miller, the Trinity Killer. Like Dexter, Arthur experienced the brutal death of this sister and suicide of his mother. Also like Dexter, Arthur lives a double-life: loving family man and murderer. Ultimately, the balance of Trinity and Arthur Miller is a myth, and Dexter comes to realize the emotional and physical damage on Arthur's family. When Dexter kills Arthur, like Rudy, Arthur asks 'Is this who you are?' ('The Getaway' 2009). In trying to define who he is, Dexter defines himself as Arthur's opposite, rebutting with 'You are a very special kind of monster. You destroyed your own family'. By trying to establish himself as Arthur's opposite, Dexter hopes to spare his own family from the Dark Passenger and hopes for change. Arthur asks Dexter, 'You think you're better than I am?', to which Dexter responds, 'No. But I want to be.' Dexter has to learn to 'control the demon inside' if he wants to protect his family. By defeating the Arthur side of himself, Dexter could avoid negatively affecting his family. After Arthur's death, Dexter recommits to a path of redemption: 'My Dark Passenger has been hogging me all to himself. It's my time now [...] to embrace my family and maybe one day not so long from now I'll be rid of the Dark Passenger' ('The Getaway' 2009). Because of family, Dexter could embrace life and start a journey to synthesis by rejecting his antithesis, his Dark Passenger. However, this redemption is denied Dexter upon coming home and finding Rita murdered in the bathtub by Trinity and his son, Harrison, sitting in her blood. At this moment, Trinity's final words of 'It's already over. It's already over' make sense. In killing Rita, Trinity has taken Dexter's chance at a 'normal' life free of a Dark Passenger. Instead of the potential for a positive character development, he closes the season by saying 'But it doesn't matter what I do, what I choose. I am what's wrong. This is fate' ('The Getaway' 2009).

Because of facing Trinity at the cost of losing Rita, Season 4 is a formative season in establishing the core theme of the last four seasons of *Dexter*: Dexter may never get a chance at humanity or redemption. This argument for Dexter as 'bad' and Dexter as antagonist is marked not just by Rita's death, but by the continual deterioration of Harry's code. Already in Season 4, Dexter breaks the code in trying to kill Arthur himself. Dexter stops Arthur from committing suicide and throws the police off Arthur's trail. Subsequent seasons also have Dexter thwarting the police and hindering investigations in order to kill someone before s/he is caught. However, in Season 7, Dexter breaks Harry's code in two new ways. Instead of killing Hannah McKay, whom he has tied to his kill table, he has sex with her and, eventually, falls in love with her. The bigger violation is the murder of Captain LaGuerta. LaGuerta, a regular character on the show since the first season, is a 'good' character as defined by the show and by Harry's code. However, in Season 7 she suspects that Dexter is the Bay Harbor Butcher. This culminates in Dexter deciding to kill her by faking a crime scene that would suggest that LaGuerta shot a man and then was shot by him. Ultimately, Debra comes in while Dexter is framing LaGuerta and Debra ends up shooting LaGuerta herself to protect Dexter. Although a

crucial moment to wrestle with regression and redemption, having Debra kill LaGuerta keeps Dexter in stagnation and the show ends with the familiar 'who am I?' question:

> we all make rules for ourselves. It's these rules that help define who we are. So when we break those rules we risk losing ourselves and becoming something unknown. Who is Deb now, who am I? Is this a new beginning or the beginning of the end?
>
> ('Surprise, Motherfucker!' 2012)

Although Dexter reflects on Debra breaking her rules, Dexter is the one who is turning his back on the rules of the Code.

Each season finishes with a similar punchline: Dexter is going to figure out who he is, Dexter will never figure out who he is; Dexter can achieve humanity, Dexter will never be human. Through facing and defeating all of the polar opposites, he slowly approached a future of being an integrated, feeling person, only to cycle through the realization that his Dark Passenger has doomed him. While the ending of the show should have provided resolution, Dexter is ultimately denied either redemption or regression. From a narrative viewpoint, *Dexter* had choices. There is redemption: (1) let Dexter run away to South America with his son and Hannah McKay and be rid of his Dark Passenger; (2) confront his new emerging humanity and turn himself in to the police; or (3) commit suicide, another form of facing the knowledge and awareness of his killings. The alternative, a completely regressive arc, would be for Dexter to kill Debra, which showrunner Scott Buck gave as the core idea for the season ending (Hibberd 2013).

Instead, Dexter chooses to drown the body of his sister and protect Hannah and Harrison from himself by faking his death. Oddly, this option was dismissed in Season 4 as being a cheat. When Dexter is killing Trinity, Dexter says, 'what's the alternative, Arthur? Leave? Disappear? Fake my own death and start over again?' to which Arthur responds, 'No. You'll still be you' ('The Getaway' 2009). In this scenario, Dexter fails to embrace antithesis (abandoning the code and becoming the killer Rudy wanted him to be) and he refuses synthesis (finally relinquishing his Dark Passenger and living a 'normal' life). In running away, the show chooses purgatory. Even within the show's own rhetoric, Dexter's self-banishment is offered not as an ending, but as a stagnation, a refusal to acknowledge self, and an inconclusive answer to the 'who am I?' question.

The series finale of Dexter is a failure of the redemptive narrative structure of a hero or the regressive arc of the antihero. Potentially, the problem lies in an ongoing desire to still allow the character of Dexter some dignity and respect from his fans while also figuring out how to best resolve his quest. With Macbeth, there was no need to maintain Macbeth's good name while also sending him down a down spiralling path to destruction. So, how can a character devolve in a downward arc to being a villain while still maintaining the adoration of fans? The answer: Walter White.

Walter White is a modern Macbeth. Walter White's regression from protagonist to antagonist, the roles of external justification and cognitive dissonance at play in that regression, and the failure to synthesize them, are all narrative characteristics that Walter shares with Macbeth. Somewhat of an anomaly in television, Walter's regressive arc is neat and tidy. This is surprising because the nature of TV shows tends to be open-ended. So it is notable when a television series establishes in the very first episode all the relevant themes that will be at the core of every season and at the centre of the finale.

Breaking Bad starts most episodes with a cryptic and startling glimpse at the ending of the episode, then pulls back to show how it got to that point. Our first introduction to Walter White is to his other, who will later be known as Heisenberg. At the episode start, an RV drives frantically down a desert road: trousers are blowing in the air, Walter wears a gas mask, and Jesse is passed out in the passenger seat. Finally, the RV crashes and Walter emerges wearing only his underwear. He speaks into a camcorder:

> To all law enforcement entities, this is not an admission of guilt, I am speaking to my family now. Skyler, you are the love of my life, I hope you know that. Walter Jr., you're my big man. There, there are going to be some things, things you'll come to learn about me in the next few days. I just want you to know no matter how it may look, I only had you in my heart. Goodbye.

> ('Pilot' 2008)

Then he grabs a gun as the sound of sirens come closer and points the gun at the distance. All the major themes of the show are there. Who is Walter White? Is he a criminal or a family man? Did he do it for himself or did he do it for his family? How much violence will he risk to preserve himself? And, most notably, will he ever acknowledge guilt?

The show then cuts to the beginning, which establishes that he is powerless and without self-respect. Walter is in his home, waking up early in the morning. He exercises on a strange small stair-climber of sorts, a symbol of the thwarted ambition of progressing to nowhere. To make that theme stronger, Walter stares at a plaque: 'Walter White: Crystallography Project Leader for Proton Radiography 1985 Contributor to Research Awarded the Nobel Prize' ('Pilot' 2008). Although in 1985 he had lots of potential, now he is sick, teaches unmotivated high school students, has to work at a carwash where he is bossed around by the owner, and has a wife who dictates when he should come home. To top it off, he is eating veggie bacon at his celebratory 50th birthday breakfast, and at his own birthday party the guests are more engaged by Hank, Walter's DEA brother-in-law, than him.

By establishing Walt's powerlessness, the show sets up the appeal of Heisenberg and the power, prominence and wealth of cooking meth. Upon receiving a diagnosis of terminal lung cancer, he decides to cook meth to create a nest egg for his family. When asked by Jesse why he decides to 'break bad', Walt says 'I am awake' ('Pilot' 2008) and he

smiles in a way that suggests he is actually happy for the first time. With entry into the world of being a meth cook, Heisenberg is born. Heisenberg is the authoritative, dominating man that Walter White is not. Like Dexter, Walter White is his own shadow and thus the quest for synthesis is the reconciliation of Heisenberg – the antithesis – with Walter – the thesis.

Breaking Bad introduces the idea of the other in the second episode. Walter lectures a group of high school students on the idea of the *chirality*. He lectures that the word, 'chiral', comes from the Greek word for hand, because hands are mirror images of each other, like each other but opposite: 'Although they may look the same, they don't always behave the same' ('Cat's in the Bag' 2008). As he says that line, he gets an awkward look on his face and loses his train of thought, possibly because of reflecting on his own emerging chiral self. He then continues on to an example of thalidomide, a drug whose 'right-handed' isomer version can treat morning sickness in pregnant women, but whose left-handed version can cause birth defects. By the use of right-handed and left-handed, it plays on the idea of the left as the sinister side, and also plays on the idea of 'active/inactive' and 'good/bad' sides. Thus chirality becomes the show's version of binary opposition and reminds the audience of the potential of both good and bad versions. Walter, inactive, is the opposite of Heisenberg, who is active. In the series, Walt progresses from stealing a barrel of Methylamine to stealing 1,000 gallons from a train car. He goes from struggling to kill one man, Krazy 8, in Season 1, to being able to order the death of nine inmates in Season 5. One of the most famous speeches is when the powerful Heisenberg side slips through Walter White's family-man veneer, and he reveals to his wife how dangerous he has become: 'Who are you talking to right now? Who is it you think you see? [...] I am not in danger, Skyler. I am the danger' ('Cornered' 2011).

The last two episodes of the series bring closure to the themes set up in the first two episodes. While in banishment in New Hampshire, Walt is sick, lonely and beaten down. Seeing his imminent death, Walter sneaks into a town to call his son, Walter Jr., with plans of mailing money to him and Skyler. In the conversation, Walter Jr. reveals that he no longer has any affection or respect for his father by saying that he does not want Walt's money and asking Walter, 'why can't you just die?' ('Granite State' 2013). Walt, seeming to realize that it has all been for nothing, calls the FBI to notify them of where he is. Walt rallies, however, after seeing an interview on TV which questions him and his motives. He escapes the police and conceives a plan of how to get the money to his family. In choosing to recommit to forcing the money on his family, Walter gives up on redemption.

Instead of coming clean as Walter White, he instead chooses Heisenberg. Before confronting Jack Welker, who stole Walt's money and took over his meth business, he first visits Skyler to say it is over and asks for a proper goodbye. When Skyler assumes that 'over' means going to the police, Walter deflects with 'they'll be coming to me', to turn submissively going to the police to willing the police to come to him ('Felina' 2013).

For Walter, 'it's over' means it is over for Heisenberg and he has to resolve the messes surrounding Walt's chiral self. The moment when Walt begins to try and explain his motives, the camera frames the shot with the two divided by a large vertical wooden beam, which creates a visual of the barrier between them. He begins to explain 'All the things that I did, you need to understand' ('Felina' 2013). She then cuts him off, afraid he will once again claim he did it for the family. Considering the use of 'our' money, the need to say goodbye, and the quest to get revenge on Jack, you expect Walt to try and stay true to the theme that was planted in the very first episode when he said into the camcorder, 'I just want you to know no matter how it may look, I only had you in my heart' ('Pilot' 2008). Instead, Walt recognizes the truth of his duality: his true self is Heisenberg. Instead, he says, 'I did it for me. I liked it. I was good at it. And, I was really, I was alive' ('Felina' 2013). The 'alive' is reminiscent of Walt's 'I am awake' response in the first episode. The Walter who was a responsible family man, but who was powerless, became the formidable Heisenberg and discovered who he really was. The scene ends as Walter hides behind a building to watch Walter Jr. walk into the house, and it becomes clear that there is no family forgiveness or redemption for Walter White. As Walter walks away from the scene, he becomes fuzzy behind a window with fogged glass.

Though unsuccessful at redeeming himself with his family, Walter goes to end the story of Heisenberg. In the showdown with Jack's gang, Heisenberg is redeemed. Walt shields Jesse with his own body in order to protect him, an act which costs Walt his own life. Then, when Jack tries to save himself by using the money Jack took from Walt as a bargaining chip, Walt shoots Jack. Walt's life's work, as he has called it, no longer means anything to him. Walt then slides the gun to Jesse who then points it at Walt. Like Macduff's revenge on Macbeth, the appropriate death of the antagonist Walter White would be death by Jesse. But, Jesse refuses to be bossed around by Walt anymore ('Pilot' 2008).

The final ending for Walt is what Gilligan described as being like Gollum finally reunited with 'the precious' (Snierson 2013). Walt walks around the meth lab, inspecting it with pride, before falling dead. Although there is no redemption for Walter White, through the protection of Jesse and through refusing to keep searching for his money, there is redemption for Heisenberg. Heisenberg ends the meth enterprise he helped build, gives all the principal players their comeuppance, and ensures that his legacy and his meth recipe does not go on without him. Heisenberg also ends with knowledge of who he is: proud and powerful, who died on his own terms through a shootout instead of as a victim of cancer. The song at the end, Badfinger's 'Baby Blue', has the first line 'I guess I got what I deserved / Kept you waiting there too long, my love [...] that special love I had for you, my baby blue' (Snierson 2013). In another blurred image of Walt, the camera shows his reflection in one of the pieces of steel equipment. By making meth Walt's tortured object of love, the shows ends with the synthesis of Walt as Heisenberg, which is an embracing of Walt's antithesis chiral self.

While the creators of *Dexter* denied their antihero a clear framing as either hero or antihero, Vince Gilligan allowed Walt a complete regression from hero to antihero. By making him an antihero, the show gives Walter White depth and shows that antiheroes need finite endings. Given that the antihero has found prominence in movies and television in the early twenty-first century, the lessons of Dexter and Walter reveal that being bad, tortured, unlikeable or even a killer is not enough to make a successful antihero. A successful antihero must complete a negative character arc. While Dexter is considered an antihero, the show was confused about whether he is the protagonist or the antagonist, and the failure of the ending was the inability to make that distinction clear. Gilligan showed that antiheroes deserve an ending that is consistent with the arc of their character. By breaking the open-ended rule of television, *Breaking Bad* broke good. ∗

REFERENCES

'Born Free', Michael Cuesta, dir., *Dexter,* Season 1, Episode 12, 17 December, New York: Showtime.

'Cat's in the Bag' (2008), Adam Bernstein, dir., *Breaking Bad*, Season 1, Episode 2, 27 January, New York: AMC.

'Cornered' (2011), Michael Slovis, dir., *Breaking Bad,* Season 4, Episode 6, 24 August, New York: AMC.

Day-Preston, B. (2013), 'Dexter Finale: A Betrayal of the Characters We Knew', *The Guardian*, 20 September, http://www.theguardian.com/tv-and-radio/tvandradioblog/2013/sep/30/dexter-finale-betrayal-characters. Accessed 15 January 2015.

'Felina' (2013), Vince Gilligan, dir., *Breaking Bad*, Season 5, Episode 16, 29 September, New York: AMC.

'The Getaway' (2009), Steve Shill, dir., *Dexter*, Season 4, Episode 12, 13 December, New York: Showtime.

'Granite State' (2013), Peter Gould, dir., *Breaking Bad,* Season 5, Episode 15, 22 September, New York: AMC.

Hibberd, J. (2013), '"Dexter" Producers Explain Finale, Defend Final Season', *Entertainment Weekly*, 23 September, http://insidetv.ew.com/2013/09/23/dexter-interview-series-finale/. Accessed 7 January 2015.

Lacey, N. (2000), 'Chapter One: Introduction to Narrative Theory', *Narrative and Genre: Key Concepts in Media Studies*, [PDF Version], New York: St. Martin's Press.

Lowry, B. (2013), 'TV Review: "Dexter Finale's Sloppy Sendoff', *Variety*, 22 September, http://variety.com/2013/tv/reviews/dexter-series-finale-review-1200655158/. Accessed 7 January 2015.

Moorhouse, D. (2013), '"Breaking Bad" Kills It in Series Finale', *Today Pop Culture*, 29 September, http://www.today.com/popculture/breaking-bad-kills-it-series-finale-8C11293218. Accessed 7 January 2015.

Neumyer, S. (2013), 'Five Revelations from the Near-Perfect "Breaking Bad" Finale', *Rolling Stone*, 30 September, http://www.rollingstone.com/tv/news/lessons-of-the-breaking-bad-series-finale-20130930#ixzz3PO1VUzrU. Accessed 7 January 2015.

'Pilot' (2008), Vince Gilligan, dir., *Breaking Bad*, Season 1, Episode 1, 20 January, New York: AMC.

Rys, R. (2013), '*Dexter* Series Finale Recap: A Terrible End', *The Vulture*, 23 September, http://www.

vulture.com/2013/09/dexter-recap-series-finale.html. Accessed 7 January 2015.

Segal, D. (2011), 'The Dark Art of "Breaking Bad"', *New York Times*, 10 July, http://www.nytimes.com/2011/07/10/magazine/the-dark-art-of-breaking-bad.html?pagewanted=all&_r=0. Accessed 10 January 2015.

Shakespeare, W. (1997), 'Macbeth' in S. Greenblatt (ed.), *The Norton Shakespeare: Based on the Oxford Edition*, S. New York: W. W. Norton Company.

Snierson, D. (2013), '"Breaking Bad": Creator Vince Gilligan Explains Series Finale', *Entertainment Weekly*, 30 September, http://insidetv.ew.com/2013/09/30/breaking-bad-finale-vince-gilligan/. Accessed 7 January 2015.

'Surprise, Motherfucker!' (2012), Steve Shill, dir., *Dexter*, Season 7, Episode 12, 16 December, New York: Showtime.

Vogler, C. (2007), *The Writer's Journey: Mythic Structure for Writers*, 3rd ed., Studio City, CA: Michael Wiese Productions.

GO FURTHER

Books

Vogler, C. (2007), *The Writer's Journey: Mythic Structure for Writers*, 3rd ed., Studio City, CA: Michael Wiese Productions.

Lacey, N. (2000), *Narrative and Genre: Key Concepts in Media Studies*, New York: St. Martin's Press.

Articles

Snierson, D. (2014), 'Vince Gilligan on the "Breaking Bad" Finale, the Abandoned "Wild Bunch" Bloodbath Ending, and the All-time Best Finale', *Entertainment Weekly*, 14 April, http://www.ew.com/article/2014/04/14/vince-gilligan-breaking-bad-finale-better-call-saul.

Hibberd, J. (2013), '"Dexter" Producers Explain Finale, Defend Final Season', *Entertainment Weekly*, 23 September, http://www.ew.com/article/2013/09/23/dexter-interview-series-finale.

Tannenbaum, R. (2013), 'Vince Gilligan: "Walt is Not Darth Vader"', *Rolling Stone*, 25 September, http://www.rollingstone.com/tv/news/vince-gilligan-walt-is-not-darth-vader-20130925.

Dunes, A. (1997), 'Binary Opposition in Myth: The Propp/Lévi-Strauss Debate in Retrospect', *Western Folklore*, vol. 58, no. 1, pp. 39-50.

Television

Better Call Saul (2015, New York: AMC).

Mad Men (2007–15, New York: AMC).

Breaking Bad (2008–13, New York: AMC).

Dexter (2006–13, New York: Showtime).

The Sopranos (1999–2007, New York: HBO).

Online

Podcasts

Gilligan, V. and Dixon, K. (2015), *Better Call Saul Insider Podcast*, https://itunes.apple.com/us/podcast/better-call-saul-insider-podcast/id966297954?mt=2.

----- (2009-2013), *Breaking Bad Insider Podcast*, https://itunes.apple.com/us/podcast/breaking-bad-insider-podcast/id311058181?mt=2.

ALICE MORGAN
NATIONALITY: BRITISH / CREATOR: NEIL CROSS

'Change the state of play':[1] *Luther* and female antiheroes
Sabrina Gilchrist

Recently, shows like *Breaking Bad* (AMC, 2008–13), *Dexter* (Showtime, 2006–13), *Sons of Anarchy* (FX, 2008–14), and others have depicted the antihero paired with an assertive, family-oriented woman as his wife and, putatively, his moral 'better half'. However, when she rejects the role of dutiful, unquestioning, faithful wife (e.g. disagreeing with or critiquing the antihero, defying his authority or seeking a different sexual partner), she has been vilified by a vocal contingent of viewers. In light of the (predominantly male) outcry against the female character's resistance to the conventional, supportive role, a character like Doctor Alice Morgan (played by Ruth Wilson) from BBC's *Luther* (Neil Cross, 2010–ongoing) is an anomaly – a woman who acts in complete opposition to this description but still enjoys most viewers' support. In this chapter, I examine Alice Morgan as an aberration, both in viewer reception and in her position as a woman within the heteronormative antihero narrative. As Alice navigates this new position within the antihero subgenre, I contend that she becomes an antihero(ine) in her own right. This shift destabilizes the structure of the narrative and (as she enjoys a more central role) exposes the limited and restrictive roles that supporting actresses are traditionally given within that narrative.

Alice Morgan is first depicted as a sociopath, a genius and a murderess (she kills her parents, thereby disrupting the traditional nuclear family, a key piece of her resistance), which, I argue, is the beginning of her antiheroine journey – a path that is distinct from the antihero's, the villain's and the heroine's. Like the hero, the antihero story follows a clear trajectory (or cycle as Joseph Campbell illustrates in his heroic journey), and Alice disrupts the female role in this trajectory, creating an alternate (and unregulated) path. In part, it seems as if it is because of her alternate path that her transgressive role did not anger audiences. Additionally, as a beautiful and sexy genius, she appears to take on the role of the femme fatale, whose wiles prompt audiences

to gravitate toward her. Therefore, she connected with audiences to the point where both producers and audiences began discussing an Alice spin-off series or miniseries less than a year after *Luther* first aired. Like the antihero, the audience wanted her to succeed, even when her actions challenged Luther's authority. By considering Alice's actions and characterization, the viewer can more clearly see how the role of women within the antihero narrative expands and challenges previously accepted restrictions, anticipating popular shows like *Orange Is the New Black* (Netflix, 2013–ongoing), *Scandal* (ABC, 2012–ongoing), or *Orphan Black* (BBC America, 2013–ongoing) by providing a narrative-liberation from the typical masculine storyline.

Luther is a crime-drama television series that features DCI John Luther (played by Idris Elba) as he attempts to get into the minds of murderers as a means of apprehending them. Luther is the typical brooding, morally ambiguous and conflicted antihero. Each episode features a new murderer (usually a serial killer) who is eventually caught by Luther in the end, oftentimes with the help of Alice Morgan and his partner, Justin Ripley. The audience watches the murderer commit the crime and then traces both the path of the killer and Luther's investigation as he gets closer to apprehending the criminal. The exception to this is the first episode where the audience meets Alice (who then becomes a fixture of the show, appearing in nine out of the fourteen aired episodes). Unlike the other murderers, the audience does not initially see Alice commit the crime; however, the viewer is able to trace her steps as she investigates Luther. Even in this first interaction, Alice demonstrates the power she holds throughout the rest of the series – her episode remains unique in that the audience follows her path rather than Luther's – illustrating her power over the narrative, over Luther and over the audience.

Several scholars have discussed the supporting female role in contemporary televised antihero stories; however, most focus solely on the role of 'wife' instead of certain supporting female leads that are positioned in alternative and marginal roles in order to resist socially accepted norms of archetypal female characters. In other words, these scholars are focusing on the women who challenge the patriarchal system from within it (resisting certain accepted norms of female behaviour), but only those that are still judged by the system they are resisting and incapable of escaping.[2] For example, in 'Taking Control: Male Angst and the Re-Emergence of Hegemonic Masculinity in *Breaking Bad*', Faucette (2014) explains that Skyler's 'statement [about not letting the boss "screw" him on his hours] shows concern for the family but also indicates that in effect Skyler is the person who is in charge in the home' (77). While Faucette describes Skyler as taking on a more 'masculine' role, her power is still restricted to the home, keeping her contained within the feminine sphere. It should be noted that Faucette's article was focusing primarily on Walter White's reclamation of his masculinity; nevertheless, even this premise positions Skyler as an obstacle to achieving masculinity or a means to assert masculinity through the domination of her. This, I would argue, is central to why audience members dislike Skyler: she attempts to challenge the woman's role within

the patriarchal system while still being viewed (by the audience) through a patriarchal lens and the gendered binaries it establishes. Alice, on the other hand, seems capable of escaping the patriarchal image of the feminine ideal through her liminality. Alice plays contrasting roles throughout the series, keeping her from being categorized as one specific role, thereby preventing audiences from assigning her corresponding (and restrictive) characteristics.

Few scholars have addressed Alice Morgan, but the little scholarship that does mention her focuses primarily on her relationship to Luther, as can be seen in Newman's *Nightmare Movies: Horror on Screen Since the 1960s*, where Alice is described as a 'stalker, admirer, tempter and nemesis' (2011: 322). Although these adjectives are strictly relational, it begins to point to how Alice is an enigma: she becomes a 'tempter' (note the masculine form of the word) and a 'nemesis' (she is a love interest, yet also an enemy), a 'stalker' and an 'admirer' (she is an unwanted and unseen prowler, but also a desirable fan or lover). Furthermore, these adjectives, like Alice, convey a sexually charged relationship between Luther and Alice; however, Alice and Luther never have a physically romantic relationship. Alice repeatedly escapes categorization, and, therefore, escapes the patriarchal system that relies upon categorization, allowing her to defy the narrative structure that privileges the 'male perspective over a female one' (Johnson, cited in Donnelly 2014: 149).

Unlike many other lead female roles in antihero narratives,[3] Alice Morgan does not reinforce the traditional female role or the nuclear family by being a wife and mother;[4] she kills it (literally) when she murders her parents in the first episode and when she mentions killing her husband in the third season ('Episode 3.4' 2013). However, the first time the audience meets Alice in 'Episode 1' she appears to be the epitome of conventional femininity: small (in a seated fetal position when the police arrive), beautiful, helpless and fragile. Alice's parents have been murdered. Shaken and crying, she calls the police for help: 'Police. Please, please. It's my mum. Hurry, it's my mum... Oh. Oh, God! Oh, I think my mum and dad are dead! Oh, God. Please, please, please, please' ('Episode 1.1' 2010). Alice stammers, stutters, shakes and sobs – she plays the role of the helpless female victim in need of rescuing. Later, when Luther realizes Alice is the murderer, DSU Rose Teller (the chief and Luther's boss) refuses to believe Luther's accusation, 'No, she doesn't look the type', and later, 'Right now – she's a little girl lost. We've got no real motive' ('Episode 1.1' 2010). Alice, with her pale skin, doe eyes, pouty lips and small frame, 'doesn't look the type' because she looks almost childlike. Teller voices the expected norm – Alice is a scared, submissive 'little girl'. Alice appears to uphold the traditional feminine ideal at the start of this episode, but, in actuality, she uses this ideal to disrupt both audience expectation and the prescribed norm for the female role within the antihero narrative. Alice utilizes the male gaze as a means to her own end: troubling and reconfiguring the gaze to destroy her nuclear family and the role she plays in it.

The previous example illustrates a more significant point about Alice's liminality

that allows her the space to shift from one role to the next, resisting the categories conventionally enforced on women in the antihero narrative. Alice is creating her enigmatic status – she is both victim because her parents were murdered, and villain because she murdered them; both in control because she can plan the perfect crime, yet out of control because she is a narcissistic sociopath; both guilty because she commits murder, yet innocent because no one can prove her guilt. It is through this indeterminacy that she gains power: Luther is not able fully to understand her, what motivates her or what she will do next. This is confirmed by Luther himself when he says to Alice, 'I don't know what that means coming from your mouth [...] Why do you do this? I don't understand. I'm – I'm lost' ('Episode 1.2' 2010). The typical markers Luther uses to interpret people (their roles, their language, their expressions, etc.) are not intelligible for Luther when he attempts to read Alice – she is outside categorization, outside Luther's realm of understanding. And when Alice answers his questions with 'Because we are friends', Luther responds, 'We're not friends. I don't know what we are, but we're not friends' ('Episode 1.2' 2010). Luther does not understand her, and, therefore, he cannot determine how she relates to himself. Luther, in this way, appears to represent the heteronormative, traditional lens: incapable of understanding what falls outside of its constructs and predetermined categories. If the audience is expected to view characters and events through the eyes of Luther, it prevents the audience from being able to categorize Alice as well. Alice, without a label or category, and unlike the archetypal female television characters, is able to shift smoothly from one role to the next (e.g. love interest to villain to consultant to partner, etc.), embodying a variety of characteristics namely because she is not assigned a certain set of qualities based on one prescribed role. As Ruth Wilson explains in an interview, 'She's [Alice is] a child, a clown, nasty, psycho – you can play anything you want and get away with it. I quite like that she's completely free' (Martin 2013).

Before considering viewer reception, it is necessary to first establish that Alice acts in a similar way to the often hated 'wife' characters in the antihero narrative when she challenges Luther's power and authority. Alice often openly defies Luther, doing what she wants to do – sometimes to help Luther, sometimes to hurt him. For example, in Season 1, Episode 4, Luther is under surveillance (and at risk of losing his position as detective) because the police are worried he will execute Henry Madsen, a child-murderer he was suspected of attempting to kill. The surveillance combined with Alice's own role as suspected murderer prompts Luther to tell Alice, 'I can't see you anymore. I can't talk to you [...] I can't do this anymore. Not while this thing is hanging over my head. It's over' ('Episode 1.4' 2010). Alice, growing increasingly agitated, repeats 'no', to which Luther quietly responds 'yes'. As he walks away, her final 'no' echoes throughout the room as the scene closes. Luther seems in control as he walks away, establishing his authority over Alice. She is expected to listen and follow directions as he asserts his masculine dominance, clearly gesturing to the role of the dutiful female lead. However,

this power dynamic almost immediately shifts when Alice kills Henry Madsen and then calls Luther. She openly defies Luther by phoning him (and murdering Henry Madsen), in addition to manipulating his life to demonstrate her power over him: '[I have g]iven you back your wife, saved your job, saved you from disgrace and imprisonment [...] I WOULD APPRECIATE SOME GRATITUDE!' ('Episode 1.4' 2010). Alice is demonstrating her power, but also acknowledging her own subjectivity (when she says she *gave* Luther his wife) and subordinating Luther as inferior, as the object. Luther, in a fit of rage, throws materials off of a desk and kicks the wall, becoming a conflicting image of both masculinity (through a demonstration of strength and force) and a petulant child (throwing a temper tantrum). He realizes he is not in the dominant position of power and begins screaming into the phone: 'I want you to stay away! Do you understand?! Stay away from me! Stay away from my life! Stay a-fucking-way! Do you hear me?!' ('Episode 1.4' 2010). And so, after this desperate attempt to reclaim his power, Alice takes away what she has given to him, what means the most to him: Alice prompts Zoe to leave Luther and return to her boyfriend, Mark.

Throughout the series, Alice demonstrates her power to manipulate John's life; she changes his story to fit her will. Despite his best attempts to maintain control of his life, Alice is able to control it effortlessly. When it suits her, she gets in the way of what Luther wants because she likes and 'want[s] to toy with John', which she describes as 'a bit like pulling legs off flies' ('Episode 1.3' 2010). Alice sees herself as more powerful, more important and smarter than John (who is merely a fly or a toy), able to use him as a means for her own entertainment without fear of any consequences (undoubtedly a demonstration of domination). Alice recognizes her own power and subjectivity, but needs Luther to recognize (and acknowledge) her dominance, prompting her to ask, 'Are you afraid of me?' ('Episode 1.1' 2010), and later, 'Are you still frightened of me?' ('Episode 1.2' 2010). Both times, Luther responds with a simple, 'Yes', because Alice is in control. Luther feels rage and frustration – the same rage and frustration that the audience typically feels toward the lead female if she obstructs the antihero's path to his goals or desires, or if the female lead emasculates the antihero. However, the audience is not prompted to feel this way about Alice (unlike many other female leads in antihero narratives) because Alice is framed as the antihero(ine), and the audience wants her to succeed.

To better understand the implications of Alice's status as an antihero, it is important to understand the relationship between the audience and the antihero. Through various narrative techniques employed by the director, the audience *typically* aligns themselves with the antihero, opposing those who stand in the way of the male protagonist. This reception theory has been addressed often, especially in terms of *Breaking Bad*'s Skyler White, and at length by Donnelly (2014), who explains that

for fans of Walter White, Skyler becomes 'a bitch' early on, a victim of the writing of a very masculine show focused on a male anti-hero. The presence of anti-Skyler White commentary from fans has led to something now referred to [...] as 'The Skyler White Effect' [...]: 'a female character judges the male protagonist's bad behavior in a completely rational way, and the audience hates her for it.' In Alyssa Rosenberg's July 16, 2012, *Slate* post, she describes Skyler as 'one of many TV wives who fans turn on rather than visiting moral judgment on the anti-hero men themselves'.

(Donnelly 2014: 147–48)

'The Skyler White Effect' can be applied to many of the lead women's roles in antihero television series featuring a male protagonist (as Donnelly discusses). Contemporary viewers seem to align themselves with the antihero because they can identify with feeling powerless and desperate; therefore, the show can become their outlet for those desires. When Skyler (or other female leads like Skyler) step(s) in as the voice of reason, the audience is not prepared to hear it. The audience actively resists listening to the voice of reason, vilifying her instead of the protagonist. However, this vilification of the female lead extends beyond the fictional world Donnelly focuses on in her book. The fans do not only hate Skyler; they begin to confuse fiction and reality, lashing out at the actress (not just the character), through derogatory and/or condemning message board posts, memes, GIFs, Facebook pages, hate mail, and more.[5]

Alice, on the other hand, appears to be adored by *Luther* viewers. Popular websites that feature articles with titles like, 'Forget about Luther, What We Care about is Alice' explain how she 'provides the show with its most visceral kicks' (Lacob 2013). Fans have created memes, GIFs, Facebook pages, artwork, websites, blog posts, etc., many of which recall their favourite lines and moments from an episode, illustrating their fascination with and attraction to this character. The audience craves Alice, which is undoubtedly one of the reasons why Neil Cross referenced the potential for an Alice spin-off series in his *Variety* interview less than one year after the first season finished airing (Weisman 2012; Shady 2012). However, if Alice is relational (as previously mentioned in regard to Newman's description: 'stalker, admirer, tempter and nemesis'), this invites audiences to investigate how it is possible to imagine Alice as a protagonist.

Alice does not fit within the traditional antihero narrative as the female lead, so her appearance in the show becomes less frequent, and her primary motivation is convincing Luther to leave – pulling him (at the conclusion of Season 3) into her narrative rather than remaining in his own. Although Alice's smaller role in later seasons can be attributed to scheduling conflicts (Weisman 2012), Wilson explains that 'It wasn't even guaranteed that [Alice] was gonna be doing this third series. [Wilson] wanted to. Neil [Cross, series creator] wasn't sure exactly how to bring her in' (Martin 2013). And in the fourth season, Alice is not scheduled to appear at all. The reason Cross 'wasn't sure [...]

how to bring her in', I would argue, is that Alice could no longer be limited to the arche-typal female role that could fit within the *Luther* antihero narrative. Alice plays a much different role in the second and third seasons of *Luther* – she is difficult to categorize, to describe, to contain. Throughout the first season, Alice is somewhat familiar: the brilliant, sociopathic murderess. Some compare her to Hannibal Lecter or Dexter Morgan; Neil Cross compares her to Tom Ripley, though admits that 'she spiraled out of control into a much more exotic creature' (Truitt 2013). In other words, although Alice began as a typical (male) trope, her character began to change into the unfamiliar. Ruth Wilson captures something similar as she searches for a way to describe Alice in relation to Luther saying, Luther and Alice 'are a good team, but like Batman and Robin or Batman and Catwoman [...] Alice is like Catwoman, and the Joker' (Martin 2013). Truitt reiter-ates this comparison, seeing Alice as 'a redheaded hybrid of the Joker and Catwoman' (2013). Wilson's and Truitt's analogy to Alice as a fusion of Catwoman and the Joker is reflective of that change into the unfamiliar – a kind of female chaos – which amalgam-ates sanity and insanity, feminine and masculine, stealthy and brazen. Once again, Alice's enigmatic role becomes more apparent, shifting from hero to villain, from sidekick to nemesis, a fusion of multiple characters rather than a more direct analogy. The rea-son she is difficult to define is primarily because she is unique to the antihero narrative, yet she is limited to comparisons of characters from traditional patriarchal narratives.

Alice diverges from the masculine storyline, Luther's storyline, to create an alter-nate narrative because she is an antiheroine – neither a hero nor villain. If Alice were a hero, villain, or damsel in distress, she could fit within the traditional (masculine) an-tihero narrative as a female lead. For example, as a hero, she could easily be configured as a sidekick; as a villain, she would act solely as Luther's nemesis. Instead, Alice begins creating her own plotline alongside Luther's, where sometimes the narratives overlap and other times they do not; she becomes the protagonist of her own storyline. This is especially obvious during the third season, in which the audience watches Luther as he looks at exotic postcards from Alice and smiles ('Episode 3.1' 2013). Ruth Wilson discusses this particular scene and the postcards that regularly ask Luther, 'Why don't you join me?' Wilson suggests this proposal insinuates that Alice and Luther 'are equals [...] are similar beings' and suggests that Luther 'join [Alice's] fun world' (BBC 2013). Wil-son's observations are significant, not just to understand the motivations behind Alice's character, but to understand how the character is functioning within the larger narra-tive. Alice's postcards create their own storyline, an alternative one that exists outside of the masculine antihero narrative. The postcards (from various places around the world) allow Alice's narrative to come in broken pieces, jumping in and out of time and space – disrupting the more linear patriarchal storytelling. Furthermore, the dialogue of that storyline consistently asks, 'Why don't you join me?' which acts as a means to pull the masculine antihero protagonist out of his own narrative and into Alice's – one where she would act as the antihero and Luther would play the supporting role. Luther's far

away look as he glances at Alice's postcards seems to confirm that Alice is, in part, succeeding. Luther is mentally leaving his own narrative to daydream about Alice's, once again disrupting the linear storyline.

Having established the atypical relationship with the protagonist and the uniqueness of her position within the antihero narrative, we can consider the ramifications of Alice as an antiheroine, how that impacts the antiheroine trope, the antihero narrative, and the potential opportunity it provides for future female characters. To understand these effects, it is necessary to look at how an antihero compares to a hero. For a male antihero, especially one in contemporary television, the quest often centres on a pursuit of power, a reclamation of masculinity, and/or a desire to fix or maintain the traditional family unit (with the patriarchal head). Therefore, the male antihero often displays some common characteristics: violence, virility, excessive protectiveness of his children/family, and the willingness to bend or break the law to achieve his own ends. This stands in stark opposition to the familiar hero, who upholds the law as sacrosanct, attempts to avoid unnecessary violence, and appears to protect all of humanity equally (not solely his family or self).[6] Based on this polarized relationship, a female antihero would need to be the opposite of the model female hero, who is frequently depicted as beautiful, strong, faithful to her spouse (or chaste if she does not have a spouse), kind and maternal. However, the opposite of these characteristics tends to signal a female villain, not an antihero. Therefore, the female antihero becomes a marginal character without predetermined characteristics and plotlines – displaying both feminine and masculine characteristics of heroes, villains and antiheroes – once again escaping the masculine system of binary categorization and the masculine narrative. Alice murders her nuclear family and mutilates the family dog, demonstrating a capacity for violence and rejecting the maternal characteristic ('Episode 1.1' 2010); she is narcissistic, which allows her to privilege her own desires and goals; she regularly calls on her own sexuality and sensuality to tempt, but also to cloak her own power; Alice works to prove to the police that Luther is innocent of crimes on multiple occasions which is often the role of the hero ('Episode 1.6' 2010; 'Episode 2.1' 2011; 'Episode 3.4' 2013); she protects a damsel in distress which (again) is often associated with a hero ('Episode 3.4' 2013); and she prevents Luther from spiralling into an inescapable depression ('Episode 3.4' 2013 and Episode 2.1' 2011). What I am attempting to illustrate with these examples is that the antiheroine is not limited to one set of characteristics (i.e. masculine, feminine, hero, villain or antihero) or one predictable storyline – she is free. She can choose to have an end goal or not, to break the rules or enforce them. In other words, her indefinableness allows her to remain fluid, unclassifiable and unpredictable.

Luther's Alice disrupts the traditional antihero narrative and its trajectory and instead moves toward a distinct female antiheroine. Because Alice is creating and controlling her own narrative, she becomes difficult to define in terms of narratology (since narratology is grounded in the masculine narrative). She accomplishes this erasure, in

part, by teasing the other characters of *Luther* and the *Luther* audience, saying she is one thing (e.g. a victim, a lover, a friend), but never completely fulfilling any one role on-screen; her character and storyline are always left unresolved. Therefore, Alice's character resists being codified because she remains enigmatic in terms of the main narrative thread. Alice adopts a conventionally male habitus – she exerts agency, has control, manipulates others and the storyline – but through it all, she remains distinctly feminine. Her blunt sexuality allows her access to the male gaze, not to escape it, but to code it differently (once again making her both distinctly feminine – the object of the male gaze – and masculine in her manipulation of it). Season 3 (the originally planned series finale) does not end with John Luther's destruction or reintegration into a traditional nuclear family; instead, Luther decides to follow Alice: in short, he exits his own narrative. Alice, through her liminality, reconfigures the masculine antihero narrative, rewriting the role of the female supporting actress to create an antiheroine protagonist, anticipating the need for a distinctly female narrative that could offer new roles for women in television. *

REFERENCES

BBC (2013), 'Ruth Wilson Talks Alice – *Luther: Series 3* – BBC One' [YouTube], 20 July, http://www.youtube.com/watch?v=TPHAyO18x_o. Accessed 22 January 2015.

Campbell, J. (2008), *The Hero with a Thousand Faces*, 3rd edn, Novato: New World Library.

Donnelly, A. (2014), *Renegade Hero or Faux Rogue: The Secret Traditionalism of Television Bad Boys*, Jefferson: McFarland & Company, Inc.

'Episode 1.1' (2010), Brian Kirk, dir., *Luther*, Season 1, Episode 1, 4 May, London: BBC.

'Episode 1.2' (2010), Brian Kirk, dir., *Luther*, Season 1, Episode 2, 11 May, London: BBC.

'Episode 1.3' (2010), Sam Miller, dir., *Luther*, Season 1, Episode 3, 18 May, London: BBC.

'Episode 1.4' (2010), Sam Miller, dir., *Luther*, Season 1, Episode 4, 25 May, London: BBC.

'Episode 1.5' (2010), Stefan Schwartz, dir., *Luther*, Season 1, Episode 5, 1 June, London: BBC.

'Episode 1.6' (2010), Stefan Schwartz, dir., *Luther*, Season 1, Episode 6, 8 June, London: BBC.

'Episode 2.1' (2011), Sam Miller, dir., *Luther*, Season 2, Episode 1, 14 June, London: BBC.

'Episode 2.2' (2011), Sam Miller, dir., *Luther*, Season 2, Episode 2, 21 June, London: BBC.

'Episode 3.1' (2013), Sam Miller, dir., *Luther*, Season 3, Episode 1, 2 July, London: BBC.

'Episode 3.4' (2013), Farren Blackburn, dir., *Luther*, Season 3, Episode 4, 23 July, London: BBC.

Faucette, B. (2014), 'Taking Control: Male Angst and the Re-emergence of Hegemonic Masculinity in *Breaking Bad*', in David Pierson (ed.), Breaking Bad: *Critical Essays on the Contexts, Politics, Style, and Reception of the Television Series*, Lanham: Lexington Books, pp. 73–86.

Gunn, A. (2013), 'I Have a Character Issue', *New York Times*, 23 August, p. 21a.

Lacob, J. (2013), 'Forget About Luther, What We Care about is Alice', *BuzzFeed*, http://www.buzzfeed.com/jacelacob/forget-about-luther-what-we-care-about-is-alice#.idedOK3gL. Accessed 19 January 2015.

Martin, D. (2013), '*Luther*'s Ruth Wilson on playing Alice Morgan and Showtime's *The Affair*', *Vulture*,

http://www.vulture.com/2013/09/luther-ruth-wilson-interview.html. Accessed 23 December 2014.

Newman, K. (2011), *Nightmare Movies: Horror On Screen Since the 1960's*, 2nd edn, London: Bloomsbury Publishing, pp. 297–332.

Shady, J. (2012), 'Dark and Stormy *Luther* Presses on Ruth-lessly', *Variety*, http://variety.com/2012/tv/news/dark-and-stormy-luther-presses-on-ruth-lessly-1118057783/. Accessed 19 January 2015.

Truitt, B. (2013), 'Ruth Wilson Makes *Luther* Character a Seductive Psycho', *USA Today*, http://www.usatoday.com/story/life/tv/2013/09/06/ruth-wilson-idris-elba-luther-tv-series/2774783/. Accessed 23 December 2014.

Weisman, J. (2012), 'Exclusive: *Luther* Creator Eyes Alice Spinoff', *Variety*, http://variety.com/2012/film/awards/luther-creator-eyes-alice-spinoff-35016/. Accessed 19 January 2015.

GO FURTHER

Novels

Cross, N. (2013), *Luther: The Calling*, New York: Touchstone.

Extracts/Essays/Articles

Donnelly, A. (2014), 'The Woman and the Faux Rogue', *Renegade Hero or Faux Rogue: The Secret Traditionalism of Television Bad Boys*, Jefferson: McFarland & Company, Inc., pp. 125–56.

Morrell, J. (2008), 'Bitches: Dangerous Women', *Bullies, Bastards and Bitches: How to Write the Bad Guys of Fiction*, Cincinatti, OH: Writer's Digest Books, pp. 215–42.

Television

Orange Is the New Black (July 2013–ongoing, California: Netflix).

Orphan Black (March 2013–ongoing, Canada: BBC America).

Scandal (April 2012–ongoing, New York: ABC).

Luther (May 2010–ongoing, London: BBC).

Online

Wicks, K. (2015), 'First Look: Idris Elba on Set of *Luther* Two-Part Special; Rose Leslie among Cast', *BBC America.com*, 3 March, http://www.bbcamerica.com/anglophenia/2015/03/first-look-idris-elba-set-luther-two-part-special-rose-leslie-among-cast/.

Slezak, M. (2014), 'BBC American Slates *Luther* Season 4', *TVLine*, http://tvline.com/2014/11/19/luther-season-4-bbc-america-idris-elba-2015-return/.

Truitt, B. (2013), 'Ruth Wilson Makes *Luther* Character a Seductive Psycho', *USA Today*, http://www.usatoday.com/story/life/tv/2013/09/06/ruth-wilson-idris-elba-luther-tv-series/2774783/.

BBC America (2010), '*Luther* – Ep1 Extended Inside Look' [YouTube], https://www.youtube.com/watch?v=qyxIcBasiJM.

Website

BBC America | Luther, http://www.bbcamerica.com/luther/

Notes

1 ('Episode 1.3' 2010).

2 Skyler (*Breaking Bad*), Tara (*Sons of Anarchy*) and Rita (*Dexter*), for example, are challenging the 'ideal wife' image by resisting the idea that women are docile, submissive, obedient, faithful, etc.; however, they are vilified by the audience who view them through the patriarchal lens, vilifying them because they are not portraying the traditional supportive wife. Alice, on the other hand, seems to escape this patriarchal lens because, while she exhibits some of the same characteristics as Skyler, Tara and Rita, she is beloved by audiences.

3 It should be noted that Luther does have a wife (Zoe Luther), and some may argue that Zoe should be considered for this paradigm rather than Alice. However, Zoe and Luther are separated and have no children. Furthermore, Alice comes to play more of a central role than Zoe. This is in part because Zoe is murdered in the first season; however, even before this event, Alice interacts more frequently with Luther (and has more screen time) than Zoe.

4 This trope can be seen in several of the previously mentioned antihero television series: *Breaking Bad*, *Dexter*, *Sons of Anarchy*, *Mad Men* (AMC, 2007–15), etc.

5 I find this to be a significant point in that it illustrates how the rules or expectations of women within fiction can then influence viewers, prompting them to carry those expectations out of the fictitious world and into reality. Anna Gunn submitted an article to the *New York Times* Opinion Page entitled 'I have a Character Issue' (2013), in which she discusses the 'vitriolic response' to Skyler White. She questions the rationale, wondering if 'they despise her because she won't back down or give up [...] [o]r [if it is] because she is, in fact, Walter's equal'. Gunn makes an interesting observation that their reaction was prompted by how they view and categorize 'women and wives' and that 'Skyler didn't conform to a comfortable ideal of the archetypical female, she had become [...] a measure of our attitudes toward gender' (Gunn 2013). Gunn observes similar negative comments and threats toward other female supporting actresses from *The Sopranos* (HBO, 1999–2007) and *Mad Men*.

6 These characteristics can be seen in familiar characters like Superman, Wonder Woman, Captain America, etc.

'Some little girls grow up wanting ponies. I always wanted to be a widow.'

ALICE MORGAN

SARAH LINDEN
NATIONALITY: AMERICAN / CREATOR: VEENA SUD

The Killing and the exemplary anomaly of the female antihero
Joseph Walderzak

In the finale of the third season of *The Killing* (Veena Sud, AMC, 2011–13, Netflix, 2014; based on Danish TV series *Forbrydelsen* [Søren Sveistrup, DR1, 2007–12]), Detective Sarah Linden (Mireille Enos) holds Lieutenant Skinner (Elias Koteas) at gun point after having uncovered his identity as the 'Pied Piper' serial killer. Having already fired one shot into Skinner's abdomen after his false confession of murdering another child, Linden's partner Stephen Holder (Joel Kinnaman) arrives and attempts to coax Linden to lower her gun. Despite Holder's efforts, Linden fires a fatal shot at the unarmed and capitulating Skinner. Over the last decade on cable television, the sight of a cop taking justice into their own hands has become nearly quotidian. Even more, the viewer's expectations of a noble and magnanimous protagonist has waned in favour of morally compromised, often murderous, protagonists who have been broadly identified as antiheroes. However, Detective Linden's gender definitively challenges and exposes the rigidity of antihero representation. Complicated and flawed female protagonists had begun to proliferate cable television prior the premiere of *The Killing* (*Weeds* [Showtime, 2005–12], *Damages* [FX, 2007–10, Audience Network, 2011–12], *True Blood* [HBO, 2008–14], *Sex and the City* [HBO, 1998–2004]) but never had the moral ambiguity so closely matched what had begun to become customary in male protagonists within the genre. Moreover, Sarah Linden strikingly juxtaposed the comparable moral clarity of female protagonists in network crime procedurals (*Law and Order* franchise [NBC, 1990–ongoing], *CSI* franchise [CBS, 2000–ongoing], *Cold Case* [CBS, 2003–10]). Her actions in the finale of the third season affirmed her position as an antihero, but her behaviour throughout the three-dozen episodes leading up to that season's denouement had subtly entrenched her as an impactful anomaly amidst a wealth of crime-genre antiheroes on television. The exceptional anomaly of the female antihero on cable television possesses far more than just novelty value. I argue that the female antihero

is more fully illustrative of the ideology of the antihero, one of the most pervasive and important figures on twenty-first-century television. Ultimately, the female antihero of *The Killing* allows for a more profound understanding of what Lotz (2014: 57) describes as the 'submerged sentiments about gender scripts that lurk beneath the surface of largely reconstructed masculinities'. *The Killing*'s Sarah Linden clarifies the antihero's discourse on masculinity by demonstrating the shared plight of ambiguously fluctuating gender scripts.

The prominence of the antihero in contemporary culture has been a site of fascination for those both inside and outside the academy. Works wholly dedicated to the antihero have been produced solely by media journalists. Sepinwall (2012: 143) devotes a chapter to a number of the most seminal antihero narratives on contemporary television, but he only goes as far as to conclude that the classically sympathetic protagonist has been rendered to a state where he can be viewed as a hero, a monster, or anything between. Martin's (2013) work on the topic advances the conversation yet remains predominantly descriptive. Martin (2013: 4–5) outlines the antihero as 'unhappy, morally compromised, complicated, deeply human' and 'badgered and bothered and thwarted by the modern world'. Elsewhere, Martin (2013: 87) attempts to transcend the merely descriptive by arguing the antihero as political polemic, the newly empowered right of the early twenty-first-century effectively shaping and commenting upon the discourse on masculinity. Throughout the work, Martin recognizes when plotlines and season arcs serve as allegories to real-world events but, shockingly, he jettisons meaningfully engaging with the antihero phenomenon in favour of predominantly recounting its recent historical development. This dynamic of lamenting the antihero's ubiquity or the tracing of its history overshadowing any investigation of its ideological ramifications litters commentary on television, from the pages of *Entertainment Weekly* to the *New Yorker*. The common refrain of exhaustion with the antihero is certainly compounded by the fact the most exceptional television programmes of the last twenty years are considered to incorporate an antihero protagonist; replication is made to seem overtly derivative when compared with a medium's finest products. Its status of being the target of parody and pastiche, such as the *The Good Wife*'s (CBS, 2009–ongoing) petty send-up 'Darkness at Noon' presumably targeting *Low Winter Sun* (AMC, 2013), degrades its implications and deflects genuine critical intrigue. Amidst the problematic disposition of antihero exhaustion, one has to ask if the urgency of the ideological implications of the antihero coincide with the collective feelings of narrative exhaustion.

Fortunately, scholars such as Lotz have meaningfully engaged with the ideological ramifications of the antihero. Understanding the antihero as representative of a contemporary crisis of masculinity, Lotz (2014) examines the work on masculinity in order to analyse twenty-first-century cable programming. Importantly, much of the work on masculinity has fixated on how male gender scripts are shifting. Ehrenreich (1983) describes a 'male revolt' against a system which bound male value to their work. Kimbrell

(1995: xiii) advances Ehrenreich's work claiming American men no longer know their role and are locked into stereotypes and responsibilities. Kimbrell describes a culture of 'masculine mystique' or a 'male vertigo' in which no one knows what it means to be a man, faced with the dilemma of dividing time between family and careers. Kimmel (1996: 213) adopts the language of 'mystique', interpreting it as a critique of the self-made man or the chasm between new liberal values and the expectations of traditional masculinity. Other scholars (Rosin 2012; Garcia 2008) have devoted their attention to the struggles of contemporary men (health, educations, career growth) in contrast with the gains of women. These works problematically exaggerate the male plight, conflating a link with feminine ambivalence to enduring equivalent tribulations. Essential to this chapter, nearly all the theories on masculinity position themselves as responses to feminist theories: the 'male revolt' and the second-wave feminist movement and, quite patently, the masculine mystique to Friedan's 'feminine mystique'. In sum, the scholarship describes a crisis in masculinity of which the contemporary television antihero, although ignored even by recent publications on masculinity, articulates the dilemma of the contemporary man often attempting to retreat into traditional masculinity. Lotz's work on the subject of masculinity and television successfully navigates this provocative terrain.

This chapter is unapologetically indebted to Lotz's work on masculinity and television in her *Cable Guys: Television and Masculinities in the 21st Century* (2014). Lotz discards the popular vernacular of 'antihero'. She argues the characters are both courageous and noble, despite those qualities often being misguided. In its place she implements the problematically generic term, although superiorly veracious, 'flawed protagonists'. I will continue to adhere to the language of antihero for the sake of consistency despite finding Lotz's criticism of the term to be compelling. Lotz offers both a comprehensive descriptive assessment of the flawed protagonist as well as an ideological analysis. The antihero is described as male, morally ambiguous, heterosexual and entrenched in unstable marriages in various stages. The instability is nearly always the fault of the antihero protagonist. Further, the antihero is middle class yet struggles to provide sufficiently for their family. Finally, the figures are always fathers and embody a complication of fatherhood in which they resist relinquishing familial responsibility.

Ideologically, Lotz (2014: 84) argues the antihero exemplifies the identity crisis formed by the collision of new aspects of masculinity, paternal involvement and non-patriarchal marriage relations, with old aspects which demand great responsibility and family provision. In other terms, the antihero embodies the collision of 'patriarchal masculinity', defined by Lotz (2014: 34) as behaviours that reinforce male dominant gender status, with 'feminist masculinity', which seeks to end all ideologies purporting dominance. The discourse between 'feminist masculinity' and the intransigent remnants of 'patriarchal masculinity' result in a shifting culturally idealized 'hegemonic masculinity' in which the antihero struggles to abide to the shifting gender norms (Lotz

2014: 37). Lotz identifies these dynamics in a number of programmes, such as gender role reversal and the decay of male exceptionalism in *Hung* (HBO, 2009–11) (2014: 96) and the contradictory challenge to and perpetuation of 'patriarchal masculinity' in *Sons of Anarchy* (FX, 2008–14) (2014: 109–10). Importantly, Lotz notes it is the struggle of 'having it all' for the male antihero protagonist which evokes the work on masculinity fabricated around a shared gender crisis between men and women. It is the contradictory gender scripts – men unsure how to be men – that bares such a striking resemblance to what women have faced since the mid-century feminist movement. To this point, Lotz (2014: 115) surmises that the antihero articulates how men must adhere to the 'traditional masculine mystique', being the financial provider and finding satisfaction at work, as well as the 'new masculine mystique' of being an active parent and husband in lieu of fully accepting feminist masculinities. Lotz's work is not only cogent and persuasive but it establishes a call for scholars to address the myriad issues of masculinity. Ironically, I answer this plea by analysing a female character who might have more to say about masculinity than her cohort of male character peers.

If the male antihero is representative of an ideological crisis in masculine identity, how does the female antihero inform or complicate this dynamic? If the contemporary crisis in masculinity mirrors the crisis of femininity, the so-called plight of 'having it all', can the female antihero afford to be ignored if we hope to understand these shifting gender scripts? The rest of this chapter aims to acknowledge these questions through an analysis of Sarah Linden in *The Killing*. My goal is to show how Linden overwhelmingly meets the description of the antihero established by Lotz. Secondly, I will position the female antihero as illuminating the ideology of the male antihero and demonstrating a uniquely shared gender crisis. The seemingly regressive politics of the female antihero are unavoidable but are severely complicated when understood in the context of her male counterparts.

Corrupt cop, reprehensible parent, mentally unstable: The female antihero

The Killing debuted on AMC in April 2011. The series, set in Seattle, features season-long story arcs employing narratives weaving between a police investigation and the various lives of those affected by the case. The first and second season follow the investigation of the murder of teenager Rosie Larsen (Katie Findlay) and its effects on the mayoral campaign. Linden, planning on retiring and moving to California with her fiancé, becomes emotionally invested in the case and partners with her planned replacement, Holder. The third season involves the simultaneous investigation of a string of murders of teen girls, perpetuated by the 'Pied Piper' serial killer, and how it possibly connects with one of Linden's previous cases in which the convicted awaits execution. The aftermath of the culmination of the third season, Linden's killing of Skinner described in the opening paragraph, is what preoccupies the fourth season which streamed on Netflix

in 2014. Holder and Linden struggle to cover up Skinner's murder under the subterfuge of staging his disappearance while investigating the murder of a wealthy family and its entanglement with an elite private military school.

Insisting the female antihero in *The Killing* is an exceptional anomaly should not be misconstrued to suggest an absence of female antiheroes on television. Rather, what is exceptional is how directly similar Sarah Linden is to male crime antiheroes, a wholly unique alikeness. The inundation of strong female characters on television in recent years should not dilute *The Killing*'s significance either. It debuted prior to the introduction of famed, flawed and complex female protagonists Carrie Mathieson (*Homeland* [Showtime, 2011–ongoing]), Olivia Pope (*Scandal* [ABC, 2012–ongoing]), Claire Underwood (*House of Cards* [Netflix, 2013–ongoing]), and the significance of Alicia Florrick (*The Good Wife*) was still in a nascent form. Notably, the small wealth of female antiheroes prior to 2011 (*Sex and the City*, *Weeds*, *Nurse Jackie* [Showtime, 2009–2015], *Damages*) did not breach the crime genre to which so many male antiheroes belonged. It was, and still remains, an exceptional addition to the crime antihero subgenre and since its release female crime antiheroes have begun to proliferate (*The Americans* [FX, 2013–ongoing]), *The Bridge* [FX, 2013–14], *The Fall* [BBC Two, 2013–ongoing]), *Top of the Lake* [Sundance Channel, 2013–ongoing]), but none have so unapologetically embraced the moral ambiguity and severity of character defect.

Linden's antihero status is predicated predominantly on her struggle to be a parent and her willingness to forgo police procedure in order to pursue justice. Linden's eschewing of correct, presumably ethical, procedure for the sake of expediting justice begins with minor illegalities. In 'Stonewalled' (2011), Linden has an officer e-mail the files of the Rosie Larsen case to her personal e-mail, fabricating permission from her superior, Lt. Michael Oakes (Garry Chalk). Later in the same episode, Linden breaks chain of custody by taking photographs of evidence in FBI possession. In 'I'll Let You Know When I Get There' (2011), Holder and Linden lie to Oakes about the whereabouts of a missing girl who absconded in order to be transported to Canada to avoid ritual castration. Typically, these infractions are for the sake of the greater good but other occasions are less morally defensible. In 'Ghost of the Past' (2012), Linden downloads information from a suspect's cell phone without a warrant. She does this in spite of Holder's plea that anything they find would be inadmissible, assuaging his concerns by claiming no one will find out if he 'keeps his mouth shut'. In the following episode, 'Openings' (2012), Holder is able to persuade Linden not to further pursue an illegal wiretap of the same suspect. Her illegal activity escalates in 'Keylela' (2012) when she trespasses onto Indian burial land which results in Holder being accosted by Indian police and in her suspension in the following episode ('Off the Reservation' 2012). Her actions become even more unscrupulous when suspended. In 'Bulldog' (2012) she secretly steals a key-card from the scene of Rosie's attack, without submitting it to evidence for proper testing, and illegally enters City Hall eventually using the key-card to access the Mayor's office.

The third season introduces Linden as living alone in a rural setting outside the city, working for the transit authority. Holder visits her in order to get her opinion about a possible connection between a string of murders and one of her old cases. All the evidence to the case is missing and Linden suspiciously dismisses Holder's questions about its whereabouts; later it is revealed that Linden is hoarding the evidence at her house. Once Linden is added back onto the case she quickly returns to her contentious tactics such as in 'Seventeen' (2013) when she improperly questions Adrian (Rowan Longworth), a child witness to the murder, without ascertaining permission. In 'Eminent Domain' (2013), Linden badgers a teen witness in the hospital, pressing her to identify the lead suspect, causing Holder to castigate her behaviour. Later in the episode, she breaks into an apartment in order to see where Adrian was sleeping the night his mother was murdered. Her behaviour escalates in 'Reckoning' (2013) when Holder apprehends a suspect who had accosted her, and she repeatedly kicks him until Holder pressures her to stop. When Holder is offered a chance to brutalize the suspect he refuses, establishing a moral division between himself and Linden. This division materializes later in the episode when Linden suggests they bury evidence of Adrian's false testimony in order to challenge the pending execution of his convicted father. Holder dismisses the possibility as it would never hold up in court; Linden's moral ambiguity is continually contrasted with the ethical disposition of Holder. Linden has entered Skinner's house illegally when she makes the discovery that he is the 'Pied Piper' killer. Skinner ploys her into driving out to the woods under the pretence of revealing where he is keeping Adrian. Even after Holder informs her of Skinner's chicanery and Adrian's well-being, Linden shoots Skinner forcing both detectives to spend the duration of the fourth season obstructing an investigation into Skinner's whereabouts while another suspect remains imprisoned for the Pied Piper murders. The challenge of maintaining their cover-story further clouds Linden's moral ambivalence, perhaps exemplified in 'The Good Soldier' (2014) in which she drags a suspect with amnesia through his family's brutal crime scene.

Linden's decision to murder Skinner is unavoidably personal. The two were romantically involved when she worked with and for him years prior and they had resumed an intimate relationship in the days prior to her discovery. Her self-disgust with having been involved with a vicious killer of young women, as well as her guilt for not being able to detect his depravity, clearly influenced her decision to dole out justice as she saw fit. Yet, personal motivations are not a foreign characterization trait of the male crime antihero. In *Low Winter Sun*, as one example, Frank Agnew's (Mark Strong) involvement in police corruption is entirely inspired by his personal feelings for Katia (Mickey Sumner). Likewise, Raylan Givens (Timothy Olyphant) of *Justified* (FX, 2010–15) is driven by lifelong grudges and family rivalry. The antihero is frequently influenced by familial legacies or mandates (*Sopranos* [HBO, 1999–2007], *Ray Donovan* [Showtime, 2013–ongoing], *Dexter* [Showtime, 2006–13]). Linden's moral ambiguity in her career

aligns her with the male crime antihero, but its importance cannot be truly understood without addressing her role as an uninterested and struggling parent.

Linden's struggles as a single parent arise immediately in the first episode when she is assigned the Rosie Larsen case. Her plans to fly with Jack (Liam James), her 15-year-old son, to Sonoma to start a new life with her fiancé are derailed when Oakes forces her to stay for 24 hours. Eventually, the 24 hours becomes a week to the dismay and confusion of Jack. When Jack expresses his frustration about the uncertainty of their situation, Linden asks Oakes how he managed to raise his four boys to which he quips 'I had a wife', leaving Linden to jokingly lament 'maybe I should get one of those' ('The Cage' 2011). Not only does this comment situate her masculine position, but it also speaks to Lotz's description of the antihero as struggling to provide for their families. Her wavering whether to provide a stable new beginning for her and Jack in Sonoma continues throughout the first season culminating in the season finale in which she takes a call, while boarding a plane, inadvertently informing her that the suspect arrested for Rosie Larsen's murder had been framed. The premiere of the second season opens with Linden and Jack exiting the airport and her vowing to Jack, once again, that it would be the final time.

What is most remarkable about her relationship with her son is how infrequently it factors into the show's plot, Jack frequently being left to fend for himself for days at a time. In other instances he is left in the stead of Regi (Annie Corley), Linden's social worker, such as in 'Stonewalled' when Linden opts to listen in on a wiretap with Holder. When Linden's fiancé comes looking for her on Regi's boat in 'A Soundless Echo' (2011), Jack quips, 'She's gone. Get used to it'. After Regi blames Linden for Jack's acting out, drinking and smoking on Regi's houseboat and verbally abusing her, Linden wakes Jack up in the middle of the night to take up residency at a hotel. Nearly every scene involving Linden and Jack demonstrates her failure to be a successful parent. In one telling scene in 'Vengeance' (2011), she drops Jack off at a birthday party and is unaware of issues with his friends and is looked at as an outsider by the other mothers. In a rare showing of parental interest, she quickly mentors Jack on how to aim and shoot a paint-ball gun. Tellingly, this rare parental effort involves teaching Jack something definitively masculine. Linden's traditionally masculine career has neutralized her ability to be accepted as a mother, not at all unlike the struggle of the domestically unsatisfied male antihero.

Linden and Jack's conflict escalates as the series progresses. In 'Stonewalled', Linden takes a call from an angry parent after Jack e-mailed her son pictures from the Larsen case. In 'Missing' (2011), a highlight of the series, the school reports that Jack's been absent for the last three days. Fellow parents inform her that Jack is the ringleader of a group of delinquent kids. In 'Numb' (2012), Linden makes an effort by asserting she is going to cook dinner to which Jack jests that putting something in the toaster is not cooking. Linden's propensity for feeding Jack out of vending machines recurs through-

out the series. Later in the episode, Jack takes over the cooking when Linden becomes preoccupied with a call involving the case. The scene brilliantly articulates how Linden's career directly interferes with her ability to be a mother. This dynamic, of forcing Jack to subsume the parental duties, is demonstrated earlier in the episode when he scolds her for driving while using her cell phone. In one of the most striking scenes, in 'Ghost of the Past', an ill Jack calls asking for her to bring him medicine. Holder insists she go and take care of Jack and that he will handle an interview by himself, but she refuses, preferring to pursue the case to the detriment of her parental rights. Her inadequacy as a parent peaks in 'Keylela' when child protective services (CPS) respond to accusations of neglect. Jack flees through the bathroom window and Linden evades the officers under the pretence of taking a phone call. In the following episode ('Off the Reservation'), Linden leaves Jack at Holder's apartment, despite his pleas for her to stay, in order to offer superfluous aid in the search for a missing Holder.

Holder is often offered as the voice of criticism and reason involving Linden's parenting. After Linden instructs Jack to stay with Regi, Holder sardonically comments 'I never had dinner with my moms and look how I turned out' ('El Diablo' 2011). In the introspective 'Missing', Linden confides in Holder that she moved from foster home to foster home as a child after her mother left when she was 5. Holder callously remarks that this is why she does not know how to be a mother. He compounds the criticism when she discovers that Jack called him earlier in the week to which he defends by claiming 'at least I picked up the phone'. Holder similarly places guilt on Linden in 'Scared and Running' (2013). After Linden admonishes a missing girl's mother saying 'people like you shouldn't have kids', Holder jests 'if you spot it, you got it'. Holder often acts as the representative of Jack, voicing his parental concerns over how Linden fails to properly eat and sleep. It is not until Holder insists she check on Jack in 'Ghost of the Past' that Linden does so, discovering Jack had called his father, Greg Linden (Tahmoh Penniket). Greg informs her that Jack's temperature was 103 and accuses her of caring 'more about the dead girl than you do your own son'. The pervasively immature Holder, a single, childless recovering addict, is an ironic juxtaposition of passionate parenting advice. Linden's struggle to provide for her family is dramatically illuminated by Holder's superiority and pointed remarks. Her shortcoming as a parent, her inability to successfully have a career and a family, are essential antihero qualities.

Linden's failed marriage and her resistance to relinquish familial responsibility directly align her with Lotz's description of the male crime antihero. Throughout the series, Linden has to perpetually fight Jack's dogged interest in living with his father. A common refrain of Jack appears in 'Stonewalled' when he begs 'why don't you just send me to live with dad' to which Linden harshly explains that he walked out ten years ago and does not care about him. When Holder and Linden locate Jack in 'Missing', he explains that he has been clandestinely meeting with his father. Linden's custody is challenged on grounds of neglect and failure to meet basic needs until in 'Off the Reser-

vation', following their evasion of CPS, when she capitulates and sends Jack to Chicago to live with his father. When Jack comes to visit in 'The Jungle' (2013) he asks her if she has considered moving to Chicago so they could see each other more. She distantly dismisses the notion by saying she does not know anyone in Chicago other than him, ostensibly the only person that should matter. In 'Hope Kills' (2013), Holder asks her what is stopping her from moving to Chicago, but she ignores his seemingly logical quandary. When abducted by a suspect in 'Try' (2013), she confesses she ran out of money and the courts deemed Jack's father the more fit parent, perhaps suggesting a sense of shame hindering her from even trying to be Jack's parent. If a worse mother has existed on cable television, particularly over the course of more than forty episodes, it would be only marginally. The series highlights Linden's deficiencies of lacking traditional motherly qualities to reify her inability to balance feminist ideals of working and parenting. She cannot cook, is ostracized by other mothers, is clueless about her son's school life and whereabouts, and fails to be nurturing even when Jack falls ill. Her traditionally masculine career has compromised her ability to access traditional femininity, the inverse but equivalent dynamic of the male crime antihero.

Insanity and illegality: The antihero and 'having it all'

Unlike her male counterparts, Linden's nobility – banishing Holder when thought corrupt, attempting to stay an execution, always prioritizing justice for the victims of her case – is compromised by attacks on her sanity. Her past issues are hinted at throughout the first two seasons. A typical exchange takes place in 'A Soundless Echo', when her fiancé ponders if 'it's happening again' while bringing up her past fixation on a picture drawn by a victim in a previous case (the case with Adrian, revisited in Season 3). In other episodes, Regi attempts to normalize her erratic behaviour by warning her against 'doing the same exact things that almost lost you custody' ('Vengeance'). Awareness of Linden's past psychiatric travails is also used by her superiors to regulate her behaviour. Oakes makes mention of 'the last time' when she 'got sick' to allay her zealous pursuit of Rosie's killer ('Reflections' 2012) and Oakes replacement, Lt. Erik Carlson (Mark Moses), intimidates Linden by commenting that he has looked at her file and she should not let emotions get the best of her ('Openings' 2012). The psychotic aura of Linden's past is foregrounded in '72 Hours' (2012) when she is detained in a psychiatric hospital in order to prevent her from pursuing the Larsen case. Regi explains to Holder about her history, her willingness to neglect sleep, eating and Jack for the sake of the case. After her release ('Donnie or Marie' 2012), Linden muses 'do you think I'm going crazy again' to Holder, bravely acknowledging her own plight. An unfortunate amount of female antiheroes on both cable and network programming are characterized by a similar questioning of their sanity. In the context of the crime antihero, Linden's disability is representative of a crisis in gender-scripts. She is punished by claims of insanity for

not being able to adhere to patriarchal ideals of motherhood. *The Killing* is the most demonstrative in its gender scripts politics but it is certainly not an isolated incident. Consider *Homeland*'s Carrie Mathieson (Claire Danes), her sanity prominently featured and questioned, who abandons her child with her father and sister, outright conceding her inability to have her important and traditionally masculine career and be a mother. Elsewhere, *The Americans*'s Elizabeth Jennings (Keri Russell) resents her family, often viewing them as purely a burdensome necessity to accomplish her mission.

In 'Missing', Linden describes a time when Jack was young and they played in the park and danced to a song playing on someone's stereo. Linden's tender memory is threatened by her preoccupation with when she and Jack stopped being happy. For Linden, this patently rare memory of being happy with her child is representative of the choice she made to have her career. It is her career, both the time required as well as its emotional and psychological demands, which compromises her ability to be a success-ful mother. If the male crime antihero that Lotz investigates is a manifestation of the struggle of changing gender scripts, a shifting and ever-mutable hegemonic masculinity influenced by patriarchal and feminist masculinities, then how suggestive is it that the female antihero is influenced by this same conflict? The antihero, regardless of gender, defrauds the idealism of feminist masculinity. Female antiheroes must sacrifice their traditional patriarchal roles in order to pursue traditionally masculine positions where-as male antiheroes fail to find contentment as parents, seeking to provide meaning in their lives typically through illegal enterprises. Neither gender can escape the demands of their traditional roles; patriarchal masculinity both looms and punishes those preoc-cupied with its demands. The proverbial 'having it all', the meaningful career and fam-ily life, is presented as leading to insanity or illegality. The female antihero is punished through pervasive questioning of her sanity while the male antihero, no matter how capricious his behaviour, is punished when his illegality becomes unsustainable. With both genders, the antihero is severed from their traditional role, outwardly indicating broadening gender scripts. However, the antihero subtly, yet substantially, complicates essential notions of a shifting gender ideology accepting of diverse roles. The antihero, both female and male, is a truly regressive figure secluded in some of television's most progressive programming. ∗

REFERENCES

'72 Hours' (2012), Nicole Kassell, dir., The Killing, Season 2, Episode 10, 27 May, New York: AMC.

Braudy, L. (2003), *From Chivalry to Terrorism: War and the Changing Nature of Masculinity*, New York: Alfred A. Knopf.

'Bulldog' (2012), Ed Bianchi, dir., *The Killing*, Season 2, Episode 7, 3 June, New York: AMC.

'The Cage' (2011), Ed Bianchi, dir., *The Killing*, Season 1, Episode 2, 3 April, New York: AMC.

'El Diablo' (2011), Gwyneth Horder-Payton, dir., *The Killing*, Season 1, Episode 3, 10 April, New York: AMC.

'Donnie or Marie' (2012), Keith Gordon, dir., *The Killing*, Season 2, Episode 12, 10 June, New York: AMC.

Ehrenreich, B. (1983), *The Hearts of Men: American Dreams and the Flight from Commitment*, Garden City, NY: Anchor Press/Doubleday.

'Eminent Domain' (2013), Keith Gordan, dir., *The Killing*, Season 3, Episode 6, 30 June, New York: AMC.

Garcia, G. (2008), *The Decline of Men: How the American Male Is Tuning Out, Giving Up, and Flipping Off His Future*, New York: Harper.

'Ghost of the Past' (2012), Ed Bianchi, dir., *The Killing*, Season 2, Episode 5, 22 April, New York: AMC.

'The Good Soldier', (2014), Ed Bianchi, dir., *The Killing*, Season 4, Episode 3, 1 Aug, California: Netflix.

'Hope Kills' (2013), Tricia Brock, dir., *The Killing*, Season 3, Episode 7, 7 July, New York: AMC.

'I'll Let You Know' (2011), Ed Bianchi, dir., *The Killing*, Season 1, Episode 10, 29 May, New York: AMC.

'The Jungle' (2013), Ed Bianchi, dir., *The Killing*, Season 3, Episode 1, 2 June, New York: AMC.

'Keylela' (2012), Nicole Kassell, dir., *The Killing*, Season 2, Episode 7, 6 May, New York: AMC.

Kimbrell, A. (1995), *The Masculine Mystique: The Politics of Masculinity*, New York: Ballantine Books.

Kimmel, M. (2013), *Angry White Men: American Masculinity at the End of an Era*, New York, Nation Books.

----- (1996), *Manhood in America: A Cultural History*, New York: Free Press.

Lotz, A. (2014), *Cable Guys: Television and Masculinities in the 21st Century*, New York/London: NYUP.

Martin, B. (2013), *Difficult Men Behind the Scenes of a Creative Revolution: From* The Sopranos *and* The Wire *to* Mad Men *and* Breaking Bad, New York: Penguin.

'Missing' (2011), Nicole Kassell, dir., *The Killing*, Season 1, Episode 11, 5 June, New York: AMC.

'Numb' (2012), Brad Anderson, dir., *The Killing*, Season 2, Episode 3, 8 April, New York: AMC.

'Off the Reservation' (2012), Veena Sud, dir., *The Killing*, Season 2, Episode 8, 13 May, New York: AMC.

'Openings' (2012), Kevin Bray, dir., *The Killing*, Season 2, Episode 6, 29 April, New York: AMC.

'Reckoning' (2013), Jonathan Demme, dir., *The Killing*, Season 3, Episode 9, 21 July, New York: AMC.

'Reflections' (2012), Agnieszka Holland, dir., *The Killing*, Season 2, Episode 1, 1 April, New York: AMC.

Rosin, H. (2012), *The End of Men and the Rise of Women*, New York: Riverhead Books.

'Scared and Running' (2013), Dan Attias, dir., *The Killing*, Season 3, Episode 5, 23 June, New York: AMC.

Sepinwall, A. (2012), *The Revolution Was Televised: The Cops, Crooks, Slingers, and Slayers Who Changed TV Drama Forever*, New York: Touchstone.

'Seventeen' (2013), Kari Skogland, *The Killing*, Season 3, Episode 3, 9 June, New York: AMC.

'A Soundless Echo' (2011), Jennifer Getzinger, dir., *The Killing*, Season 1, Episode 4, 17 April, New York: AMC.

'Stonewalled' (2011), Dan Attias, dir., *The Killing*, Season 1, Episode 8, 15 May, New York: AMC.

'Try' (2013), Lodge Kerrigan, dir., *The Killing*, Season 3, Episode 8, 14 July, New York: AMC.

'Vengeance' (2011), Ed Bianchi, dir., *The Killing*, Season 1, Episode 7, 8 May, New York: AMC.

GO FURTHER

Television

The Killing (August 2014, California: Netflix).

The Killing (April 2011–August 2013, New York: AMC).

STEPHANIE DELACOUR
NATIONALITY: FRENCH / CREATOR: JULIA KRISTEVA

James Bonds of feminism: Intellectual antiheroism
Mary Marley Latham

Increasingly over the past few decades, detective novels and series like Barbara Neely's *Blanche on the Lamb* (1992), Barbara Wilson's *The Dog Collar Murders* (1992) and Alexander McCall Smith's *No. 1 Ladies Detective Agency* (1998) have emerged, manipulating the popular pulp genre's conventions to mainstream core-feminist principles. In terms of academic pedigree, perhaps the most noteworthy contributor to the subgenre of feminist detective fiction would be Julia Kristeva – French post-structuralist, psychoanalyst, intellectual rock star and the (self-named) 'James Bond of feminism' – whose third novel, *Possessions* (1996, translated 1998) figures a protagonist, Stephanie Delacour, who can be read fruitfully as an adapted self-portrait of the author. Taken as a whole, the novel works within Kristeva's larger programme of challenges to and transformations of discourse and other patriarchal orders of things. A figure of Kristeva's own model of embodied intellectual courage, Stephanie Delacour as antihero challenges sexist modes of characterization and ways of telling stories to unseat crime fiction's generic, patriarchal conventions.

Given the womanizing ways and tone of general misogyny in the Bond novels and especially the film adaptations and series, for a feminist to style herself as a type of Bond may appear to be something of a paradox. Nevertheless, Judith Halberstam offers a discussion of the Bond franchise in the introduction to *Female Masculinity* (1998) which reveals its cultural significance. Despite Bond's machismo and chauvinism, Halberstam argues that Bond could not operate successfully without the support of characters whose attributes call into question their masculinity or straightness. The inventor Q, for instance, specializes in technology through which the less physically powerful can become as dangerous as the most muscle-bound stereotype of masculine competence. According to Halberstam, gadgetry's augmentation allows Bond to move beyond the limits of his masculine identity in ways that challenge heteronormativity. Likewise,

the maternal M validates, authorizes and creates Bond's assignments, domesticating him whether through her absence or presence and, in effect, marking him in all his endeavours (Halberstam 1998: 3–5). Kristeva has made a practice of playing alternately the revolutionary and the institutional authority, the liberal and the conservative, insisting upon and explicating the bisexual nature of language and, by extension, the unconscious. Like a secret agent, her allegiance should be understood as suspect – one might most safely regard her as a free agent.

Kristeva is an intellectual bad girl, going undercover into the criminal depths of the unconscious. She champions the act of thinking with valour, bucking any attempts that obstruct her from getting the job of intellectual inquiry done. Espionage agent, honoured warrior, renegade: the bisexual-friendly James Bond of feminism. After escaping the totalitarianism of Bulgaria for personal liberty in Paris, Kristeva has since maintained a fierce commitment to free inquiry, regardless of drawing considerable criticism for her methods. The subject matter she explores in both her academic and fictional writing reflects Kristeva's ethical commitments to reading culture. In order to broadcast her groundbreaking contributions to feminism as a global social movement, Kristeva has extended the boundaries of the discursive forms in which she participates to include more popular, even journalistic, genres. The novel *Possessions* fictionally explores the significance to women of cultural phenomena expanded upon in Kristeva's non-mimetic, academic and philosophical writing: decapitation, the nature of 'possession' and the intersection of horror and maternity.

Journalist-cum-detective Delacour, by keeping her head (for the most part), speaks to the need that an intolerable world has for antiheroes. Although Delacour picks up a 'demon' as the novel's mystery resolves, experiencing an alien yet seemingly natural compulsion to make a self-sacrificing, nurturing gesture, she ultimately retains most of her self-possession – never having been fully convinced she had a stable self to begin with – in her recognition of the compulsion's uncanniness and, thus, is awakened to the recidivistic revenant of normative femininity with which she must cohabit but at the same time resist. Her ambivalence (even towards her own self) lends her the mobility necessary to slip loose the trap which bound and killed, slowly and then in a quick succession of brutal assaults, her fellow intellectual Gloria. Kristeva constructs Stephanie Delacour as a feminist intellectual antihero to foment radical ways of being in resistance to possession of women by patriarchal myths, particularly the myth of the self-sacrificial maternal woman.

In decidedly un-maternal detachment, Delacour expresses, at best, benign tolerance for the other characters in *Possessions*, inward-turning with all the arrogance of a Bond antihero in the body of a woman. For instance, the same day Delacour flies to the fictional nation of Santa Varvara, she meets Gloria's research assistant, Brian Watt, who upon meeting Delacour promptly suffers an epileptic seizure, much to Delacour's indifference and exasperation: 'Santa Varvara always gives me a spectacular reception,

but this time it has excelled itself' (Kristeva 1998 [1996]: 17). Delacour's gaze – perceptive and abstract even when falling on the mutilated remains of her friend – underscores her antiheroic nature. She observes that, even though 'Gloria was lying in a pool of blood with her head cut off', Gloria's 'arrogant breasts' made her body distinct (1998 [1996]: 3). While crime fiction increasingly valorizes the acute perception which appears to accompany such detachment in antiheroes, female antiheroes like Delacour seem to lack the charismatic effect their male counterparts enjoy, counterweighing the male detective's often antisocial personalities. Perhaps these emotionally unavailable female characters suffer, as do 'real women', from the consequences of the less-human state assigned to women, including allowance for self-interestedness.

In truth, Delacour's detachment facilitates her survival. In *The Severed Head: Capital Visions* (2012), Kristeva observes that primitive people decorated caves with the modified heads of, most frequently, women and girls. These artworks illustrate a desire in the heart of man to mould, shape and take female caps. Perched at the highest point of the body, erect like a phallus, heads could have been seen as secondary sexual organs. To take her head, then, would symbolically castrate a woman (2012: 9–27).[1] Furthermore, the dark passion to decapitate and symbolically castrate and render powerless women, particularly those living outside normatively feminine roles and spaces, grows out of aggression rooted in sexism. Therein, true butchery takes place. The castrated status of women and the psycho/socio-sexual symbolism of decapitation intersect in Kristeva's vision of the *Possessions* world: a world where one might imagine and even fetishize the symbolic and actual beheading of an intellectual, successful, sexually active woman like Gloria... and also Delacour. That such a world is so very *thinkable* makes Delacour's hyper-critical, hyper-analytical perspective an effective self-defence mechanism.

Delacour's detached intellectualism not only challenges the conventions of charismatic characterization, it also breaks the plot structure. Delacour's near-misanthropy aside, Kristeva structures the first half of *Possessions* almost mechanically. Shortly after arriving in Santa Varvara, Delacour attends a party hosted by Gloria which all suspects for Gloria's murder later that night attend, excepting her suspiciously absent lover. Upon discovery of Gloria's body, police inspector Northrop Rilsky, conveniently a friend of Delacour, gathers the suspects together to take their stories, intending to interview Delacour last. However, Rilsky's partner appears with Gloria's absent and thieving maid, who had fled after witnessing, from a hiding place, the appearance of Gloria's aforementioned lover; a subsequent argument over Gloria's will; and the lover's horrific sexual assault upon Gloria before creeping out to discover Gloria's dead body, head still intact.

A post-mortem blood test reveals that Gloria had champagne, Rohypnol and Elavil (a different drug switched with some of Gloria's Rohypnol by Pauline – though only Delacour ever realizes this and only much later) in her system the night she died. Gloria's breast also carries a mysterious stab wound, inflicted post-mortem by a dis-

turbed young man unwisely released by the director – one of Gloria's guests the night she died – of a local children's psychiatric care facility, largely as a result of budgetary problems. In all likelihood, her death immediately resulted from the combined stress of the intoxicants and a powerful panic attack triggered by her lover's sexual assault. Furthermore, Delacour muses upon the lifetime of suffering Gloria lived: a life of isolation peppered with emotional wounds. However, the question of who had literally or psychologically killed Gloria had never been the mystery to begin with – as far as Delacour was concerned. Delacour asks,

> But what dark passion [...] could have guided the hand that cut away with such delicate skill the flesh of the neck, the larynx, and the spine and left the smooth wide stream, the red mirror, the dreadful crimson edge outlining the corpse where the head should have been?
>
> (Kristeva 1998 [1996]: 13)

Having resolved to 'take the case', Delacour, instead of beginning the active investigation crime fiction readers might expect at such a moment in the story, attends a concert with Rilsky (who shares the facts of the case with her) and then returns to Paris shortly thereafter. Delacour's discoveries regarding the nature of Gloria's beheading once she returns to Paris occur happenstance.

Delacour encounters Odile (another dinner guest: married heiress to a perfumery) by coincidence in a London bar some months after Gloria's murder. Odile then mentions that Pauline had been a girlhood friend and that Pauline raised a younger brother Aimeric while their biological mother worked. Aimeric drowned though, and Pauline's mourning almost killed her – she went mute, dropped out of medical school and attempted suicide. She sought 'rebirth' by learning Santavarvaran and becoming a speech therapist. In this new country and in this new language, she transferred her maternal love to Jerry: Gloria's deaf son and surrogate for her Aimeric. Later, Delacour imagines Pauline thinking while taking Gloria's head:

> even her son wouldn't recognize her remains. Are you really yourself when you haven't got a head? A headless body has nothing, it has no self anymore so it can't own anything, it owns neither mine nor thine. Nor hers. Her what? Her son, your son, my son? Aimeric, Jerry.
>
> (Kristeva 1998 [1996]: 202)

Pauline wanted to claim Gloria's maternal rights to Jerry so Pauline could possess him, the boy who possessed her by giving her a vessel apparently empty enough to fill with her image of Aimeric. Delacour perceives this in an epiphany during a visit with Jerry. She does not tell Rilsky, she does not confront Pauline (who is present at the house,

having been given custody of Jerry), and she had no plans to expose the truth anytime soon. Instead, she leaves the house immediately and flies, again, back to Paris. She flees the responsibility of exacting legal justice, but, even more so, her unexpected impulse to care for Jerry, the vulnerable child of her brutalized and murdered friend. She fears he could 'possess' her as he had 'possessed' Gloria and then Pauline.

In *Gyn/Ecology: The Metaethics of Radical Feminism* (1990 [1978]), landmark feminist Mary Daly writes that radical feminism requires women to travel through an 'Otherworld', a voyage in which the 'Godfather' must be exorcized, 'for he is allied with and identified with The Possessor' (Daly 1990 [1978]: 1–2). Pragmatically, women on the radical feminist path should not martyr themselves for men who have become possessed within the patriarchal order because, in doing so, the feminine martyr falls 'deeper into the pit of patriarchal possession' (2). Instead, the radical feminist must exorcize the Godfather from within herself (1–2). In the 'State of Possession', the possessed woman becomes 'autoallergic', rejecting her true self to absorb her predatory Possessor and then furthering his predation by binding her daughters and becoming a 're-sister of her Sister'. To heal herself of her autoallergy, the possessed must 're-member' the 'dis-membered Sister within' (337–43). Kristeva as author of *Possessions* performs something like such a 're-membering'. Instead of 'dis-membering' Gloria, the killer(s) in Kristeva's *Possessions* 'de-capitates' ' her in a re-vision of Daly's victim of possession, emphasizing the violence against the mind – seat of psyche – implicit in contamination by the 'Godfather'.

In *The Severed Head: Capital Visions,* Kristeva remarks that women novelists use language to describe beheading in a 'kind of cathartic elaboration [...] through a detailed observation of the logic and economy of the violence itself' (2012: 118). In detective novels, the murderous 'usurping man' and 'other woman, from whom the woman writer is trying to free herself' enact the 'reverse side of depression' (2012: 118). In authoring a text, writers perform a form of psychoanalysis upon themselves as they imagine being each character. In imagining committing the murder, being murdered and uncovering the murder – assuming the role of killer, victim and detective in turn – the woman detective novelist wades through depression and reconceives herself (2012: 118–19). Accordingly, the figures of decapitating re-Sister Pauline and re-membered/re-capitulated Sister Gloria represent alternate self-portraits of Kristeva, as opposed to escaping antihero Delacour. However, Delacour the character most closely resembles the reconstituted self-image of the recovering analysand.

Daly writes that mere escape, literally in etymology to 'slip from head-coverings', falls short of the 'enspiriting' necessary to transcend patriarchy and create a time and place where women possess full rights to their own humanity, free to cast off even the 'hood' of 'woman-hood' (1978: 341). Perhaps, though, the narrative of the quest might not fulfil the needs of the radical feminist becoming a free agent. While quests end, present sexist society offers seemingly infinite variations of mental binds from which

no honest woman could claim to have totally slipped loose. So long as the feminist liberated time and space remains projection (not yet manifest), she must remain an adept escape artist or risk corruption.

Pauline's desire to decapitate did not grow autochthonous from her soiled heart. She lives in a society with a fetish for beheading women. She craved maternity even as a child and her lost chance with Aimeric left an emptiness in her psyche predetermining her complete collapse. Maternity, as constructed by pscyho-sexual myth, fulfils a desire to possess another person to compensate for a woman's own lack of self-possession. So what does one do with a self-possessed mother? One seeking sexual satisfaction, living in financial independence and relative social solitude? 'But Gloria's not fit to be a mother. No mother is', Delacour supposes Pauline thinks (Kristeva 1998 [1996]: 201). Even Delacour feels susceptible to the seduction of an all-encompassing 'mother identity', an appeal that literally drives her from the house and out of the country in horror.

'Horror' as an emotional response does not arise 'naturally' but rather as a consequence of how one becomes socialized in the preconscious infantile state, a socialization process in which each person forms a sense of herself as discontinuous from the environment around her – especially from the body of her mother. Mother, the first other 'I' recognize, embodies the horrible because in the depths of the unconscious is retained the memory of a time when one and one's mother were continuous: the time of gestation in the womb. Be aware: 'I' is a word, not me – the writer writing. 'I' refers to the pronoun, the word in place of the noun, the noun that stands for the self just as an infant as young as 6 months old recognizes her image in the mirror as a representation of herself without actually being herself. Yet, this image provides the means by which an infant develops awareness of her condition as a being separate from the world with an apparent unity enclosed by firm borders between her and her environment.

An infant perceives herself through a gap. First, she cannot view her body whole, being inside it, and so can only perceive the self in reproduction – as in a mirror reflection. Yet, mirror perception is incomplete and presents the appearance of a body more contained and controlled than the infant feels itself to be. Furthermore, the mirror inverts one's image, so that the infant perceives its self-image in reverse. Therefore, all 'I's' ('we'?) lack some*thing* always.

The inconsistency between self-image and self-experience produces an alienation, a phantom leftover sense of (not) being, a sense of being an automaton in a complete world that cannot account for these ghosts of one's own self. Thus, one's self-image, veiled or in semi-darkness, acts as threshold to the visible world (as much in question as one's own selfhood) as the world seen is distorted and flipped in hallucinations, dreams, projections and doubles, all of which reminds one of psychic zones and actions left unaccounted for in the conscious mind, generating irrational anxiety and aggression.

As an infant becomes a child, then an adolescent, that person no longer understands the world through sense alone but through analysis of the actions and words

of other people. The 'social identity' predetermines which desire can be recognized... or not. Desire, product of warped self-image, seeks in others the things made invisible within each person as s/he is socialized (Lacan 2010: 1163–69).[2]

Anxiety, aggression and sublimated desire, particularly for girls, often lead to identity crisis. Creative women tend to teeter between identifications in wily response to ever-shifting situations (Kristeva 1986 [1977]: 41). Great women writers often fall mad speaking from such a position – but they also have the most potential for originality (Kristeva 1986 [1977]: 38). The woman writing murder experiences a renaissance; the written description of decapitation sacrifices self-protective but also binding cognitive barriers in exchange for power over the process of signification... the making of meaning in all its sublime potential.

Heroes in such worlds as Delacour's (and perhaps the reader's own) sacrifice their heads and thus cannot reach this potential. Yet, Delacour's detached intellectualism saves her neck. She would not lean over the chopping block, and why should she? In such a circumstance, the antihero survives while the hero is made sacrifice, and who can say which is the better choice? What right does anyone have? She never asked to be a heroine in this foreign land of commonplace corruption.

Delacour lives within herself even as that self becomes something entirely new: 'Conscious or dreaming, I have no definable place. To "have a roof over your head" – the ultimate form of property! But it's not for me' (Kristeva 1998 [1996]: 21). Delacour thinks this as she beds down in her 'laser cube' modernist apartment in Santa Varvara: a space where she finds she cannot sleep on the expansive surface of the bed, opting instead for a pull-out drawer-bed that most closely resembles a womb or a tomb. She embodies French post-structuralist morality – the revolutionary challenge begun in 1968 Paris – in rigorous intellectual liberty unbound by culture or law: 'I learned to travel through different languages, dying every time I crossed a frontier, then being reborn elsewhere' (Kristeva 1998 [1996]: 22). What could be construed as her arrogance is really her belief in the worth of her own perception through the shifting filters of space, time and culture. ✳

REFERENCES

Daly, M. (1990 [1978]), *Gyn/Ecology: The Metaethics of Radical Feminism*, Boston: Beacon Press.

Halberstam, J. (1998), *Female Masculinity*, Durham: Duke University Press.

Kristeva, J. (1980), *Desire in Language: A Semiotic Approach to Literature and Art* (trans. T. Gora, A. Jardine and L. Roudiez), New York: Columbia University Press.

––––– (1982 [1980]), *Pouvoirs de l'horreur. Essai sur l'abjection/Powers of Horror: An Essay on Abjection* (trans. L. Roudiez), New York: Columbia University Press.

––––– (1984), *Revolution in Poetic Language* (trans. Margaret Waller), New York: Columbia University Press.

––––– (1986 [1974]), *Des Chinoises/About Chinese Women* (trans. A. Barrows), London: Marion Boyers.

––––– (1992 [1990]), *Les samouraïs/The Samurai* (trans. B. Bray), New York: Columbia University Press.

–––– (1998 [1996]), *Possessions* (trans. B. Bray), New York: Columbia University Press.

–––– (2012), *The Severed Head: Capital Visions* (trans. J. Gladding), New York: Columbia University Press.

Lacan, J. (2010), 'The Mirror Stage as Formative of the Function of the I as Revealed in Psychoanalytic Experience', in V. Leitch (ed.), *The Norton Anthology of Theory and Criticism*, 2nd edn, New York: Norton, 1163–69.

McDermott, L. (1996), 'Self-representation in Upper Paleolithic Female Figurines', *Current Anthropology*, 37: 2, pp. 227–75.

Neely, B. (1992), *Blanche on the Lam*, London: St Martin's.

Smith, A. M. (1998), *No. 1 Ladies Detective Agency*, Edinburgh: Polygon.

Wilson, B. (1989), *The Dog Collar Murders*, London: Virago.

GO FURTHER

Novels

The Stephanie Delacour novels

Kristeva, J. (2006 [2004]), *Meurtre à Byzance/Murder in Byzantium*, New York: Columbia University Press.

–––– (1998 [1996]), *Possessions* (trans. B. Bray), New York: Columbia University Press.

–––– (1994 [1991]), *Le vieil homme et les loups/The Old Man and the Wolves* , New York: Columbia University Press.

Website

Julia Kristeva [Official website], http://kristeva.fr/

Notes

1 What Kristeva does not address is a more recent theory proposed by anthropologists such as Leroy McDermott that the figures of feminine bodies without heads and with exaggerated sexual organs could as easily have been self-portraits created by ancient women without access to reflective surfaces. They could not see their own faces but could see their bodies. Furthermore, if one takes such a figure and looks down from the head position as opposed to facing the front, then the proportions cease to appear exaggerated and match the view many women would see when gazing down at their torsos (McDermott 1996).

2 Lacan first read 'The Mirror Stage as Formative of the Function of the I as Revealed in Psychoanalytic Experience' at the *16th International Congress of Psychoanalysis* in Zurich, Switzerland, 17 July 1947.

RUST COHLE
NATIONALITY: AMERICAN / CREATOR: NIC PIZZOLATTO

The philosophical antihero in *True Detective*
Isabell Große

What started off as another crime procedural spiced up with two Hollywood celebrities, developed into one the most acclaimed mini-series of the year 2014. HBO's *True Detective* was almost universally lauded[1] for its unsettling atmosphere, its Scorsese-like style and for its compelling protagonists Rust Cohle (Matthew McConaughey) and Martin Hart (Woody Harrelson). In fact, the success of *True Detective* primarily rests on the antiheroic character and dark visions of Cohle. Watching his character develop throughout eight episodes seems like venturing into the abysmal depths of Pandora's Box. Yet, what are the grounds for such a fascination? A first answer may be found in the general difference between heroes and antiheroes. Whereas the former impress us with their super-human powers or exceptional achievements, the latter usually appear as flawed, rebellious or immoral. It is the unconventional nature of antiheroes that arouses our interest since it does not correspond to any ready-made, straightforward categories. The human brain constantly tries to establish meaningful patterns in life, but antiheroes defy classifications, remain puzzling and, therefore, are able to keep up our interest. Moreover, antiheroes appeal to us because of their high level of self-confidence which in turn allows them to cross boundaries, violate rules and act contrary to general expectations without showing any remorse or restraint.

How does *True Detective* fit into these observations? Unlike other American TV shows focusing on crime, Nic Pizzolatto's *True Detective* was originally conceived as 'a literary police novel' about life in south Louisiana (Pizzolatto 2014a). Instead of using the genre only as a means for portraying the hunt for a serial killer, he transformed it into a thorough character study 'tracking two personalities and two points of view' (Pizzolatto 2014b). We encounter the two detectives Rust Cohle and Martin Hart at two different points in their lives: in January 1995, they investigate the murder of a woman named Dora Lange. Seventeen years later, the case files are reopened by FBI agents

since they suspect a connection between a recent murder case, the murder of 1995 and the private activities of Cohle. Thus, the story moves between Cohle's and Hart's statements and flashbacks revealing what actually happened in the past. While the first six episodes uncover the original investigation, the two final episodes reveal how the two ex-partners reunite to stop the real murderer, Eroll Childress.

Against this background, Cohle reveals a twofold allure: on the one hand, he continues the line of the traumatized, solitary hardboiled detective. On the other hand, he enhances the tough-guy model by acting as a philosophical antihero who is concerned with deconstructing how human beings employ 'cathartic narratives' in order to handle their lives.[2] Although he attacks others for believing in such illusions, his entire identity rests on a narrative, too. Accordingly, he regards himself as someone who does not avert his eyes from the illusions and stories human beings create in order to conceal the nothingness or senselessness underlying their existence ('The Long Bright Dark' 2014). Taking this into consideration, this chapter aims at illustrating how Cohle develops this image of himself and what kind of effect he creates with it. In order to provide insights into these aspects, the first part of the following investigation will focus on Cohle's private life, his social context and his work methods. The second part will analyse his wisecracking soliloquies as well as their reference to nineteenth- and twentieth-century philosophy.

Rust Cohle as the stereotypical lone wolf

In the first episode, 'The Long Bright Dark' (2014), Cohle's appearance and habits mirror those of the unconventional heroes of twentieth-century American hardboiled fiction. Before the audience actually meets Cohle, Hart introduces him retrospectively as a 'raw-boned, edgy [guy] who would pick up a fight with the sky if he didn't like its shade of blue' ('The Long Bright Dark' 2014). This initial image of a quarrelsome, yet determined man is corroborated in the following scene where the elder Cohle presents himself as dishevelled, shabby and arrogant in front of the two FBI investigators. Through these indirect and direct introductions, Pizzolatto illustrates the distance that Cohle creates between him and his surroundings. Cohle's otherness is underlined further by his gestures, posture, facial expressions and way of speaking: when he and Hart arrive at the crime scene, Cohle appears to engage in a mental conversation with both the victim and the murderer. In contrast to his colleagues, Cohle acts as a silent observer, approaches the dead body slowly and scrutinizes it carefully, yet not without empathy. He concentrates solely on detecting traces, taking notes and making sketches. As a result, he does not even look at Hart when he summarizes his findings. This ability to immerse himself completely in reconstructing the crime forms an important aspect of Cohle's work as a detective. On the one hand, his immersion symbolizes his obsession with his work and already hints at his deep sense of personal responsibility towards the victim.

On the other hand, his haunted looks and aloofness create an isolation which he keeps intact at all times.

Cohle's private life further bespeaks his disposition as a nonconformist and lone wolf. If one considers all eight episodes of the series as a character study, this solitary nature appears to be a narrative or mask Cohle consciously constructed to cover his traumatized self. Like the stereotypical hardboiled private eye, the antihero of *True Detective* shows signs of an alcohol and drug problem. These symptoms of his inner tension usually emerge when he is confronted with emotionally testing situations such as having dinner with Hart's family. Being unable to keep the memories of his own lost family at bay, he loses control, gets drunk and reveals parts of his vulnerable self. In comparison to his well-measured demeanour at the crime scene earlier in the same episode, Matthew McConaughey at this point gives an excellent rendition of a shaky, devastated Cohle who dares not look Hart in the eye. Cohle's sense of indignity is further emphasized by his crooked posture as well as his dishevelled hair. In addition, his face remains in the dark so that we perceive his silhouette like that of a guilty man in front of his judge. The trauma underlying Cohle's descent into alcoholism is the death of his daughter, whose birthday coincides with the discovery of Dora Lange's body.

At the beginning of the second episode, Cohle sheds more light onto his personal trauma by describing his insomnia: 'Back then I'd sleep and I'd lay awake thinking about women. My daughter, my wife. I mean, it's like [. . .] something's just got your name on it, like a, like a bullet or a nail in the road' ('Seeing Things' 2014). The similes in the second part of his comment exemplify his feeling of being haunted by his past. From the little that Cohle reveals about his life before he joined the Louisiana State Police, one can deduct that losing his daughter Sophia radically changed his life. In terms of classical myths about heroes, this loss initiated a transformation in Cohle insofar as it made him withdraw from other people and embark on his private mission to 'bear witness' to the futility of human existence ('The Long Bright Dark' 2014).

Later on in the same episode, agents Papania and Gilbough ask Cohle to elaborate in more detail on his private life and career up to 1995. This interrogation scene provides an insight into how he uses narratives to conceal his feelings. For the second time in the series, Cohle loses control over his emotions if only for a brief while. Although he claims that no one 'cares a shit' about his past, his voice falters and he seems more pensive as he explains how his daughter died in a car accident and how his marriage collapsed ('Seeing Things' 2014). In contrast to the manner in which he presents his philosophical ideas, Cohle appears less self-confident and his eyes seem unfocused. Nevertheless, he quickly resumes his tough attitude when talking about his transferral to the narcotics department. In a matter-of-fact tone, he admits that he turned into a workaholic, shot a drug addict, worked as an undercover agent and finally had to spend four months in a psychiatric hospital in 1993. McConaughey does not only emphasize the change in Cohle by speaking faster, but he also returns to Cohle's usual gravelly voice and casual

pose. The rapid change from a thoughtful to a tough-guy attitude illustrates Cohle's tendency to suppress emotions. At times of stress or excitement, e.g. when Cohle discovers a new lead in their case, he also suffers from hallucinations. But like his emotions, he manages to suppress them and rationalizes them as either PTSD or side effects of his undercover work.

Summarizing all these aspects of Cohle's past and private life, one may conclude that Cohle's antiheroic nature primarily depends on his traumatic experiences. In order to suppress his painful memories, he developed two different, but related strategies. Firstly, he immerses himself in his detective work to such an extent that his job becomes an obsession. Except for his partnership with Hart, he does not form any social bonds. Even his apartment does not bear any traces of a private life besides a crucifix above his bed and his numerous books about forensics and criminal psychology. Secondly, he tries to rationalize his impressions and experiences by inventing 'cathartic narratives', e.g. about the possibility of a painless death for his daughter. While these narratives help him to cope with his nightmares, pain and anger, they also represent his tool for deconstructing other people's hopes and, thereby, guarantee his solitary lifestyle.

Yet, although he seems to reject human beings, he still stays inside the law enforcement system. When asked by Papania and Gilbough why he joined the homicide department, Cohle presents the following response in his idiosyncratic, cryptic way:

> Oh, something I saw at Northshore [Psychiatric Hospital]. Quote from Corinthians. *'The body is not one member, but many. Now are they many, but [. . .] of one body.'* [. . .] I was just trying to stay a part of the body now.
>
> ('Seeing Things' 2014, emphasis added)

According to Cohle, religion provides people with an illusion in order to keep them reined in. So, why does he himself refer to a biblical quote at this point? The reason lies once again in his fascination with storytelling. Firstly, he needs his work in order to be released from the psychiatric hospital and remain part of society. Secondly, investigating homicides provides him with the perfect opportunity to occupy his mind since it consists in reconstructing plots underlying crimes.

'No, buddy, without me there is no you': The relationship between Cohle and Hart

True Detective does not only capture a murder investigation, but it also explores how it impacts the life of the two detectives. With respect to this, the juxtaposition between Rust Cohle and Martin Hart is crucial for characterization, atmosphere and plot development. Although the two characters differ considerably in terms of their social context, work methods and world-view, they both fit into the category of obsessive anti-

heroes. Whereas Cohle prefers staying single and believes that he is 'just not good for people' because of his critical attitude, Hart clings to his conservative vision of family as 'the one place where there's supposed to be peace and calm' ('Seeing Things' 2014). The flashbacks to 1995 prove Hart's ideals to be double standards. Hart considers a man's family the best counterbalance to his work. All the same, he relies on extramarital sex as a means of releasing his inner pressure and, at the same time, he does not tolerate being criticized for this behaviour. On the whole, Hart's attitude towards women can be regarded as possessive rather than protective. In contrast, Cohle neither adheres to moral values, nor does he judge others on a value basis.

With respect to their work methods, Hart and Cohle are well-matched since they supplement each other's qualities *and* their weaknesses. Since Cohle works on his own and refuses to make any social connection with his team, none of his colleagues welcome him. Being his partner, Hart tries to get to know him and protects his partner when his insubordination and disrespect towards authorities threaten their investigation. Apart from their way of dealing with superiors, they also differ in their work experience. Hart relies on his practical knowledge, sometimes lets his work be influenced by his personal opinions and displays more caution in dangerous situations. Cohle, however, actively developed a deeper understanding of forensics, criminology and profiling. He does not hesitate to use physical and/or psychological violence when dealing with suspects or witnesses and his intuition appears to be more pronounced than Hart's. Due to their contrasting work styles, each of them assumes a different role in the original Dora Lange case. When talking to witnesses, Hart often takes the lead and in doing so he appears more patient and empathetic than Cohle. Instead of interfering, the latter listens quietly with his ledger behind his back and observes the witness's surroundings discretely, yet keenly.

Besides his shrewd observation skills, Cohle's methodology is characterized by his exceptional ability to extract confessions. Instead of threatening or torturing his suspects physically, he exerts psychological pressure on them. His interrogation strategy is based on the religious assumptions that all human beings are flawed and guilty. As a result, 'everybody wants confession' which according to Cohle consists in 'some cathartic narrative for' their faults ('The Secret Fate of All Life' 2014). For someone who is guilty of a crime or who considers themselves guilty, catharsis lies in forgiveness. Therefore, Cohle invents a story about the crime at hand in which he presents the events as an inevitable sequence of cause and effect. By suggesting that the perpetrator is as guilty as everybody else, Cohle invokes their longing for forgiveness. Finally, he wins their trust and the suspects confess without knowing it. The fascination of watching Cohle's interrogation strategy is twofold. His ability to invoke people's deepest anxieties and desires fascinates viewers since it appears subtle and powerful at the same time. Equally, it contributes to Cohle's aura of the insensitive, ruthless antihero as he does not show any signs of remorse when he gives anxious people false hope. Another

reason why Cohle's method of extracting confessions creates fascination can be found in its connection to religion. In the episode 'The Locked Room' (2014), Cohle defines religion as 'transference of fear and self-loathing to an authoritarian vessel' that promises the ultimate spiritual catharsis. In order to achieve this effect, the priest 'absorbs their [the believers'] dread with his narrative' or he infects them with 'a language virus that rewrites pathways in the brain, [and] dulls critical thinking' ('The Locked Room' 2014). Strikingly, Cohle's definition of religion could also be used to describe his interrogation method: he identifies the suspects' anxieties, delivers a sermon about the grace of forgiveness, entices them to abandon their self-determination and, finally, makes them hand themselves over to his authority.

In the 2012 interview, Hart claims that all police officers 'fit a certain category – the bully, the charmer, the [. . .] surrogate dad, the man possessed by ungovernable rage, the brain' ('The Long Bright Dark' 2014). The difference between these categories, he elaborates, consists in 'how they manage authority' because 'there can be a burden in authority, in vigilance, like a father's burden [that can be] too much for some men' ('The Long Bright Dark' 2014). If one transferred this categorization to the world-view of the two detectives, Cohle could be classified as the smart type whose burden consists not in an ungovernable rage, but in an unfathomable sense of hidden frustration. Hart's burden consists in his contradictory views concerning his family life and sexuality. Since Hart tries to reconcile his job with his duties as a husband and father, he appears to be the less ambitious member of the team. Considering this, one could argue that the first three episodes, or the first act, of the series illustrate Hart as a conservative man who tries to separate work and private life. The second part of the series focuses more thoroughly on Hart's moral struggle and Cohle's increasing obsession with his duty to identify the real murder of Dora Lange.

Metaphysical monologues and misanthropist visions

If one only took into account Cohle's past, his social context and his relationship to Hart, he could be defined as an example of a traditional tough, yet restless and haunted, hardboiled detective. What separates him from other protagonists of mainstream crime series is the way he relentlessly thrusts his philosophical reflections at his colleague and at the audience. Answering Hart's question about his beliefs, Cohle explains that he 'consider[s] [him]self a realist, but in philosophical terms [he is] what's called a pessimist' ('The Long Bright Dark' 2014). But Pizzolatto's antihero is far more complex than he pretends since his metaphysical monologues represent a rich tapestry of allusions to philosophers such as Arthur Schopenhauer and Friedrich Nietzsche, as well as to more controversial thinkers such as Peter Zapffe and Thomas Ligotti. Cohle's monologues focus on three existential concepts, namely human individuality, time and death. They contribute to Cohle's characterization as an antihero insofar as they form

the basis for the cathartic narrative of contemplating the futility of existence. In order to comprehend his self-image it is helpful to examine his philosophical convictions and their development throughout the series in more detail. Due to the confinement in length, the philosophical references in Cohle's monologues can only be illustrated in a simplified manner.

Human beings have always prided themselves on their individuality since it distinguishes them from all other beings in the world and, above all, provides them with a purpose in life. Cohle repeatedly attempts to deconstruct this belief as a mere illusion concealing our primitive nature:

> *I think human consciousness was a tragic misstep in evolution.* We became too self-aware. Nature created an aspect of nature separated from itself. We are creatures that should not exist by natural law. We are things that labour under the *illusion of having a self,* this *accretion of sensory experience* and feeling programmed with total assurance that we are each somebody; when, in fact, everybody's nobody.
> [. . .] I think the honourable thing for our species to do is *deny our programming, stop reproducing,* walk hand in hand into extinction.
>
> ('The Long Bright Dark' 2014, emphasis added)

Such a nihilist approach to the notion of human beings as individuals combines the ideas of three related philosophical theories of the nineteenth and twentieth century: firstly, Cohle's comment on the 'accretion of sensory experience' alludes to the discussion of human consciousness in Schopenhauer's *The World as Will and Representation* (1818, 1844). Highly simplified, Schopenhauer defined our 'self' (i.e. our status as individual subjects), as the human ability to experience the world by transforming sensory perceptions into thoughts. He did not consider the self as independent since '[i]t is [. . .] the will that gives [consciousness] unity and holds together all its representations and thoughts' (Schopenhauer, cited in Janaway 2003 [1999]: 129). The term 'will' refers to human drives and desires such as the 'will to live (survive)'. Secondly, Cohle's comment alludes to Nietzsche who took Schopenhauer's ideas to an extreme and portrayed the self as an 'illusion' or 'fiction'. In Nietzsche's opinion, human beings are determined by their 'will to power', i.e. by the desire to expand their influence on the world around them. One way of satisfying this will consists in creating the illusion that every person has an independent personality with a free will. From this Nietzsche concluded that the 'I' only represents a fiction resulting from the will to power (cf. Janaway 2003 [1999]: 356). Thirdly, Cohle's comments on evolution and reproduction correspond to the misanthropist philosophy of Thomas Ligotti whose ideas in turn originate in the works of the Norwegian anti-Natalist Peter Wessel Zapffe. In his 1933 essay, 'The Last Messiah', Zapffe describes mankind as '[a] species [that] had been armed too heavily' with the 'two-edged blade' of consciousness (Zapffe 1933). Our ability to think in abstract terms

Case Study: Rust Cohle

over-evolved. As a consequence, humanity has reached a state where human beings are able to perceive themselves as part of an endless cycle of life, death and suffering. Although the majority of people learned to develop repression mechanisms in order to avoid madness, Zapffe closes his essay with the cryptic message, 'be infertile and let the earth be silent after ye' (Zapffe 1933). In *The Conspiracy Against the Human Race,* Ligotti agrees with Zapffe in that 'consciousness has forced us into the paradoxical position of striving to be unself-conscious' (Ligotti cited in Panayotov 2011: 148). In summary, Cohle agrees with all four philosophers in the notion that human life and consciousness constitute 'a dream that you had inside a locked room, a dream about being a person and like a lot of dreams there's a monster at the end of' ('The Locked Room' 2014).

If Cohle rejects reality and individuality as artificial constructs covering up the emptiness of human existence, why does he want to stay alive? The aforementioned philosophers suggested various ways of answering this question. Whereas Schopenhauer proposed aesthetic contemplation (i.e. immersing oneself in artistic activities), Nietzsche and Zapffe identified repression mechanisms such as religion, social isolation or distraction (cf. Zapffe 1933; Janaway 2003 [1999]). Again, Cohle combines these philosophical standpoints insofar as he applies two different strategies, namely contemplation and work. Since he 'lack[s] the constitution for suicide', he devised 'a form of meditation' in which he 'contemplate[s] the moment in the garden [Gethsemane], the idea of allowing your own crucifixion' ('The Long Bright Dark' 2014). Hence, his first anchor point consists in repeatedly reminding himself of the omnipresence of death. With respect to his past, this strategy could be regarded as an attempt to prolong his own suffering resulting from losing his daughter. Although he claims that his daughter 'spared him the sin of being a father', he torments himself by staying alive and contemplating the cruelty of life in order to punish himself ('Seeing Things' 2014).

The notion of punishment also occurs in Cohle's theory of time as a 'flat circle' or loop.[3] Thus, he lectures agents Papania and Gilbough that human beings consider time as a progression or linear movement. But if one considered existence from a 'fourth-dimensional perspective', i.e. outside time and space, time would be replaced by eternity or infinite recurrence:

> In eternity, where there is no time, nothing can grow. Nothing can become. Nothing changes. So death created time to grow the things that it would kill [. . .] and you are reborn, but into the same life that you've always been born into. I mean, how many times have we had this conversation, detectives? Well, who knows? When you can't remember your lives, you can't change your lives, and that is the terrible and the secret fate of all life. You're trapped by that nightmare you keep waking up into.
>
> ('The Secret Fate of all Life' 2014)

151

Cyclic patterns played a significant role in various ancient cultures. Buddhism, Hinduism and other Indian religions present existence as an endless cycle of birth, life, death and rebirth from which human beings try to escape. In (European) philosophy, on which Cohle bases most of his reflections, the idea of eternal return was prominently discussed by Nietzsche. Although Nietzsche never developed his idea of recurrence into a coherent theory, he believed that due to the finite number of atoms in the universe the number of atom configurations is limited. As a consequence, every being or event has existed before and will be repeated infinitely (cf. Tanner 2000: 62).

Cohle adopts these theories of recurrence because they confirm his personal narrative of infinite pain. Furthermore, they also form part of his obsession with death. Working for the homicide department, he encounters death in all its facets. When he tries to identify other likely victims of Dora Lange's murderer, he studies countless photos of crime scenes and post-mortem reports. Eventually, he concludes that death liberates us from the 'life trap' of false hopes and illusions:

> It's an unmistakable relief, see, because they were afraid and now they saw for the very first time how easy it was to just let go, and they saw – in that last nanosecond, they saw what they were, that you, yourself, this whole big drama, it was never anything but a jerry-rig of presumption and dumb will and you could just let go finally now that you didn't have to hold on so tight.
>
> ('The Locked Room' 2014)

But, considering death as a relief contradicts both his concept of recurrence and his claim that '[n]othing is ever over' ('The Locked Room' 2014). Cohle vehemently denounces fulfilment and closure – although his job consists in providing closures. Nevertheless, by using the term 'relief', he expresses a spark of hope. Infinity and hope lead us to the final chapter in Cohle's cathartic narrative, namely the insights he gains from his near-death experience in the last episode of *True Detective*. In the first seven episodes, Cohle presents himself as a disillusioned investigator who regards humanity as a failure, who denies the existence of sense in life and who represses all his feelings. His metaphysical monologues result from his self-reflexivity as well as his scrutinizing of human behaviour. Their function consists not only in isolating him from others, but also in being employed as a form of self-lacerating contemplation. By contrast, the final episode reveals Cohle to be as ordinary a human being as everybody else. According to his moral code that 'every man has got a debt', Cohle convinced Hart to resume the case on their own in 2012. When they eventually discover the premises of Errol Childress, Cohle is irresistibly drawn into the murderer's spiritual labyrinth and follows his call 'Come die with me, little priest'. As Childress stabs Cohle, he demands: 'Now, take off your mask' ('Form and Void' 2014). These words seem like an invitation for Cohle to let go of his delusions about life and evoke his comments on being relieved through death.

Having been wounded by the murderer, Cohle indeed has to face death. The scene fades out with the image of Hart holding Cohle while they wait for help.

This near-death experience initiated a radical change in Cohle's personality insofar as it tears down the self-image he constructed in the first seven episodes. His appearance after the events resembles representations of the crucified Jesus. His body is still heavily bruised, his hair is loose and he lies immobile in his bed contemplating. The visual rendering of his physical and mental suffering is further enhanced by the blurred reflection of his image in the window of his room in the hospital.

Rust Cohle, the quarrelsome guy who would pick up a fight with the sky, turned into a broken man. In his conversations with Hart, Cohle confesses that he is 'not supposed to be here' because he did not recognize the murderer when he met him in 1995 ('Form and Void' 2014). However, the real epiphany consists in the following confession:

> There was a moment – I know when I was under in the dark. [. . .] It was a vague awareness in the dark, and I could – I could feel my definitions fading. And beneath that darkness, there was another kind. It was – it was deeper, warm, you know, like a substance. I could feel, man, and I knew, I knew my daughter waited for me there. So clear. I could feel her. I could feel, I could feel a piece of my – my pop, too. It was like I was a part of everything that I ever loved, and we were all the three of us, just – just fadin' out. And all I had to do was let go and I did. I said, 'Darkness, yeah, yeah.' And I disappeared. But I could – I could still feel her love there, even more than before. Nothing. There was nothing but that love. (*Crying*) Then I woke up.
>
> ('Form and Void' 2014).

Such an experience of reunion proves his denial of hope and meaning in life as wrong. For the first time in the series, Cohle lowers his mask completely and expresses his grief as openly as possible. Throughout his life, Cohle has been telling himself and others stories about life, stories that helped him repress his feelings. Having shared his pain with Hart, Cohle realizes that all life 'is just one story [. . .] [of] 'light versus dark' ('Form and Void' 2014). Unlike his former restless self, the storyteller in Cohle allows him to finally create an alternative, more hopeful ending. 'Well, once, there was only dark. If you ask me, the light's winning' ('Form and Void' 2014).

Conclusion

The first season of *True Detective* unfolded a psychodrama about how the human mind formulates narratives in order to make life more comprehensible. In other words, all the main characters of the series transform their experiences into individual versions of reality. Errol Childress lives in a bizarre world of his own resembling the setting of H.

P. Lovecraft's horror fiction. Martin Hart's story is that of a conservative patriarch who struggles with double standards. The most complex form of storytelling is doubtlessly displayed by the antihero Rust Cohle. He epitomizes the eponymous 'true detective' since he is obsessed with his work as well as with his sense of duty. As far as his solitary lifestyle and work methods are concerned, Cohle continues the narrative of the tough hardboiled detective of the noir tradition. Above all, he symbolizes the series' misanthropist who intends to deconstruct our illusion of a meaningful life. His monologues engage in philosophical discussions about existential anxieties and could be regarded as a means of keeping others at bay. At the same time, they allow Cohle to punish himself by prolonging the grief for his dead daughter and by denying him any chance of hope. It is only after he faced death that he stops clinging to this narrative of a martyr. Altogether Cohle's fascination for the audience derives from his uncompromising behaviour, his exceptional methodology and, most of all, from his subtle strategies to conceal his personal trauma. And is it not such a daring unconventionality that we all secretly long for? *

REFERENCES

Alsford, M. (2010), *Heroes and Villains* [e-book], Luton: Andrews UK, http://www.amazon.de/Heroes-Villains-Culture-Book-English-ebook/dp/B003F24J4I/ref=sr_1_1?ie=UTF8&qid=1422550503&sr=8-1&keywords=heroes+and+villains+alsford. Accessed 26 October 2014.

Campbell, J. (1973), *The Hero with a Thousand Faces,* Princeton, NJ: PUP.

Chotiner, I. (2014) 'True Detective's Critics Are Wrong', *New Republic*, http://www.newrepublic.com/article/116561/true-detective-matthew-mcconaughey-and-woody-harelson. Accessed 19 January 2015.

Cobley, P. (2000), *The American Thriller,* Basingstoke: Palgrave.

'Form and Void' (2014), Cary Joji Fukunaga, dir., *True Detective*, Season 1, Episode 8, 9 March, New York: HBO.

Janaway, C. (2003 [1999]), *Self and World in Schopenhauer's Philosophy* [e-book], Oxford Scholarship Online, http://www.oxfordscholarship.com /view/10.1093/0198250037.001.0001/acprof-9780198250036. Accessed 16 January 2015.

Korbelik, J. (2014), 'Harrelson & McConaughey Shine in HBO's *True Detective*', *Lincoln Journal Star*, http://journalstar.com/entertainment/tv-radio/jeff-korbelik-harrelson-mcconaughey-shine-in-hbo-s-true-detective/article_ab10132f-1f39-5918-885b-8883023b53e3.html. Accessed 19 January 2015.

'The Locked Room' (2014), Cary Joji Fukunaga, dir., *True Detective*, Season 1, Episode 3, 26 January, New York: HBO.

'The Long Bright Dark' (2014), Cary Joji Fukunaga, dir., *True Detective*, Season 1, Episode 1, 12 January, New York: HBO.

Nietzsche, F. (1974), *Thus Spoke Zarathustra,* [e-book], Harmondsworth: Penguin, http://www.amazon.de/Thus-Spoke-Zarathustra-Friedrich-Nietzsche-ebook/dp/B002RI9RDO/ref=sr_1_3?ie=UTF8&qi

d=1422550682&sr=8-3&keywords=nietzsche+thus+spoke+Zarathustra. Accessed 26 October 2014.

Nussbaum, E. (2014), 'Cool Story, Bro: The Shallow Deep Talk of *True Detective*', *The New Yorker*, http://www.newyorker.com/magazine/2014/03/03/cool-story-bro. Accessed 19 January 2015.

Panayotov, S. (2011), 'Ask the Puppet: Towards Thomas Ligotti, "The Conspiracy Against the Human Race"', *Identities: Journal for Politics, Gender and Culture*, http://www.ceeol.com/aspx/ publicationdetails.aspx?publicationId=F780D0B4-1E1A-4CB3-B464-5648537D003F. Accessed 12 January 2015.

Pizzolatto, N. (2014a), 'Inside the Obsessive, Strange Mind of *True Detective's* Nic Pizzolatto', *The Daily Beast*, 2 April, http://www.thedailybeast.com/articles/2014/02/ 04/inside-the-obsessive-strange-mind-of-true-detective-s-nic-pizzolatto.html. Accessed 22 January 2015.

————— (2014b), '*True Detective* Creator Nic Pizzolatto Looks Back on Season 1', *Hitfix*, 10 March,http:// www.hitfix.com/whats-alan-watching/true-detective-creator-nic-pizzolatto-looks-back-on-season-1/1. Accessed 23 January 2015.

Romano, A. (2014), '*True Detective* Review: You Have to Watch HBO's Revolutionary Crime Classic', *The Daily Beast*, http://www.thedailybeast.com/articles/2014/01/11/true-detective-review-you-have-to-watch-hbo-s-revolutionary-crime-classic.html. Accessed 19 January 2015.

'The Secret Fate of All Life' (2014), Cary Joji Fukunaga, dir., *True Detective*, Season 1, Episode 5, 16 February, New York: HBO.

'Seeing Things' (2014), Cary Joji Fukunaga, dir., *True Detective*, Season 1, Episode 2, 19 January, New Orleans: HBO.

Smith, D. (2006), *H.P. Lovecraft in Popular Culture*, Jefferson: McFarland.

Tanner, M. (2000), *Nietzsche: A Very Short Introduction*, Oxford: OUP.

Walton, P. (1999), 'Antihero', in R. Herbert (ed.), *The Oxford Companion to Crime and Mystery Writing*, Oxford: OUP, pp. 19–20.

Wiegand, D. (2014), '*True Detective* Review: 2 Stars Shine Brightly', *San Francisco Gate*, http://www. sfgate.com/tv/article/True-Detective-review-2-stars-shine-brightly-5129041.php. Accessed 22 January 2015.

Zapffe, P.W. (1933), 'The Last Messiah' (trans. Gisle R. Tangenes), *Philosophy Now*, https:// philosophynow.org/issues/45/The_Last_Messiah. Accessed 13 January 2015.

GO FURTHER
Novels and Short Story Collections

Bierce, A. (2012), *Can Such Things Be?*, [Kindle, e-book], Amazon Media EU S.à.r.l.

Pizzolatto, N. (2010), *Galveston*, New York: Scribner.

Barron, L. (2007), *The Imago Sequence and Other Stories*, San Francisco: Nightshade Books.

Chambers, R. W. (2006), *The King in Yellow*, [e-book], BiblioLife.

Lovecraft, H.P. (1999), *The Call of Cthulhu and Other Weird Stories*, (ed. S. T. Joshi), New York: Penguin.

Books

Cioran, E. M. (2012 [1968]), *The Temptation to Exist,* (trans. by Richard Howard), New York: Arcade
Publishing.

Ligotti, Thomas (2011), *The Conspiracy Against the Human Race,* New York: Hippocampus Press.

Smith, D. G. (2006), *H.P. Lovecraft in Popular Culture: The Works and their Adaptations in Film,
Television, Comics, Music and Games,* Jefferson: McFarland.

Houellebecq, Michel (1999), *H.P. Lovecraft: Contre le Monde, Contre la Vie,* Paris: Éd. J'ai lu.

Extracts/Essays/Articles

Creeber, G. (2015), 'Killing us Softly: Investigating the Aesthetics, Philosophy and Influence of Nordic
Noir Television', *Journal of Popular Television,* 3: 1, pp. 21–35.

Janning, F. (2014), '*True Detective*: Pessimism, Buddhism or Philosophy?', *Journal of Philosophy of Life,*
4:4, pp. 121–141, http://www.philosophyoflife.org/jpl201408.pdf.

Pizzolatto, N. (2014), 'Writer Nic Pizzolatto on Thomas Ligotti and the Weird Secrets of *True Detective*',
Wall Street Journal – Speak Easy [blog], 2 February, http://blogs.wsj.com/speakeasy/2014/02/02/
writer-nic-pizzolatto-on-thomas-ligotti-and-the-weird-secrets-of-true-detective/.

Hanegraaff, W. J. (2007), 'Fiction in the Desert of the Real: Lovecraft's Cthulhu Mythos', *Aries,* 7: 1, pp.
85–109.

Hull, Thomas (2006), 'H.P. Lovecraft: A Horror in Higher Dimensions', *Math Horizons,* 13: 3, pp. 10–12.

Television

True Detective (2014–ongoing, New York: HBO).

Notes

1 Cf. Romano 2014; Chotiner 2014; Korbelik 2014; Wiegand 2014; Nussbaum 2014.

2 According to the French philosopher Jean-Francois Lyotard, the concept of the 'narrative' refers
to the way that human beings fictionalize their reality into meaningful, coherent stories and
universal truths such as the biblical account of creation. The adjective 'cathartic' signifies the
psychological relief gained by the help of these narratives.

3 Cohle copied the phrase 'flat circle' from Reginald Ledoux who in turn embeds the concept of
recurrence into his worship of the fictional Yellow King and the world of Carcosa. The latter
are derived from Robert Chamber's short story collection *The King in Yellow* and the world of
supernatural horror in the works of H.P. Lovecraft. By invoking these writings, Pizzolatto does not
only illustrate the fanatic aspects of crime, but he also creates a horrific atmosphere matching the
Louisiana setting and the psychological abysses examined through his characters.

'The world needs bad men. We keep the other bad men from the door.'

RUST COHLE

INTERROGATION

conducted by Fiona Peters

160
JOHNSTON, Paul

JOHNSTON, Paul

The heroes of your novels are often flawed mavericks. Do you think of them as antiheroes?
I've written three series and one stand-alone, though the latter may turn into a series. I suppose all my protagonists (to avoid confusion with the word 'hero' – see below) are flawed mavericks; the crime novel has many precedents and, more recently, the fair and incorruptible Sergeant Dixon/Joe Friday figure that almost everyone looked up to has gone out of fashion. I wouldn't go as far to say that my leads are antiheroes though. Rather, I'd say that my novels are anti-detective novels or anti-crime novels, at least as regards the traditional forms of detective/crime fiction. I'm driven primarily by ideas rather than characters, though I try to ensure that my protagonists don't become didactic or paradigmatic. They operate in complex societies and the emphasis is on the effect those societies have on people, including the protagonists.

My writing is as much informed by ancient Greek and Latin literature – rather like 'Golden Age' dons' delights – as by modern writing, film and TV. For me, one of the great antiheroes is Odysseus who, unlike his dull Roman counterpart Aeneas, is a trickster – cunning, quick-witted, unscrupulous and unfaithful. While his wife Penelope fights off suitors for the twenty years he is absent, he spends seven of them with the nymph, Calypso, having earlier had a fling with the witch, Circe. He also returns home an utter failure as a leader, having lost all his men in the Trojan War and on the return. Of course, the Greeks did not view Odysseus as an antihero, though the Romans did. Shakespeare's portrayal of him as Ulysses in *Troilus and Cressida* shows the Ithacan's intelligence but, by the end, he has sunk into cynicism.

Perhaps for these reasons I did not use Odysseus as a template for Alex Mavros, my half Scots–half Greek missing-persons specialist. He is, however, a classic marginal private investigator – because of his dual nationality, he is to some extent outside the Greek society in which he operates, a flaw in his eye stressing that he views things differently from others. He is idealistic and brave when he has to be, though both qualities take a battering through the seven novels in the series [*A Deeper Shade of Blue/Crying Blue Murder* (2002); *The Last Red Death* (2003); *The Golden Silence* (2004); *The Silver Stain* (2011); *The Green Lady* (2012); *The Black Life* (2013); *The White Sea* (2014)]. Like many

detectives, he has a moral code, but it is a highly relative one that takes into account the political and historical conditions he uncovers while looking for people.

In *The Black Life*, Mavros investigates the case of a Greek Jew from Thessaloniki, who supposedly died in Auschwitz but has recently been seen in the city. That character, Aron Samuel, can be classed as an antihero. He participated in the extermination of his fellow Jews, working in the Sonderkommando that took them into the gas chamber, and subsequently looted and burned their bodies. Given that refusal meant instant execution, Samuel can hardly be seen as a collaborator, but what he did after the war is more morally ambiguous. He led a squad of avengers, who killed concentration camp guards (this is based on fact), and is still doing that work into his eighties. Is acting outside the law against the perpetrators of genocide justifiable? Mavros, seeing the rise of Holocaust deniers and neo-Nazis in Thessaloniki, is ambivalent, but he pays a terrible price for that. The Nazis, of course, are much worse than antiheroes, or even conventional baddies, not least because of their ongoing attraction to the extreme right.

In fact, do you believe that the traditional concept of 'the hero' exists within literature today, and more generally within the concept of the contemporary broader popular culture framework?
There's no shortage of antiheroes in contemporary popular culture – Walter White of *Breaking Bad* is one of the most striking. Hannibal Lecter could be taken as another, but I'd argue that the real heroes of Thomas Harris's books and the associated films and TV series are law enforcement – Will Graham, Clarice Starling, Jack Crawford. Lecter is an out-and-out villain, no matter how seductive he might be. Protagonists may be flawed – abusers of women, alcohol, drugs, suspects and so on – but they usually have some sort of moral compass, however hypocritical that might be on the part of the writer. Apart from the noir novel, with its focus on criminals and losers, the main proponent of the antihero is Patricia Highsmith, a writer who occupies her own hallowed place in the psychological crime novel. The Simenon of the romans durs runs her close, but the overwhelming majority of crime writers stay within the parameters of the genre: push readers a little out of their comfort zone, then reel them back in again as the protagonist controls his/her faults and solves the crime.

It's certainly the case that experimental novels such as Alain Robbe-Grillet's *Les Gommes* [1953] and Paul Auster's *The New York Trilogy* [1987] reduce the 'hero' to a two-dimensional construct of words, genre conventions and literary motifs (such as the double/doppelgänger), rather than attempting old-style realism in character-building. To some extent we're all postmodernists now and I'm stimulated by the exploding of old standards – the crime novel is often a very conservative beast. I've brought this to the fore in all of my novels by applying a satiric edge. The relation to post-structuralist thought is most evident – for those who care to seek it out – in my Matt Wells series [*The Death List* (2007); *The Soul Collector* (2008); *Maps of Hell* (2010); *The Nameless Dead* (2011)]. Wells

is a crime writer, so self-reflexivity is the order of the day. He is also targeted by a serial killer, who copies methods of killing from Wells's books – intertextuality, you're on. As the series progresses, Wells takes steps to become a trained killer to defend himself against his former lover, who's become a hit woman; and he is unwittingly brainwashed to make him even more dangerous, leaving his sense of identity fractured. The novels operate both as knowing constructs and as standard thrillers – in fact, *The Death List* was by far my most successful novel commercially. But Matt Wells, for all his textualized nature, still acts like a conventional 'hero', nailing the bad guys and girls, and regaining his identity. Maybe you can eat your postmodern cake and wash it down with a cup of generic tea.

Your Quint Dalrymple novels are set in a futuristic Edinburgh. In what ways does that enable you to throw your characters' idiosyncrasies into greater relief?
The Quint series [*Body Politic* (1997); *The Bone Yard* (1998); *Water of Death* (1999); *The Blood Tree* (2000); *The House of Dust* (2001); *Heads or Hearts* (2015)] shows the eponymous maverick fighting the establishment as much as criminals – in fact, the criminals are often from the establishment. Edinburgh in 2020 has been an independent city-state on the ancient Greek model since the last election in 2003 and is governed by a small Council of City Guardians modelled on that in Plato's *Republic*. While the Council views itself as a benevolent dictatorship and there is – supposedly – no crime, citizens lead a hard life: no phones, TV, private cars, cigarettes, popular music, though they have guaranteed work, life-long education, basic accommodation and food – and a compulsory weekly sex session, partner chosen by the Recreation Directorate. The city is bankrolled by the year-round festival that attracts tourists from those parts of the world that haven't fallen prey to warring drug-gangs and religious terrorists. The set-up is resolutely low-tech and Orwellian.

In some ways, Quint is an antihero. He grew disillusioned with the regime, was demoted to ordinary citizen and starts the series working as a labourer in the Parks Department. In his spare time he is a PI, using his knowledge of the system and the vast paper archives to help his fellow citizens. Then the Council calls him in when the first murder in the city for five years is committed. Quint's attitude towards Edinburgh's leaders is highly critical – even though, or perhaps because, his mother is the senior guardian in *Body Politic*. He is less ambivalent about the system because he was involved in the drugs wars that tore the United Kingdom apart and drove Edinburgh to independence. But, like Mavros and Wells, he fights injustice and rights wrongs, albeit in a maverick and insolent manner. For Council members, he is definitely an antihero, especially to those who are corrupt.

The Quint novels are primarily ideas-driven. They include my takes on Scottish independence, democracy, totalitarianism, the white slave trade, nuclear power, global warming, cloning, the privatization of universities, robotics and... football. The books are written in the first person, enabling Quint to channel Hammett and Chandler, with

added swearing. The underlying motif of the series is that of the violence done to individual citizens' bodies by the people in power; hence the body parts in all the titles, and the metaphor of the body politic. Some critics have found the characterization thin, apart from Quint and his sidekicks, but this is appropriate to a city where individuals are subjugated to the requirements of the state. Quint's opposition to this underlines his status as an antihero, though he remains at heart a supporter of the regime – until *Skeleton Blues*, the book I'm writing now...

Has your recent adoption of a pseudonym allowed you a greater freedom in relation to character?

I wrote *Carnal Acts* [2014] under the pseudonym Sam Alexander. The reason was partly commercial, as the novel has a mixed-race female protagonist and I wanted a gender-neutral author name, and partly practical – I wanted to see if writing under a different name would afford me a different take on the process. It was a curious project as the first 40,000 words of the novel were submitted for my Ph.D., another 40,000 words being my critical analysis of the book.

Although *Carnal Acts* contains many social and political ideas, primarily about historical and contemporary slavery, it is more character-led than most of my books. It is my take on the police-procedural, a subgenre I enjoy reading but never had much interest in writing, mainly because the bureaucratic aspects struck me as dull and restraining. The main character, Joni Pax, is a detective who fell out of favour in London and relocated to north-east England. She works for Hector 'Heck' Rutherford, a detective of the old school, who has recently recovered from cancer. As a mixed-race woman, she faces a lot of opposition in the newly formed Police Force of North East England. She can't be classed as an antihero, though her mother, a former hippy who is now a practitioner of Wicca, is hardly conventional – as a result, Joni learns to trust her subconscious and her emotions more than she was trained to do.

If there is an antihero in the novel, it is Suzana, an Albanian sex-slave, who kills a pimp when she escapes from the brothel where she was imprisoned. She is brave and single-minded, but also extremely violent when she has to be. Joni is sympathetic to her, although she is a murderer (as, strictly, she didn't kill in self-defence). Gender politics come into play too, as do issues of class (the local aristocrat, whose family made a fortune from the slave trade in the eighteenth century, is a sexual pervert) and immigration – the Albanian mafia is trying to take over the area. At the end, SPOILER ALERT, Joni connives in Suzana's escape and feels no guilt. Heck, aware of what she's done, supports her. So, the book is a kind of anti-police procedural, with one of the criminals allowed by law enforcement to get away – though whether Suzana is in fact a criminal is ultimately left to the reader to decide.

Did the gender-neutral pseudonym allow me greater freedom as regards character building? It may have stimulated me to enter Jamesian centres of consciousness that, as

a less experienced writer, I would have avoided. The publisher ran a Twitter campaign, inviting readers to guess who the author was. About 250 names were suggested (ranging from Ian McEwan via almost every British crime writer to Jeffrey Archer – thanks for that). The split was roughly fifty–fifty male–female, suggesting I had written female characters that were convincing, at least to some – so the pseudonym may have played a part.

Do you think that evil characters are more fascinating than good, and if so, does that account for the recent upsurge in antiheroes in literature, film and television? And how does it affect your writing?

Ah, evil. I've always had a problem with that word, probably stemming from enforced church attendance at school. (I haven't yet read Mary Evans's *The Imagination of Evil* [2009], though it's in my to-read room.) Is Walter White evil? He does evil things, though his motivation is the good of his family. Is Hannibal Lecter evil? He's classed as criminally insane in *Red Dragon* [1981] and *The Silence of the Lambs* [1988]. Evil is a tricky term, mainly because of the theological overtones, and I'm not a believer. I do have an Antichurch of Lucifer Triumphant in Maps of Hell, but it turns out to have been revived by the son of a Nazi doctor. And vodoun, the West African root religion of voodoo, plays a part in *Carnal Acts*, particularly in stressing how vile (note anagram) the slave trade was.

Actually, I'm not sure if there is a great upsurge in antiheroes. For example, Stieg Larsson's Lisbeth Salander is justified in her actions, given the abuse she undergoes. There's no doubt that flawed heroes rule the roost, but even as dark a writer as Derek Raymond, in his Factory novels, uses a first-person narrator, an unnamed detective who wades through blood and guts to solve his cases. Although influenced by existentialist angst, Raymond still gives his hero a purpose, no matter how futile it may seem, especially to his bosses.

As to evil – or rather sociopathic and damaged – characters being more fascinating than good ones, I feel that's rarely the case. Two of the most convincing novels about serial killers are the late lamented Ruth Rendell's *A Demon in My View* [1976] and Joyce Carol Oates's *Zombie* [1995]. Both protagonists are presented with great insight, but limited sympathy. I could never see myself writing such characters, just as I struggled to watch John MacNaughton's *Henry, Portrait of a Serial Killer* [1986]. Of course, none of those was anything like as successful as the stylized Hannibal Lecter books and movies and their numerous copies.

Here we come to the real problem that faces the crime novel. Readers are ideologically and textually conditioned to want the status quo to be restored before murder or other crimes disrupted it. But the real-world status quo is unjust, corrupt and self-serving. How does the crime novel suggest that without turning readers off? One way is to provide micro-analyses of damaged human beings – see Highsmith and non-Maigret Simenon. Another is to give panoramic views of broken societies, using the protagonists as guides and champions, as I've tried to do with Quint Dalrymple and Alex Mavros. Don Winslow's

long and lengthily researched portrait of narco-ruined Mexico in *The Power of the Dog* [2005] is a fine example of the panoramic approach. Unfortunately, happy endings are either temporary or non-existent in such novels – see also my 'mentor' Orwell's *Nineteen Eighty-Four* [1949].

Still, I'm looking forward to *The Cartel* [2015], Winslow's sequel to *The Power of the Dog*, though I don't know what that says about me. Flawed? Definitely. Maverick? I'd like to think so. Heroic? You're having a laugh... ✳

Photograph ©Francesco Moretti

'Readers are ideologically and textually conditioned to want the status quo to be restored before murder or other crimes disrupted it. But the real-world status quo is unjust, corrupt and self-serving.'

PAUL JOHNSTON

REPORTS

Double Identity: Crime Fiction by Cain and Highsmith

Carl Malmgren

The pursuit of crime

You and I, Hastings, are going hunting once again.
> – Agatha Christie, *Curtain: Poirot's Last Case*

The narrative formula for mystery and detective fiction is quite simple: someone is looking for someone or something. A pursues B, where B is in some way an unknown factor: this is the basic narrative sentence for most murder fiction. George Grella identifies the quest as the masterplot of detective fiction: 'its central problem is a version of the quest, both a search for the truth and an attempt to eradicate evil' (1980: 104). Grella notes that this plot structure aligns detective fiction with the romance tradition. Raymond Chandler draws attention to the medieval quest tradition by featuring the painting of a knight-errant on the opening pages of his first novel, *The Big Sleep* (1939). The insertion of an unknown factor into the narrative sentence (whodunit?) also means that these narratives find closure in revelation. In 'The Simple Art of Murder', Chandler notes that murder fiction necessarily recounts the detective's 'adventure in search of a hidden truth' (1946: 237). The revelation of the 'hidden truth' results in a moment of discovery and disclosure leading to a reversal of fortune, similar to the ending of classical tragedy. There are thus two powerful motives driving the quest-engines of murder narratives: the pursuit of an agent and the discovery of the whole truth.

Because it appropriates the basic quest formula, murder fiction lends itself to a functional analysis. That is to say, the characters in this fiction can be sorted according to the function they perform in the basic narrative sentence. Functional analysis identifies six basic principles in a quest narrative: the Sender, the Subject, the Object, the Helper, the Opponent and the Receiver. The Sender is the one who assigns the quest to the Subject, whose objective is the Object of the quest. For example, in *The Lady in the Lake* (1943), Derace Kingsley (of the race of kings) asks Philip Marlowe (the would-be Malory) to find his missing wife Crystal (an object of value). In the course of the quest, the Subject encounters those who assist him and those who try to thwart him – Helpers

and Opponents. The successful conclusion of the quest returns the Object to the Receiver (who is frequently the Sender himself). In the basic mystery or detective formulation, the Detective/Subject is appointed or hired by the Client/Sender to find the murderer and the truth. The Subject encounters and interviews various Helpers and Opponents and eventually delivers the Truth/Object (in most cases the identity of the murderer, usually one of the Helpers or Opponents) to the Client/Sender/Receiver. The tangled events surrounding the murder or crime are reworked into a meaningful narrative, and the quest is at least partly successful.

Critics such as Julian Symons and Tony Hilfer have identified a distinctive sub-genre within murder fiction, which they call the 'crime novel'. The crime novel lives up to its name by violating a basic convention of mystery and detective fiction: it tells the story from the point of view of the perpetrator – the pursued criminal becomes the main protagonist. Crime fiction shifts interest from mystery and its (always rational) detection and solution to its criminal protagonist and the irrational aspects of human psychology: 'The crime novelist tends to make the story secondary to the characters' (Symons 1975 [1972]: 185). In addition, because the story unfolds from the point of view of the criminal, readers already know 'whodunit', so what is unknown necessarily shifts. P. D. James suggests that the 'prime interest in the crime novel may be the effect of this crime on the murderer himself' (quoted in Hilfer 1990: 2). Readers of crime fiction want to know what happens to the protagonist, what she or he will do next, and whether it will result in another victim. They wonder if the perpetrator will 'get away with it'. As Todorov notes, in novels of this sort, the reader's interest shifts from curiosity (the basic readerly motive for mystery fiction) to suspense (1977: 47). It seems no accident that Patricia Highsmith refers to her own *oeuvre* as 'suspense fiction'.

Explaining the genesis of his own crime fiction, James M. Cain says that he felt '[m]urder [...] had always been written from its least interesting angle, which was whether the police could catch the murderer' (Cain n.d.: ix). Cain determined to look at murder from the vantage point of the murderer. This simple move has profound consequences for crime fiction, consequences that a functional analysis can effectively identify, in so doing accounting for the subgenre's peculiar effect on readers. For one thing, in crime fiction the narrative sentence goes from simple to compound. The text necessarily contains two separate storylines: the protagonist as Subject of his own search (for selfhood, for safety, for treasure, etc.); and the protagonist as Object of the search for the perpetrator, usually carried out by surrogate Subject-figures such as the police or private detectives. There is always a double quest. In terms of the quest motif, it is appropriate to use the noun 'pursuit', insofar as the phrase 'pursuit of crime' embeds the double-plot structure of the narrative: the protagonist as Subject of his own pursuit and as Object of pursuit by others.

Hilfer and other critics have drawn attention to the fact that schizophrenia seems to haunt the crime novel's protagonists. Hilfer rightly adds that the reader gets caught

up in the narrative's psychopathology and is converted into something 'discomfitingly close to guilty bystander' (1990: 4). A functional analysis of the subgenre takes Hilfer's analysis a step further by accounting for this curious effect. It explains *why* the schizophrenia affecting the protagonist is so contagious, and how it manages to 'finger' its readers. They inevitably and effectively experience the doubleness informing the text. Readers in effect conduct their own 'pursuit of crime', functioning as both Subject and Object of the double-quest structure. As a result, reading a crime novel can be a very disquieting experience. A functional analysis of two classic crime novels clarifies the etiology of the readers' anxiety and discomfort.

Cain's *Double Indemnity*

> I thought of hunters stalking big game, and while they did so, the game closed in on its own prey, and with the circle eventually completing itself, unknown disaster drew near to the hunters.
>
> – Kenneth Fearing, *The Big Clock*

As noted above, crime fiction necessarily involves the 'pursuit of crime', the phrase capturing the double action informing the subgenre. Turning to Cain's *Double Indemnity* (1936), we are obliged by the novel's discourse to substitute a slightly different but related predicate, that of predation. Several of the characters in the novel are out to 'make a killing', in its double sense: to perform a murder of some kind in order to win a prize or make a bundle. *Double Indemnity* is a novel comprised of predators who have identified their apparently helpless prey and swoop in to finish it off, only to find out that that action inevitably converts them into prey; a novel in which the apparently clear-cut line between predators and prey is blurred and twisted, the hierarchical structure frequently inverted.

There are three main layers of predation in Cain's novel. First Walter Huff and Phyllis Nirdlinger scheme to do away with her husband in order to cash in on an accident insurance policy. Once the murder has been perpetrated, Walter and Phyllis warily circle one another, each trying to figure out how to convert the other from predator into victim. Meanwhile, Walter's supervisor Keyes tracks down and trails the various suspects and witnesses in the case, eliminating the false clues and targeting the co-conspirators in order to save the insurance company's money. As will be seen, the novel seems predisposed to multiply Subjects and Objects, Pursuers and Pursued, Predators and Prey.

The novel begins with a quest in a minor key. Huff drops by the Nirdlinger house in order to get Mr Nirdlinger to renew his automobile insurance. That Huff is something of a shrewd operator, and therefore an able predator, is made clear by the clever strategy he uses to get past the servant who opens the door. He attributes his success to his

uncanny ability to size people up: 'you sell as many people as I do, you don't go by what they say. You feel it, how the deal is going' (Cain 1989 [1936]: 6). Walter may congratulate himself on his discernment, but he initially misreads Mrs Nirdlinger, who strikes him as 'sweet' but 'washed-out' (5). He soon becomes aware that under her blue lounging pyjamas is 'a shape to set a man nuts', and his skin quite literally crawls when she looks straight at him, as if targeting him, and asks about accident insurance for her husband. He nonetheless arranges another meeting with her at his apartment where they consummate the relationship, and the contract to murder the husband is sealed.

In functional terms Phyllis serves as Sender, Receiver and Object insofar as she initiates the plan, stands to profit from the insurance payout and offers herself as object of desire, the multiple roles suggesting the slipperiness of her identity. While Phyllis is indeed an object of desire, for Huff she is also a means to another end. As Irwin observes,

> [t]he speed with which Huff agrees to help Phyllis kill her husband for the insurance money, and with which he then generates the plan for the perfect crime, makes it clear he'd been thinking about this possibility long before they'd met.
>
> (Irwin 2002: 259)

Evidently Huff had been looking for a way to beat the insurance system, which he thinks of as 'the biggest gambling wheel in town':

> one night I think up a trick and get to thinking I could crook the wheel myself if I could only put a plant down there to put down my bet. That's all. When I met Phyllis I met my plant.
>
> (Cain 1989 [1936]: 234)

Walter mistakenly believes that in masterminding Nirdlinger's murder he is the croupier in charge of the crooked roulette wheel and that Phyllis is his plant – his patsy, his pawn, his prey.

He of course underestimates Phyllis, who is in fact the consummate predator. When Huff prematurely uses the word 'murder' during a conversation, he is surprised at her reaction: 'I thought she'd wince [...] She didn't. She leaned forward. The firelight was reflected in her eyes like she was some kind of leopard. "Go on. I'm listening"' (20). Once the word 'murder' is spoken and the hunt is on, the real beast of prey makes her appearance. Huff may initiate the talk of murder, but Phyllis turns out to be the experienced killer. As Huff learns from Keyes at the end, Phyllis is suspected of four other murders and is linked to five more suspicious deaths, all orchestrated in order to gain control of several estates. Huff's competent planning of the minute mechanics of murder pales before Phyllis's grand scheme of mass murder and appropriation.

Right after the murder is committed, the couple turn on each other. With Phyllis

raving and Walter snapping, the two predators square off over their victim: 'There we were, after what we had done, snarling at each other like a couple of animals, and neither one of us could stop' (52). The relationship between the 'snarling animals' is, however, hardly equal. After swearing eternal love to Phyllis during one of their post-murder phone calls, Huff admits to the reader: 'I loved her like the rabbit loves the rattlesnake.' That simile captures the true order of the predator relationship. Huff understands that the murder has shifted the balance of power between him and Phyllis: 'I had put myself in her power, so that there was one person in the world that could point a finger at me, and I would have to die' (70). The pointing finger reference makes Phyllis into the huntress who has him in her sights. Huff goes from Subject to Object, from successful predator to helpless prey, in an instant.

Soon after the murder, Phyllis takes up with her stepdaughter's boyfriend Sachetti, possibly with the intent to involve him in her machinations. When Walter learns of Sachetti's attentions, he realizes that he might be the 'plant' in Phyllis's master plan. Backed into a corner, now in love with Lola Nirdlinger, Huff decides that his only recourse is to do away with Phyllis and frame Sachetti for the murder. Again he makes an elaborate murder plan, but again Phyllis is one step ahead. At the appointed rendezvous spot, he rolls the car window down, hears the snapping of twigs as Phyllis stalks him, and takes a bullet in the chest: 'I had come there to kill her, but she had beaten me to it' (94). Keyes effectively summarizes the situation when he tells the wounded Huff that he got himself 'tangled up with an Irrawaddy cobra' (105), the second reference to Phyllis as a mesmerizing and deadly snake.

Huff starts out thinking he's a smart enough 'croupier' to 'crook' the roulette game that is the insurance business, but it is Huff's supervisor Keyes, the agent for 'the house', who turns out to be the true predator of the group, something Huff suspects from the very beginning: he introduces Keyes as 'a wolf on a phony claim' (8), identifying him as the 'best claim man on the Coast, and [...] the one I was afraid of' (56). In his first appearance in the novel, in fact, Keyes is acting as top dog, 'roaring' about a phony truck policy and treating Huff like a side of 'beef'.

Because of the double indemnity clause, Keyes knows instinctively that Nirdlinger's death is no accident and no suicide, that the beneficiary wife was party to the murder, and that she had a paramour accomplice. He soon figures out how the murder was accomplished and decides that his best hunting strategy is to stalk the 'bereaved' widow. After Phyllis shoots Walter, Keyes correctly reads the feelings that Huff has for Lola and turns the pressure up on the insurance agent by suggesting that Lola shot him and that the way to prove it is to use a rubber hose on the girl. Cornered and desperate, protective of the girl, Walter sacrifices himself by confessing to the murder. Keyes is not, however, done. In order to clean up the messy affair, he administers the *coup de grace*. He plays 'matchmaker' (113) and arranges a kind of 'honeymoon' cruise to Mexico for Huff and Mrs Nirdlinger, knowing that the two will inevitably prey on each

other. Huff's getting involved in a murder scheme with this woman under the watchful eyes of father-figure Keyes suggests some kind of death wish, one that both superior predators eventually grant.

It becomes clear to readers that Walter is, in fact, near the bottom of the food chain in his predatory world. He is a self-deluded plant and a self-destructive sucker, Object of various pursuers and Subject of a futile pursuit. At one point or other, most of the characters are hunting for him, and he becomes the novel's ultimate victim, in so doing earning the readers' sympathy. But readers also admire his intelligence, as manifested in the elaborate schemes he constructs to perpetrate his crimes. Irwin calls these schemes 'the most engrossing passages' in the novel: 'what is evident is Huff's pleasure both in exhibiting his own cleverness to the reader and in outwitting the people he works for' (2002: 260). Huff's intelligence also shows itself in his searing indictment of the 'insurance' business as an elaborate and rigged game of chance. The fact that he challenges the house, and that he sacrifices himself for Lola, win for him the reader's regard.

More important, the reader identifies with him; as Subject he effectively ingratiates himself to the reader, who becomes a co-Subject pursuing the same Objects – beating the house, outsmarting the vamp, winning the love of a good woman. Huff's first-person narration inevitably underwrites the process of identification, and what he narrates is a confession, an act which solicits the reader's admiration. The man is both coming clean and paying the maximum price for his transgressions, which he apparently regrets. Everyone feels for a repenting sinner, especially one who tells his own story.

But when Cain discusses the central theme of all his fiction, he hints at a more subtle reason why readers identify with Huff: 'I [...] write of the wish that comes true, for some reason a terrifying concept, at least to my imagination. [...] My stories have some quality of the opening of a forbidden box' (cited in Irwin 2002: 265). Cain here describes his protagonists as offspring of Pandora, with a beautifully embellished and absolutely lethal box before them, an Object which tantalizes their curiosity. But readers too figure as Pandora, with a carefully crafted literary artefact (in the shape of a box) before them. And like Pandora they know that it might be dangerous to lift the cover and look within; they are, after all, holding a crime novel. Reading crime fiction is a matter of inevitably opening the box and hoping against hope.

Huff begins the last chapter of his confession as follows: 'What you've just read, if you've read it, is the statement [that he has prepared at Keyes's insistence]' (Cain 1989 [1936]: 112). The interpolated dependent clause, 'if you've read it', is gratuitous. Once the devotee of crime fiction opens the box and reads a few sentences, turns a couple of pages, he or she is hooked, caught up in the contagion of the pursuit of crime, under the spell of the narrating voice, watching and living the unfolding debacle.

Patricia Highsmith's *The Talented Mr Ripley*

You! Hypocrite lecteur – mon semblable – mon frère!

<div align="right">– T. S. Eliot, The Waste Land</div>

The opening sentences of Patricia Highsmith's *The Talented Mr Ripley* (1955) are exemplary in regard to the motif of the 'pursuit of crime': 'Tom glanced behind him and saw the man coming out of the Green Cage, heading his way. Tom walked faster. There was no doubt the man was after him' (1975 [1955]: 1). We meet Tom Ripley on the run, the Object of a pursuit. That Tom has reason to feel guilty and therefore the possible object of a 'collar' is made immediately clear: 'Was that the kind they sent, maybe to start chatting with you in a bar and then *bang!* – the hand on the shoulder, the other hand displaying a policeman's badge. *Tom Ripley, you're under arrest*' (1–2, original emphases). Tom has been perpetrating a futile IRS scam and is therefore guilty right from the start. Over the course of the novel, readers watch him escalate his criminal ways to forgery, theft and murder.

The man originally pursuing Tom is not a law officer but a worried father looking for help with his wayward son. Herbert Greenleaf tracks Ripley down to ask him to go to Europe and persuade his son Dickie to come home to New York. Highsmith thus starts the novel off by foregrounding the quest motif. Ripley, who will be the Object of an extensive police search later on, initially serves as the Subject of a quest commissioned by the Sender, Herbert Greenleaf. Ripley takes up the quest, but not from any knightly sense of loyalty or obligation; he is unemployed, bored and sick of the losers and deadbeats who make up his New York City acquaintance. Greenleaf is giving him the opportunity to start over. On the boat to Europe Tom feels 'as he imagined immigrants felt when they left everything behind them in some foreign country, left their friends and relations and their past mistakes, and sailed for America. A clean slate!' (1975 [1955]: 35).

Ironically, when Tom meets Dickie, he does in fact see the latter as an Object. Dickie, however, is not the Object that Tom will proudly bring home to Mr Greenleaf, but rather the Object of Tom's desire: 'The first step [...] was to make Dickie like him. That he wanted more than anything else in the world' (1975 [1955]: 53). This objective Tom achieves for a while, until Dickie balks at the homoerotic implications of the relationship and terminates it. He and Dickie have an argument, and Tom receives a letter from Mr Greenleaf 'firing' him from his original assignment. His romantic Object having eluded him, his quest abrogated, Tom chafes at the brusque and unfair way that he has been treated. But rather than lapsing into self-pity, as he might have done in New York City, the European version of Tom Ripley takes action. He strikes back at his principal tormentor in what he sees as the only logical way: he murders Dickie and assumes his identity. The Subject thus transforms himself into the Object, both by taking on the

identity of the Object and by becoming the Object of another search, the multifaceted attempt to find the missing Richard Greenleaf. At the same time Ripley remains the Subject of his own search for the selfhood and lifestyle that can satisfy him.

For the rest of the novel, Tom plays the roles of Tom or Dickie as circumstances dictate. When Tom is playing the role of Dickie, one that he relishes because of the wealth and status it gives him, he painstakingly avoids all those who knew Dickie personally, telling them that Dickie has gone into seclusion to work on his painting. Dickie's friends of course are anxious to see him and so participate in their own quest venture. At various times, Dickie's Mongibello companion Marge, Italian friend Fausto, and family friend Freddy Miles come looking for 'Dickie' in Rome.

Freddy's pushiness during their encounter leads to his murder, and Tom is forced to give up his impersonation and do away with Dickie once and for all. Not surprisingly, 'Dickie's' disappearance implicates 'Dickie' in Freddy's murder at the same time as it exculpates Tom Ripley. 'Dickie' and Tom thus become the Objects of a series of searches by any number of Subject figures. Marge, Freddy Miles, Fausto, Roverini the Italian policeman, Herbert Greenleaf and Alvin McCarron (the PI whom Greenleaf hires) all try to find Dickie and/or Tom. Tom/Dickie is interviewed by many of them, but not recognized as the Object of their search because he never appears as the character they are looking for. When the police interview him looking for Tom, he plays Dickie; when Marge shows up in Rome desperately seeking Dickie after Freddie's murder, he reverts to Tom. The question becomes: why do so many Subject figures fail to identify the Object of their quest? Even Tom wonders at their failure to 'find' that Object: 'There remained only one more step for them to take, and wasn't somebody going to take it today or tomorrow or the next day?' (1975 [1955]: 218). That step is never taken, in large part because of the talent ballyhooed in the novel's title.

Ripley had originally come to New York to be an actor, and acting, it turns out, is his one true talent. Hilfer has shown convincingly how the 'main thematic pattern in *The Talented Mr. Ripley* is Tom's confirmation in the belief that acting creates reality' (1990: 133ff.). Tom has an uncanny ability to slip into the role that people expect of him. In so doing, he becomes what they want him to be. As Hilfer argues, 'Tom's strength is in his indeterminacy of identity, in an emptiness of self that allows for the superior performance of roles' (1990: 134). A myriad of successful impersonations convince Ripley that acting creates reality, that fake appearances create 'real' realities. In time even his own 'self' turns into a put-on or put-up job; 'Tom Ripley' becomes purely a role to embrace and explore and enjoy, one capable of regular re-definition, not an identity that one is stuck with or circumscribed by. In Ripley's world, there are no identities, only roles.

In terms of the quest narrative, Tom has in fact successfully secured his Object: the Selfhood of a non-Self, the consummate actor, a perfect impersonator. Playing the Dickie role in Paris on Christmas Eve, Tom at last feels completely at ease:

> This was the clean slate he had thought about on the boat coming over from Amer-
> ica. This was the real annihilation of his past and of himself, Tom Ripley, who was
> made up of that past, and his rebirth as a completely new person.
>
> (Highsmith 1975 [1955]: 127)

The superb quality of his acting results in 'a completely new person', an active and act-
ing non-entity, someone who is able to avoid the long arm of justice. The Object of the
various searches is at the end of the novel a free and happy man, telling the cabbie to
take him to the best hotel in Athens.

But all this acting, this bouncing back and forth between two identities, does have
its cost; it lends itself to schizophrenia, a mental illness to which Tom Ripley apparently
succumbs. Throughout the novel, Tom refuses to take responsibility for his actions. He
remembers stealing a loaf of bread when a child and feeling no guilt because 'the world
owed a loaf of bread to him, and more' (1975 [1955]: 40). He frequently resorts to the
argument from circumstance, claiming that he had no choice but to do what he did. He
blames his Aunt Dottie for his lack of perseverance and imagines striking out at her vio-
lently (39). He in effect holds Dickie responsible for his own death: 'Dickie was just shov-
ing him out in the cold. If he killed him on this trip, Tom thought, he could simply say
some accident had happened' (100). In an identical way he blames Freddie Miles for the
latter's murder. This refusal to take responsibility, the condition of blaming the world,
might be seen as the first symptom of mental disease, an incipient paranoia based on
the conviction that the world is out to get one.

The incessant role-playing that Tom indulges in exacerbates the condition, re-
sulting in full-blown schizophrenia. Once he has assumed Dickie's identity, for exam-
ple, he puts money from the Greenleaf bank account into the Ripley account because
'[a]fter all, he had two people to take care of' (1975 [1955]: 135). On the boat to Palermo,
after having escaped the clutches of Marge in Rome, he wonders if she now understands
that '[h]e and Dickie were very happy together, and that was that' (179). When Ripley is
forced to do away with his 'Dickie' persona, he justifies it to himself as follows: 'Being
Tom Ripley had one compensation, at least: it relieved his mind of guilt for the stupid
unnecessary murder of Freddie Miles' (194). Tom's matter-of-fact schizophrenia here
absolves him of the guilt for 'Dickie's' violent actions. Readers must remind themselves
that it was Tom masquerading as Dickie who killed Freddy.

Tom's schizophrenia clearly results from the two roles he is forced to play once he
has 'become' Dickie. It is also acted out in the 'figural' narration adopted by Highsmith,
which keeps Ripley in the third person, but locks the reader into his point of view at
the moment of the narrative's unfolding. In this way Highsmith makes Ripley into both
the subject of a set of experiences and the object of the reader's regard. She objectifies
Ripley while at the same time encouraging the reader to identify with him. But func-
tional analysis of crime narratives points out that all criminal protagonists necessarily

play two roles: that of Subject of their own pursuit(s) and that of Object of their various pursuers. It follows then that crime narratives told from the vantage point of the criminal are inherently schizoid. Functional analysis thus accounts for Hilfer's observation about 'Tom's schizophrenic tendencies' (1990: 133). The crime narrative's compound sentence inevitably makes every protagonist prey to such splitting.

Ripley's mental illness also manifests itself in paranoia. At the beginning of the novel he is being shadowed by an unknown pursuer. In Rome Tom is apparently followed home by a 'sick, passionate pursuer' with 'a dark, panting young face' (1975 [1955]: 152). In Venice Tom thinks he is being watched all the time: he suffers from 'the feeling that he was being followed, especially when he walked through the long narrow street to his house door' (218). For this reason, he worries incessantly:

> Nowhere to run if he were attacked, no house door to duck into. Tom did not know who would attack him, if he were attacked. [...] He was afraid of nameless, formless things that haunted his brain like Furies.
>
> (Highsmith 1975 [1955]: 218)

But even when Ripley is not being followed, he suspects that he is: 'If there was any sensation he hated, it was that of being followed, by *anybody*. And lately he had it all the time' (10, original emphasis). And, of course, he *is* being followed all of the time – by the Fury-ous readers of the novel, who follow his tracks everywhere and share his experiences, anxieties and suspicions. We trail after him; we tail him; we follow his lead. In every way we are his *followers*. That Highsmith is aware of this compromising position seems clear from the fact that she subsequently pens a narrative called *The Boy Who Followed Ripley* (1980).

The most disquieting fact about reading crime novels such as *The Talented Mr Ripley* is that the schizophrenia depicted within it is contagious; it leaks out and readers invariably 'catch' it. Experiencing crime from the point of view of the criminal renders readers of two minds, both of them functions of the double-quest storyline. Since readers know that Ripley is the guilty party, the Object of the search, they feel an obligation to act as loyal Subjects, officers of the Law, and see that he is brought to justice. He can't get away with it, they think. At the same time, being on the inside, part of an inside job, makes readers into co-Subjects who want Ripley to escape punishment. The Law's arm is long, but maybe we can get away with it! Subjects and Objects of the pursuit of crime, readers become 'sick, passionate pursuers' with 'dark, panting faces'.

The best crime fiction inevitably turns readers into accessories after the fact. As a female character in perhaps the greatest crime fiction of all effuses to the saintly Alyosha Karamazov,

> 'Yes, yes! You have expressed my thought, [people] love crime, everyone loves

crime, they love it always, not at some "moments". You know it's as though people have made an agreement to lie about it ever since. They all declare that they hate evil, but secretly they all love it.'

(Dostoyevsky 1976 [1880]: 551)

By way of response Alyosha poses one simple question that succinctly identifies how people indulge this forbidden love: '[A]re you still reading nasty books?' (551). The nasty books comprising the crime fiction canon allow readers to be at once both voyeurs and participants in the pursuit of crime. *

REFERENCES

Cain, James M. (1989 [1936]), *Double Indemnity*, New York: Vintage.

----- (n.d.), 'Preface', *Three of a Kind*, London: Robert Hale. pp. v–ix.

Cawelti, John G. (1976), *Adventure, Mystery, and Romance*, Chicago: University of Chicago Press.

Chandler, Raymond (1946), 'The Simple Art of Murder', in Howard Haycraft (ed.), *The Art of the Mystery Story: A Collection of Critical Essays*, New York: Simon and Schuster, pp. 222–37.

Dostoyevsky, Fyodor (1976 [1880]), *The Brothers Karamazov*, Norton Critical Edition (trans. Constance Garnet; ed. Ralph E. Matlaw), New York: Norton.

Grella, George (1980), 'The Hard-boiled Detective Novel', in *Detective Fiction: A Collection of Critical Essays* (ed. Robin W. Winks), Englewood Cliffs, NJ: Prentice-Hall, pp. 103–20.

Highsmith, Patricia (1975 [1955]), *The Talented Mr Ripley*, Harmondsworth: Penguin.

Hilfer, Tony (1990), *The Crime Novel: A Deviant Genre*, Austin: University of Texas Press.

Irwin, John T. (2002), 'Beating the Boss: Cain's *Double Indemnity*', *American Literary History*, 14: 2, pp. 255–83.

Malmgren, Carl D. (2001), *Anatomy of Murder: Mystery, Detective, and Crime Fiction*, Bowling Green, OH: Bowling Green University Press.

Symons, Julian (1975 [1972]), *Bloody Murder: From the Detective Story to the Crime Novel*, Harmondsworth: Penguin.

Todorov, Tzvetan (1977), *The Poetics of Prose* (trans. Richard Howard), New York: Cornell University Press.

‘I had killed a man, for money and a woman. I didn't have the money and I didn't have the woman.’

WALTER HUFF

From Antihero to Superhero: Tom Ripley Fanfiction

Jacqui Miller

Tom Ripley as a cultural phenomenon

Tom Ripley is a character of many incarnations. Originally the literary creation of Patricia Highsmith, there are five novels in her Ripliad (1955–1991). There are also five film adaptations of three of the novels: two versions of *The Talented Mr Ripley* – *Plein Soleil/ Purple Noon* (Rene Clement, 1960) and *The Talented Mr Ripley* (Anthony Minghella, 1999); two of *Ripley's Game* – *Der Amerikanische Freund/The American Friend* (Wim Wenders, 1977) and *Ripley's Game* (Liliana Cavani, 2002); as well as *Ripley Under Ground* (Roger Spottiswoode, 2005). To these may be added numerous television, radio and stage adaptations. During the course of the novels, Ripley evolves, most notably from a gawky, if self-seeking, youth of 25 in *The Talented Mr Ripley*, to a self-assured man of independent and ill-gotten means in his mid-thirties by the time of *Ripley Underground*, but he continues to develop in terms of self-reflection, especially with regard to his criminality through the remaining three books. Each of the cinematic Ripleys is quite different, and I have written elsewhere about Ripley as a textual palimpsest (Miller, in press).

As well as having a wide range of manifestations, Ripley is a character that excites high emotions in academic and review discussions. I have described him as 'a sociopathic killer but also one of the most beguiling characters in modern literature' (Miller 2010: 151), while Fiona Peters sees him as 'charismatic' with 'perverse charm' (Peters 2014: 282). In his review of Minghella's film Roger Ebert says, 'He's a monster, but we want him to get away with it' (Ebert 1999). There is also fierce debate about which adaptation is the 'best' Ripley: 'Matt Damon might make a credible Tom Ripley, but only for those who never experienced Alain Delon's portrayal' (Berardinelli 2006). Some of this has to do with the snobbish/populist tussle between defenders of the art house versus mainstream Hollywood, but it is also the case that every Ripley reader and viewer tends to believe that they are the only ones who know the 'real' Ripley; this phenomenon is most marked in the considerable body of Ripley fanfiction.

To be a 'fan' in the era of fanfiction is more than to merely enjoy or admire an

artist or character, it is to revise the character, to reclaim them according to the way you perceive them to be. This chapter will examine Ripley fanfiction making a comparative analysis of the layers of Ripley's reinscriptions, from the *The Talented Mr Ripley* (1955) through to Minghella's adaptation, to a range of fanfiction interpretations. Particular consideration will be made of the extent to which fans amplify the homoeroticism implicit in Highsmith's novel and confirmed in Minghella's film, but also the elision of Ripley's dark side, the ambiguity that made him so intriguing both to academics and reviewers. Through constructions of his meek vulnerability and redemption through love, neither characteristic being a facet of Highsmith's work, the fanfiction heroizes and reclaims Ripley rather than concurring with his antiheroic status in the novel's primary text.

Ripley and fanfictive revisions

Fandom is not a new phenomenon. The cult of Janeitism dates to the publication of *A Memoir of Jane Austen* (Austen-Leigh 1869) but, the proliferation of fandom has increased in tandem with the development of new technologies on the one hand, bringing the objects of fandom to their devotees, and on the other, bringing fans into easy proximity with each other. Thus the printing press, radio, cinema and television in turn increasingly generated objects of fandom, whilst the Internet not only increased that possibility, its social media enabled fans to form communities. If fandom itself has a long history, its academic study is a recent and growing discipline. Developing the audience theories of Stuart Hall (1980) and Michel de Certeau's definition of 'textual poachers' (1984), in which spectators will 'reread' a text in the light of their own context, Henry Jenkins published the foundational text of fan theory, *Textual Poachers: Television Fans and Participatory Cultures* (1992). Thus fans may not only reinterpret a text in the sense of having a different opinion of a character or their motivations, but will themselves create new works based on but revising the events of the original. These include films, art and songs, but fanfiction – with stories varying from a few sentences to multiple volumes – are its most common form.

Fanfiction arising from Patricia Highsmith's work began, not directly from her writing but from Anthony Minghella's film of *The Talented Mr Ripley*. Although there is no fanfiction based on her other writings, or from any other adaptations, there is a significant body of fanfiction from this film, taking the form of short stories mainly posted at two sites, www.fanfiction.net and http://archiveofourown.org/, as well as individual posts on fans' http://www.livejournal.com/ sites. These stories, and the fans' motivations for writing, reveal not only evidence to support aspects of fandom theory – such as fanfiction as a rebuttal of the notion of a passive audience (Harris 1998: 42), and the complexities of the sexualization, particularly the queering of the source text (Green, Jenkins and Jenkins 1998) – but also demonstrate the continued proliferation and liminality of the cultural phenomenon of Tom Ripley.

Highsmith's Ripley is from the outset a law breaker. When we first meet him, he is practising, more or less for his own amusement (as he cannot gain from it financially), a tax fraud. He is also intrinsically dishonest, recalling a possible description of himself as 'intelligent, level-headed, scrupulously honest, and very willing to do a favour' as 'a slight error', the error being the honesty (Highsmith 1990 [1955]: 8), and he is a compulsive liar: 'That had been the only time tonight when he had felt uncomfortable, unreal, the way he might have felt if he had been lying, yet it had been practically the only thing he had said that *was* true' (1990 [1955]: 20, original emphasis). Later, he premeditates and carries out the murder of Dickie Greenleaf, partly because Dickie has grown tired of his friendship, and partly because 'he could become Dickie Greenleaf himself' (87). To secure his safety he also kills Freddie Miles and forges Dickie's will in his own favour. In the subsequent four novels, as well as gaining the majority of his income from various illicit means, he kills, either to protect himself or a character with whom he feels some connection, several more times, as well as choosing not to save the lives of others. In *The Talented Mr Ripley*, he is at first, not without feelings of guilt and inadequacy, mostly because he lacks self-discipline: 'He tried to take an objective look at his past life. The last four years had been for the most part a waste, there was no denying that' (Highsmith 1990 [1955]: 34). He is however ambitious, beginning a transformation on the journey to Europe to find Dickie, concerned with 'the present and future of Tom Ripley' (36), a transformation that is catalysed by Dickie's murder, and although this is at first fulfilled by taking on Dickie's persona, his confidence grows further after resuming the character of Tom Ripley: 'He had decided in Venice to make his voyage to Greece an heroic one. He would see the islands [...] as a living, breathing, courageous individual – not as a cringing little nobody from Boston' (238–39). Minghella chose to make Ripley both more conventionally sensitive and less complex. He lacks the original's neurosis, such as the emotional collapse – muttering 'I want to die' (79) – that he suffers when he feels Dickie's friendship ebbing, but also his cold-blooded premeditation. Minghella's Ripley attacks Dickie after intense verbal provocation: Dickie thinks he's 'a leech', 'boring', 'a third class mooch', and he instantly regrets the violence, finally killing Dickie in self-defence, and adopting his identity not by original design, but because the idea is planted by a hotel desk clerk who mistakenly calls him Mr Greenleaf. The film opens and closes with Ripley's regret at killing both Dickie and Peter Smith-Kingsley, wishing that he could 'go back'. For Minghella it was imperative that crime should not pay: 'There should be something about killing in the film which is primal and taboo-like, as if the character were crossing some kind of divide. Once he has the mark of blood on him, he can never go back' (Bricknell 2005: 168). Minghella may have deliberately subverted one of the key reasons for Highsmith's readers' perpetual fascination with antiheroic Ripley: 'A legitimate gripe that the fans of the novel might voice is that I entirely missed the point of the book, because the book celebrates an amoral character who gets away with murder and doesn't seem to suffer for it' (Bricknell 2005: 167), but in fact he extends his victims to include the amplified charac-

ter, Peter Smith-Kingsley, with whom the novel's Ripley has only a fleeting acquaintance, and of whom he dismisses the thought that 'the same thing could happen with Peter' on the grounds that they look too dissimilar (Highsmith 1990 [1955]: 236). The majority of fanfiction writers, in common with Minghella, and usually taking his film as their basis, soften and sensitize Ripley's character, but, most startlingly, for the most part, remove his criminality, especially the murders.

Ripley gets in touch with his sensitive side

The fanfiction story 'Don't Change a Hair for Me' (Maxette 2013) has Marge playing matchmaker by introducing Ripley to Peter Smith-Kingsley, revising the point in the film when Ripley's being dropped from the Cortina jaunt presages his disappointment that soon leads to Dickie's death. Instead, Ripley and Peter fall in love. Ripley's worst 'crime' in this story is deceit; as the three meet by accident, Ripley is exposed to Peter as having masqueraded to Meredith Logue (a character invented for the film) as Dickie. Later Ripley confesses other deceptions to Peter, such as not attending Princeton, but Peter's understanding provides a happy ending as Ripley thanks Peter for 'having saved his soul'. The author's notes specifically acknowledge 'canon divergence' – presumably from the film – with the justification that 'Peter really GETS Tom [...] and if they'd only met sooner Tom probably wouldn't have killed anybody and we would have had a lovely gay romance instead of this creepy psychological thriller' (Maxette 2013). Jestana's (2013) 'The Real Tom Ripley', the notes to which tell us 'Peter is the only person who seems to like the real Tom', has a similar scenario and ends with Ripley thanking Peter for being 'the first person who's ever wanted *me*' (original emphasis). In other stories, Ripley has killed Dickie and Freddie. As I have shown earlier, the novel's Ripley is capable of guilt, but this is because of self-interest, having let down his own ambition. Fanfiction gives him guilt at 'wrongdoing' that the literary character wouldn't recognize. In babel's (2014) 'This Lost Lamb', written from Peter's perspective, Tom raises the issue of lying, and starts to cry, presumably in anticipation of strangling Peter, and making 'tragic' their 'great love story'. In SevlinRipley's (2013) 'Hush', Ripley breathes, '"I'm sorry. I'm so sorry" [...] into the wet sponge that is his pillow. No, no, not his pillow. Peter's, before gathering strength to kill himself.' Suicide, unimaginable as an element of the literary Ripley's psyche, is also contemplated in 'For Peter' (Niciasus 2013). Highsmith's Ripley admits only once, to a young man with whom he feels an emotional connection, in *The Boy Who Followed Ripley* (1980), to having killed a man, but in 'For Peter' Ripley regrets confessing murdering Dickie and Freddie to Peter, because it had set in train another aspect to their relationship. 'When the time came,' Ripley thinks, 'he would do the honourable thing and set them both free. Or maybe not.'

Ripley as 'a lost lamb'

The motivations for revisions relate to the fanfiction writers' reinterpretation of Ripley's character and circumstances, which in turn have a basis in aspects of fandom theory. Ripley's Highsmith is personally impoverished, but he comes from a moneyed extended family. Between jobs, he survives on Aunt Dottie's occasional cheques, particularly resented for their random piffling amounts, 'considering what [she] might have sent him, with her income' (Highsmith 1990 [1955]: 33), and later inherits $10,000 in her will (Highsmith 1980: 56). Likewise, Ripley may not share his rarefied economic and social rank, but he *had* socialized with Dickie in New York and was recommended by mutual acquaintances to Mr Greenleaf as a likely candidate to persuade him to return home. From the outset Minghella demotes Ripley socially, he is working as a men's lavatory attendant, and it is the accident of Ripley's borrowed Princeton jacket that catches Mr Greenleaf's eye, when in fact this incarnation of the character has not yet met his son. Ripley's déclassé status is emphasized when Dickie learns he can't ski: 'Such little class! Marge, can this guy do anything?' The fanfiction writers unequivocally make a virtue out of Ripley's impoverishment and mean status. 'Don't Change a Hair for Me' (Maxette 2013) specifically refers to his 'low class', while in Jane St Clair's (2011) 'Light', Peter is 'well aware that Tom's poverty is a deeper thing than he's ever revealed'. More significant than Ripley being merely financially down on his luck, is the vulnerability this creates. Highsmith's Ripley is capable, at least prior to Dickie's murder, of feeling sorry for himself, but at those moments he is singularly unappealing, for example when he met Dickie in Mongibello and 'envied him with a heart-breaking surge of envy and self-pity' (Highsmith 1990 [1955]: 47). Instead of the vulnerability being introspective, the fanfiction ennobles or heroizes Ripley through its imposition. The title alone of 'This Lost Lamb' (babel 2014) sets the tone. The story also describes Ripley as 'being like a little stray kitten who wants to be petted, but can't stand to be close', the metaphor continued in eyebrowofdoom's (2014) 'Sleeper' in which Ripley 'felt as needy as a stray cat [...] when Peter touched him'. It is this very vulnerability, his 'otherness' created by being poor and shy in a circle of the rich leisure class, that furnishes Ripley's appeal, in keeping with a fictive subculture in which 'issues of social class and power [are] dominant themes in understanding and building theories of fandom' (Harris 1998: 78).

Ripley comes out from behind the closet door

Ripley's vulnerability, as well as the acquisition of feelings unknown to Highsmith's character, is tied to another aspect of his 'otherness': sexuality. In the novel, he certainly has a fraught relationship to his sexual identity. When he realizes he is being followed in New York, Ripley is relieved that Mr Greenleaf 'certainly wasn't a pervert' (Highsmith 1990 [1955]: 6). A range of terms are used that might at first glance appear to have an equally

pejorative meaning for homosexual men: Marge suspects Ripley is 'queer' (70); Freddie 'was the kind of ox who might beat somebody up he thought was a pansy' (123); Aunt Dottie accuses Ripley of being a 'sissy' (86); and Dickie looks askance at a troupe of 'fairy' acrobats (86). In fact, to those immersed in 1950s urban subculture, as Highsmith and Ripley both were, these terms had very specific, not necessarily derogatory, nuanced meaning with reference to different 'types' on the scene, who chose to assume dress and behaviour codes as a signal of attraction for their desired partner. However, Ripley is tormented by his feelings for Dickie. On the afternoon he believes Dickie might be sleeping with Marge, he fantasizes about strangling her because 'You were interfering between Tom and me – no, not that! But there *is* a bond between us!' (69, original emphasis). When Dickie arrives home, to find Ripley trying on his clothes, Highsmith slyly draws on subcultural slang to capture Ripley's ambivalence and repression as he 'had been half concealing himself from Dickie behind the closet door' (70). The film both retains Ripley's repressed longing, and affirms Dickie's heterosexuality through his sexual relationships with Marge and an Italian girl. Dickie is also aware of his impact on Ripley. Over a game of chess played with Dickie in the bath – Ripley fully dressed – Ripley asks if he can get in because he's cold. Dickie declines, and Ripley stutters that he hadn't meant while Dickie was still in the bath, at which he gets out. In this notoriously erotic scene, Minghella seems to play to the fans. It is specifically Jude Law's rather than simply Dickie's (pardoning the pun) full-frontal nudity that is explicitly displayed, and a taunting 'look-fuck' is exchanged with a longing Ripley. Subsequently, Ripley's homosexuality is confirmed by his relationship with Peter, although his sexuality is still fraught. He has to kill Peter to maintain his cover, but in killing Peter whilst apparently initiating sex, he is perhaps repressing the sexuality that would undermine his disguise as Dickie and thus his status within the leisure class.

Fan writers cite various characteristics of their fiction, including the original source on which it is based, the characters involved, and more particularly the romantic pairings of the characters, as well as their sexual orientation. In the latter sense, the Ripley fanfiction is of a particular subgenre that predominates in fandom: 'slash', so-called because readers will understand that seeing names presented as e.g. Kirk/Spock, will mean the story will feature at the very least, an emotional relationship between the pair, which may also be sexual, the latter often coded as 'smut'. Of the stories I researched, all but one had at least one m/m, meaning male/male, pairing. In most of these instances, Tom Ripley was paired with Peter Smith-Kingsley, the exception being Tom Ripley/Dickie Greenleaf. The only m/f (male/female) pairing which did not also have an m/m relationship was of Marge Sherwood/Dickie Greenleaf, although even this story was ambiguous, featuring Marge alone, back in New York after Dickie's presumed although inexplicit death, lamenting the past ('each silvery star fades out of sight').

Fandom and stardom

Minghella's film has been singled out of Highsmith's work and its adaptations as an enduring inspiration and source of fascination for fan writers. Although the film was released in 1999, babel's 'This Lost Lamb' to take one typical example, was published on 22 December 2014 and its 'hits' increased from 104 on 20 January 2015 to 115 on 1 April 2015. Reading the stories, Minghella's casting and audience reception make clear why this is so, as the writers emphasize the star personae of the lead actors. Highsmith's Dickie, first seen almost prophetically cinematically through Ripley's eyes 'from a distance of about a block', is 'burnt a dark brown and [has] crinkly blond hair' (Highsmith 1990 [1955]: 40). Ripley bears enough superficial resemblance to Dickie to slip into his identity when tested against a passport photograph, but is aided by his essentially unremarkable looks, while we are given no description of Peter. Jude Law, according to the *FreshSite* 1999 poll the sixth sexiest male star (Fredrik Gunerius Fevang 2007–15), was physically a perfect fit for Dickie. Matt Damon, with one facial exception, accurately captured Ripley, but Jack Davenport in the significantly developed role of Peter, was a major catalyst for the fan writers.

Each character is fetishistically described by the writers, focusing on body parts and visual cues associated both with the actors' appearances and behaviour traits accumulated through past roles. Dickie, the male character who appears least often in the stories, captures Jude Law's Adonis-like physical perfection. Marnie's (2005) 'Victims' describes his 'improbable golden curls bared to the sun'; lyryk (s_k)'s (2003) 'Still Life', his 'glorious backside'; while Jainie's (n.d.) 'If Not Devotion...?' gives the full picture: 'the sheer physical perfection that Dickie Greenleaf embodied. Sandy brown hair touched with gold [...] Broad, brown shoulders, narrow waist and hips, carefully muscled arms and a firm, flat stomach.' Tom's looks are little described, with the exception of Matt Damon's trademark smile. In Maria Singer's (2000) 'Life in Venice', 'A huge grin engulfed Tom's face'; merely 'a big grin' in LadyBush's (2004) 'Not Whole for Love'; further exaggerated to 'beaming maniacally' in 'Sleeper' (eyebrowofdoom 2014); but softened to 'a pretty smile' in 'Don't Change a Hair for Me' (Maxette 2013). *The Talented Mr Ripley* was Jack Davenport's breakthrough film. Hitherto he was best known as a British television actor, particularly for his role as the outwardly abrasive but inwardly vulnerable lawyer, Miles, in *This Life* (BBC2, 1996–97), so for many fans introduced to him for the first time, his character was something of a blank canvas on which to define iconic trademarks which became hair and eyes. His eyes are variously 'deep brown' ('Sleeper' [eyebrowofdoom 2014]); 'kind' ('Life in Venice' [Maria Singer 2000]); and framed by communicative eyebrows ('Gaze No More' [Erjika Tevkana 2001a]). Peter's hair is 'deliciously tousled' (Erjika Tevkana 2001a) and brings his key features together when 'Tom couldn't believe how beautiful he was; his hair falling in his eyes' 'Could Be Normal' (Nightengale 2007).

As hinted at in some of these quotations, for the fans, the features described are not

merely aesthetically appealing, they encode the characteristics, exaggerated or revised, from the novel and/or film, that inspired the writers. Thus, Dickie is gloriously handsome, but in ways that convey an upper-class carelessness for the feelings of others. He wears 'his nudity with the kind of effortless confidence that Tom will never have' ('Still Life' [lyryk (s_k 2003]). Ripley's mainly nondescript looks reflect his lowly status: 'plain old Tom: the slightly scrawny kid' ('The Real Tom Ripley' [Jestana 2013]), while his smile encapsulates vulnerability: 'He grins boyishly [...] and he glances at you in this bashful, nervous sort of way' ('This Lost Lamb' [babel 2014]). Peter's eyes capture his unruffled kindness, even his eyebrows waggle masterfully ('Gaze No More' [Erjika Tevkana 2001a]) and his personality, constructed through his appearance, is an exact counterpoint to Dickie's cruelty. When first meeting him, Ripley notices 'that Peter's very handsome. Not handsome like Dickie – or, really, handsome exactly like Dickie, but not so flawlessly – he's water to Dickie's ice [...] and a smile that seems to give you something' ('Don't Change a Hair for Me' [Maxette 2013]).

These traits define the 'slash' relationships. Ripley now has genuine feelings for others, but they are shaped by Dickie's callousness, and Peter's compassion as he contrasts his experiences: 'I thought I was in love with Dickie. When he looked at me, I felt like I was the center of the universe, but when he looked away I was lost in the blur of the scenery'; 'When he [Peter] speaks, I can feel his words passing through his body into mine. I can feel the vibration, I can feel the muscles in his back shifting, I can feel how much I love him' ('What Love Is' [Karen Cecil 2004]).

These characteristics similarly define the erotic relationships. 'If Not Devotion...?' (Jainie n.d.) graphically rewrites the film's bathtub scene, but after 'Tom released the spent flesh and let his hand glide through the water and over Dickie's abdomen, gently cleaning any traces of the deed', Dickie's inherent coldness is reasserted as he tells Tom to get out in a tone that 'was sharp, impatient and impassive'. Conversely, the sex between Ripley and Peter is redemptive. In 'Life in Venice' (Maria Singer 2000), Peter offers the street-waif Ripley a home and a job, and in return, 'to make sure that Peter knew his intentions were honest, Tom pressed his mouth to his and kissed him deeply and passionately'.

Writing 'the real Tom Ripley'

The motivations for writing fanfiction have been theorized since the publication of Jenkins's *Textual Poachers*. The Ripley fanfiction broadly illustrates the range of key theses. On the one hand, all fanfiction essentially democratizes the act of writing, and is a popular embodiment of Roland Barthes's concept of 'the death of the author' (1967). Certainly, the fans emphasize the wrangle to really 'know' Ripley, epitomized in the title 'The Real Tom Ripley' (Jestana 2013). They also self-consciously reinterpret. Feline Artistry's (2010) author's notes to 'Out of the Nightmare' comment: 'Ever since I saw the movie, I wanted to fix the ending. I tried reading others' fics, but none of them seemed quite right.' Some also

invite revisions to their own work, such as SevlinRipley's (2014) note that 'There may also be a "choose your own adventure" chapter to "The completely necessary alternate universe where the characters of *The Talented Mr Ripley* attend Hogwarts"' ('301: Charading (is this love we're imitating)'). The emphasis captured in the title 'This Lost Lamb' (babel 2014) of investing Ripley's character with vulnerability, and often removing any criminality or social deviance, speaks to the opportunity fanfiction gives to valorize the socially and economically excluded, 'to redress their alienation through the social nature of fan practice' (Harris 1998: 5). This may also be linked to the graphic homoeroticism of many of the stories. Ripley's repression of his sexuality in the novels reflected Highsmith's own unease over her lesbianism in 1950s America, leading her to explore therapy that supposedly might enable her to marry and enjoy heterosexual sex (Wilson 2003: 147). Even for the virtuous Peter, lying 'rather comes with the territory [...] as a homosexual' in the 1950s ('This Lost Lamb' [babel 2014]). Rereading apparently 'straight' or at least ambiguous characters is a recognized conduit of self-empowerment and pleasure for fans. Michael de Angelis writes of his fantasies after seeing Mel Gibson play George in *The Road Warrior* (George Miller, 1981): 'realizing that I, and only I, had finally enlightened him to the joys of a same-sex sexual relationship' (DeAngelis 2001: 2). Likewise, fans celebrate Tom Ripley/Peter Smith-Kingsley pairings, such as the author of 'Cinquanta' (Elskegaderian 2006), who rates the story 'R, for sex [...] Good times!' Again, one of the most significant appeals to the fans is the blurring of Jack Davenport with Peter. The same writer notes, 'I *so love* Peter Smith-Kingsley; he's one of my favourite fictional characters in the history of ever.' 'Not Whole for Love' (LadyBush 2004) is dedicated to 'Jack Davenport, who really is beautiful', while Erjika Tevkana's (2001b) 'Mask and Mirror' has the author's note, 'I could take better care of Peter than Tom ⊗.' Moreover, many of the fans writing erotic slash are female. One theory underpinning this tendency is a female desire to reconstruct masculinity by inscribing male characters with 'emotional closeness' (Cicioni 1998: 158), and this chapter has cited numerous such examples within the stories. However, female fan authors also revel in the sexual explicitness of their writings. 'Don't Change a Hair for Me' (Maxette 2013) in which Peter 'nudges Tom's legs apart and presses his thigh to Tom's cock, which starts to harden immediately' ends with the author's note to the fan community: 'Lemme know if you want some sexy times – prompt me some kinks.' This exemplifies the title of the fan theory essay, 'Normal Female Interest in Men Bonking', in which one fan declares 'I'm prurient and salacious and simply *adore* to watch' (Green, Jenkins and Jenkins 1998: 17, original emphasis).

Conclusion

Fanfiction is a fascinating epigone in the extended Tom Ripley canon. It demonstrates the passion and even obsession Ripley incites as a cultural phenomenon – an author's note to 'Life in Venice' (Maria Singer 2000) comments wryly, 'Yes, another Ripley fan

fic – you'd think I'd something better to do with my time.' In so doing, it both utilizes aspects of Ripley's antihero status, his exclusion from the leisure class because of his initial impoverishment, whilst reinscribing this 'otherness' with a heroism comprised of his vulnerability and redemption through Peter Smith-Kingsley's love. Some fan authors take this further and posit Ripley not as an antihero, or a mere hero, but a superhero. In a throwaway moment in the film, Ripley calls Dickie, in his borrowed spectacles, 'Clark Kent', but without them he is 'Superman'. Drawing on fanfiction's origins in science fiction and comic book characters, 'Sleeper' (eyebrowofdoom 2014) makes a virtue, not a crime, from Ripley's ability to lie, in this instance to avoid meeting Meredith: 'He was superhuman in such moments: able to make and mend the whole universe.' Ripley literally is superhuman in 'The Real Tom Ripley' (Jestana 2013). His beguiling talent of reinvention is not mere imitation, but an ability to shapeshift. Seeing him literally become Dickie, Peter is shocked: 'I thought the rumours of people with superpowers were just silly nonsense.' Ripley replies: 'No, we're out there, but the few I know prefer to keep their powers secret.' *

REFERENCES

Austen-Leigh, J. (1869), *A Memoir of Jane Austen*, London: Richard Bentley and Son.

babel (2014), 'This Lost Lamb', *Archive of Our Own*, 22 December, http://archiveofourown.org/
 collections/yuletide2014/works/2825681. Accessed 3 February 2015.

Barthes, R. (1967), 'The Death of the Author' (trans. Richard Howard), *UbuWeb*, http://www.tbook.
 constantvzw.org/wp-content/death_authorbarthes.pdf. Accessed 10 February 2015.

Berardinelli, R. (2006), '*Purple Noon* (*Plein Soleil*, France 1960)', http://www.reelviews.net/top100/86.
 html. Accessed 10 September 2014.

Bricknell, T. (ed.) (2005), *Minghella on Minghella*, London: Faber and Faber.

Certeau, M. de (1984), *The Practice of Everyday Life*, Berkeley: University of California Press.

Cicioni, M. (1998), 'Male Pair-Bonds and Female Desire in Fan Slash Writing', in C. Harris and A.
 Alexander (eds), *Theorizing Fandom: Fans, Subculture and Identity*, Cresskill, NJ: Hampton Press.

DeAngelis, M. (2001), *Gay Fandom and Crossover Stardom: James Dean, Mel Gibson, and Keanu Reeves*,
 Durham, NC: Duke University Press.

Ebert, R. (1999), '*The Talented Mr Ripley*', http://www.rogerebert.com/reviews/the-talented-mr-
 ripley-1999. Accessed 15 September 2014.

Elskegaderian (2006), 'Cinquanta', *LiveJournal*, 25 July, http://dedicaces.livejournal.com/15088.html.
 Accessed 3 September 2014.

Erjika Tevkana (2001a), 'Gaze No More', *FanFiction*, 4 January, https://www.fanfiction.net/s/164294/1/
 Gaze-No-More. Accessed 5 October 2014.

––––– (2001b), 'Mask and Mirror', *FanFiction*, 7 January, https://www.fanfiction.net/s/168886/1/Mask-
 and-Mirror. Accessed 15 September 2014.

eyebrowofdoom (2014), 'Sleeper', *Archive of Our Own*, 20 December, http://archiveofourown.org/
 works/2806130. Accessed 16 September 2014.

Feline Artistry (2010), 'Out of the Nightmare', *LiveJournal*, 25 December, http://feline-artistry.
livejournal.com/96872.html. Accessed January 3 2015.

Fredrik Gunerius Fevang (2007–15), 'The 33 Most Handsome Male Movie Stars of All Time', *The FreshSite*, http://www.thefreshfilms.com/actors/30male.htm. Accessed 20 October 2014.

Green, S., Jenkins, C. and Jenkins, H. (1998), 'Normal Female Interest in Men Bonking: Selections from the *Terra Nostra Underground* and *Strange Bedfellows*', in C. Harris and A. Alexander (eds), *Theorizing Fandom: Fans, Subculture and Identity*, Cresskill, NJ: Hampton Press.

Hall, S. (1980), 'Encoding/Decoding', in S. Hall, D. Dobson, A. Lowe and P. Willis (eds), *Culture, Media, Language*, London: Hutchinson.

Harris, C. (1998), 'A Sociology of Television Fandom', in C. Harris and A. Alexander (eds), *Theorizing Fandom: Fans, Subculture and Identity*, Cresskill, NJ: Hampton Press.

––––– (1998), 'Introduction', in C. Harris and A. Alexander (eds), *Theorizing Fandom: Fans, Subculture and Identity*, Cresskill, NJ: Hampton Press.

Highsmith, P. (1990 [1955]), *The Talented Mr Ripley*, Harmondsworth: Essex: Penguin.

Jainie (n.d.), 'If Not Devotion…?', *All My Fault*, http://www.allmyfault.org/movieslash/if_not_devotion.txt. Accessed 4 October 2014.

Jane St Clair (3jane) (2011), 'Light', *Archive of Our Own*, 8 August, http://archiveofourown.org/works/236822?view_adult=true. Accessed 4 October 2014.

Jenkins, H. (1992), *Textual Poachers: Television Fans and Participatory Culture*, New York: Routledge.

Jestana (2013), 'The Real Tom Ripley', *Archive of Our Own*, 5 July, http://archiveofourown.org/works/870222. Accessed 1 February 2015.

Karen Cecil (2004), 'What Love Is', *FanFiction*, 17 May, https://www.fanfiction.net/s/1865672/1/What-Love-Is. Accessed 4 October 2014.

LadyBush (2004), 'Not Whole for Love', *FanFiction*, 23 December, https://www.fanfiction.net/s/2184355/1/Not-Whole-For-Love. Accessed 4 October 2014.

lyryk (s_k) (2003), 'Still Life', *Archive of Our Own*, 21 November, http://archiveofourown.org/works/179248. Accessed 4 October 2014.

Maria Singer (2000), 'Life in Venice', *FanFiction*, 11 December, https://www.fanfiction.net/s/137618/1/Life-In-Venice. Accessed 4 October 2014.

Marnie (2005), 'Victims', *FanFiction*, 28 July, https://www.fanfiction.net/s/2506345/1/Victims. Accessed 4 October 2014.

Maxette (2013), 'Don't Change a Hair for Me', *Archive of Our Own* , 9 September, http://archiveofourown.org/works/961333?view_adult=true. Accessed 4 October 2014.

Miller, J. (2010), 'An American in Europe: US Colonialism in *The Talented Mr Ripley* and *Ripley's Game*', *Journal of European Popular Culture*, 1: 2, pp. 151–60.

––––– (in press), 'The Tremors of Forgery: The Palimpsest of Tom Ripley's Identity', *Clues*.

Minghella, A. (1999), *The Talented Mr Ripley*, USA: Paramount/Miramax.

Niciasus (2013), 'For Peter', *Archive of Our Own*, 28 May, http://archiveofourown.org/works/821381. Accessed 4 October 2014.

Nightengale (2007), 'Could Be Normal', *FanFiction*, 23 March, http://www.fanfiction.net/pm2/post.

php?uid+27846. Accessed 4 February 2015.

Peters, F. (2014), 'The Perverse Charm of the Amoral Serial Killer: Tom Ripley, Dexter Morgan and Seducing the Reader', in U. Elias and A. Sienkiewicz-Charlish (eds), *Crime Scenes: Modern Crime Fiction in an International Context*, Frankfurt: Peter Lang.

SevlinRipley (2013), 'Hush', *Archive of Our Own*, 27 July, http://archiveofourown.org/works/900256. Accessed 4 November 2004.

————— (2014), '301: Charading (Is This Love We're Imitating)', *Archive of Our Own*, 27 March, http://archiveofourown.org/works/1377706/chapters/2883100. Accessed 3 November 2014.

usingmyoxygen (2012), 'Each Silvery Star Fades Out of Sight, *Archive of Our Own*, 31 August, http://archiveofourown.org/works/621987. Accessed 4 November 2014.

Wilson, A. (2003), *Beautiful Shadow: A Life of Patricia Highsmith*, London: Bloomsbury.

Seeking a Womanless Paradise: The Inflexibility of Southern Heroes in *True Detective*

Mark Hill

In January 2014, HBO premiered *True Detective*, a neo-noir police thriller written by Nic Pizzolatto and directed by Cary Joji Fukunaga. Woody Harrelson and Matthew McConaughey star as Martin Hart and Rustin Cohle, two officers of the Louisiana State Criminal Investigative Division out of Lafayette. Marty and Rust, as the characters are usually called, are cast as partners with opposing personalities; however, unlike the traditional 'odd couple', there are no neat-freaks or slobs here. Instead, Marty encapsulates traditional southern good-ole-boy swagger, while Rust is a nihilistic intellectual who, as an outsider from Texas, constantly questions the traditions upheld by every aspect of Louisiana culture. The central plot of the first season is a seventeen-year-long investigation into Errol Childress, a ritualistic, incestuous, paedophilic serial killer. The eight episodes begin with Childress's first public murder and end with his death, but Childress is not much more than a two-dimensional character whose portrayal, while certainly deserving of its own examination for its continuance of negative southern stereotypes, serves as a foil to highlight the real meat of *True Detective* – the relationship between Rust and Cohle, and (from their point of view) the redemption they achieve after their failure to protect the defenseless women of bayou Louisiana. Numerous memes and social groups have cropped up in the last year celebrating their presumed heroic nature, glorifying the two cops as unified soldiers dedicated to a war against a world prone to evil.

Unfortunately, while the pair succeed in ending the decades-long murder spree, they fail in understanding the evolving needs and desires of the living women characters they encounter. Although it seems that they sacrifice everything (families, careers, relationships, health) to save lives and serve justice by locating and killing the man responsible for the horrible deaths of an unknown number of women and children, the real reason the protagonists end the show separated from the women and children of their own families is primarily because of their inability to alter their confining beliefs about gender and identity. A recurring battle of the women characters, especially for Marty's wife Maggie, played by Michelle Monaghan, and his mistress Lisa, played by Alexandra Daddario, is a struggle against the confining roles assigned to southern women: the wom-

en wish to define themselves outside of the traditional strictures allowed. Both Marty and Rust resist these desires, Marty, in ways that are often violent, and Rust by retreating from ties with women, especially after the death of his 2-year-old daughter and the dissolution of his marriage. When Rust and Marty find what they seem to believe is redemption, it is not within the family sphere – but in a womanless fantasy world where their masculine friendship reigns supreme. The denouement of the show focuses on the reconciliation between the policemen, not in any sort of reunion with their loved ones. While the last shot of Marty's family is by his bedside, as the tears begin to fall down Marty's face, the camera slowly pans in to push the women off-screen, effectively separating him from his ex-wife and daughters forever, as far as viewers are concerned. After all, Maggie's new wedding ring is framed in her last shot, a physical reminder that, no matter how heroic Marty might have been, his wife has moved on and their romance will not be rekindled. The final episode shows us that the only true relationship in Marty's and Rust's lives is with each other. As the two embrace after years of bad blood, they walk towards a sunless horizon, and while they may speak about an eventual reunification with their family, that family is nowhere in sight.

It is the tension between the rigid expectations desired by its male protagonists and the resistance by their female counterparts that is the heart of *True Detective*. More than one viewer was initially turned off by the show's apparent sexism, most notably Emily Nessbaum, the television critic for the *New Yorker*, who claims that the show has 'fallen for its own sales pitch', and ultimately 'reeks of macho nonsense' (2014: 4). Nessbaum is no fool; she wisely compares *True Detective*'s myopic point of view to the maniac *Wolf of Wall Street* (2013) or the (arguably more sophisticated) *The Fall* on BBC Two (2013–ongoing). Pizzolatto and Fukunaga hug so closely to the viewpoint of their protagonists that it is difficult to determine if the characters or the show itself falls into misogyny. However, Marty and Rust are overlaid with strong, traditional representations of southern white masculinity, and every interaction they have with women only underscores the protagonists' attempts to force them into similar tropes of southern white femininity. I cannot deny that the show thrusts these women characters into the margins of the narrative, but they do not calmly reside there. Most of them are pushed by the protagonists, until they voluntarily exit the narrative, leaving Marty and Rust alone with the only women who will allow themselves to be written as victims in need of the heroes' protection – the defenseless, speechless, dead victims.

The protagonists' attempts to define women are deeply rooted in traditional southern notions of proper white masculinity – specifically with its rhetoric of mastery and control over women and African Americans. Historically, this began with a separation of men and women into separate spheres of influence. Lucinda H. MacKethan traces how women supported this hierarchal division in the works of Catherine Beecher, who in 1841 argued that southern white women, removed from the marketplace, 'act as faithful adjuncts providing both refuge from the world and amelioration of the hardships connected

to industrial capitalism' (1997: 225). This gendered division is a well-established tradition in southern history, supported by social institutions and practices, like evangelical Christianity through the late twentieth century whose leaders argue, as outlined by Seth Dowland, that 'God did not intend society to be an undifferentiated mass of humanity. Rather [...] God had decreed that men lead families and churches' (2009: 247). The power of authority is one that comes from hierarchal division that prevented access for women and African Americans to the institutions of authority and the means of production.

This division is an essential aspect of white southern masculinity, and especially to the men of *True Detective*. While tracing the masculine performance found in Southern Rock, the childhood music of the show's protagonists, Ted Ownby lays out several definitions for this masculinity, and 'all of them depended on difference from women and either power over them or separation from them' (1997: 371). Marty and Rust reify the necessity of their separation from the domestic sphere, as shown when Marty defines his family as one with essential boundaries. He says 'I keep things even... separate' when describing the line he draws between work and home, and he believes Rust needs similar lines, as to him family is 'boundaries [and] boundaries are good' ('The Locked Room' 2014). This emotional distance is always present in the scenes with Marty's family, and not merely because we are aware of the lies he keeps from his wife and daughters. They rarely share the same frame, and when they do, they sit like strangers sharing a meal, eyes averted and plenty of space between each member of the family. When speaking to his daughter about the graphic images she has drawn in crayon for her friends, Marty's attention keeps drifting back to the basketball game on the television as he ignores Maggie's genuine concern for their daughter's mental health. From the start of the show, Maggie seems to instinctively recognize his distance from his family. When we are first introduced to her, after all, she is sleeping in their bed, alone, and she gets up to greet her husband, who has slept on the chair in the common room, with a cup of coffee, and a 'Hey, Lone Ranger' ('The Long Bright Dark' 2014).

Her comparison to the iconic solo cowboy is not casual; in the original screenplay, the line is 'Hey, Baretta', as the show's initial focus was on police culture in post-Cold War America (Pizzolatto 2014: 10). In working with Fukunaga, Pizzolatto rewrote the show to orient its protagonists as cowboy antiheroes more than as plain clothes officers of the law. And like the Hollywood cowboy, there is no place for Marty and Rust in a comfortable, civilized domicile – they must stand apart for the good of the family unit. Unlike Ethan Edwards from *The Searchers* (1956), however, the men find it increasingly more difficult to continue the patriarchal gender dichotomies expected of American men, and they hegemonically rely upon one another to reinforce their self-perceptions as tough, undomesticated men. When Marty wrestles with the guilt of his first affair, he asks Rust if he is a 'bad man', to which Rust quips 'the world needs bad men. We keep the other bad men from the door' ('The Locked Room' 2014). Rust, who has already cleanly removed himself from the domestic sphere after his daughter's death, has little difficulty

assuming the role of outlaw soldier. When he infiltrates the biker gang, their lingo is rife with wistfulness for the days of (as Hollywood depicts it) a cowboy living on the edges of civilization, barely contained by family and home. Ginger, the criminal Rust is attempting to set up, tells Rust that he needs a 'soldier' and a 'gunslinger' to 'embrace the outlaw life' and assist him in a crime ('Who Goes There' 2014). Rust, as an undercover cop without permission from his employers, weakly attempts to beg off, stating that he 'don't ride cowboy no more' ('Who Goes There' 2014). But, when pushed, he quickly, even eagerly, offers to get his truck and ride. This collusion of southern and south-western cowboy masculinity, and the necessary separation of both from the domestic, is even found in the show's theme song 'Far From Any Road' by The Handsome Family (2003). It sings of spirits that guide a lone man on a vision quest through a landscape complete with deserts, cactuses and high suns. The theme song isn't the only music of *True Detective* to encapsulate this theme of man's rejection of a home life. We hear it again in Lucinda Williams's 'Are You All Right', in which a woman croons about a man who discards the comfort of a caring relationship (2007).

Yet, while our protagonists feel empowered through emotional distance from the domestic, this separation is not enough to ensure the mastery over it. When Marty states that family 'is boundaries', he means more than his emotional distance – he wishes to limit the behaviours, beliefs and attitudes of the women within his home, a right long-held as traditional to southern men as far back as the antebellum South. Minrose Gwin, in her examination of familial power in father/daughter incest narratives, describes how historians and literary scholars both 'have pointed to the relation of white male dominance, property ownership, and the control of women's bodies (of all kinds) in the economy of the Old South – and particular to the presence or threat of violence undergirding that economy' (1997: 417). When those whose autonomy should be contained threaten to escape their assigned place, violence or the threat of it quickly follows. This threat is central to Kris DuRocher, who sees this same narrative in the ritual of lynching in the early-twentieth-century south, where 'white male patriarchy required that white women possess feminine virtue and maintain the communal hierarchy by being subordinate to and dependent on white males' (2009: 55). According to DuRocher, the violence upon black bodies reinforced the authority of men to commit violence upon those who resisted, with an undercurrent of a threat upon white children and women for those who disobeyed the demands of the patriarchy.

There has been little change to this myth of mastery, even as southern men challenged other notions of proper masculinity, such as quiet civility and gentility or open displays of white supremacy. As Trent Watts argues in narratives of the post-Civil Rights-era south, 'notions of mastery are more likely to [overtly] manifest themselves in terms of gender' (2008: 8). The overt narrative of physical dominance over women is more socially acceptable, as 'mainstream white sexuality has been built in part upon notions of emotional and physical mastery of women' (2008: 14). *True Detective* follows in this

mould, although not cleanly in the sexist direction mentioned earlier by Nessbaum. Marty and Rust strive to possess the bodies of the women under their control, but ultimately fail to constrain them to traditional roles of either the demure, sexually pristine Madonna, or the sexually driven, morally-unclean Whore. Their struggle to define women *for* women is clear from the opening credits, shot from their point of view, wherein a collage of impressions of stoic and hard-bitten Marty and Rust are superimposed by hypersexualized images of young women. One particular image stands out – a still of a naked woman's back, and projected within her silhouette is a playground with a slide that, from a distance, resembles a stiletto high-heel shoe. This image is the visual manifestation of the protagonists' greatest fear: the imminent threat of girl children growing up into sexual women.

When women characters threaten to escape from the assigned path proscribed, Marty and Rust quickly attempt to return them to the gendered script of traditional southern femininity. When the police catch Marty's oldest daughter Audrey in a threesome with two boys, for example, Marty becomes fearful of his daughter's future as a proper southern woman and concerned about her increasing resistance to his authority, and so he shames her. He demands to know if she plans to be 'the captain of the varsity slut team', then slaps her across the face – with a quick cut to a close-up of Maggie's disapproving look ('The Secret Fate of All Life' 2014). Another such moment occurs when Marty discovers Lisa, the young court stenographer with whom he is having an affair, out on a date. He drunkenly forces himself into her apartment, misusing the authority of his badge to physically dominate her lover. He denies her right to a sexual life outside of him, and when she responds to his threats and violence by informing his wife of the affair, he threatens to violate her, repeatedly calling her a whore. She calls him out on his hypocrisy, declaring that 'all of you think it's okay you treat your wives this way [...] You're fucking liars and bullies and this is what you get' ('Who Goes There' 2014). By directly exposing his failures, Lisa has moved in Marty's eyes from one end of the spectrum where she represents solace and respite from the trials of work and home, to the other – where she is a 'filthy whore' ('Who Goes There' 2014). While she leaves the show after revealing the affair to Maggie, prompting her first attempt to dissolve their marriage, Lisa refuses to play the suffering victim – lashing out when civil discourse is refused her.

Maggie similarly undergoes this transformation in her husband's eyes when she mimics his infidelities by seducing Rust, provoking Rust to his first loss of control in the process. When Marty discovers her infidelity, he responds with the only language he knows when dealing with a woman who has violated the domestic sphere, calling her 'a whore' ('Haunted Houses' 2014). Maggie, however, encourages his violence, daring him to hit her, so that she will bear a physical mark of his hypocrisy. When he sleeps around, it is for the benefit of the family, but when the women in his life exhibit the same sexual freedom, he verbally and physically assaults them. Lisa, Audrey and Maggie all demonstrate what the madam of a trailer-park brothel explains to Marty when he attempts to

shame her for employing Beth, an underage girl. She defends the young girl, arguing that the abuse she had suffered from her uncle, and the lack of community support, left Beth little choice, then quips that men get uncomfortable when women demand money in exchange for sex, because 'suddenly you don't own it like you thought you did ('Seeing Things' 2014). When Marty's ownership of women's sexuality comes into question, he only knows one reaction. But, he cannot deny his own sexual appetites, which come full circle when he meets Beth years later and gives in (easily) to her attempts at seduction. His subsequent affair with Beth spurs Maggie to end their marriage by using the only language Marty understands – she seduces Rust.

While Maggie's sexual gambit could be seen as a simple perversion of the sexual norms required of her, rather than her actively resisting them, this view is complicated by years of attempts to get Marty and Rust both to understand their own hypocritical desires. When attempting to set Rust up, she tells him 'you guys don't give things chances. I don't know why that is' ('The Locked Room' 2014). When reflecting on her failed marriage in 2012, she says 'Marty's single big problem was that he never really knew himself, so he never really knew what to want' ('A Man's Price' 2014). As their marriage is drawing to a close in 2002, she tells Rust 'This is how you all get warped. You always shortchange the wrong things' ('Who Goes There' 2014). Maggie repeatedly entreats Marty and Rust to open up to the women in their lives, and tells Marty that change is required for a mature adulthood. Yet, the protagonists refuse to accept the possibility of sexual independence outside of their narrow definitions, and such a refusal ends with their eventual exit from the domestic sphere.

While Marty struggles throughout the show with a flesh-and-blood family, Rust spends the majority of the show in the company of the dead. He mocks Marty's struggles, both with his affairs and his divorce, but he has only replaced the loss of his loved ones with an obsession with those who suffered a violent death. In his obsession with the murdered, Rust spends hours looking over the bodies of dead women, ostensibly looking for evidence to solve the Childress case. However, instead of empathizing with the women and children, Rust rewrites their trauma and fashions for the victims an identity wherein they desire their own victimization:

They welcomed it. [...] Not at first, but right there in the last instance. It's an unmistakable relief. See, 'cause they were afraid, but now they saw for the very first time how easy it was to let go. And they saw, in that last nanosecond, they saw what they were. That you, yourself, this whole big drama, it was never anything but a jeryrig of presumption and good will. You can just let go. Now that you don't have to hold on so tight.

('The Locked Room' 2014)

Rust cannot know the stories of the hundreds of murdered women he studies, but he feels

capable of casting them as willing participants in their own deaths. His claims certainly speak to his own suicidal depression, but he writes himself as paramount in the lives of dead women. He tells Marty 'I tell myself I bear witness', and this witnessing is the true tragedy of their professional experience ('The Long Bright Dark' 2014). They see the aftermath of patriarchal oppression, the dead prostitutes and runaways powerless in a world that vilifies women, especially sexualized women, and do not recognize how their own actions with their families assist in creating a world that results in feminine victims. Even Marty is susceptible to taking ownership of a victim's trauma when he admits to retiring from the force after finding a dead baby microwaved in an oven, and confesses that 'he just couldn't see that again' ('After You've Gone' 2014).

When Rust recruits Marty in 2012 to finish their investigation into the Childress murders, this motif of vision returns when he says 'I won't avert my eyes again. Not again' ('After You've Gone' 2014). Marty initially refuses to assist, until Rust forces him to witness a video of the childhood rape of Marie Fontenot, and the camera jumps between shot/ reverse shot, allowing the audience to watch Marty watching the rape. The video itself is grainy, and the details are difficult to make out, but for the audience, Marty's trauma is fully realized (while ironically Rust turns his back to avoid watching the horrors he has sworn to witness). As Marty watches for the first time, his face twists into a horrified visage, and he at first whimpers, and then begs for it to stop. When he can no longer bear to 'bear witness', he turns away with a wordless scream of futility. For the protagonists and the viewer, the trauma is centred in men's experience of women's victimization, and more importantly, their powerlessness to stop it. It is the horrified faces of these self-proclaimed male witnesses that are presented to the audience, not Marie Fontenot's, Dora Lange's or any of Childress and Ledoux's victims. This rewrites all of the female tragedies as masculine failure, which grants Marty and Rust a vehicle to write themselves as bad enough men to be able to keep the true villains away from the defenseless, powerless, dependent women and children of Louisiana.

The fact that the living women of the world do not want to be cast in this mould makes little difference to Marty and Rust. As Lisa, Maggie, Audrey and all the rest flee the narrative one at a time, the protagonists can look to each other to fashion a narrative of themselves as the saviours of the feminine that props up their traditional notions of southern masculinity. As Noel Polk describes:

> Men's deepest needs for self- and gender-identity lead them away from the feminine and towards each other, into the homosocial [...] thus men who cannot find comfort or ease in either homosexual or heterosexual worlds revert to the sexually neutered (but not neutral) world of the homosocial, from which vantage they can both escape and control women, the domestic, that threaten them, and where they find acceptable, nonthreatening community in the company of other men.
>
> (Polk 1997: 349)

From the first episode, the two men have a tendency to defend and protect each other foremost, even when they are deeply angry with one another. Marty defends Rust to their distrusting captain in 1995 and to the two CID officers investigating Rust for the murders in 2012. When Marty kills the unarmed Reggie Ledoux after finding the two children he molested, Rust quickly takes charge, inventing a tale to cover Marty's murder and leaving evidence for CID to find. When they fight after Rust's infidelity with Maggie, Rust gives Marty a compliment for his fighting prowess and then refuses to fix the tail light that was busted during the dispute. A decade later, he still drives around with that physical remembrance of their last meeting, and the damage fills the screen in the foreground as Marty and Rust speak for the first time in over ten years. We are reminded that the divorces, relocations and professions of the intervening years hold less weight than the reminder of one of Rust's greatest failures – the betrayal of his partner that led to the dispute.

This powerful homosocial connection appears again in the final scene, wherein Rust asks Marty if they are getting engaged when the latter offers a gift of cigarettes in a small wrapped box. It is their bond of friendship, not a familial bond, that comprises the final scene of the show, and that resonates strongly with the audience. The final lines, 'once there was only dark [i]f you ask me, the light's winning', became an Internet mantra, glorifying men's struggle to end a violent threat to weak, disempowered women ('Form and Void' 2014). As the protagonists walk off-stage, towards a sunless horizon, proud of their accomplishments in getting 'their guy', it is seductive to walk off with them, satisfied with their victory. Yet, behind them is not a domestic home made whole through their struggle against a violent outsider, like the pre-eminent cowboy Shane, but a string of broken promises and broken families. They may have stopped Errol Childress, but they did not address the actual cause of the victimization of the bayou community – the wealthy, empowered, white privilege represented by the Tuttle family. Childress was a mentally deranged, bayou version of an Appalachian rapist, a classist stereotype found all too common in Hollywood fare. Those that covered for Childress, to ensure the political and financial power of their family, walk away clean. Just as Marty and Rust lie to themselves about a sense of victory, they lie to themselves about the good they have done for the living women in their lives. We should not champion them; we should pity them. Since they cannot accept an empowered, sexually free and self-initiating femininity, they can only dream of the dead women, who, by being voiceless, can fit the narrative of feminine dependence that these antiheroes require to feel justified in their masculinity. The final question is if *True Detective* is aware of its heroes' failures – is it, as Nessbaum says, 'just macho nonsense'? There are too many discarded and unhappy women at the margins of the show, too many unresolved familial issues, for *True Detective* to only exist as a blind celebration of misogynistic masculinity. However, Marty and Rust are too witty, too powerful, and ultimately, too compelling as characters to be labelled as failed warnings of misguided, conservative beliefs of masculine identity. After all, it is

the troubling notions of the show that appear in social media, championing bad men defending powerless women from worse fates, that seem to be *True Detective*'s legacy. ∗

REFERENCES

'After You've Gone' (2014), Cary Joji Fukunaga, dir., *True Detective*, Season 1, Episode 7, 2 March, New York: HBO.

Braudy, L. (2003), *From Chivalry to Terrorism: War and the Changing Nature of Masculinity*, New York: Knopf.

Carey, M. (2000–06), *Lucifer*, New York: Vertigo Press.

Dowland, S. (2009), 'A New Kind of Patriarchy: Inerrancy and Masculinity in the Southern Baptist Convention, 1979–2000', in C. T. Friend (ed.), *Southern Masculinity: Perspectives on Manhood in the South since Reconstruction*, Athens, GA: University of Georgia Press, pp. 246–68.

DuRocher, K. (2009), 'Violent Masculinity: Ritual and Performance in Southern Lynchings, 1877–1939', in C. T. Friend (ed.), *Southern Masculinity: Perspectives on Manhood in the South since Reconstruction*, Athens, GA: University of Georgia Press, pp. 46–64.

'Form and Void' (2014), Cary Joji Fukunaga, dir., *True Detective*, Season 1, Episode 8 , 9 March , New York: HBO.

Friend, C. T. and Glover, L. (2004), *Southern Manhood: Perspectives on Masculinity in the Old South*, Athens, GA: University of Georgia Press.

Gwin, M. (1997), 'Nonfelicitous Space and Survivor Discourse: Reading the Incest Story in Southern Women's Fiction', in S. V. Donaldson and A. G. Jones (eds), *Haunted Bodies: Gender and Southern Texts*, Charlottesville: University of Virginia Press, pp. 416–42.

'Haunted Houses' (2014), Cary Joji Fukunaga, dir., *True Detective*, Season 1, Episode 6, 23 February, New York: HBO.

Kimmel, M. (2011), *Manhood in America: A Cultural History*, Oxford: OUP.

Kirkman, R. and Moore, T. (October 2003–ongoing), *The Walking Dead*, New York: Image Comics.

Kleinfield, J. and Kleinfield, A. (2004), 'Cowboy Nation and American Character', *Society*, 41: 3, pp. 43–50.

Lehman, P. (2001), *Masculinity: Bodies, Movies, Culture*, New York: Routledge.

'The Locked Room' (2014), Cary Joji Fukunaga, dir., *True Detective*, Season 1, Episode 3, 26 January, New York: HBO.

'The Long Bright Dark' (2014), Cary Joji Fukunaga, dir., *True Detective*, Season 1, Episode 1, 12 January, New York: HBO.

MacKethan, L. H. (1997), 'Domesticity in Dixie: The Plantation Novel and *Uncle Tom's Cabin*', in S. V. Donaldson and A. G. Jones (eds), *Haunted Bodies: Gender and Southern Texts*, Charlottesville: University of Virginia Press, pp. 223–42.

Nessbaum, E. (2014), 'Cool Story, Bro: The Shallow Deep Talk of *True Detective*', *The New Yorker*, http://www.newyorker.com/magazine/2014/03/03/cool-story-bro. Accessed 20 October 2014.

Ownby, T. (1997), 'Freedom, Manhood, and White Male Tradition in 1970s Southern Rock Music', in S. V. Donaldson and A. G. Jones (eds), *Haunted Bodies: Gender and Southern Texts*, Charlottesville:

University of Virginia Press, pp. 369–87.

Pizzolatto, N. (2014), *True Detective Chapter One: 'Long Red Dark'*, Los Angeles: RWSG Literary Agency.

Polk, N. (1997), 'Around, Behind, Above, Below Men: Ratliff's Buggies and the Homosocial in Yoknapatawpha', in S. V. Donaldson and A. G. Jones (eds), *Haunted Bodies: Gender and Southern Texts*, Charlottesville: University of Virginia Press, pp. 343–66.

Rotundo, E. A. (1994), *American Manhood: Transformations in Masculinity from the Revolution to the Modern Era*, New York: Basic Books.

'The Secret Fate of All Life' (2014), Cary Joji Fukunaga, dir., *True Detective*, Season 1, Episode 5, 16 February, New York: HBO.

'Seeing Things' (2014), Cary Joji Fukunaga, dir., *True Detective*, Season 1, Episode 2, 19 January, New York: HBO.

Slotkin, R. (1998), *Gunfighter Nation: The Myth of the Frontier in Twentieth-Century America*, New York: University of Oklahoma Press.

Steffen, J. O. (1993), 'Cycles of Myth Restoration: One Approach to Understanding American Culture', *Journal of American Culture*, 16:1, pp. 25–33.

Watts, T. (ed.) (2008), 'Introduction: Telling White Men's Stories', in T. Watts (ed.), *White Masculinity in the Recent South*, Baton Rouge: Louisiana State University Press, pp. 1–29.

'Who Goes There' (2014), Cary Joji Fukunaga, dir., *True Detective*, Season 1, Episode 4, 9 February, New York: HBO.

James Ellroy's Antiheroic History

Rodney Taveira

From Fritz Brown, the compromised private investigator of James Ellroy's Chandlerian debut, *Brown's Requiem* (1981), to his latest novel *Perfidia* (2014), Ellroy writes antiheroes that align with his public persona: the 'Demon Dog of American Fiction', an outsized braggart who rose from criminality and addiction to become the self-proclaimed world's greatest crime novelist. These characters change, yet they also stay the same. For example, *Perfidia* sees the reprisal of the homicidal but honey-tongued container and purveyor of perversion, Dudley Smith of the LAPD. Smith appeared in *Clandestine* (1982) and in the last three novels of the LA Quartet (and was portrayed memorably by James Cromwell in Curtis Hanson's 1997 Academy Award-winning film adaptation of *L.A. Confidential*). The real-life LAPD Chief William Parker, previously appearing in *L.A. Confidential* (1990) and *White Jazz* (1992), is depicted as an alternatingly pathetic then determined alcoholic, fighting internal weakness and institutional corruption.

This chapter charts the course of Ellroy's textual and performative antiheroism. Ellroy, the Demon Dog, is also one of his fictional antiheroes – the most persistent, too. Ellroy's personal life, and its relation to his development as a writer, can be divided into three stages; Ellroy's two memoirs, *My Dark Places* (1996) and *The Hilliker Curse* (2010), punctuate this periodization. In these two books, Ellroy presents himself as a man out-of-time and aberrant, a loser antihero. He was a petty criminal, an alcoholic, a voyeur, a boy who wished his mother dead only for her to be murdered in an unsolved sex crime. He then sobered up and straightened out, working single-mindedly to become a critically acclaimed and world-famous writer. The second memoir is somewhat dismissive of the first, and so these texts must be read as strategic looks-back, retrospective rewritings of what Ellroy's life means for his work, and what his work means for his life. Similarly, interviews I conducted with Ellroy for this chapter provide yet another layer, or densification, to the complex writing life of Ellroy. (Any reference to 'James' in this chapter refers to a series of conversations about the idea of antiheroes in his work, held between 28 January and 17 February 2015.) They offer the latest commentary from whom I will call 'James', someone very different from the Demon Dog. James is a deco-

rous, church-going man, who lives alone with no television or computer, counts LAPD officers as close friends, and double-checks his locks each night so, he says, 'no-one will get me'.

The fiction, the memoirs, the public persona, the man: it is a complex antiheroic history that calls for a book-length treatment. In this chapter, I hope to indicate productive connections, to offer new insights into a voluminous and intense writing life of a major American author, and to relate Ellroy's latest thoughts about his work, his life and the antiheroic.

Now and then

They were rogue cops and shakedown artists. They were wiretappers and soldiers of fortune and faggot lounge entertainers. Had one second of their lives deviated off course, American History would not exist as we know it.

– James Ellroy, *American Tabloid*

'It's time to embrace bad men and the price they paid to secretly define their time', continues Ellroy in the prologue to *American Tabloid* (1995: 5), where he articulates his vision of antiheroic American history. James now sees these 'bad men' as 'rogue authoritarians', violent men of state and the law who swerve between serving the lowly pursuits of profit and coercion to a higher calling of justice and penance. This swerve, says James, 'is driven by romantic love'. He has often cited Don DeLillo's fictional recreation of President John F. Kennedy's assassination in *Libra* (1988), focusing on Lee Harvey Oswald, as inspiration for *American Tabloid*. 'How could Don DeLillo', says James, thinking back on the novel, 'have come up with Lee Harvey Oswald as the ultimate American loser, malcontented dipshit, autodidactical antihero, and not me?' Casting Oswald as an antihero indicates that James concentrates on the *anti* side of the contradictory figure of the antihero, bracketing off the *hero* for when his rogue authoritarians operate in a romantic and redemptive mode.

There is a history to the antiheroism of Ellroy, both inside and outside his work. *Time* magazine rated *American Tabloid* the Best Book (fiction) of 1995, which marks a curious moment in the reception of antiheroes in the United States. Francis Fukuyama's pronouncement of the End of History was endlessly repeated: the Cold War was over; America exercised unipolarity. America was experiencing its biggest peacetime economic expansion. The *first* first black president was in power, to paraphrase Nobel Laureate Toni Morrison's often misunderstood quip about Bill Clinton. Morrison, Ellroy's fellow novelist, understood that other forces, less rosy, were at work as the end of an apparently *heroic* history played out. These forces were so powerful that they could foist racial animus onto a white president.

And when virtually all the African-American Clinton appointees began, one by one, to disappear, when the President's body, his privacy, his unpoliced sexuality became the focus of the persecution, when he was metaphorically seized and body-searched, who could gainsay these black men who knew whereof they spoke?

(Morrison 1998)

Unlike Morrison, Ellroy has always been a vocal critic of Clinton. He lambasted Clinton during his promotional tours in the 1990s, scandalizing audiences by disparaging the size of the Presidential penis. In the prologue to *American Tabloid* quoted above, Ellroy directly compares the Camelot of the Kennedy Presidency to the Clinton years. The novel reimagines the assassination of President Kennedy as a conspiracy comprising the intersecting interests of organized crime, anti-Castro Cuban exiles and J. Edgar Hoover's intense animosity for the Kennedy family. Instead of affectionately writing over Kennedy's womanizing and mixed record as the tragic loss of American innocence – a hero vanquished too soon – Ellroy, like the media and the Starr Report (the wide-ranging investigation of Clinton's financial and personal dealings, approved by the US Attorney General, conducted by Independent Counsel Kenneth Starr), places the failings of the president front and centre.

Anticipating Morrison's analysis of the scrutiny of Clinton but rejecting her sympathy, Ellroy wrote in his 'Preliminary Statement Notes' to his publisher Alfred A. Knopf in 1991 that *American Tabloid* will be a 'literary crime', a 'raw, funny, mordant, dark, revisionist recounting of John F. Kennedy's *private* orbit' (original emphasis). His affairs with Marilyn Monroe and other women would be central (and exploited by the 'bad men' that will 'secretly define their time'). 'My desired result', writes Ellroy to his publisher, is a 'long, profane colloquial novel [...] History exposited through a complex weave of public fact and secret incident': in other words, *anti*heroic history. While the Clinton–Lewinsky scandal was seven years away, rumours from Slick Willy's days as Arkansas Governor murmured throughout his presidential campaign. Secret incidents gurgled under the exposition of private, increasingly public fact.

The 24-hour news cycle amplified the gurgle – the scrutiny was, and is, relentless. To be sure, Ellroy's mastery of labyrinthine narratives is unrivalled in crime fiction – and fiction in general – and finds superlative execution in *American Tabloid*, but even he cannot match the breathless and constant verbiage of the cable television commentariat. This scrutiny informs Morrison's 'gainsay' of muted black voices and Clinton's 1993 slippery, two-faced rhetorical policy of 'Don't Ask, Don't Tell' (that, in a way, by endorsing the complex weave of public fact and secret incident, prefigures the persecution of Clinton's personal and sexual history) that Ellroy deploys in *American Tabloid*. Perhaps this provides a clue to why such a grim and unremitting portrayal of a corrupt, antiheroic United States was regarded as the best book of 1995 by *Time*, the world's most circulated weekly news magazine.

The similarly slippery, ironic milieu in which Ellroy's characters operate provides the bait and hook for the ardent reception of his ugly stories and their antiheroic history. Further, the increasingly complex evolution of Ellroy's attractively repellent antiheroes maps onto his international reputation as a literary bad boy and the changing fortunes of his personal life, particularly in relation to women. I work with the premise that Ellroy's antiheroes, and Ellroy himself, are *out of time*. As self-appointed agents of correction, they spring from the tradition of the American jeremiad, a genre that recalls the rightness of the past in order to castigate the present and to call for its restoration.

The Ellrovian jeremiad is personalized and pathologized as the less rosy forces seek to regulate the agents of correction, even as these men (they are almost always men) are also agents and embodiments of these forces. Further, Ellroy claims that the Kennedy assassination did not herald America's loss of innocence: 'We popped our cherry on the boat over and looked back with no regrets [...] You can't lose what you lacked at conception' (1995a: 5). Reflecting this understanding of never-innocent America, but inflecting it along the path of America's racial history, Morrison (1998) writes of the pursuit of Clinton's impeachment, 'The always and already guilty "perp" is being hunted down not by a prosecutor's obsessive application of law but by a different kind of pursuer, one who makes new laws out of the shards of those he breaks.' Ellroy's sneers at Clinton might be buffoonish grabs for attention, expressions of disgust at moral profligacy, or both. But the parallel he draws with Kennedy, and the magnetic contradictions of America's antiheroic history, indicate that there is more to the performance.

James cites his introduction to the Everyman collection of Dashiell Hammett's fiction when I ask him about the place of antiheroes in crime fiction. James, a life-long champion of the father of hardboiled detective fiction, paraphrases David T. Bazelon's 1949 analysis:

> The core of his art is the masculine figure in American society. He is primarily a job holder. He goes at his job with a bloodthirsty determination that proceeds from an unwillingness to go beyond it. This relationship to his job is perhaps typically American. The idea of doing or not doing a job competently has replaced the whole larger issue of good and evil.
>
> (Ellroy 2007: ix)

The Continental Op and Sam Spade, and Hammett himself (a Pinkerton agent who, so the legend goes, turned down $10,000 to kill a man), are antiheroic, but Ellroy finds something else in them – himself. 'They are lab rats in perpetual reaction to stimuli. They are ascetics tamping down emotional turbulence and willing it flatlined in the name of the job' (2007: xi). 'I need to shut myself off from the culture, from now', James asserts. He says that he rises at dawn to write with pen and paper. A personal assistant takes care of day-to-day matters. He says he had his office painted black, and covered its

windows with thick velvet drapes.

This puts Ellroy, and his antiheroes, out of step with the current crop of televisual antiheroes that Ann Larabee (2013) identifies:

> Tony Soprano, Dexter Morgan, and Walter White have the old-fashioned values of the professional-managerial class: accumulation and sequencing of possessions, generational continuity, prosperity through education and highly skilled work, supervision and correction of others, and masculine authority.
>
> (Larabee 2013: 1131)

James, as he describes his workday, operates, like Hammett, in an industrial mode that pre-dates the emergence of the post-war professional-managerial class. Possessions mean little (except for a sports car), there is no generational continuity, he works in solitude – 'If I am not meeting a friend or associate for dinner, I'll eat oatmeal three times a day', says James. 'Who gives a shit?' Nonetheless, the patriarchal through-line remains: correction, masculine authority and highly skilled work.

Early Ellroy

> Good evening peepers, prowlers, pederasts, panty-sniffers, punks and pimps. I'm James Ellroy, the demon dog, the foul owl with the death growl, the white knight of the far right, and the slick trick with the donkey dick. I'm the author of eighteen books, masterpieces all; they precede all my future masterpieces.
>
> – James Ellroy

So says Ellroy for the 1000th time. The above is Ellroy's standard patter when giving a public reading – only the number of 'masterpieces' has changed. An entertaining demand for attention, its vulgarity is of a piece with his writing: gross, engrossing, impossible to ignore. Until *American Tabloid*, Ellroy's novels centred on violent sex murders and institutional corruption. Tortured white men working for various arms of American law provided a cast of antiheroes. These men pursue justice for a murder victim, even if it means killing and maiming along the way.

This form has grown and become more complex over the last 35 years. James rejects what he calls the 'simplistic, there are no good guys, there are no bad guys' readings of his work. 'I don't know what antihero means', he continues, when asked about the antiheroism of his characters. James says he 'got bored quickly when rereading the *LA Quartet*' in preparation for *Perfidia*. He 'started focusing on the facts – nothing surprised me about the characters'. Ellroy may have reached a breadth in his writing that encompasses the genre of historical romance to the point that, I argue, he writes within and expands the juncture of the hyphen between *anti* and *hero*, but his earliest work

finds him bound to his life and the generic conventions of crime fiction.

Ellroy's work is suffused with the central event of his life: the murder of his mother, Jean Ellroy née Geneva Hilliker, in June 1958, when Ellroy was a 10-year-old boy. Ellroy has worked this event throughout his writing life by exploiting it for publicity, and commingling Jean and the infamous Black Dahlia murder for his break-out first novel of the LA Quartet (*The Black Dahlia* [1987]). Jean was strangled after possibly being raped. Her corpse was dumped on a road beside a high school. During these fatal hours, Lee Earle Ellroy ('James' is a *prénom de plume*) was at home with his father Armand, whom James describes as a 'lazy dipshit'.

Ellroy laments in the opening address to his mother in *My Dark Places*: '*I failed you as a talisman*' (1996a: 2, original emphasis). He is physically and performatively distant, *not* dutifully playing the role of obedient son as he gleefully does the things she forbade. Ellroy lived with his father on weekends, staying up late, reading books, watching television (2004: 29), perving on local girls (2010: 24). After his mother moved to El Monte, 'I told her I wanted to live with my father [...] I could scratch her face and ruin her looks so men wouldn't want to fuck her' (1996a: 111); the son flouts filial fealty by rejecting the mother while simultaneously recognizing her sexual desirability. This negative dramaturgy casts Ellroy as unable and unwilling to protect his mother. Ellroy turns this antiheroism into villainy, albeit childish and innocent, in *The Hilliker Curse*. After reading a book about witchcraft, he issued a curse wishing his mother dead. A few months later, someone murdered her.

Jean's murder remains unsolved and it structures Ellroy's antiheroism. He moves from the villainous boy who wanted to maim his mother and wished her dead to a man continually seeking feminine connection (he subtitled *The Hilliker Curse* '*My Pursuit of Women*') and to impose order (James says he 'rewrites history to my own specifications, and nobody gets hurt'). Jean's murder is solved repeatedly, compulsively, in his fiction (in *Clandestine* an avatar of his father was the culprit), as compromised men relentlessly pursue the perpetrators of violence against women. Jean's murder projects narrative and affective lines that are out of time, that cannot help but return to the past, an obsession sustained by women, death, sex and American history.

Ellroy's biography, like Ellroy's public audience patter, has been repeated hundreds of times in interviews and profiles. Beginning with The Hardy Boys series (Franklin W. Dixon, 1927–2005), the young Ellroy read mystery and crime books voraciously (Ellroy 1996a: 120). After his mother's murder, he lived in Hollywood, 'the film noir epicenter during the film noir era' (Ellroy 2004: 29) in a rundown house on Beverly and Western. Ellroy stole books, then stole voyeuristic visions through the picture windows of nearby, upscale Hancock Park. 'I was still preadolescent', he writes. 'I was a thief and a voyeur. I was headed for a hot date with the desecrated woman' (1996a: 124). Ellroy broke into the houses he had previously just peeped. He was operating in a creepy world of lustful fantasies that saw him saving virgins from male killers. 'My rescue fantasies

were richly detailed. My intercessions were swift and brutal. Sex was my only reward' (1996a: 131). His breaking and entering, his forcing his way in, while a gesture toward correcting a wrong, makes him aesthetically complicit in the sexualized murders he was hooked on – all, of course, repetitions of his mother's murder.

During his long stretch of delinquency, Ellroy internalized the social geographies of Los Angeles: space, race, law, class, sex, violence, religion. The early books may be 'a blur' and, says James, their characters now 'so far behind me that I can't take them seriously', but nonetheless antiheroes are their prime movers. These characters are produced by the generic confines in which Ellroy was working. The city, especially Los Angeles, is a plastic site, a reconfigurable space in which he can write out his repetition compulsion in the form of procedural crime fiction: 'I'm fucked up in a horrible, neurotic way', says James. 'I get to impose order on my life by writing astonishing books that no one else can write'.

When James describes his first central character and narrator, the private investigator Fritz Brown of *Brown's Requiem*, he points to himself as he recites Brown's characteristics: classical music lover; recovering alcoholic; repo man; seeker of redemption in women; golf as a backdrop (Ellroy wrote his first six novels while working as a golf caddy). 'I was determined to write an autobiographical epic second to none', says Ellroy in the 1996 re-issue of his debut.

'I dig this book', he continues, 'because its [*sic*] a summation of my life up to that point when I picked up a pen to write it'. This is clear from the first chapter. Street names firmly place the reader in contemporary Los Angeles. Brown inventories past interpersonal wrongs, a process that the AA-attending Ellroy would have performed. Even coffee, the single stimulant James takes, figures repeatedly. The chapter finishes with the epiphany of a recovering alcoholic: 'I felt again that my life was going to change' (1996b [1981]: 19).

His second novel, *Clandestine*, set in 1951, in which he first attempted to deal with his mother's murder, is called a 'period cop book' by Ellroy in his introduction to *L.A. Noir* (1997). Both *Brown's Requiem* and *Clandestine* figure an evil father behind the gruesome murders. Neither main characters, Brown nor Fred Underhill, are publically acknowledged for solving the crimes; neither finds redemption or gets the girl.

In the following Lloyd Hopkins trilogy (*Blood on the Moon* [1984]; *Because the Night* [1984]; *Suicide Hill* [1985]), Ellroy says

> Hopkins was my antidote to the sensitive candy-assed philosophizing private eye. I wanted to create a recognizably racist and reactionary cop and make his racism and reactionary tendencies casual attributes rather than defining characteristics = wanted to build a complex monument to a basically shitty guy – and I didn't care whether my readers liked Lloyd Hopkins – as long as they liked the books he was in.

Hopkins may sound like a typical antihero, yet Ellroy's intention runs against the grain.

Antiheroes are supposed to be liked. You like Tony Soprano, Walter White et al. They attract you. (The *you* here is the classically male audience assumed by most art and entertainment.) Ellroy rejects this. James dismisses, for example, one of the culture's most contemporary antiheroes, Rust Cohle. He says a friend recently showed him an episode of *True Detective*, and he thought that it was 'young male idiot shit'. Of course, Ellroy is looking back and askance, and writers should not be the last authority on their work. Moreover, in saying he hopes readers like the books, Ellroy hopes readers like *him*.

A forensic line connects the early procedurals to the later work. The private investigator, the LAPD police officers Underhill and Hopkins, and the FBI agent who cracks the Plunkett–Anderson case in *Killer on the Road* (1986), all focus on the past. The forensic gaze they deploy becomes an obsessive attempt to answer the question, 'What happened?' This is precisely the temporality that antiheroes inhabit. They are out of time, and their actions of the present are all concerned with uncovering a past that will correct the history that leads to the present. This rupture between *then* and *now* reflects Ellroy's antiheroic history. Brown descends into alcohol-fuelled violence, even if he solves the larger case by the end of the novel. Underhill's overweening ambition finds him complicit in the suicide of an innocent gay man. Hopkins is a serial adulterer and a ('casual') racist, who commits crimes in order to solve crimes he deems more important. Ellroy's investigators pursue, like the writer, the past at the expense, or dismissal, of the present. Heroism is impossible – they cannot save the day because they do not exist in it. Instead of being, for example, violent sentimentalists that (claim to) want the best for their families, like Tony Soprano or Walter White, they turn away. The early Ellrovian antihero is not so much a mixture of good or bad, but an obsessive oriented away from the present.

Middle Ellroy

I wrote six novels in breathless preparation.

– James Ellroy, *The Hilliker Curse*

By 1986, Ellroy was ready to tackle his life-long obsession with the infamous Black Dahlia murder, whose horribly mutilated victim, Elizabeth Short, had become 'a symbiotic stand-in' for his mother (Ellroy 1996a: 125). Living in New York away from the scenes of his early profligacy, Ellroy returns to the scene of the crime in his fiction. Middle Ellroy is set in Los Angeles 1946–58: two years before Ellroy was born to the year his mother was murdered.

The books of Ellroy's middle period, comprising the LA Quartet – *The Black Dahlia* (1987), *The Big Nowhere* (1988), *L.A. Confidential* (1990), *White Jazz* (1992) – and *My Dark Places* (1996) have received the most critical attention (along with *American Tabloid*). For example, Jim Mancall analyses the effect of pornography in the LA Quartet

and its formal relation to crime fiction. He finds both keep the reader in a state of arousal, 'the play of delay and release, delay and release [...] provides the pleasure in reading detective fiction' (Mancall 2006: 11). Ellroy's techniques are analogous to the consumer of pornography cueing up his favourite scenes, an apposite image of Ellroy's voyeuristic past and the repetition compulsion of solving his mother's murder in his work. Further, this messing with chronology is congruent with the antihero's essential temporality. His actions are necessarily linear. He is good; then he is bad; or vice versa. Either way, this causes a look back, a kind of rewind and reappraisal that reframes and complicates the character.

This untimeliness is a feature of what Sigmund Freud called 'screen memories'. He identified three kinds; for the third, 'screen memories displaced forward', we have an image of the link between Ellroy's biography and the Black Dahlia: 'the screen memory is connected with the impression that it screens not only by its content but also by contiguity in time: these are *contemporary* or *contiguous* screen memories' (Freud 1960 [1901]: 44, original emphasis). The noirish milieu of the LA Quartet, the promiscuous woman complicit in her murder, the investigation by desperate men – contemporaneity and contiguity are produced by a particular aesthetic configuration that is circumscribed by antiheroic history. Ellroy writes in the prologue to *The Black Dahlia* (published after its 2006 film adaptation by Brian De Palma), 'I structured L.A. '47 as a passion zone subsumed by Elizabeth Short [...] Her short time span and narrow purview expand and eclipse great public events' (2006 [1987]: 392). Here Ellroy points to the intermingling of memory, media, history and images in the creation of a feminine 'passion zone'. Further, 'Bucky Bleichert [the novel's protagonist] is a fictional cop and a doppelganger/writer-filmmaker. He's the man writing out the great adventure of his life and voyeur viewing sex with a camera' (393). That is, he is Ellroy, or at least a version of Ellroy he can slip into for an interview or a public appearance.

Other critics have traced the symmetries between Ellroy and Bucky by linking Bucky's and Ellroy's Oedipal dramas. In what she labels 'Ellroy's intimate cinema' (2006: 361), Carole Allamand connects the buck-toothed Bleichert, the instances of biting and blinding and the loss of family members in *The Black Dahlia*, Ellroy's spying of his mother's absent left nipple as a boy, and Ellroy's always-too-late search for his mother's killer:

> Jean Ellroy's blind nipple exposes the crime while rendering it invisible to the (private) eye. Obviously, the blind nipple figures the blindness of the detective [...] Ellroy turned to literature in order to make sense of his mother's absence [...] Ellroy cannot tear himself away from the site where their corpses lie.
>
> (Allamand 2006: 361–62)

But Ellroy's project is more than literary; Bucky is not just a writer but a '-filmmaker'.

The hyphen is important for it marks the movements between the conflicting states of the antihero. He 'writes out', but is also a 'voyeur viewing sex with a camera'. When I asked about the inspiration for certain repeated images in his writing, James says his eye once caught a glimpse of a friend's girlfriend's breast as she leaned forward to grab a cigarette lighter in 1979. This image has stayed with him ever since, appearing in *Brown's Requiem* when Sister Kallie pulls Brown out of his alcoholic relapse by letting him sleep with his face on her bare breasts (1996b [1981]: 147). Similarly, in *Because the Night*, Lloyd Hopkins's mother 'gives her breasts' to Hopkins after he was raped as a child (*L.A. Noir* 1997 [1984]: 229). This now explicitly maternal association appears, following Allamand's analysis of *The Black Dahlia*, in *The Big Nowhere*, when the closeted homosexual deputy sheriff, Danny Upshaw, is thrust out of the closet when he cannot seduce a tall, red-headed older woman because he is turned off by her asymmetrical breasts. This revelation via an incarnation of Ellroy's mother leads to Danny's suicide. In middle Ellroy, his biography enters deeply into his fiction, moving from murders solved at great personal cost to psychosexual nightmares of trauma and failure.

Late Ellroy

> *So women will love me.*
>
> – First line of *The Hilliker Curse* (original emphasis)

Ellroy's Underworld USA trilogy comprises *American Tabloid* (1995), *The Cold Six Thousand* (2001) and *Blood's a Rover* (2009), novels of antiheroic political history punctuated by the assassinations of major historical figures: John F. Kennedy, Martin Luther King, Robert Kennedy, J. Edgar Hoover. The emotional tenor of the novels comes from Ellroy's changing intimate relations with women between 1992 and 2010. When Ellroy is asked publically why he writes, he recites Dylan Thomas's poem, 'In My Craft or Sullen Craft' (1946). James says that it is an impressive thing to do for an audience, but one night he could not conjure the words. He was forced to answer the question directly: 'so women will love me.'

The presence of Ellroy's second wife, Helen Knode, an *LA Weekly* feminist critic who now writes crime novels (*The Ticket Out* [2003]; *Wildcat Play* [2012]), stamps the beginning of late Ellroy. Knode gave Ellroy a photograph of himself from a 1958 newspaper as a Christmas present in 1993. He was 10 years old, posed at a workbench with an awl, in the hours after his mother's murder. This seeded the idea for *My Dark Places*. But the fifteen-month re-investigation of his mother's murder (an attempt to correct the past) meant that he and Knode were often living apart. They moved to Kansas City, even though Ellroy remained in Los Angeles. Sex dwindled as they maintained a relationship by long-distance phone calls.

Further, Knode singularized the women Ellroy wanted to love him.

I was obsessed with *women* then. The emotional text was preordained. I was in love with *one woman* now. My whole world swerved. I got de- and re-compartmentalized. Helen rendered all other women sterile. My all-new novel got de-sexualised. [...] I know it now. I didn't know it then.

<div align="right">(Ellroy 2010: 93, original emphases)</div>

This repeats the familiar looks-back of compromised men seeking to correct the past. Each present becomes a past, and Ellroy, like his early investigators, does not know what it means until it is too late.

A nervous breakdown in 2002 during the arduous promotional tour for *The Cold Six Thousand* was followed by the end of Ellroy's marriage to Knode. During the final stages of its dissolution, Ellroy met then became engaged to Joan. When this relationship failed, he met Kathy. Both women are left-leaning academics. Both appear as socialist comrades in *Blood's a Rover*, the final instalment of the Underworld USA trilogy. 'My marriage was done', says James, reflecting on the long gestation of the trilogy (the LA Quartet was completed in five years; the Underworld USA trilogy was completed in fourteen years). 'It was time to find a woman and a project.' James describes the intimate relations in *Blood's a Rover* as 'fictional projections of perfect love. I made them into something very grand, because they were not going to work out in real life.'

Late Ellroy's antiheroic history is Romanticism revised for the failed revolutionary 1960s. Dwight Holly and Wayne Tedrow, Jr., who in the earlier books were responsible for the state-sanctioned assassination of people ranging from pimps to Dr Martin Luther King, Jr.; who enacted J. Edgar Hoover's infiltration of civil rights organizations; and who had financed these operations with CIA-overseen slave labour heroin-production in Vietnam, have revolutionary about-faces in *Blood's a Rover*. Wayne Tedrow, Jr., recognizing the similar slave labour being used in the Dominican Republic to build Mafia-connected casinos, blows them up. He is killed in retaliation by the state, and a cult of resistance is born in his image. Dwight Holly, Hoover's confidante and 'muscle', constructs an assassination plot against him. What James calls the 'rogue authoritarians' of his late work, the bad men who secretly define their time, attempt not to correct the nightmarish past in *Blood's a Rover* – as in middle Ellroy's antiheroic historical fiction, and his fictional solving of his mother's murder in early Ellroy's procedural crime fiction – but to destroy it for the women they love.

Ellroy's return to Los Angeles in *Perfidia* brings him back, yet again, to the slippery milieu of his biography, and his early and middle periods. James says he partly based the character of the younger Kay Lake (she also appears in *The Black Dahlia*) on a British journalist he met briefly on the promotional tour for *Blood's a Rover*. He says that he sent her an advance edition with a note saying as much, which led to a brief affair in late 2014. What's next? 'When in doubt', says James, 'write a story'. *

REFERENCES

Allamand, C. (2006), 'A Tooth for a Private Eye: James Ellroy's Detective Fiction', *Journal of Popular Culture*, 39: 3: pp. 349–64.

DeLillo, D. (1988), *Libra*, Harmondsworth: Penguin.

Ellroy, J. (1990a [1986]), *Killer on the Road*, New York: Avon.

––––– (1990b), *L.A. Confidential*, London: Arrow Books.

––––– (1991), *Preliminary Statement Notes* [Manuscript], Ellroy Collection (MSS. 1999:1), Irvin Department of Rare Books and Special Collections at the University of South Carolina Library, Columbia, SC.

––––– (1992), *White Jazz*, London: Arrow Books.

––––– (1995), *American Tabloid*, London: Arrow.

––––– (1996a), *My Dark Places*, New York: Knopf.

––––– (1996b [1981]), *Brown's Requiem*, London: Arrow.

––––– (1996c [1982]), *Clandestine*, London: Arrow.

––––– (1997), *L.A. Noir*, London: Arrow.

––––– (2001), *The Cold Six Thousand*, New York: Knopf.

––––– (2004), *Destination: Morgue!*, London: Arrow.

––––– (2005 [1988]), *The Big Nowhere*, London: Arrow Books.

––––– (2006 [1987]), *The Black Dahlia*, London: Arrow Books.

––––– (2007), 'Introduction', Dashiell Hammett, *The Dain Curse, The Glass Key and Selected Stories*, New York: Knopf.

––––– (2009), *Blood's a Rover*, New York: Knopf.

––––– (2010), *The Hilliker Curse*, New York: Knopf.

––––– (2014), *Perfidia*, New York: Knopf.

––––– (2015), personal phone interview, 28 January–17 February.

Freud, S. (1960 [1901]), *The Psychopathology of Everyday Life* (ed. James Strachey; trans. Alan Tyson), London: Hogarth.

Larabee, A. (2013), 'Editorial: The New Television Anti-Hero', *Journal of Popular Culture*, 46: 6, pp. 1131–32.

Mancall, J. (2006), '"You're a Watcher, Lad": Detective Fiction, Pornography and Ellroy's L.A. Quartet', *Clues: A Journal of Detection*, 24: 4, pp. 3–14.

Morrison, T. (1998), 'Comment', *The New Yorker*, 5 October, http://www.newyorker.com/magazine/1998/10/05/comment-6543. Accessed 12 December 2014.

Contributors

Fiona Peters (editor) is Senior Lecturer in English and Cultural Studies at Bath Spa University. She is the author of *Anxiety and Evil in the Writings of Patricia Highsmith* (2011) and *The McFarland Companion to Ruth Rendell* (forthcoming, 2015). She is the guest editor of *Clues: A Journal of Detection* Patricia Highsmith Special Issue (forthcoming, 2015).

Fiona has edited several books and published extensively on crime fiction, and literature and evil, love and desire. She ran the international conference *Captivating Criminality: Crime Fiction, Darkness and Desire* at Bath Spa in April 2014, and also its successor *Captivating Criminality: Traditions and Transgressions*, in June 2015.

Rebecca Stewart (editor) holds a Ph.D. from the University of Aberdeen. Her thesis, 'Constructed Selves: The Manipulation of Authorial Identity in Selected Works of Christopher Isherwood' (2009), positions Christopher Isherwood as an influential literary force of the twentieth century. Rebecca is a lecturer in the School of Humanities and Cultural Industries at Bath Spa University. She is also a lecturer

with the academic exchange programme Advanced Studies in England. Alongside Fiona Peters, Rebecca ran the *Captivating Criminality* conferences held at Bath Spa University. Her research interests are concentrated primarily in the fields of twentieth-century and contemporary English and American literature, including twentieth-century crime fiction. Rebecca has presented at a number of conferences looking at crime fiction, including *Isolation and Landscape in Modern Crime Fiction*, which is due for publication in 2015.

Abby Bentham previously enjoyed a fourteen-year career in the advertising industry. She currently teaches undergraduate modules on literature, critical theory and evil at the University of Salford. Her research interests include narrative poetics, transgression, the aesthetics of violence, psychoanalysis, gender and popular culture. She has published on subjects as diverse as Dickens and *Dexter* and is currently working on a book-length project exploring the literary trajectory of the fictional psychopath.

Carl Malmgren teaches courses on the modern novel and literary theory at the University of New Orleans. He is the author of book-length studies of postmodern fiction, science fiction and detective fiction and of more than thirty essays on modern fiction. His most recent publication is *Paris Metro*, a mystery novel set in Paris in the 1920s.

Gareth Hadyk-DeLodder is currently pursuing his doctorate at the University of Florida. He works predominantly in nineteenth-century studies, where his interests include cultural forms and understandings of memory, translation, gender studies and European Romanticism. His dissertation traces the ways in which German Romanticism, different typologies of nostalgia, and the retrospective gaze were taken up and repurposed by prominent nineteenth-century British authors.

Sabrina Gilchrist is a Ph.D. candidate at the University of Florida, where she focuses on Victorian literature and women's studies. Her primary research interests include dance, performance, class, gender studies, and the body. Her dissertation considers the role of the ballroom and its influence on Victorian social mapping. She is also interested in how certain Victorian prescribed norms and other classical tropes are carried through into contemporary mediums like television and film.

Gill Jamieson studied English, film and television studies at the University of Glasgow, graduating in 1992. She completed a Ph.D. at Glasgow Caledonian in 2001. She has been lecturing in film-making and screenwriting at the University of the West of Scotland since 1998. Her research and teaching interests include television drama (US/UK), literature on-screen and crime drama.

Isabell Große studied English, German and educational studies in Leipzig until 2010. She currently works as a Ph.D. candidate and research assistant at the Department of British Studies at Leipzig University, Germany. From 2011 to 2014, she held seminars on literary analysis as well as literary history. Her thesis focuses on the use of intertextuality and metafiction in contemporary British detective fiction. Further research interests of hers include the construction of identity, the role of narratives and images of the noir in (post-) postmodernist popular culture/literature. She continues to present and analyse the role of parody, pastiche and meta-narration in British, American and Scandinavian crime fiction.

Jacqui Miller is Principal Lecturer in Film History and Subject Leader for Media and Communication at Liverpool Hope University. She is a film historian with an interest in the representational relationship between film, history and culture. She has published widely in a range of areas within film studies, including books on film and ethics, and the relationship between fandom and Audrey Hepburn's star persona. Her most recent publication is on pioneer women directors in the classical Hollywood studio system. At Liverpool Hope she leads the Popular Culture Research

Group, and hosts an annual international conference, *Theorizing the Popular*.

Katherine Robbins has a Master of Letters in Shakespeare and Early Modern Drama in Performance and is currently working on her Ph.D. in Instructional Technology at the University of Nebraska, Lincoln. Her interest in antiheroes came out of a class she taught on 'Narrative in Film'. She is a huge fan of *Breaking Bad* and loved having an excuse to rewatch the show in order to prepare her essay.

Nicole Kenley is Assistant Professor of English at Simpson University in Redding, California. She works on contemporary fiction, genre and globalization, and has been published in *Mississippi Quarterly* and *Clues*. She earned her Ph.D. in English at the University of California, Davis.

Kent Worcester is Professor of Political Science at Marymount Manhattan College, where he teaches courses on democratic theory, green political theory, modern political theory, and the politics of popular culture. He is the author, editor and co-editor of eight books, including *C.L.R. James: A Political Biography* (1996), *A Comics Studies Reader* (2009) and *The Superhero Reader* (2013), which was nominated for an Eisner Award in 2014.

Mark Hill is an Assistant Professor of English at Alabama State University where he has created a burgeoning film studies programme. An active member of MLA, Film and History, the Society for the Study of Southern Literature and the PCA/ACA, he

has published and presented on an array of topics related to contemporary film and comic culture, especially in its relationship to changing trends in subsections of American masculinity.

Mary Marley Latham specializes in feminist critical theory and romantic poetry and is pursuing a Ph.D. in English at Southern Illinois University in Carbondale. She holds an M.Ed. from the University of Tennessee in Knoxville and an MA in English at Middle Tennessee State University. Beyond her academic work, she enjoys creative writing, cooking, the company of animals and walks in nature. Her maternal grandmother Rev. Martha Cargo, a Methodist minister's widow who became a minister herself, bequeathed Mary a library of mystery novels. This chapter is dedicated to her memory.

Joseph Walderzak studies media and cinema at DePaul University. He is contributing chapters to forthcoming anthologies on topics including the damsel of the Marvel Cinematic Universe, class in *Downton Abbey,* and gender politics in *Mean Girls*. His thesis investigates how narratives involving teen romance and popularity have shaped and shifted the discourse on class in American teen films from 1978 to present.